DARREN ALMOND JAKE & DINOS CHAPMAN
MAT COLLISHAW MICHAEL CRAIG-MARTIN
GRENVILLE DAVEY RICHARD DEACON
PETER DOIG ANGUS FAIRHURST TERRY FROST
HAMISH FULTON ANYA GALLACCIO
SIOBHÁN HAPASKA PATRICK HERON
DAMIEN HIRST GARY HUME ANISH KAPOOR
ABIGAIL LANE LANGLANDS & BELL
CHRISTOPHER LE BRUN ADAM LOWE
IAN McKEEVER BRUCE McLEAN LISA MILROY
CHRIS OFILI MARC QUINN GEORGINA STARR
SAM TAYLOR-WOOD GILLIAN WEARING
RACHEL WHITEREAD BILL WOODROW
CERITH WYN EVANS CATHERINE YASS

CONTEMPORARY ART IN PRINT

THE PUBLICATIONS OF CHARLES BOOTH-CLIBBORN AND HIS IMPRINT THE PARAGON PRESS 1995–2000

EDITED BY PATRICK ELLIOTT
WITH AN ESSAY BY JEREMY LEWISON

CONTEMPORARY ART IN PRINT

BOOTH-CLIBBORN EDITIONS

First published in 2001 by Booth-Clibborn Editions Limited
in association with The Paragon Press.

Booth-Clibborn Editions
12 Percy Street
London W1T 1DW
Tel: 44 (0) 20 7637 4255
Fax: 44 (0) 20 7637 4251
www.booth-clibborn.com

The Paragon Press
92 Harwood Road,
London SW6 4QH
Tel: 44 (0) 20 7736 4024,
Fax: 44 (0) 20 7371 7229
www.paragonpress.co.uk
email: charles.booth-clibborn@paragonpress.co.uk.

Edited by Patrick Elliott
Designed and typeset by Peter B. Willberg at Clarendon Road Studio
Printed and bound in Hong Kong
Photographic Credits: Stephen White, Prudence Cuming Associates

The text/captions/artwork in this book have been supplied by The Paragon Press.
While every effort has been made to ensure accuracy, Booth-Clibborn Editions
cannot accept responsibility for errors or omissions under any circumstances.

A Cataloguing-in-Publication record for this book is available from the Publisher.

ISBN 1 86154 210 0

Printed and bound in Hong Kong by DNP

CONTENTS

FOREWORD

In the late 1980s I met a famous American artist and a well-known American dealer. I was introduced as a rare and curious species: a publisher of prints by British artists. Both men seemed amazed and shocked that I would want to work with British artists. Today, thankfully, the reverse is true, with American galleries opening branches in London and British art occupying centre stage in the international art world. The city now boasts Tate Modern and Tate Britain, two museums but one institution unified in displaying modern and contemporary international and British art. There exists in Britain today an extraordinary pluralism in the visual arts stretching across the generations, in particular my own generation of artists in their mid-thirties to early forties, though the ages of the artists published by the Paragon Press in the past few years ranges from 30 to 85. My activities as a print publisher in many ways merely mirror this abundance of creative talent, which is mainly, though not exclusively, centred in London.

I became a publisher because I was fascinated by the printed image and wanted to work directly with artists. It was never my intention to work exclusively with British artists: my main aim was to work with the artists I admired who had, for the most part, not previously made prints. However, it soon became apparent that the success of each project depended upon a very close collaboration between the artist, the printers, the publisher and various other collaborators: publishing is not simply a question of commissioning a project and waiting for the results. I have therefore tended to work with artists who live within reach of the printmaking studios we work with (most of the projects have been made in London, but some have been made in Cornwall). In this way a project can develop in an open and fluid way, sometimes over a period of months or even years. These conditions hopefully make for an original and significant project, not one made under geographical or time pressures.

Over the last two decades the world of contemporary art has become larger and more complicated, and as the opportunities for artists to make and distribute their work has grown, so the publisher's role and independence from mainstream art dealing has, I believe, become more important. Despite having the name 'Press' as part of our publishing name, we have never owned a press or any fabricating facilities, for the simple reason that this would compromise our flexible approach. Instead we work with a number of independent printmaking studios and place artists within the most suitable environment in which to make their print projects. In this way the artists are not bound to work with a particular technique (etching, lithography, screenprinting etc.) or with a particular print studio, but can experiment before deciding which avenue to take.

As publishers we have tried, as is the historical nature of our business, to project these artists and their printed works into an international

forum. This has involved visiting museums and collectors all over the world, and placing projects in many major collections. This book is part of that same process of promulgation. It is the second book about Paragon projects: the first, *Contemporary British Art in Print* covered the publications from 1986 to early 1995 while this volume concerns the period from 1995 to the present. Patrick Elliott, Assistant Keeper at the Scottish National Gallery of Modern Art, has interviewed the artists and their various collaborators, and each project and print has been reproduced in colour. Jeremy Lewison of the Tate deals in his essay, 'Contemporary British Art in Print?' with the complicated issue of what constitutes 'Britishness'.

We owe whatever success we have as publishers to the trust, generosity and goodwill that have been invested in us by the artists and the printers. I dedicate this volume of Paragon Press publications to the thirty-two artists whose work we have published over the last six years and to our printers, especially Brad Faine, Hugh Stoneman, Simon Marsh and Peter Kosowicz. In particular I would also like to thank Patrick Elliott and Jeremy Lewison for their texts, Peter B. Willberg, who has designed the book, my assistant Charles Govett and my father Edward Booth-Clibborn, who has published the book. I would also like to thank the following printers, designers, book-binders, colleagues and friends, who have contributed to the making of the publications of The Paragon Press: Phil Baines, James Booth-Clibborn, Hiram Butler and Devon Borden, David Case and Marlborough Graphics, Richard Caves, Alan Cristea and Kathleen Dempsey, the

staff at Coriander Studio, Thomas Dane, Leslie Garfield, Charles Gledhill, Antony Griffiths and Frances Carey of the British Museum, Richard Calvocoressi of the Scottish National Gallery of Modern Art, Denny Hemming and Booth-Clibborn Editions, Katharine and Susanna Heron, Ken Hawkins and Terry Prosser of Lee Associates, Jay Jopling and Daniela Gareh and White Cube, David Kiehl, Simon and Angela King, the staff at Hope (Sufferance) Press, David Landau, Christopher London, Christopher Le Brun, Nicholas Logsdail and the Lisson Gallery, Adam Lowe and Permaprint, Adrian Lack, Etienne Lullin, Victoria Miro and the Victoria Miro Gallery, Karen McCready, Simon and Alexandra von Oppenheim, John Purcell and John Purcell Paper Ltd, Jenny Ramkalawon, Roberta Waddell of The New York Public Library, Andrea Rose and Diana Eccles of the British Council, G. Ryder & Co. Ltd, Karsten Schubert, Claus Thierbach, the staff of the Modern Collection at the Tate, Greville Worthington, Deborah Wye, Wendy Weitman, Starr Figura, Harper Montgomery, Judith Hecker of MOMA New York, Tom Zollner, Patrick McCaughey, Scott Wilcox, Gillian Forester of the Yale Center For British Art, New Haven, Bill and Pauline Woodrow and especially my wife Léonie and our children Edwina, Céleste and Evelyn.

Charles Booth-Clibborn
London, February 2001

INTRODUCTION
by Patrick Elliott

This book examines twenty-five print projects by thirty-two of Britain's leading artists. The prints — about three hundred and fifty in total — range from single images created for a group portfolio (*Screen*, published in 1997) to a series of eighty-three *Disasters of War* etchings made by Jake and Dinos Chapman. The artists span several generations and cross various disciplines, from the *Screen* artists who took part when they were in their late twenties or thirties and had, for the most part, little experience of printmaking, to Terry Frost and Patrick Heron who had been making prints for the best part of fifty years. Some of the artists are primarily painters; sculptors and others are primarily painters; some work with computers and others work with video. The common denominator is that all the prints were commissioned and published by the Paragon Press between 1995 and 2000.

The request to make the prints comes from Charles Booth-Clibborn, who launched the Paragon Press in 1986 when he was still a student at Edinburgh University. A notable aspect of the Paragon projects is that many of the artists had little previous experience of printmaking. Asking a painter or a sculptor to make a print is like asking a novelist to write a film script, or a television actor to perform on stage. These are related but different disciplines requiring a different set of skills, and this is where, as far as printmaking is concerned, the publisher makes a vital contribution, offering advice and support throughout the production of the project.

And just as it is the case that not all actors can make the transition from television to the stage (and vice versa), so it is the case that not all great painters or sculptors are natural print-makers. Think, for example, of Francis Bacon whose prints are simply reproductions of his paintings, or even Giacometti, whose litho-graphs are essentially serially-produced versions of his drawings.

So the first job of the publisher is to identify artists whose work might find some sympa-thetic correspondence in a printed medium, be it etching, lithography, screenprint, woodcut, linocut, photogravure or any of the other printing techniques. Making prints should be a test of sorts, setting the artist different questions. How does a sculptor used to working with plaster or bronze or an artist used to working with a video camera adapt to making a set of flat, printed images? In fact, prints do not necessarily have to be flat, as Langlands & Bell have shown in their embossed prints *Enclosure and Identity*. The stipulation that the artists should produce a set of prints (normally around 10 images) allows them to make a substantial statement. By making a series, the artist can construct a narrative within the print cycle, or through repetition and emphasis can build some sort of dialogue across the prints. In this way the projects act as portable exhibitions, and they have often been used as such. There is usually just one restriction: that the portfolios should be easily portable (Booth-Clibborn's original stipulation

was that they should be able to fit into the boot of a New York cab), though Damien Hirst and Gary Hume persuaded the publisher otherwise and made much larger prints.

The projects have taken anything from a few weeks to nearly a year to complete; most were under discussion for months or even years before the artists actually began the work. Owing to the length of time each project takes to germinate and materialise, and to the intense involvement required of the publisher, all the projects do, for practical reasons, involve British artists and British printing studios. In some cases, the artists have focused on their project to the exclusion of all other work (this was the case with Jake and Dinos Chapman whose twenty *Exquisite Corpse* etchings were done, methodically, one a day for twenty days), while others might visit the printmaking studio once a week over a much longer period. Some have preferred to make the prints in the calm of their own studios (Patrick Heron and Christopher Le Brun) while others have chosen to work at the printing workshop in close collaboration with the printers (Peter Doig and Grenville Davey). Screenprinting, particularly from photographic images, can be a highly technical matter, and quite a few of the artists working with screenprint have proceeded by trial and error, telling the printers what they want without knowing exactly how an effect might be achieved, and then requesting changes as each proof is made. A print may go through dozens of different states and imperceptible changes before the artist is satisfied. In this way, the printers make an

essential contribution, facilitating the realisation of the artist's vision, without imposing their own wishes.

At the start the artist may have only a vague conception of the scale and character of the project he or she wishes to make. An initial intention to make woodcuts may be set aside and the project eventually develop into a set of etchings; equally, the intention to make ten etchings may ultimately swell to twenty or more. In a number of cases, the artists have had specific projects in mind, and have been able to respond quickly when invited to produce a portfolio of prints (this was the case with Rachel Whiteread, Chris Ofili and Terry Frost). More often than not, the artists will have quite a specific idea of what they want to do, but perhaps only a tentative idea of how they might go about actually doing it. Together, the artist and publisher will discuss the almost endless possibilities and the pros and cons of different techniques and approaches. It was a leap of imagination that suggested that Peter Doig, a painter known for his vast canvases, might work so naturally on a small scale with a tiny etching needle; or that the Chapman brothers, famous for their oddball mannequins which sprout genitalia like a nasty rash, might produce such magnificent and essentially traditional etchings. Other parallels are perhaps more obvious. Like Roy Lichtenstein or Andy Warhol, Gary Hume is an artist almost destined to work in screenprint, a technique which can present a flat, unmodulated surface even more successfully than gloss paint on metal panels.

The way the artists have approached print-making is often intensely revealing. This is particularly true of Chris Ofili, whose paintings with elephant dung and collaged erotica have earned him notoriety. Yet here, in the *North Wales* series, we discover him in intense, private moments, industriously scratching away at small copper plates in seaside towns on the north-west coast of Wales. In these various print projects, we are allowed to see another dimension or facet of an artist's temperament, something which may be present in their painting or sculpture but which is not immediately apparent. At this level, the prints clarify and endorse an artist's work as a whole. Rather than simply being flat reproductions, they have the same integrity and weight as the artist's main body of work. They are an integral part of that main body of work. For this reason, Paragon projects have frequently featured in retrospective exhibitions, alongside sculpture, painting or video.

Often, the artists who have worked with Paragon Press have discovered something new about their work through printmaking, and it has become an important aspect of their work as a whole: this is the case, for example, with the Chapmans, Peter Doig, Christopher Le Brun, Ian McKeever and Chris Ofili. It has often been the case that the sculptors have taken very naturally to printmaking. This is partly because several printmaking techniques are closely related to sculpture: linocut, woodcut and even etching are, after all, basically cutting and carving processes. Also, sculptors often work with assistants who help with the manual

tasks, and this again happens in printmaking, where one or more printers will be on hand to physically produce the print on the press. A number of the painters whose work features in this volume have commented on the initial surprise they experienced in the printmaking studio, where, in contrast to the privacy and silence of their own studios, one or more expert printers would be at their beck and call and other artists would be drifting in and out.

An earlier volume, *Contemporary British Art in Print*, catalogued the publications of the Paragon Press from 1986 to early 1995, and coincided with an exhibition shown at the Scottish National Gallery of Modern Art in Edinburgh and subsequently at the Yale Centre for British Art in New Haven, USA. Quite a few of the artists featured in that first volume also appear in this one: Terry Frost, Christopher Le Brun, Ian McKeever, Bill Woodrow, Hamish Fulton and Anish Kapoor, for example. That first volume also included a group portfolio, *London*, which was published in 1992 and showcased the emerging generation of artists who were to become popularly known as YBAs (after a series of exhibitions of Young British Artists held at the Saatchi Gallery in London from 1991). Comprising eleven images, *London* included the first published prints by Angus Fairhurst, Damien Hirst, Langlands & Bell, Marc Quinn and Rachel Whiteread, and since 1995 these artists have all produced print series for Paragon. It is worth mentioning that the Paragon Press published the work of Hirst, Whiteread and Ofili before any of them had won the Turner Prize and that many of the

artists discussed in this volume made their first prints with Paragon. The group portfolio *Screen*, published in 1997, works in a similar way to *London*, sampling the production of a dozen young artists, several of whom are involved in video work, and introducing many of them to the printed medium.

Something striking about the Paragon Press is its pluralistic approach and its seriousness of purpose. Booth-Clibborn may have been the first to publish prints by the young generation of British artists, but he has not ignored preceding generations. So here we find the work of artists who have been established for twenty or thirty years, including Ian McKeever, Bruce McLean, Bill Woodrow, Richard Deacon and Hamish Fulton, as well as artists who were working before the Second World War, namely Terry Frost and Patrick Heron (their contemporary Alan Davie also produced a portfolio for Paragon back in 1988). In this way, the Paragon Press works like a museum of modern art, showing the best of a broad range of contemporary art practises which are current in Britain.

The entries on the twenty-five projects are almost all based on interviews with the artists, and I would like to thank them for the interest they have shown. My thanks also to the printers who discussed the projects with me, particularly Brad Faine, Adam Lowe, Hugh Stoneman, Peter Kosowicz and Simon Marsh, and of course to Charles Booth-Clibborn, who initiated the book. Charles Govett provided much of the basic documentation on the projects and answered numerous queries. Thanks also

to Patricia Allerston, Glynnes Newell, Isobel Johnstone, Helen Luckett, Sam Hodgkin, Katharine Heron and Susanna Heron, and the staff at the following galleries: Asprey Jacques, Victoria Miro, Waddington Galleries and White Cube.

CONTEMPORARY *BRITISH* ART IN PRINT?

by Jeremy Lewison

Contemporary British Art in Print. That was the title of the book published in 1995 to which this one is a companion. The elimination of 'British' from the present title raises a number of issues, not least the concept of Britishness. Who would have imagined that the day would come when such a simple, anodyne word as 'British' might be considered controversial? In the past we might have debated whether or not a print was an original work of art or whether a screen print could be considered fine art, or we might have discussed what is meant by contemporary. But now issues surrounding nationality, cultural diversity and ethnicity are to the fore.

A recent report by the Runnymede Trust suggests that the concept of Britishness is now redundant and outmoded, that changing demographics, a century of immigration and a heady mix of cultural and religious beliefs among the population of these isles call for the rejection of plain old 'British' as a sobriquet.[1] For the Runnymede Trust it has become imprecise and thus disposable. Traditionally, being British meant that not only were you a native of this land, but so were your forefathers over many generations. Essentially to be British was to be white. But a sizeable section of the population of Britain does not conform to this traditional description of Britishness. For the Runnymede Trust blacks are Afro-British; Jews are Jewish-British; those of Indian or Pakistani origin are Asian-British. None are simply British. It follows, therefore, that vast numbers

of the population of Great Britain are unplaced, neither British nor not British. Perhaps this is what characterises Britishness; being not not British.

Shortly after the publication of this report various newspapers interviewed a number of 'not-British' people; that is to say people who previously might have been considered British because they were born in Britain but who, by the definition of the Runnymede Trust, could not be considered straightforwardly British. Almost all the respondents, while acknowledging the importance of their roots, testified to feeling first and foremost British. They passed the Norman Tebbitt test of Britishness: under the extreme pressure of deciding which country to support in a sporting contest they invariably replied Britain.[2]

Britain, or should we say the United Kingdom of Great Britain and Northern Ireland (has there ever been such a misnomer as the United Kingdom given the long history of separatism in Wales, Scotland and Northern Ireland?) is now a multicultural society. This was, in effect, the gist of the Runnymede Trust report. But in some respects it has always been so. Who among the population can claim a long line of descent to the first people to populate these islands? Britain has been occupied, among others, by the Vikings, the Angles, the Romans, the Saxons and the Normans. The present monarch is of German extraction. Britain has a history of multiculturalism or, to be more

1 The Runnymede Trust is an independent think-tank devoted to the cause of promoting racial justice in Great Britain. In January 1998 it set up a Commission on the Future of Multi-Ethnic Britain which published its report in October 2000.

2 Norman Tebbitt, now Lord Tebbitt, was a minister in the government of Margaret Thatcher.

3 Nikolaus Pevsner, *The Englishness of English Art*, Architectural Press 1956

4 David Piper (ed.), *The Genius of British Painting*, Weidenfeld and Nicolson 1975

5 Susan Compton (ed.), *British Art in the Twentieth Century – The Modern Movement*, Royal Academy of Arts and Prestel Verlag 1986

accurate, cultural mix. So the Runnymede report was doing no more than state the obvious; that the British Isles continues to play host to a number of different races, religions and cultures each aspiring to be heard alongside the WASP culture that continues to regard itself as dominant and pre-eminent. To be British is in effect to live here, to hold an allegiance to the community that occupies this land and to support, more or less, its democratic institutions.

All the artists in this book live and work in England. If Britishness is determined by where you live why not Englishness? Britishness is highly distinct from Englishness, or Scottish-ness, or Welshness, or Irishness. Indeed, many people who were born in England, but whose family history links them to other countries and cultures, would refuse the epithet English because English implies something purer than British. Given that British already implicates English, Scots, Welsh and Irish it is impure and multivalent. English on the other hand is a singular concept. For many people the history of England is the history of an aristocratic ruling class, albeit slowly diminishing in power since the foundation of Parliament and partic-ularly since the passing of the nineteenth-century Reform Acts. Until recently history has been told by reference to great leaders, generals and politicians. Only in the last thirty years have historians turned to the history of the common people, those who fought the battles, produced the nation's wealth and farmed its land. Somehow, Englishness seems to be concentrated in the hands of the few, Britishness in the hands of the many.

So this book assembles art by artists who are neither British nor not British but is it British art? What is British art? There has never been an adequate definition of British art and I suspect there never will be. Nikolaus Pevsner tried to define the Englishness of English art[3] but never reached a satisfactory conclusion. Titles of such books as *The Genius of British Painting*[4] or *British Art in the Twentieth Century*[5] imply that there exists a definable essence to British art that differentiates it from the art of other nations. The existence of Tate Britain suggests that, through the grouping of works made within these shores and by people with varying cultural agendas, we shall be able to identify what is characteristically British. British, it implies, is everything that is not British. The opposite of British is foreign. Foreign art has no place in Tate Britain except to provide a contrast to what is British. British is thus defined by difference. Foreign art is other. British art, in the context of Tate Britain, is the norm. But is it really different? Don't British artists adopt strategies, techniques and themes common to artists of other nationalities? Has not British Art always been subject to foreign influence—think of the impact of Holbein, Van Dyck, Claude, Picasso and countless other artists some of whom settled here. Will the British art of previous centuries appear foreign, or other, to future generations when shown alongside the art of the multicultural, interna-tional society that Britain has become? Perhaps the word British was correctly eliminated from the title.

Looking at the list of artists published by Paragon Press we begin to appreciate the thrust

6 Lisa G. Corrin, 'Confounding the Stereotype', *Chris Ofili*, exhibition catalogue, Southampton City Art Gallery and Serpentine Gallery, London 1998, p.15

of the Runnymede Trust's argument: Peter Doig (Canadian), Anish Kapoor (Iraqi-Indian-British), Chris Ofili (born Manchester but family of African origin), Siobhán Hapaska (Irish), Cerith Wyn Evans (Welsh), Catherine Yass (Jewish-British), Lisa Milroy (Canadian, now naturalised British), Michael Craig-Martin (Irish-American), Bruce McLean (Scottish). While they may or may not carry British passports their art is said to reflect their cultural heritage. But cultural heritage is a complex concept. It might start with the family, it might subsume a particular artistic tradition, it might embrace a set of attitudes arising out of a particular context or a religious belief. Cultural heritage is perhaps even more wide-ranging than that. It is part of the collective unconscious, baggage that you inherit through osmosis. It is not confined to the outward trappings of national identity. It is ridiculous to assert, as some have done, that such artists as Kapoor or Ofili are searching for their lost cultural identities. While they may adopt strategies deriving in part from cultural practices found in their (ancestral) cultures of origin, these practices are as alien to them as to any other European. Indeed, it is partly a sense of otherness, perhaps even of the exotic, that they seek and find by adopting strategies of difference, a sense of otherness that expresses their own difference within the dominant 'British' culture. Thus in his earlier work Kapoor employed raw pigment after observing its use outside Indian temples, but this was a discovery made in adulthood, not a memory from childhood. Kapoor's interest in the infinite, as expressed in his use of deep blues and reds, is derived as much from his

admiration for Yves Klein and Mark Rothko, as it is from the sight of piles of pigment in India. But the association with this Indian practice gave his interest a different and particular inflection that he could identify with. And by appropriating it he achieved his European Modernist end.

Similarly, as Lisa Corrin has written, 'Ofili's "African connection"— decorating elephant dung to resemble beading, painting in a manner that privileges "craft", absorption of West African textiles and dot-patterned surfaces of ancient Matopos cave paintings — is not a search for cultural roots but for artistic routes.'[6] Ofili first travelled to Africa in 1992 while still a student. These were not traditions handed down to him by his parents or through exposure in Britain. Of course some of the themes of Ofili's art, notably the underlying racism of British society, emanate from his cultural environment but they are not specifically British. Racism is endemic throughout the world.

It is easy to focus on Kapoor and Ofili to demonstrate that there is nothing particularly British about their art. Norman Tebbitt would tell us that was obvious. So what about Damien Hirst, the quintessential YBA? Like many contemporary artists Hirst's strategies of presentation owe much to Marcel Duchamp (Franco-American or French?) in his employment of the readymade. Hirst takes Duchamp's practice to an extreme as he calls up a shark hunter to supply a dead shark, an abattoir to provide a cow and calf, a fish farmer to provide fish, all of which he presents in tanks with minimum intervention. His series of dot

paintings knowingly look back to Duchamp's assisted readymade *Pharmacy*. His series of prints, *The Last Supper*, is itself an assisted readymade. Adopting the designs of commonly found pharmaceutical packaging, Hirst substitutes his brand for theirs and the names of the drugs for traditional British 'delicacies': steak and kidney, beans and chips, sausages, omelette, Cornish pasty, liver bacon and onion, many of which are arguably as lethal and unhealthy as the cocktail of chemicals they supplant (BSE, foot-and-mouth, salmonella, saturated fat, sugar and animals heavily dosed with antibiotics have become international public health risks). The names of the dishes, however, are the only British aspect to these prints, unless one considers irony to be a British trait. If *The Last Supper* makes reference to Duchamp it does so through the filter of the American (or should it be Czech-American?) Andy Warhol, whose late paintings of the same title are now celebrated. The title creates an immediate link with Warhol, as does the strategy of using commercial design to make fine art, for Hirst's prints make obvious reference to Warhol's Brillo boxes, Coke bottles and Campbell's Soup images.

Writers about Hirst's work often harp on about the importance of the theme of death but his work is not so much about the experience of death — what it means, the emotional and physical effects on the survivors, the trauma, the pain of dying and so forth — but rather death as a spectacle. A dead shark in a tank is about the presentation of death; a cow and calf divided is not an object of sentiment or

emotion but a bald statement of fact. At times he has been interested in the mechanism of death, for example in *A Thousand Years* (1990) where the presence of a fly electrocutor is a reminder of the impersonality and arbitrariness of the act of dying. Where *The Last Supper* differs from this is in its overt interest in consumerism. It suggests that pharmaceutical products, which rely on heavy marketing, are now part of our staple diet, in some cases becoming food substitutes (think of all the slimming products or fibre substitutes consumed worldwide). The act of re-presentation becomes an act of repackaging. While medicine can be packaged as a dish, a dish can be packaged as medicine. Moreover, the fact that medicines are packaged in boxes bearing modernist designs implies that the modernist utopian dream is no more than a guise for something rather poisonous.

Hirst's engagement with consumerism is part of a continuing international discourse. The same might be said of Rachel Whiteread. Suggestions that her castings find a precedent in the work of Bruce Nauman, specifically *A Cast of the Space Under My Chair* (1965—68) are not unfounded, although that does not detract from the seriousness of Whiteread's endeavour nor the importance of her achievement. One may question her originality but what artist is ever original? It is common practice that one artist develops further the idea of another artist and Whiteread has taken the casting of objects further than Nauman cared to go. She has in effect appropriated an idiom and made it her own. It is not particularly British, nor for that matter is it American.

hand of a publisher who is encouraging without being controlling and provides an opportunity for the artist to express him or herself through an unfamiliar medium, in the hope of discovering something new about their task. In some cases the medium allows the artist to realise their ambitions more perfectly than they are able in the act of painting or sculpting. In other cases it allows the artist to develop ideas from one medium to another. For many of them the medium of print as a vehicle for translation is crucial. The unifying factor, I would suggest, is the potential each of them has found in the medium of print to establish a new idiom, or take a theme expressed in one language and translate it into another language, giving it a new inflection.

Take Patrick Heron, for example. Heron began making prints in the late 1950s when he participated in the St George's Gallery pilot project led by Stanley Jones. He made lithographs by translating into print the striped motifs familiar in his paintings of the period. Each of these prints had a handmade quality born of working directly on the stone or plate. But it was to be only a brief flirtation with autographic mark-making for, from the mid 1960s onwards, after his paintings became hard-edge, Heron abandoned lithography for screenprinting. To make a print he would deliver a gouache to the print studio and a printer would reproduce it as a screenprint. Heron's intervention was to approve the colours and final proof. How surprising, therefore, that right at the end of his life he should make a foray into etching.

The most that can be said for it is that it is now Whiteread. Her works speak of loss and memory, of human imprint and spirit of place. Whiteread's sculpture should be seen not so much in the context of the work of Nauman but rather Doris Salcedo, whose work resonates with savagery, physical pain and enforced silence. But where Salcedo leaves her negative castings embedded within the sculpture, evoking torture and gagging, Whiteread removes the cast and displays it in isolation. The absence of the mother object is a prerequisite to the dissociation of pain and memory. Whiteread's screenprinted photographs, *Demolished*, published in the aftermath of the demolition of her landmark sculpture *House*, are a trigger to evoke the memory of that lost icon as well as a memorial to 1960s urban blight and the death throes of the modernist dream. These are themes also found in art and other manifestations of culture worldwide.

So let us forget that the work in this book might celebrate Britishness and look for some other kind of coherence. Assembled here are some of the most interesting artists working in London (aside from Terry Frost, Hamish Fulton, the late Patrick Heron and Ian McKeever who work outside London). They represent three generations of artists, some of whom are currently fashionable and others who have had their time in the sun but continue to make good work. With the exception of Frost, Le Brun (after how many generations does someone become British?), McKeever, McLean and Woodrow, none of them have extensive experience of printmaking, but they have been steered towards significant projects by the guiding

The Brushwork Series was Heron's first published venture in etching and it has the appearance of an artist exploring a medium, seeking its potential, at first tentatively, as though mistrusting it, and ultimately with brio. Heron, like John Cage before him in his *Seven Day Diary (Not Knowing)* (1978), has taken the medium for a walk, exploring, with a wide-eyed innocence, the different marks he can make with a brush. Many of the motifs of his earlier paintings reappear so that the portfolio takes on the feel of a retrospective. The result is not a typical set of Heron prints, with the feel of mechanical reproduction, but a group of handmade images in which the artist has been reinvigorated by his flirtation with a new medium. Etching, I would suggest, allowed him to rediscover the enjoyment of print-making he must have experienced in the 1950s and to disinter memories and experiences of painting. Above all, the marks he made are completely different from those found in his paintings or gouaches. In etching Heron was finding a new form of expression.

The same may be said for Richard Deacon. Until he made *Show and Tell* Deacon had rarely published any photographic work except in catalogues. He had previously made prints but nearly always of a drawn nature. Deacon routinely takes photographs and has a vast lexicon of images of natural forms that may, unconsciously, inform his sculptures, but he has never made this visually evident. So what we find in *Show and Tell* is something revealing about the creative process, a glimpse of the echoes between his artistic creations and natural phenomena. This in itself is nothing

new to art — one only has to think of *On Growth and Form* (1917) by the morphologist D'Arcy Wentworth Thompson, or the parallels drawn between art and natural forms in *Circle* (1937), or indeed of Richard Hamilton and the Independent Group's interest in Thompson and their fascination for exhibits at the Natural History Museum in the early 1950s, to understand that a correlation between art and nature has long been of fascination to artists. But what is remarkable about the Deacon portfolio is the sense of artifice. Photographs, thus mechanical reproductions, of nature (or culture) are juxtaposed with drawings originally made by hand. In the translation into print, the drawings become mechanical, artificial in appearance, flat, while the photographs have a strong air of realism, of three-dimensionality. The photographs have the aura of authenticity, the drawings the semblance of the reproduced. It is as though the relationship of the hand-made to the mechanically reproduced has been reversed in the printing process. The drawings are like cartoon thought-bubbles artificially imposed upon a pastoral scene, the private thoughts and dreams that occur to the artist as he engages with the world.

Deacon's use of screenprint is thus literally revelatory. However, the conjunction of photograph and drawn image in a print is not exactly new. The juxtaposition of different qualities of image in this manner is found in, for example, *Fourteen Etchings* (1989) by Terry Winters (Russian-Jewish-American?), who also has an interest in morphology, although the relationship between the drawn and the photographed is reversed in Winters's prints

(that is the drawn image appears hand-made while the photoetched image appears mechanically reproduced). But in *Show and Tell* Deacon has allowed himself to go somewhere he has never been before, using a medium new to him to combine different kinds of image to reveal a thought process in a way that would not have been possible with drawing and collage. In a collage, the applied elements have an object quality. They literally stand out. They therefore have some degree of primacy. In a screenprint, or at least in these screenprints, the surface is absolutely flat. The drawings are prominent because they are surrounded by white, but they do not sit up like an applied piece of paper. The process is thus democratic; the two distinct images lie in the same plane.

If this has been a lone foray into screenprinting for Deacon Gary Hume is beginning to make it a regular practice, using it to perfect his approach to image making. Hume's paintings are executed in gloss paint on aluminium panel in order to achieve the smoothest possible finish. His paintings seek flatness, an almost mechanical feel, but ultimately total flatness is unachievable. Where two colours meet there is an edge, a small ridge and a sense of the materiality of the paint. Screenprinting, however, has allowed him to achieve total flatness, a unified surface with no ridges. Starting out from pre-existing paintings they end up as perfected images.

The transformative nature of the print medium, its capacity to render differently an image first expressed in another medium, is also central

to Anish Kapoor's project *Wounds and Absent Objects* where a pixel image, first created for video, has been transferred to polyester sheets and printed in pigments. While the light-emitting nature of the video version relied upon the cathode-ray tube, the print version relies on actual physical materials. The effect is totally different, the one time-based and evanescent, its pulsing quality derived from the flicker of the screen, the other permanent, its pulsing quality derived from the application of substance. Like Deacon, Kapoor employs a photo-mechanical process as a vehicle for translation and, as in all translations, the work in the new language differs from the original in nuance and resonance.

Kapoor has made prints before, above all in etching, which is a very physical medium displaying the marks of the artist. With *Wounds and Absent Objects* he has moved away from autographic mark-making to create a surface unblemished by human imprint. His sculpture has also moved in this direction. While his earlier stone sculptures displayed evidence of carving, either manual or mechanical, his recent works, made from fibreglass, are finished in such a way as to eliminate the contingent. The surfaces are sprayed like cars — in fact Kapoor employs an assistant who was a bodywork specialist — and rubbed down between coats to achieve a smooth, glossy finish.

Given the emphasis throughout his career on materials and object-making, video is not the medium one would have expected Kapoor to embrace. Similarly given the Chapman

brothers' penchant for shock tactics one would not have anticipated that they would emerge as seriously talented practitioners of the traditional medium of etching. But of course etching runs in the family, or almost. Their uncle by marriage is John Lund, the master etcher at Universal Limited Art Editions who now works exclusively with Jasper Johns. Whether or not they have had close contact with him, which they have, perhaps one might have expected this interest.

The *Disasters of War* and *Exquisite Corpse* portfolios are both predicated on the concept of appropriation, in the case of the former the magisterial etchings by Goya and in the case of the latter, the game of consequences played by the Surrealists in the late 1920s. Appropriation is a staple of Post-modernism, particularly in New York where it was done to death in the 1980s, but in the hands of the Chapmans it is not so much an act of re-presentation but rather one of translation. Passing the etching plate between them the Chapmans have created in *Exquisite Corpse* a series of horrific images which are nevertheless seductive and precious. The emphasis on detail is echoed in the amazingly detailed *Hell*, their installation in the *Apocalypse* exhibition held recently at the Royal Academy but, whereas the figures in *Hell* are all credible humans, the figures in *Exquisite Corpse* are complete fantasies. The Chapmans have played the Surrealist game to the letter allowing their imagination full range to create demons and monsters from another world. Their jewel-like quality, especially in the hand-coloured versions, belies their brutality. They betray

an equal amount of humour: there is as much Monty Python as William Blake in the Chapmans' etchings, a combination of the fantastic, the visionary, the brutal and the comic, also found in the work of the late Öyvind Fahlström.

The Chapmans are in every respect conventional printmakers. Their images, their technical means, their processes are all based on time-honoured precedent. The same can be said of Peter Doig who, like Hume, readdresses in etching themes he has previously explored in painting. Again, this is not a new practice. Traditionally artists have disseminated knowledge of their unique work through prints, although often the execution of the print was the responsibility of the specialist printmaker. Such an artist as Jasper Johns has made prints replicating paintings, using the different medium to explore a theme on a different scale and raising issues connected to the concept of re-presentation in the Duchampian sense. One effect is to make a public image more intimate, perhaps more introspective. More importantly, in the case of Doig, the etchings become third generation images, changed or perhaps perfected, through translation, transformation and editing. Doig's paintings originate in film stills or photographs. His etchings originate in the resulting paintings or vice versa. They are rarely identical. He might change or simplify the colours or crop the image using the medium of print in a filmic way. He employs the alchemical process of etching to break down, dissolve and transform the image in a manner which painting will not permit. The disintegrating process of

Tyler Graphics, to smaller scale operations working in Europe. Booth-Clibborn is one of a number of publishers who have changed the nature of print publishing from an emphasis on bravura printing and innovative techniques to a deep concern for content supported by appropriate technique. Recognising the current strength of art made in Britain, Booth-Clibborn has made a virtue out of a constraint. While he has eschewed the foreign he has begun to reflect the cultural diversity, implied by the contemporary concept of Britishness, indicated by the Runnymede Trust.

dipping the etching plate in a bath of acid is unique to etching and cannot be replicated in painting. Thus etching allows him to develop his images further or differently than in other media. It is like making a film of a book. They both tell the same story but with different emphases which are determined by the different characteristics of the medium. A translation is not a transcription but a reworking.

Doig's work, like the Chapmans', with its evident emphasis on manual process, contrasts strongly with the work of Hirst, Whiteread and Deacon and is a timely reminder, in the age of photography and video, that mark-making is still alive and well. Booth-Clibborn recognises the value of working with a wide range of artists using a broad range of media.

The character of the publications of Paragon Press has changed somewhat since the first volume devoted to its work appeared in 1995. Whereas previously Booth-Clibborn had commissioned predominantly middle generation artists, now he is prepared to work with all three generations. He recognises that age is no barrier to the production of interesting work. This is refreshing in an era when to be fifty is to be redundant and to be eighty is to be forgotten. It would not be a great compliment to say that Paragon Press is the most interesting print publisher in Britain today; it would, however, be more of one to say that it is among the leading publishers in Europe. Since the late 1980s and the collapse of the print market, the centre of attention has shifted from the great American publishers, Gemini GEL, Universal Limited Art Editions and

CONTEMPORARY ART IN PRINT

MARK QUINN
EMOTIONAL DETOXIFICATION, 1995

DESCRIPTION: 10 etchings with title-page, colophon and portfolio case.

EDITION: 30 sets numbered 1 to 30 (the first 20 sets presented in portfolio cases), plus 5 proof sets and 1 BAT.

INSCRIPTIONS: Each print signed and numbered by the artist.

SIZE: Sheet 95 × 77.5cm (37½ × 30½ in).
plate 75.6 × 60.5cm (29¾ × 23¾ in).

PAPER: 300gsm Somerset Satin; 250gsm Velin Arches Noir for print No.10.

TECHNIQUE: Colour etching: softground and drypoint.

1 One plate: softground.
2 Two plates, red and blue: softground.
3 Three plates, red, yellow and blue: softground.
4 Three plates, same as No.7, printed in black with table-top drawn by hand: softground and drypoint.
5 One plate, printed twice, turned upside-down: softground and drypoint.
6 Three plates, one used from No.5 in blue, and the two plates from No.2 in red: softground and drypoint.
7 Three plates, same as No.4 but in red, yellow and blue: softground and drypoint.
8 Three plates, yellow plate from No.3, plus plate used in both Nos.5 and 6 and third plate used in No.7, all printed in black: softground and drypoint.

9 One plate printed twice, turned upside-down, this plate used as red plate in No.7, also used in No.8: softground and drypoint.
10 Three plates, same as No.7, printed in white ink on black Velin Arches: softground.

PRINTER: Proofed and editioned at Hope (Sufferance) Press, London.

BINDING: Wooden portfolio case covered in brown buckram, with the artist's name printed in black on the cover. Made by G. Ryder & Co. Ltd.

TYPOGRAPHY: Designed by Phil Baines in Futura.

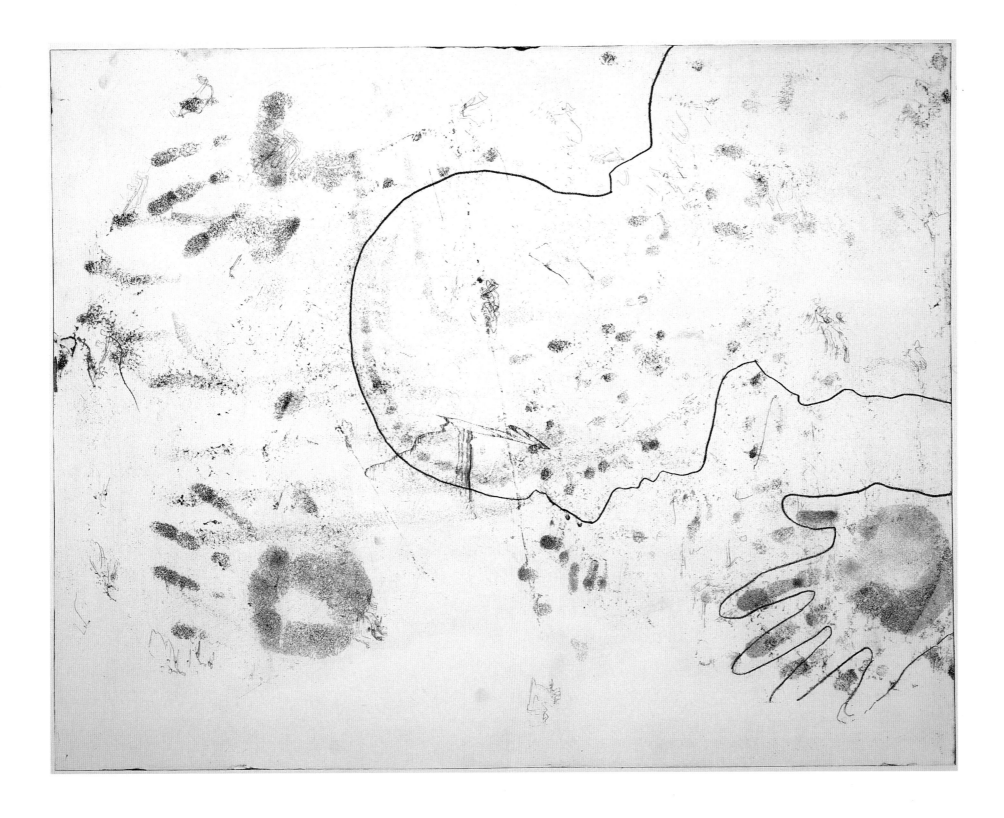

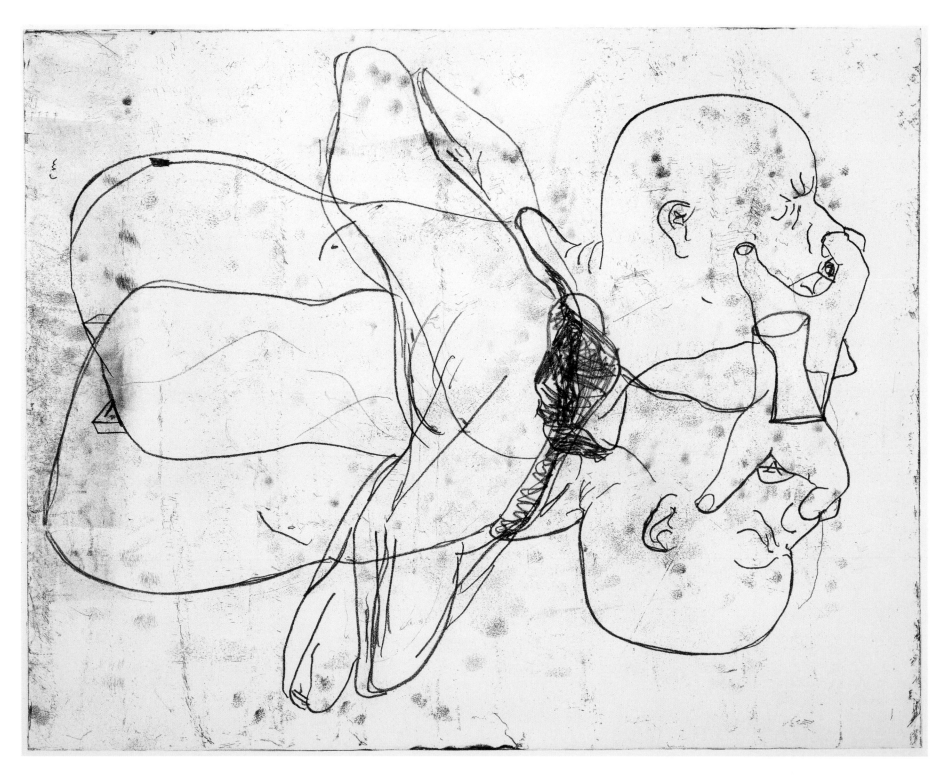

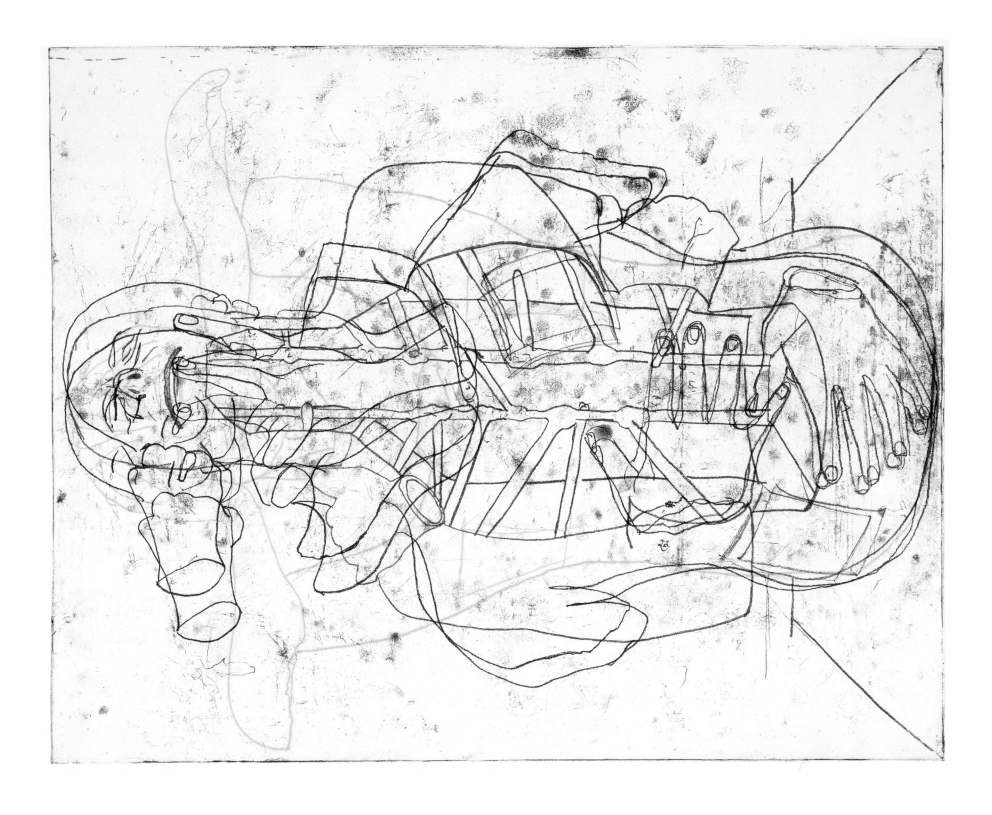

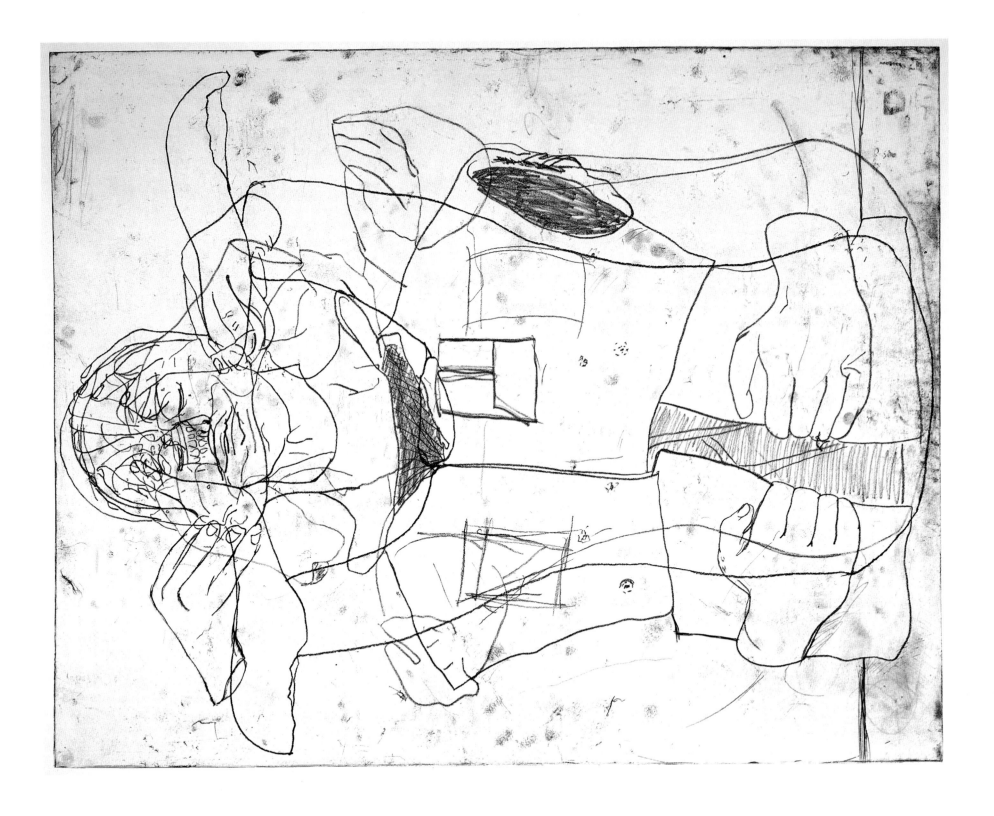

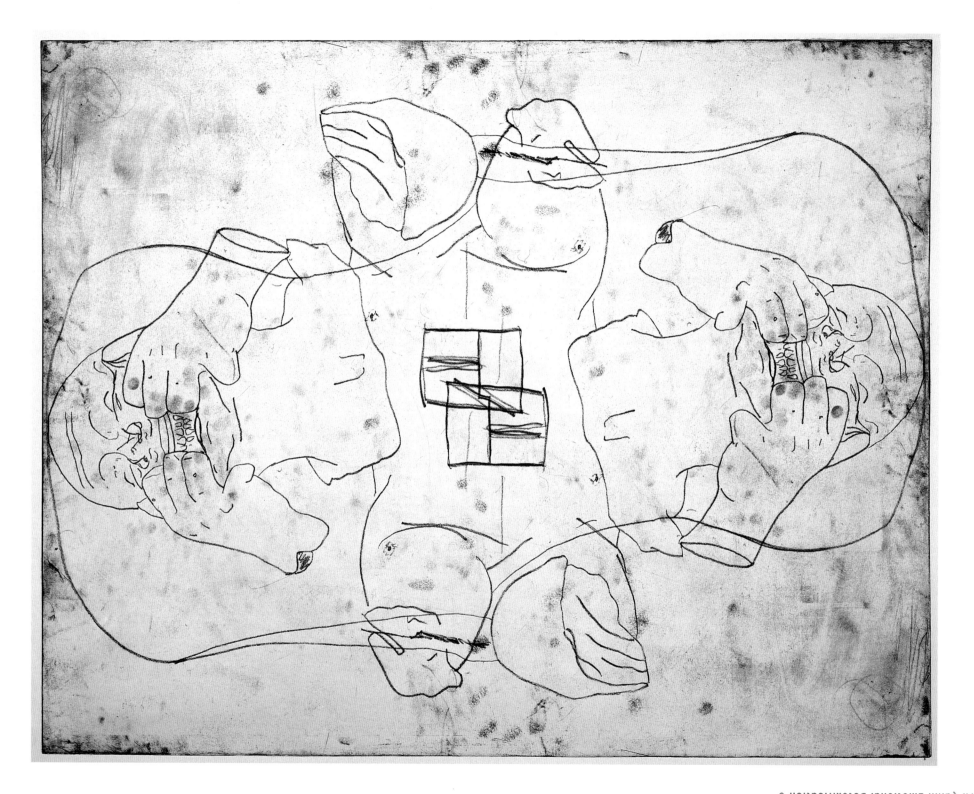

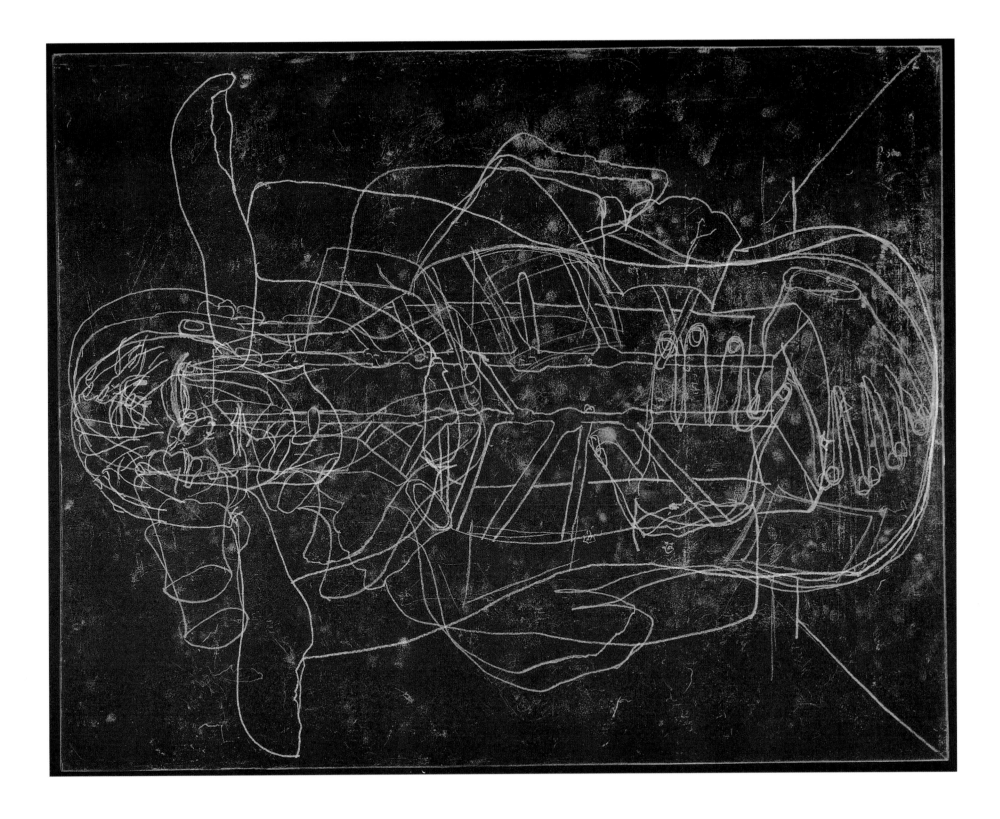

DESCRIPTION: 12 screenprints with title-page, colophon and portfolio case.

EDITION: 35 sets numbered 1 to 35, plus 10 artist's proof sets.

INSCRIPTIONS: Each print initialled by the artist on the reverse and lettered from A to L.

SIZE: Sheet and image 60.2 x 89.3 cm (23¾ x 35¼ in).

PAPER: 310gsm Somerset Tub-Sized Satin.

TECHNIQUE: Screenprint. 5 screens: a white printed over whole sheet, followed by 3 mezzotint screens, 1 black drawing screen, and varnish.

PRINTER: Proofed and editioned at Coriander Studio, London.

BINDING: Wooden portfolio case covered in black buckram, with the title printed in blue on the cover. Made by G. Ryder & Co. Ltd.

TYPOGRAPHY: Designed by Phil Baines with Richard Deacon in Caslon. Brochure designed by Phil Baines.

RICHARD DEACON
SHOW & TELL, 1996

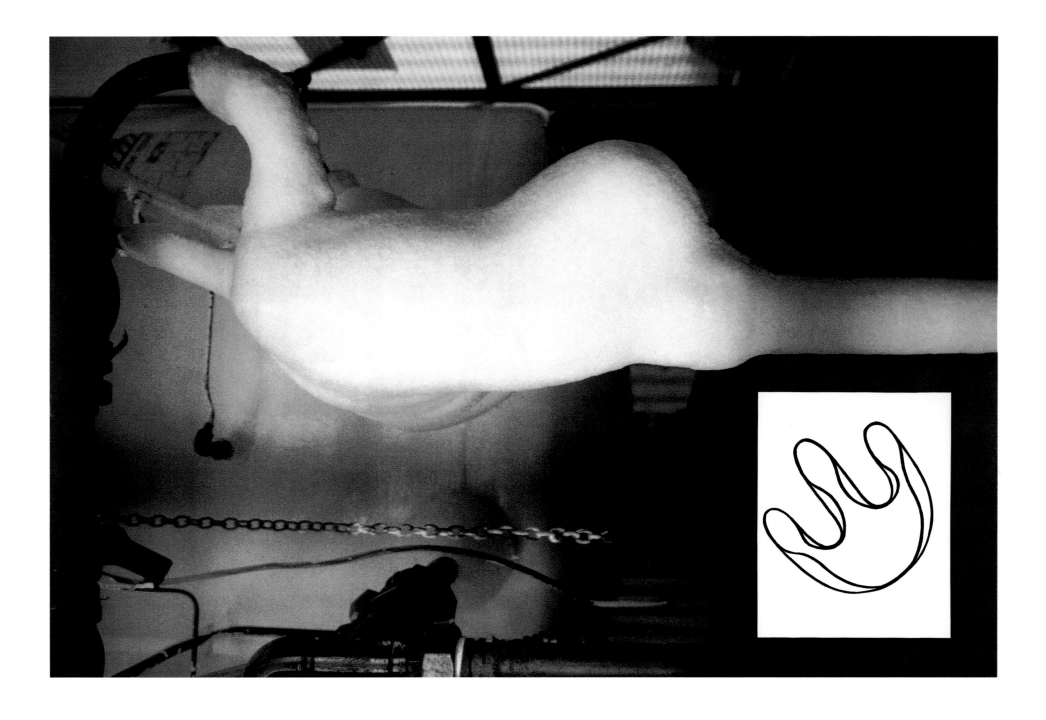

DESCRIPTION: 10 etchings with title-page, colophon and portfolio case.

EDITION: 35 sets numbered 1 to 35, plus 6 artist's proof sets and 1 BAT.

INSCRIPTIONS: Each print signed and numbered by the artist.

SIZE: Sheet 54 x 43cm (21¼ x 17 in).

PAPER: 350gsm Zerkall Etching.

TECHNIQUE: Colour etching: hardground, softground, aquatint, sugarlift, open bite, deep bite, spitbite, off-set and *chine collé*.

PRINTER: Proofed and editioned at Hope (Sufferance) Press, London.

BINDING: Wooden portfolio case covered in red cloth, with the artist's name screenprinted in orange on the cover. Made by G. Ryder & Co. Ltd.

TYPOGRAPHY: Designed by Peter B. Willberg. Screen-printed by Coriander Studio, London.

INDIVIDUAL DETAILS:

1 *Ski Jacket*, two plates: sugarlift and off-set, 21.8 x 14.6cm (8⅝ x 5¾in).

2 *Concrete Cabin*, one plate: hardground, aquatint and deep bite, 17.2 x 27.7cm (6¾ x 10⅞in).

3 *From 'Pond Life'*, one plate: hardground on woodgrain *chine collé*, 17 x 27.5cm (6¾ x 10⅞in).

4 *Red House*, two plates: hardground and aquatint, 15 x 20.5cm (5⅞ x 8in).

5 *Border House*, one plate: hardground and aquatint, 17.3 x 27.3cm (6⅞ x 10¾in).

6 *Blotter*, one plate: hardground, aquatint and spitbite, 29 x 19.5cm (11⅜ x 7⅝in).

7 *From 'Pond Life'*, two plates: sugarlift, off-set and open bite, 17.3 x 27.5cm (6⅞ x 10⅞in).

8 *Rosedale House*, one plate: hardground and aquatint, 17.5 x 27.5cm (6⅞ x 10⅞in).

9 *White Out*, one plate: hardground, aquatint and open bite on blue *chine collé*, 20.5 x 14.5cm (8 x 5¾in).

10 *Concrete Cabin*, one plate: hardground, aquatint and deep bite, 27 x 17cm (10⅝ x 6¾in).

PETER DOIG
TEN ETCHINGS, 1996

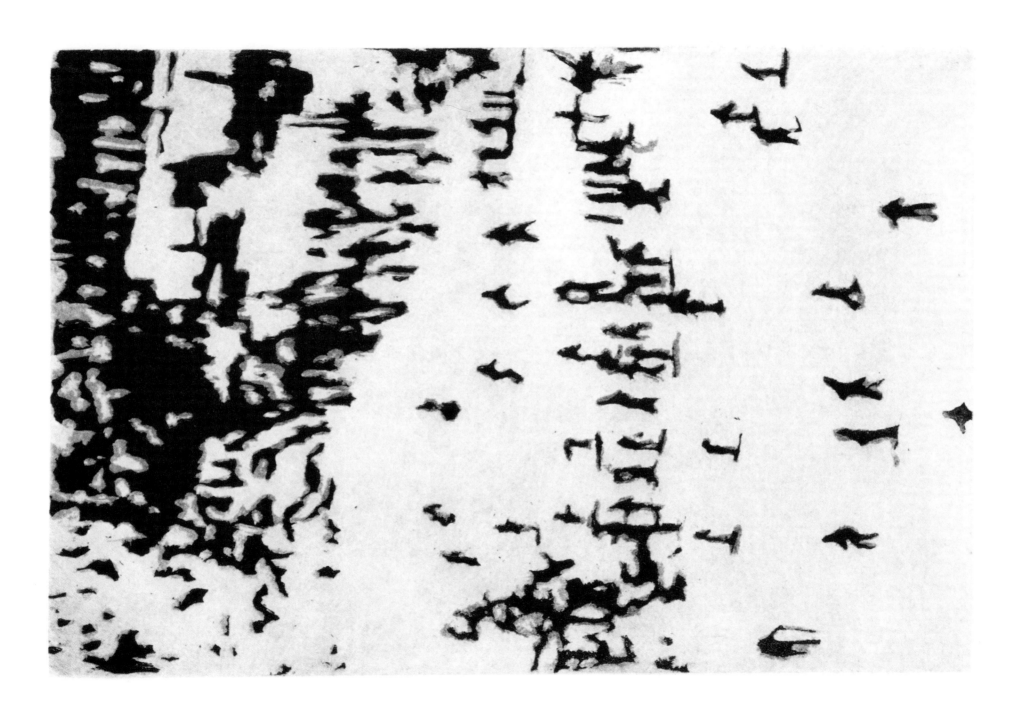

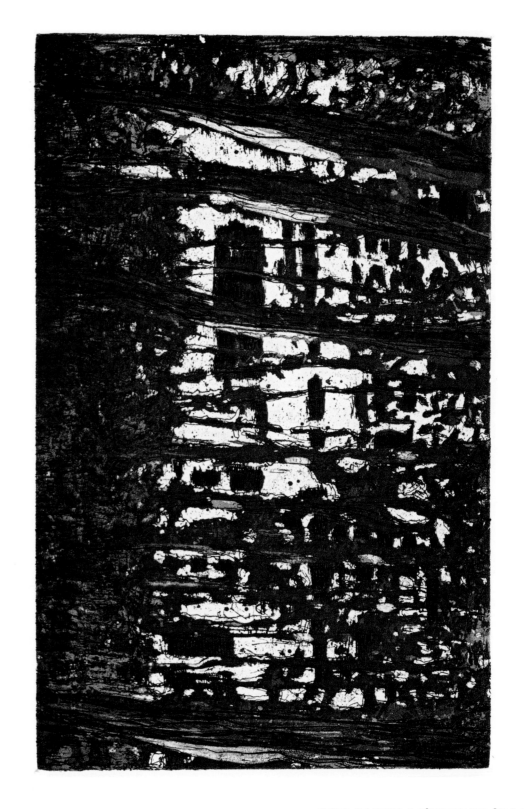

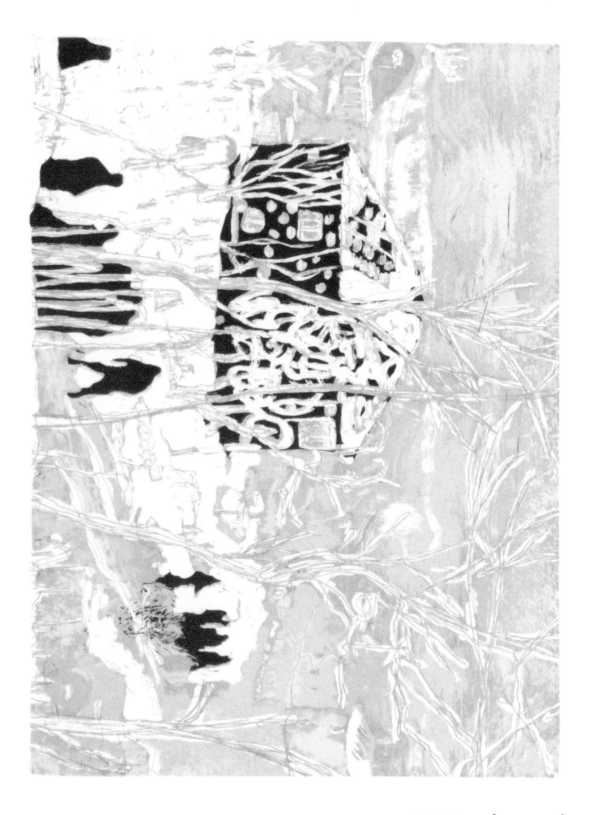

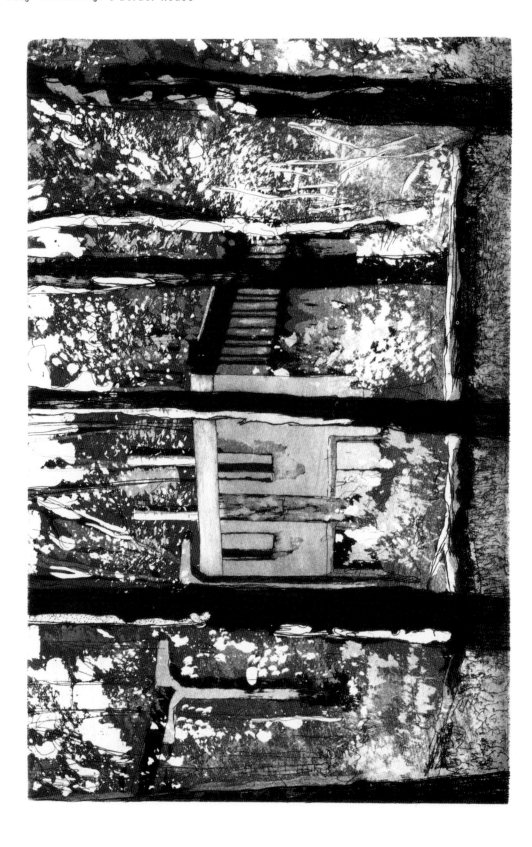

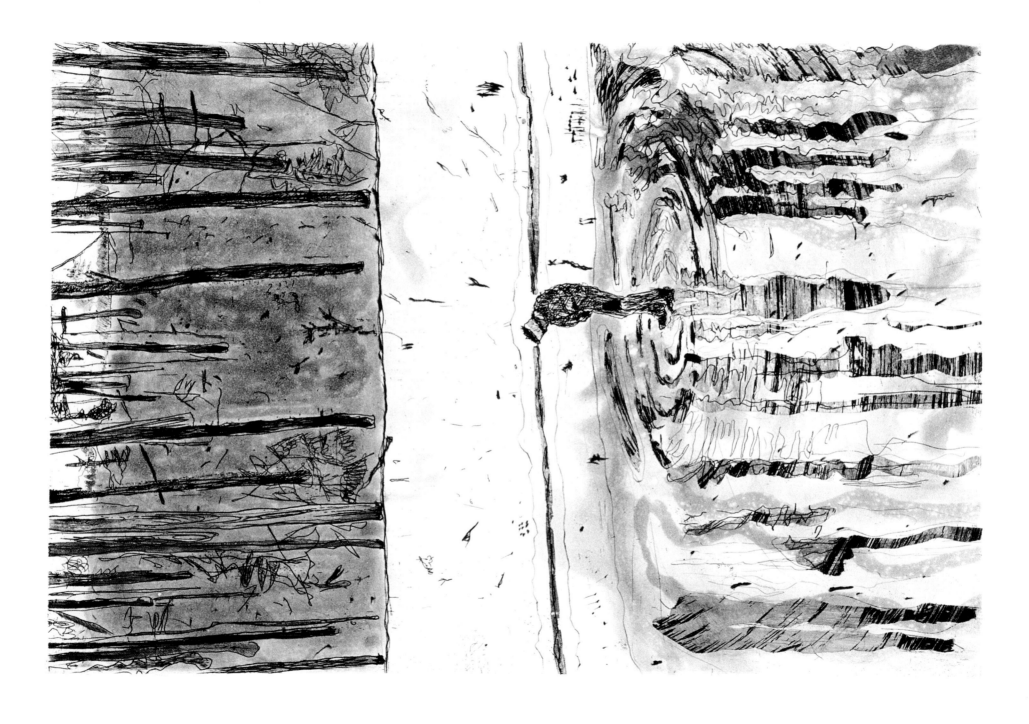

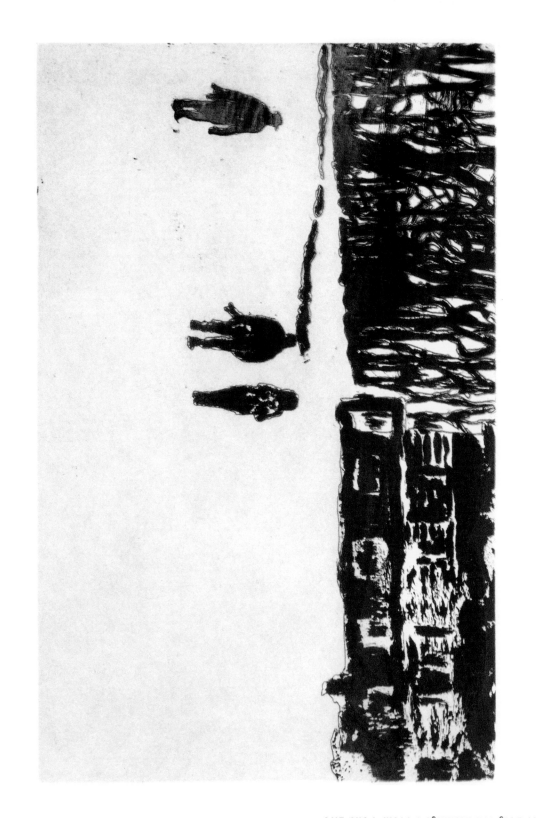

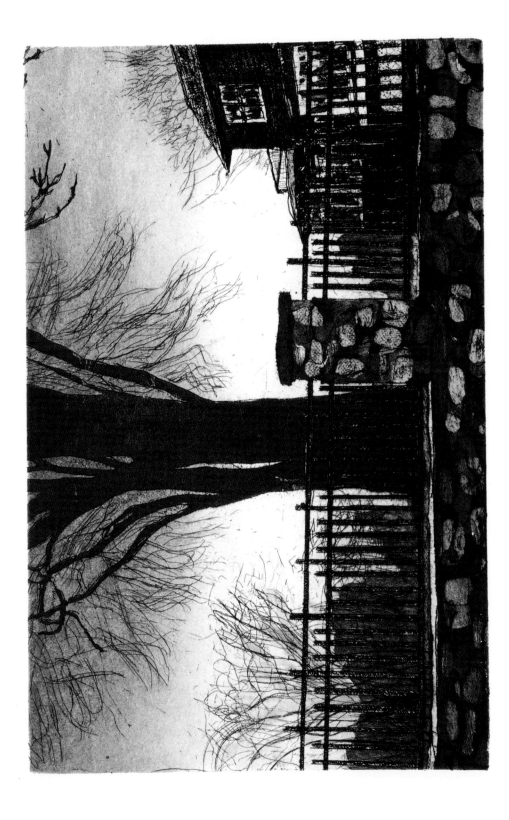

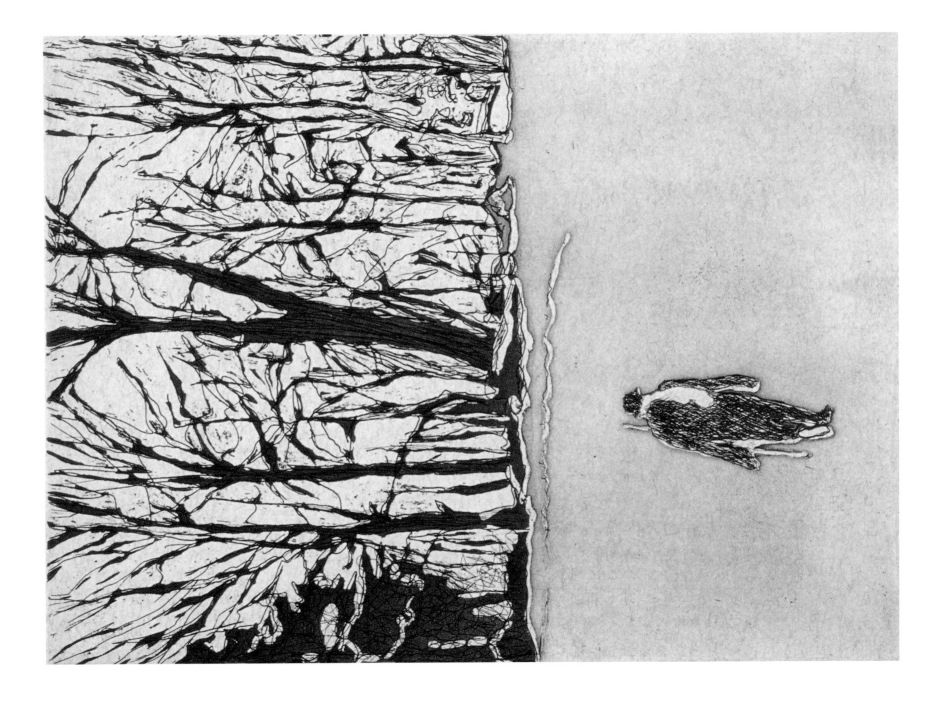

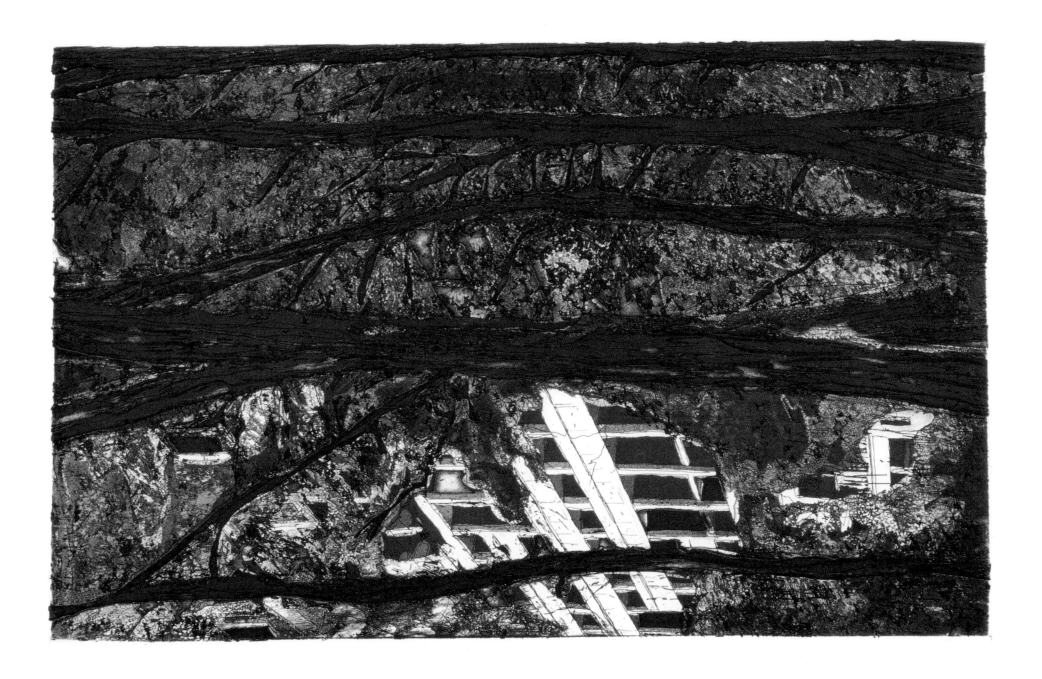

DESCRIPTION: 10 blind-embossed prints with title-page, artists' statement, colophon and portfolio case.

EDITION: 35 sets numbered 1 to 35, plus 10 artists' proof sets.

INSCRIPTIONS: Each print signed and numbered by the artists on the reverse, and marked with a letter corresponding to the title of each work.

PAPER: 300gsm Somerset Satin.

TECHNIQUE: Blind-embossed prints from zinc line-block plates (made after the artists' drawings at Tower Engraving, London).

PRINTER: Proofed and editioned at Hope (Sufferance) Press, London.

BINDING: The first 25 sets are presented in a wooden portfolio case covered in black buckram, with the title and artists' names screenprinted in matt black. Made by G. Ryder & Co. Ltd.

TYPOGRAPHY: Designed by Peter B. Willberg in Corporate and screenprinted by Coriander Studio, London.

SIZE: Sheet 76 x 72cm (29⅞ x 28⅜in).

INDIVIDUAL TITLES:

A Friday Mosque, Yazd, Iran

B Friday Mosque, Gulbarga, India

C Great Mosque, Cordoba, Spain

D Great Mosque, Kairouan, Tunisia

E Great Mosque, Abu Dulaf, Iraq

F Mosque of Al-Hassan, Rabat, Morocco

G Great Mosque, Seville, Spain

H Great Mosque, Samarra, Iraq

I Mosque of the Prophet, Medina, Saudi Arabia

J Qal'a of the Banu Hammad, Algeria

LANGLANDS & BELL
ENCLOSURE & IDENTITY, 1996

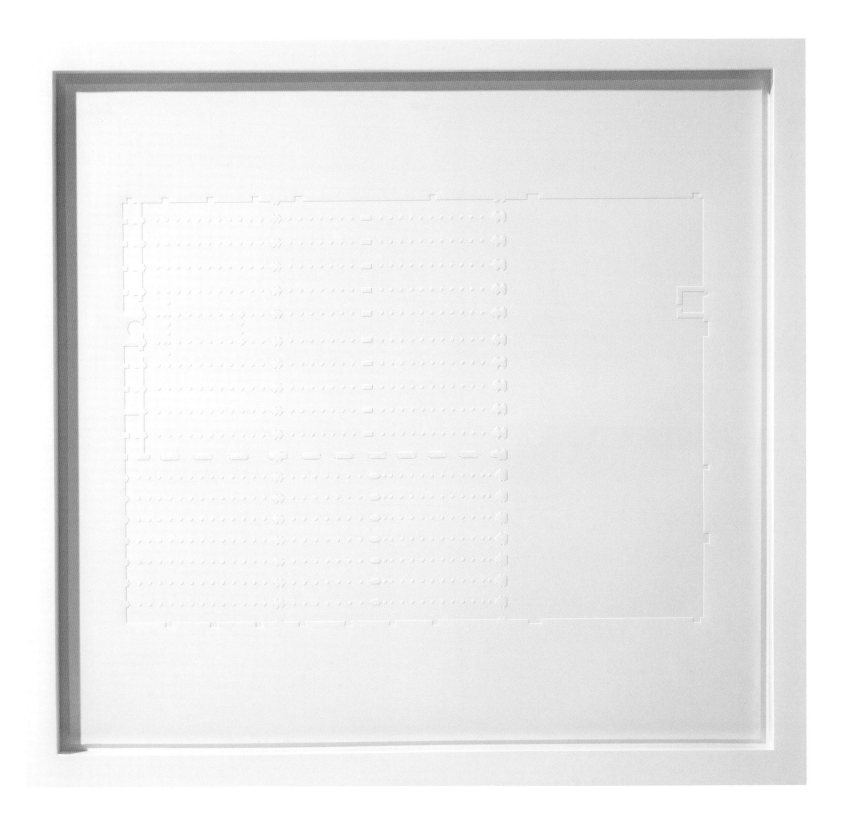

Langlands & Bell Enclosure & Identity A Friday Mosque, Yazd, Iran; B Friday Mosque, Kairouan, Tunisia; D Great Mosque, Gulbarga, India; D Great Mosque of Abu Dulaf, Iraq

Langlands & Bell Enclosure & Identity G Great Mosque, Seville, Spain

DESCRIPTION: 12 screenprints, title-page, colophon and portfolio case.

EDITION: 35 sets numbered 1 to 35, plus 10 artist's proof sets.

INSCRIPTIONS: Each print signed on the reverse and given a letter A, B or C, corresponding to the particular estate as listed below:

A Clapton Park Estate,
 Mandeville Street,
 London E5,
 Bakewell Court,
 Ambergate Court,
 Repton Court,
 Norbury Court,
 October 1993.

B Clapton Park Estate,
 Mandeville Street,
 London E5,
 Bakewell Court,
 Repton Court,
 March 1995.

C Trowbridge Estate,
 London E9,
 Hannington Point,
 Hilmarton Point,
 Deverill Point,
 June 1995.

SIZE: Sheet and image
49 × 74.5cm (19¼ x 29¼in).

PAPER: 310gsm Somerset
Tub-Sized Satin.

TECHNIQUE: Screenprint: between 5 and 8 mezzotint screens per print, plus varnish.

PRINTER: Proofed and editioned at Coriander Studio, London.

BINDING: Wooden portfolio case covered in black buckram, with the artist's name screenprinted on the cover in matt black. Made by G. Ryder & Co. Ltd.

TYPOGRAPHY: Designed by Phil Baines in Frutiger. Brochure designed by Peter Chater.

RACHEL WHITEREAD
DEMOLISHED, 1996

DEMOLISHED

A Clapton Park Estate
Mandeville Street, London E5
Ambergate Court
Norbury Court
October 1993

B Clapton Park Estate
Mandeville Street, London E5
Bakewell Court
Repton Court
March 1995

C Trowbridge Estate
London E9
Hannington Point
Hilmarton Point
Deverill Point
June 1995

Rachel Whiteread Demolished Set B: 1&2

Rachel Whiteread Demolished Set C: 1&2

BILL WOODROW, HAMISH FULTON, LISA MILROY, IAN McKEEVER, GRENVILLE DAVEY, MICHAEL CRAIG-MARTIN

A SERIES OF TWELVE PRINTS BY SIX ARTISTS, 1996

DESCRIPTION: 12 prints by six artists.

EDITION: 40 sets numbered 1 to 40, plus 12 artists' proof sets.

INSCRIPTIONS: Each print signed and numbered by the artist.

SIZE: Varies: see below.

PAPER: Either 300gsm Somerset or Somerset Satin.

BINDING: None

TYPOGRAPHY: None

BILL WOODROW

Reliquary
Softground etching
Sheet 42 × 75.8cm
(16½ × 29¾in),
each plate 25.6 × 19.7cm
(10 × 7¾in).
Proofed and editioned at
Hope (Sufferance) Press,
London.

Ghost
Softground etching
Sheet 42 × 75.8cm
(16½ × 29¾in).
Proofed and editioned at
Hope (Sufferance) Press,
London.

HAMISH FULTON

*Ten One Day Walks From
And To Kyoto July 1994*
Screenprint
Sheet and image
69.5 × 101cm
(27⅜ × 39¾in).
Proofed and editioned at
Coriander Studio, London.

LISA MILROY

Koyto House
Pair of prints with
photogravure, etching and
aquatint on *chine collé*
Sheet 22 × 30cm
(8⅝ × 11¾in).
Left image 20.1 × 28.2cm
(7⅞ × 11⅛in),
right image 20.6 × 28.9cm
(8⅛ × 11⅜in).
Proofed and editioned at
Hope (Sufferance) Press,
London.

Koyto House
Pair of prints with
photogravure, etching and
aquatint on *chine collé*
Sheet 24 × 32.5cm
(9½ × 12¾in).
Left image 22.9 × 29.6cm
(9 × 11⅝in),
right image 22.6 × 31.9cm
(8⅞ × 12½in).
Proofed and editioned at
Hope (Sufferance) Press,
London.

IAN McKEEVER

After Marianne North No.1
Drypoint and aquatint
Sheet 84.7 × 57.7cm
(33⅜ × 22¾in),
image 56.6 × 44.4cm
(22¼ × 17½in).
Proofed and editioned at
Hope (Sufferance) Press,
London.

After Marianne North No.2
Drypoint and aquatint
Sheet 85.5 × 58.4cm
(33⅝ × 23in),
image 56.6 × 44.4cm
(22¼ × 17½in).
Proofed and editioned at
Hope (Sufferance) Press,
London.

GRENVILLE DAVEY

Pair '96
Sugarlift aquatint (3 plates)
Sheet 77.3 × 111.8cm
(30⅜ × 40in),
each plate 58.7 × 41.9cm
(23⅛ × 6½in).
Proofed and editioned at
Hope (Sufferance) Press,
London.

Eye '96
Sugarlift aquatint (3 plates)
Sheet 75.7 × 57.2cm
(29¾ × 22½in),
plate 58.6 × 41.7cm
(23⅛ × 16⅜in).
Proofed and editioned at
Hope (Sufferance) Press,
London.

MICHAEL CRAIG-MARTIN

Distant Relations
Screenprint
Sheet and image
96.5 × 76.2cm (38 × 30 in).
Proofed and editioned at
Advanced Graphics, London.

Close Relations
Screenprint
Sheet and image
96.5 × 76.2cm (38 × 30 in).
Proofed and editioned at
Advanced Graphics, London.

*An 18 Day Road Walking
Journey From The River Rhône
At Valence To The Atlantic
Coast On The Border Of Spain
And France Spring 1995*
Screenprint
Sheet and image
24 × 100.5cm (9½ × 39½ in).
Proofed and editioned at
Coriander Studio, London.

1996

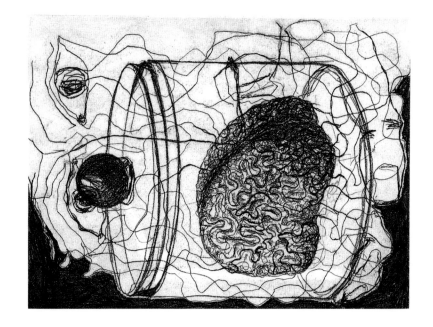

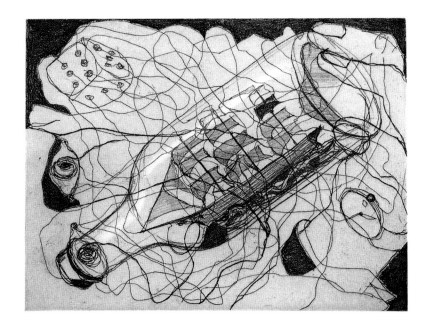

LE RHÔNE

L'EYRIEUX

L'ARDECHE

LE LOT

LE DOULOU

L'AVEYRON

L'ALZOU

LE TARN

LA GARONNE

LA SERE

L'ARRATZ

L'AUROUE

LE GERS

LA PETITE BAISE

LA GRAND BAISE

L'OSSE

LE BOUES

L'ARROS

L'ALARIC

SPAWNING FISH
19/4/95

HOUSE MARTINS
CUCKOOS
CRICKETS
20/4/95

RAIN THUNDER AND LIGHTNING
21/4/95

HALF MOON
22/4/95

HERONS
23/4/95

HOUSE MARTINS
KESTREL
MIST COVERED HILLS
PETAL ROADS
24/4/95

COLD RAIN
25/4/95

MUDDY R...
26/4/9...

CUC...

THE NAMES OF RIVERS AND STREAMS CROSSED ON ROAD BRIDGES

AN 18 DAY ROAD WALKING JOURNEY FROM THE RIVER RHÔNE AT V...

Hamish Fulton top: Ten One Day Walks from and to Kyoto... bottom: An 18 Day Road Walking Journey... from A Series of Twelve Prints by Six Artists

79

TEN ONE DAY WALKS FROM AND TO KYOTO

TRAVELLING BY WAY OF MOUNT HIEI

WALKING ROUND THE HILL ON A CIRCUIT OF ANCIENT PATHS

FIVE DAYS WEST TO NORTH TO EAST TO SOUTH TO WEST

FULL MOON

FIVE DAYS WEST TO SOUTH TO EAST TO NORTH TO WEST

JAPAN JULY 1994

ATLANTIC OCEAN

BASQUE COAST

RIO BIDASOA

REGATA CEBERIA

RIO BAZTAN

RIO ARANEA

LA NIVE DES ALDUDES

LA NIVE

LE GAVE DE MAULEON

LE LAURHIBAR

LE BOUES

LE GAILLAN

LE GHECHAL

LE VERT

LA MIELLE

LE GAVE D'ASPE

LE GAVE D'OSSAU

LE GAVE DE PAU

L'ADOUR

MOUNTAIN STREAMS
LIVE SNAKE
5/5/95

31 BUZZARDS CIRCLING ABOVE THE PASS
4/5/95

DEAD SNAKES
3/5/95

CRICKETS DEAD DOG
2/5/95

SMALL FISH
1/5/95

DEAD SNAKE DEAD POLECATS
30/4/95

SCREAMING SWIFTS
DEAD TOAD
29/4/95

DEAD HEDGEHOGS

BIRD SONG SWIFTS
28/4/95

CRICKETS
95

FISH IN THE RIVER NEAR THE OCEAN
6/5/95

ROUTE CROSSINGS

AT THE TOWN OF RODEZ WITH: A ROAD JOURNEY FROM THE MEDITERRANEAN SEA TO THE ENGLISH CHANNEL FRANCE 1–21 JUNE 1992
AT THE TOWN OF AUCH WITH: AN EIGHT AND A HALF DAY WALK ACROSS FRANCE FROM THE MEDITERRANEAN SEA TO THE ATLANTIC OCEAN JULY 1983

ATLANTIC COAST ON THE BORDER OF SPAIN AND FRANCE SPRING 1995

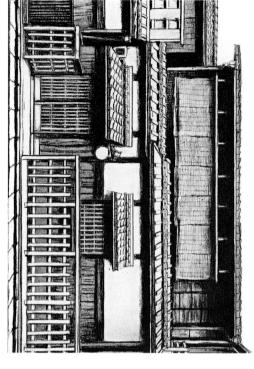

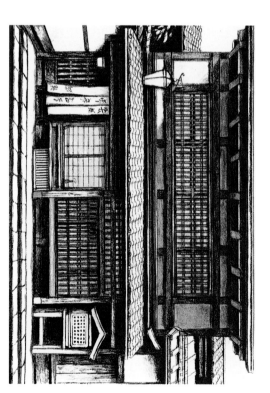

Lisa Milroy Kyoto House from A Series of Twelve Prints by Six Artists

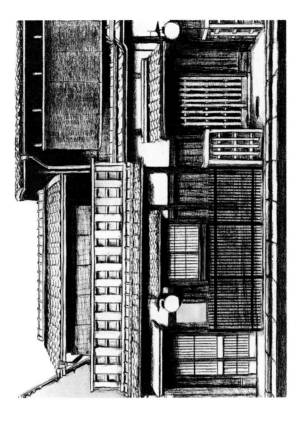

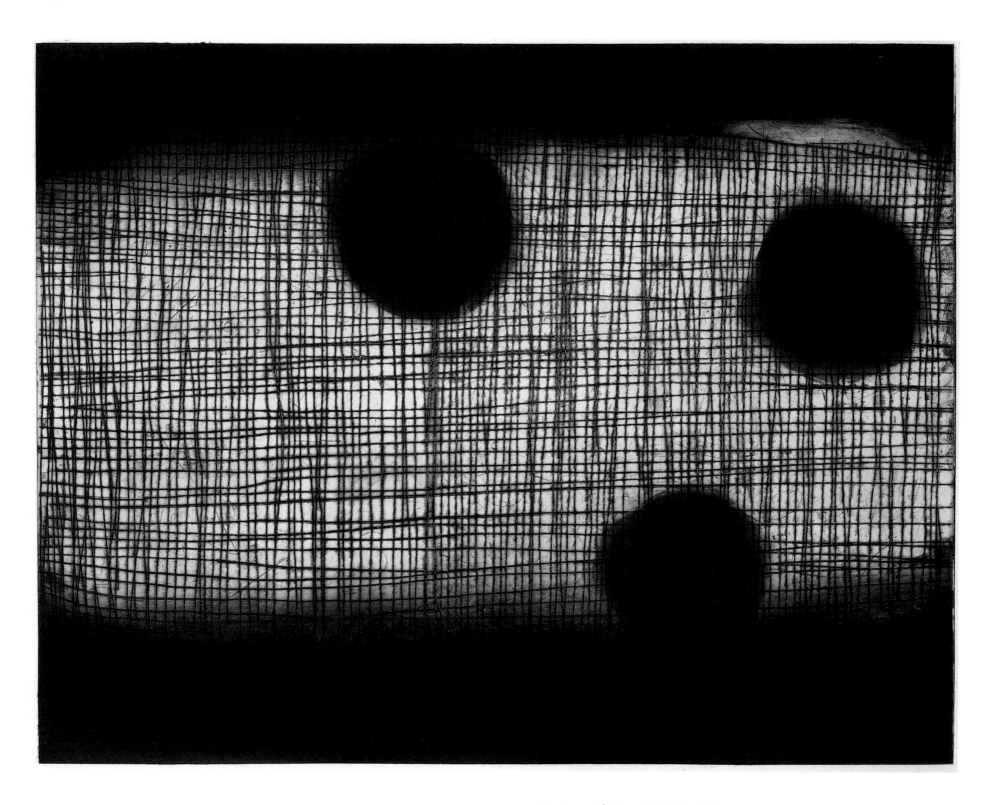

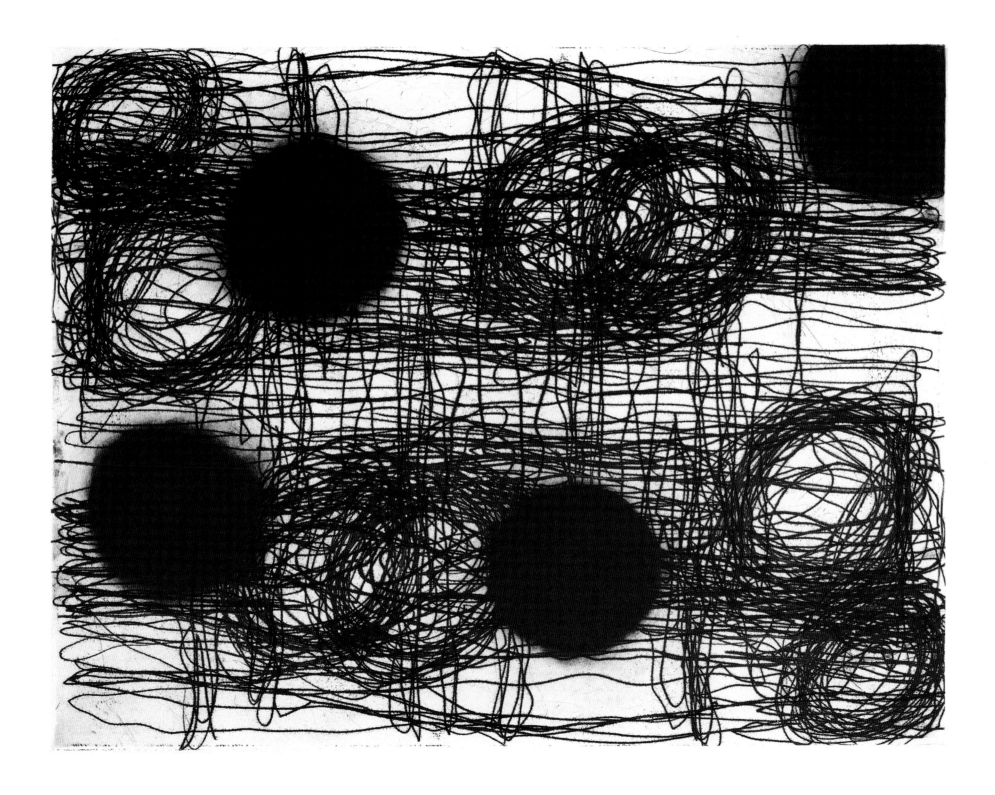

Grenville Davey Pair '96 from A Series of Twelve Prints by Six Artists

CHRIS OFILI
NORTH WALES, 1996

DESCRIPTION: 10 etchings with title-page, colophon and portfolio case.

EDITION: 35 sets numbered 1 to 35, plus six proof sets and 1 BAT.

INSCRIPTIONS: Each print signed and numbered by the artist.

SIZE: Sheet 38 x 28.5cm (15 x 11¼in), plate 24.8 x 19.8cm (9¾ x 7¾in).

PAPER: 300gsm Somerset TP Textured.

TECHNIQUE: Hardground etching.

PRINTER: Proofed and editioned at Hope (Sufferance) Press, London.

BINDING: Wooden portfolio case covered in orange cloth with the artist's hand-written name screenprinted in black on the cover. Made by G. Ryder & Co. Ltd.

TYPOGRAPHY: Title and colophon pages designed by the artist and printed from a line block by Simon King in Cumbria.

INDIVIDUAL TITLES:

1 Twynitywod Morfaharlech, 10/9/96
2 Portmeirion, 10/9/96
3 Blaenau Ffestiniog, 11/9/96
4 Llanbedr, 12/9/96
5 Llwyn Hwleyn, 13/9/96
6 Porthmadog, 14/9/96
7 Castle Harlech, 15/9/96
8 Penrhyndeudraeth, 16/9/96
9 Llanberis, 17/9/96
10 Snowdon, 17/9/96

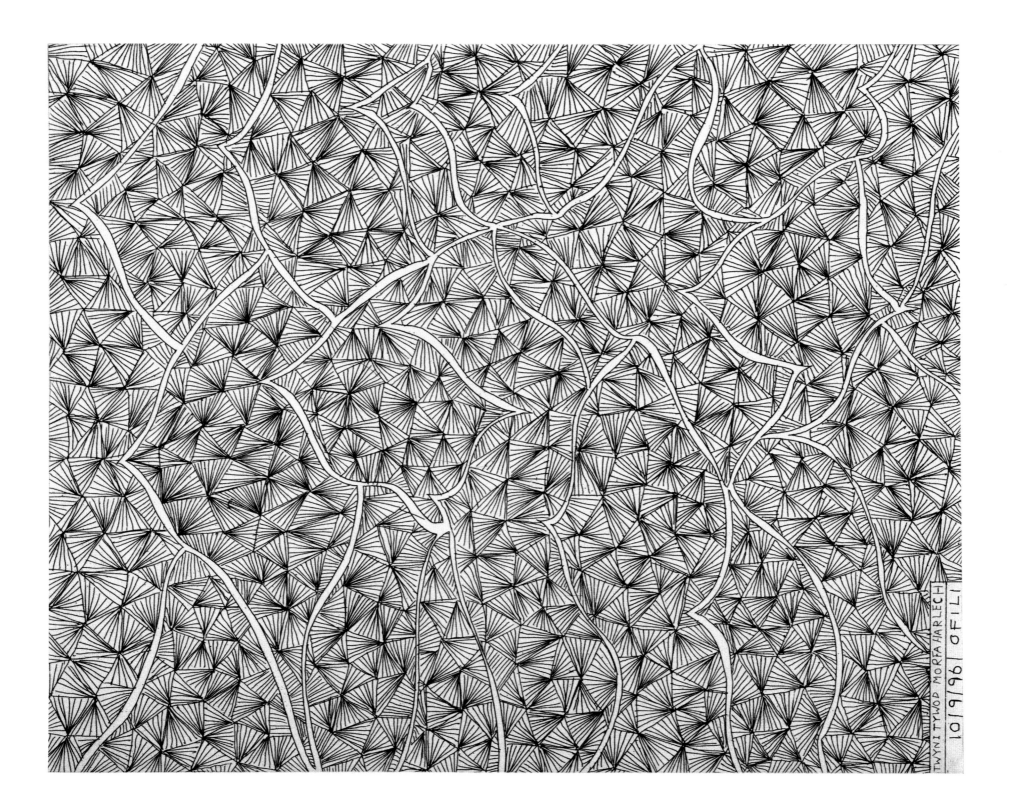

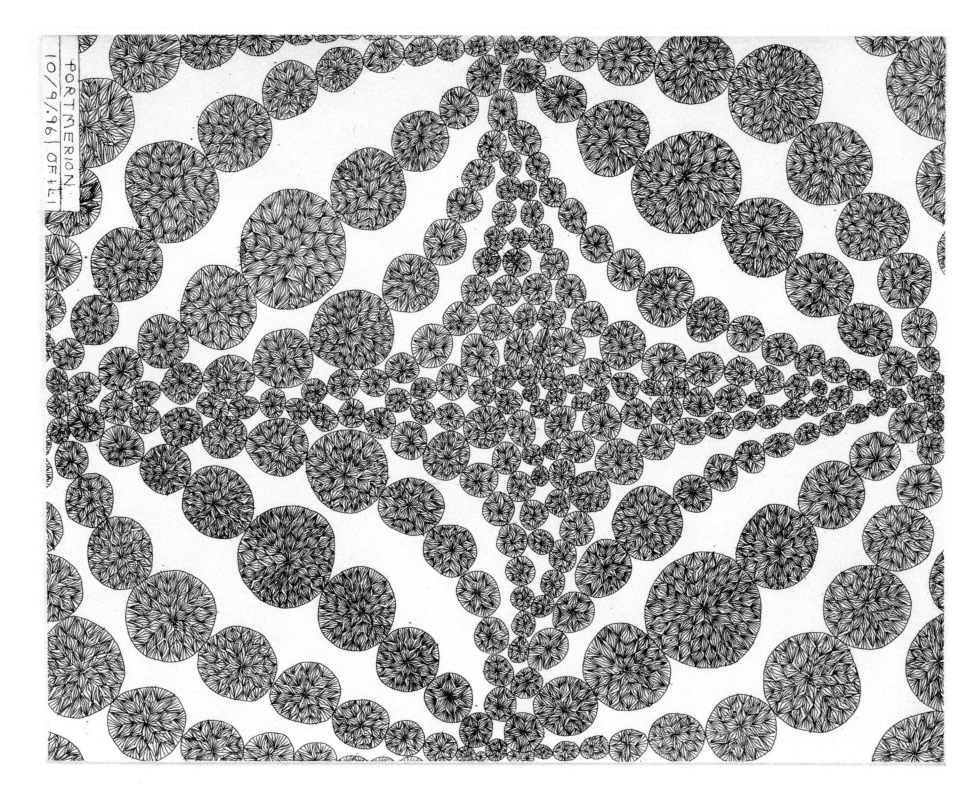

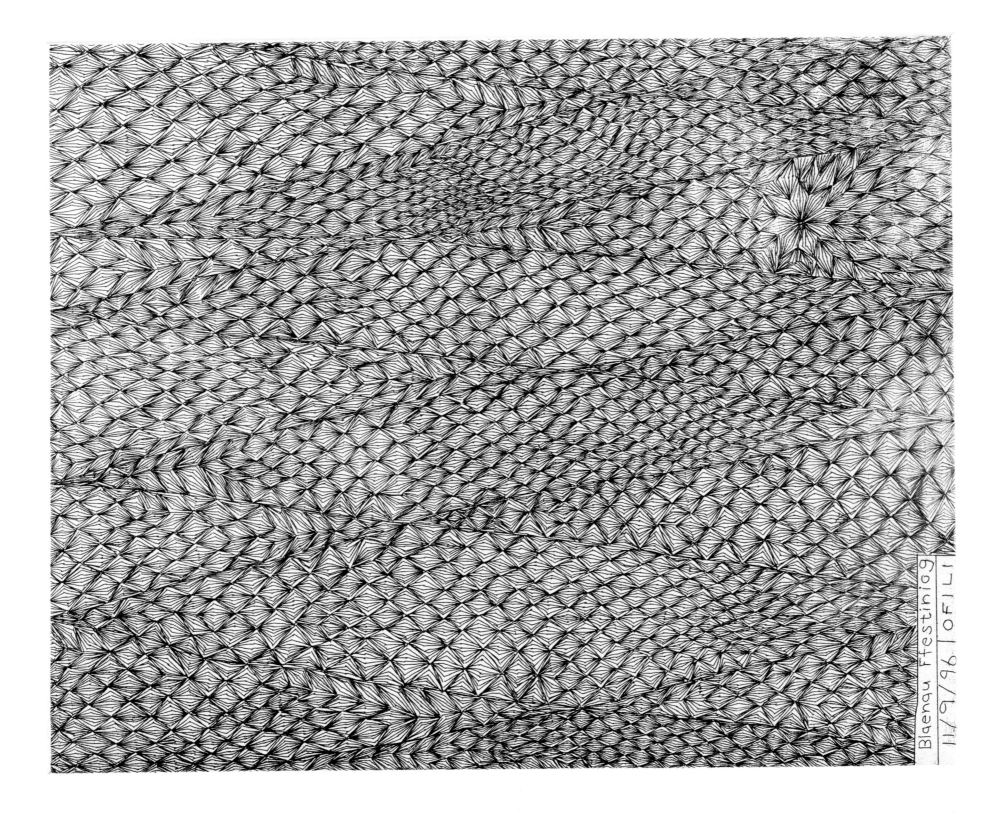

Blaenau Ffestiniog 11/9/96 OFILI

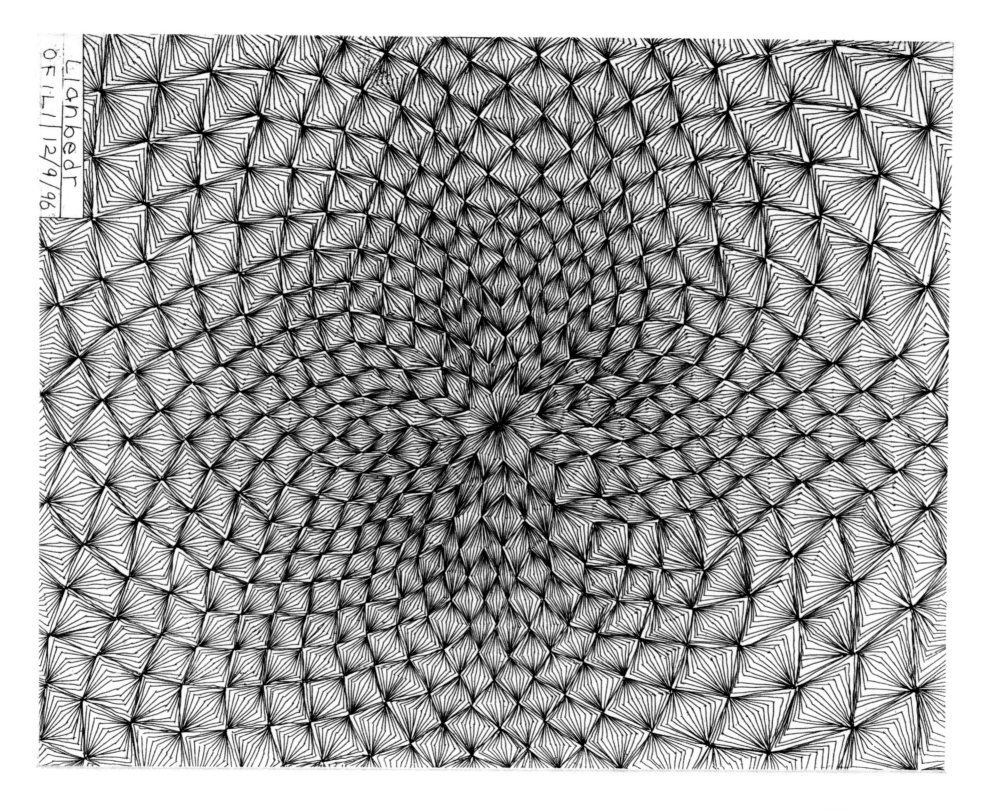

Llanbedr
OF iLl 12/9/96

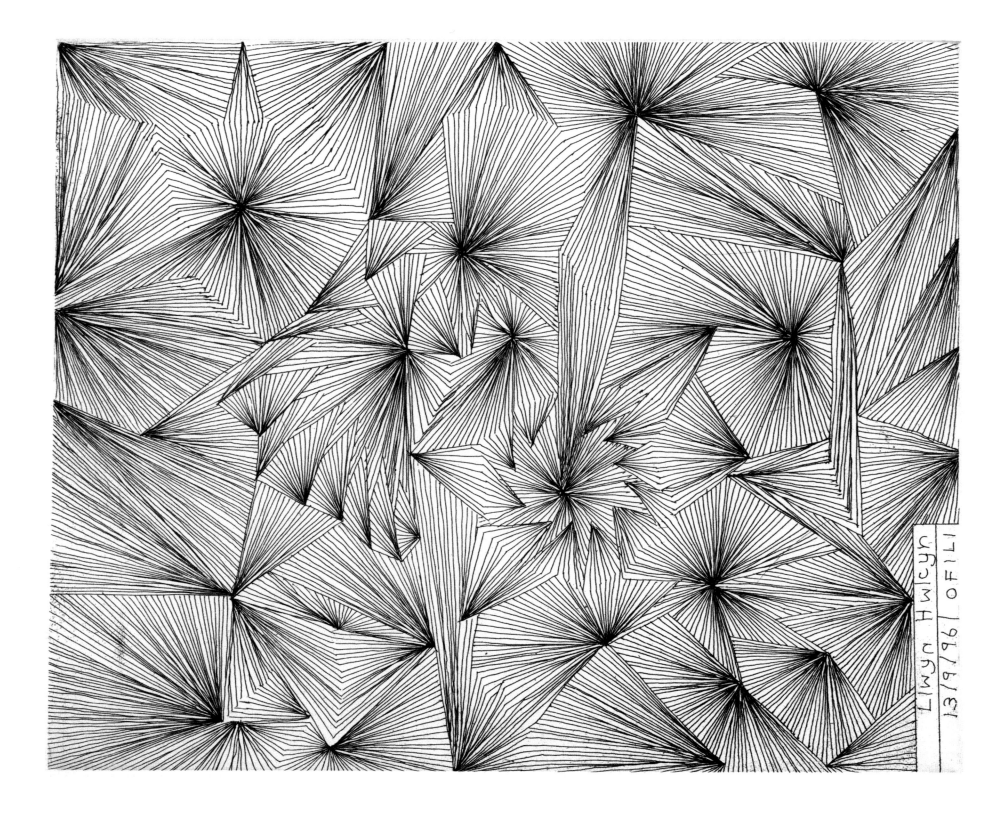

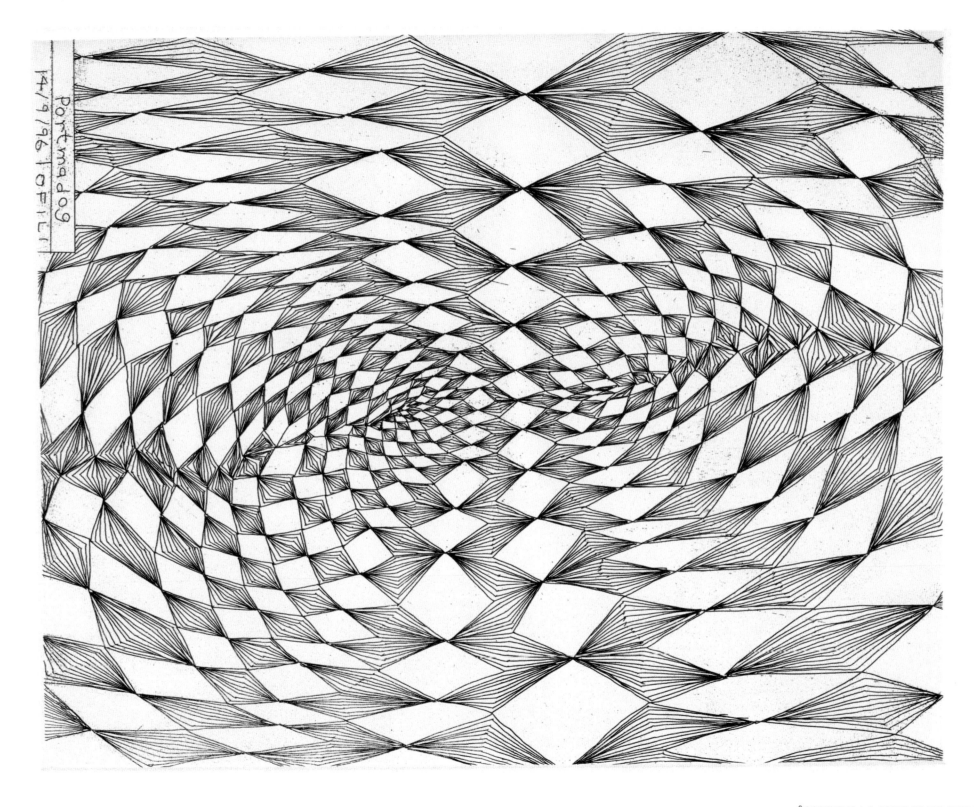

Portmadog
14/9/96 TOP LEFT

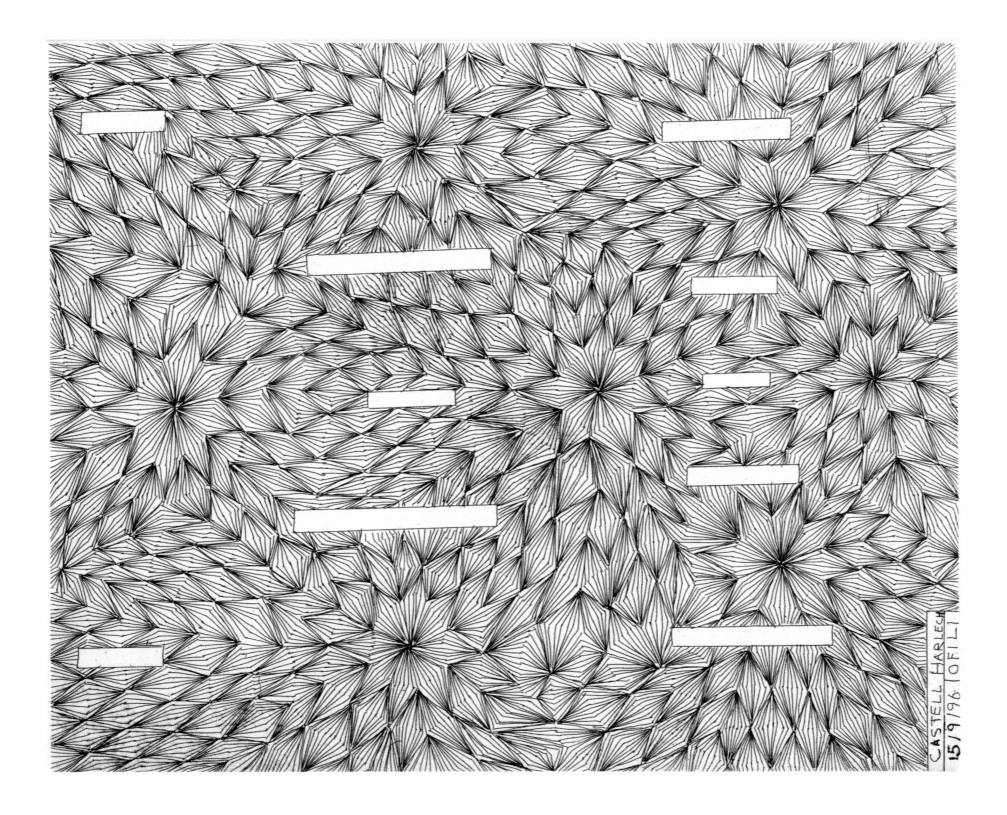

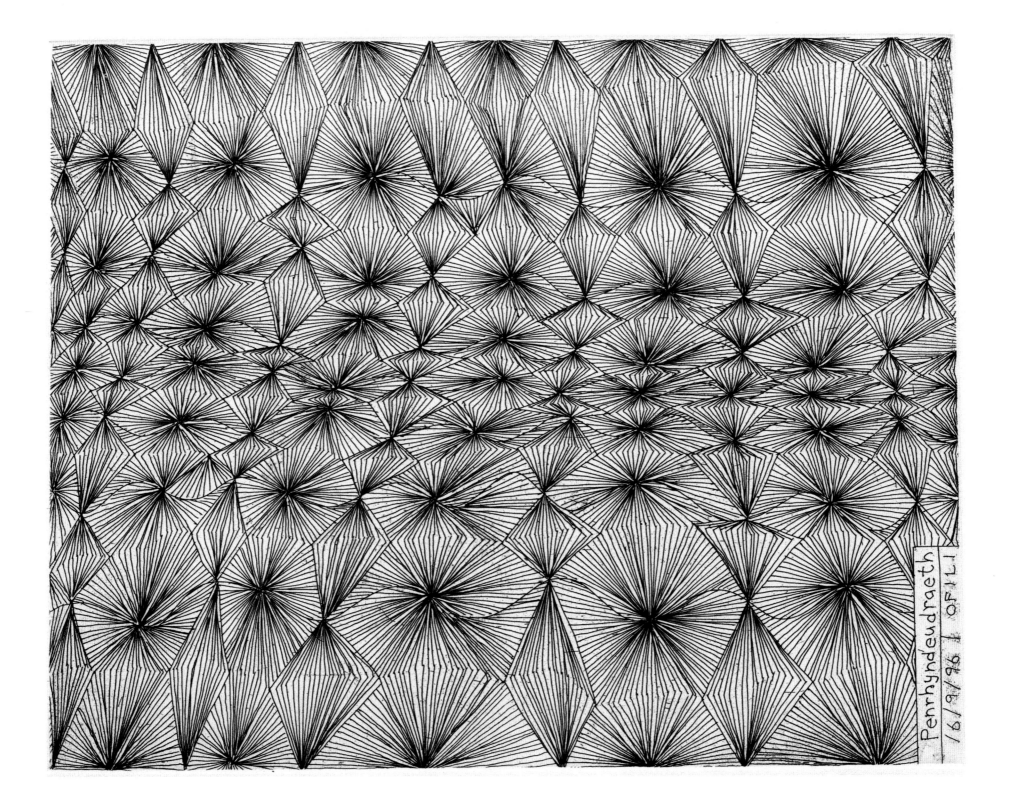

Penrhyndeudraeth
16/9/96 OFILI

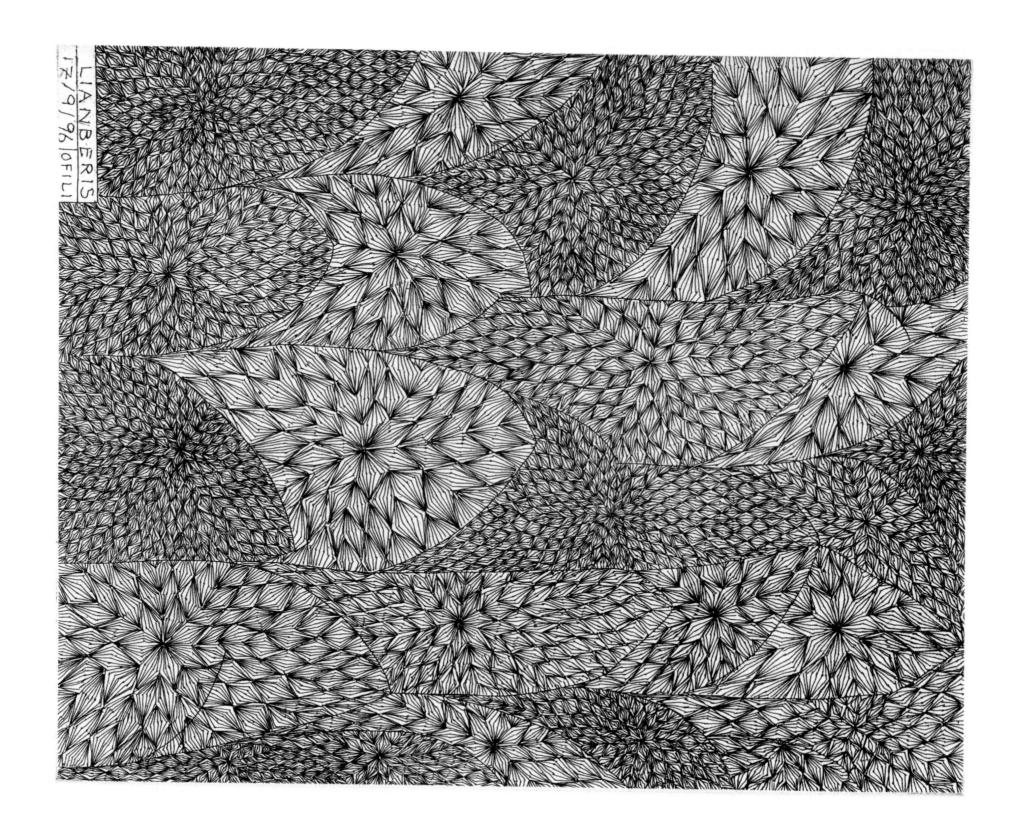

LIANBERIS
18/9/96 (0FILI)

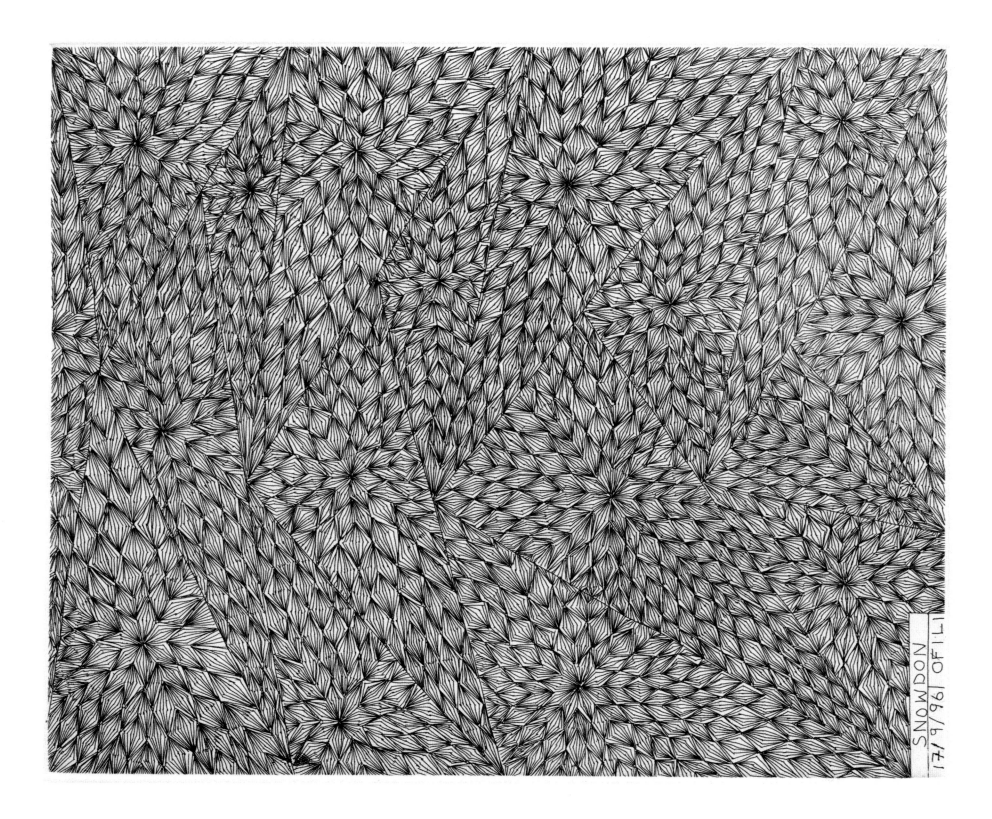

SNOWDON
17/9/96
17 OF ILI

PETER DOIG GRASSHOPPER, 1997

DESCRIPTION: 10 etchings with title-page, colophon and portfolio case.

EDITION: 35 sets numbered 1 to 35, plus 6 artist's proof sets and 1 BAT.

INSCRIPTIONS: Each print signed and numbered by the artist.

SIZE: Sheet 45.5 × 55.5cm (17⅞ × 21¾in).

PAPER: 350gsm Zerkall Etching.

TECHNIQUE: Colour etching: hardground, softground, open bite, spitbite and sugarlift.

PRINTER: Proofed and editioned at Hope (Sufferance) Press, London.

BINDING: Wooden portfolio case covered in cream cloth, with the artist's name screenprinted in brown on the cover. Made by G. Ryder & Co. Ltd.

TYPOGRAPHY: Designed by Peter B. Willberg. Screenprinted by Coriander Studio, London.

INDIVIDUAL DETAILS:

1 *Reflection (What Does Your Soul Look Like?)*, two plates: softground, sugarlift and hardground, 30 × 20cm (11¾ × 7⅞in).

2 *Window Pane*, one plate: spitbite, sugarlift and hardground, 30 × 20cm (11¾ × 7⅞in).

3 *Ski Lift*, two plates: sugarlift and hardground, 17 × 27.3cm (6⅝ × 10¾in).

4 *Canoe Lake*, one plate: softground, hardground and aquatint, 27.5 × 40cm (10¾ × 15¾in).

5 *Daytime Astronomy*, two plates: hardground, aquatint and burnishing, 19.8 × 29.8cm (7¾ × 11¾in).

6 *Lunker*, two plates: spitbite and sugarlift, 17.5 × 27.5cm (6⅞ × 10¾in).

7 *Camp Forestia*, two plates: open bite, hardground and aquatint, 27.5 × 17cm (10¾ × 6⅝in).

8 *Ski Hill*, one plate: sugarlift, 27.5 × 40cm (10¾ × 15¾in).

9 *Figure in a Mountain Landscape*, three plates: spitbite and sugarlift, 30 × 20cm (11¾ × 7⅞in).

10 *Night Fishing*, two plates: sugarlift and hardground, 17.2 × 27.4cm (6¾ × 10¾in).

Peter Doig **Grasshopper** 1 Reflection (What Does Your Soul Look Like?)

101

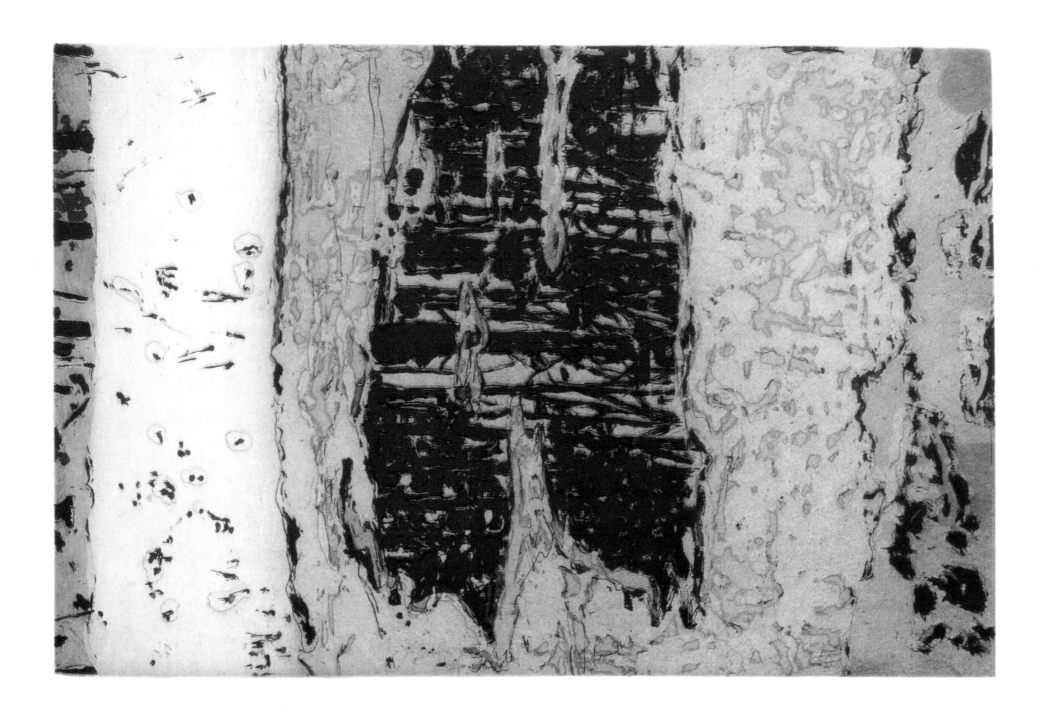

104

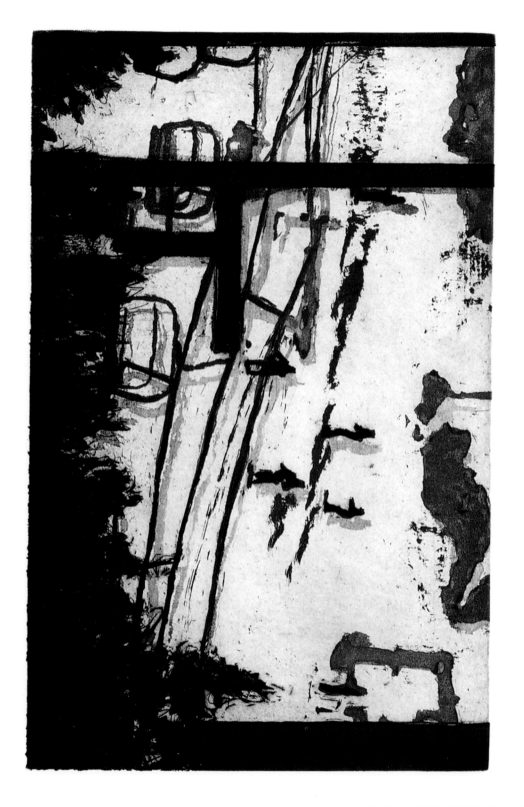

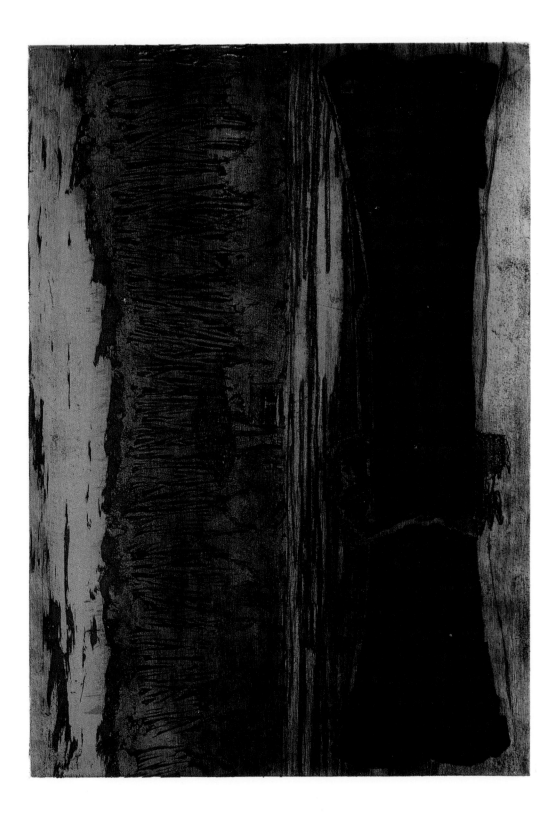

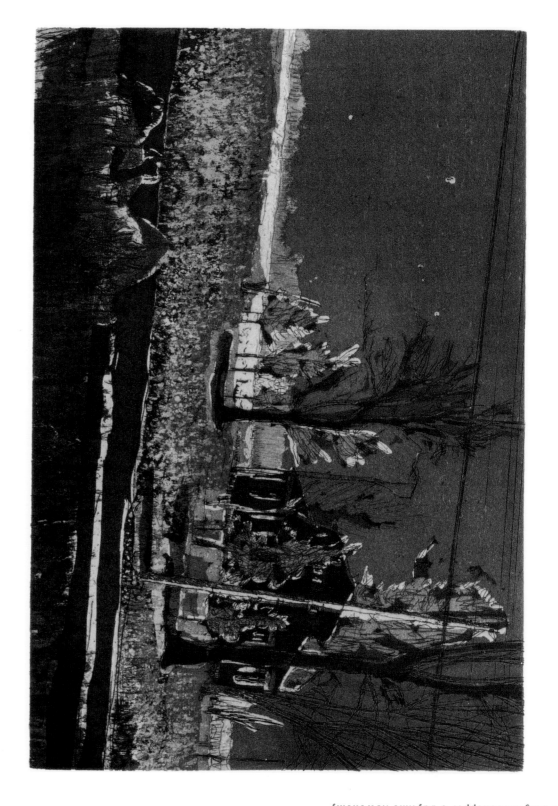

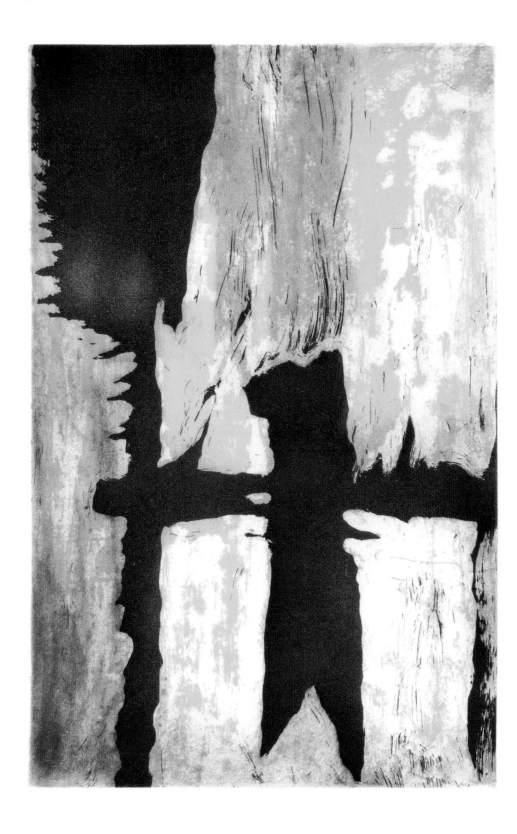

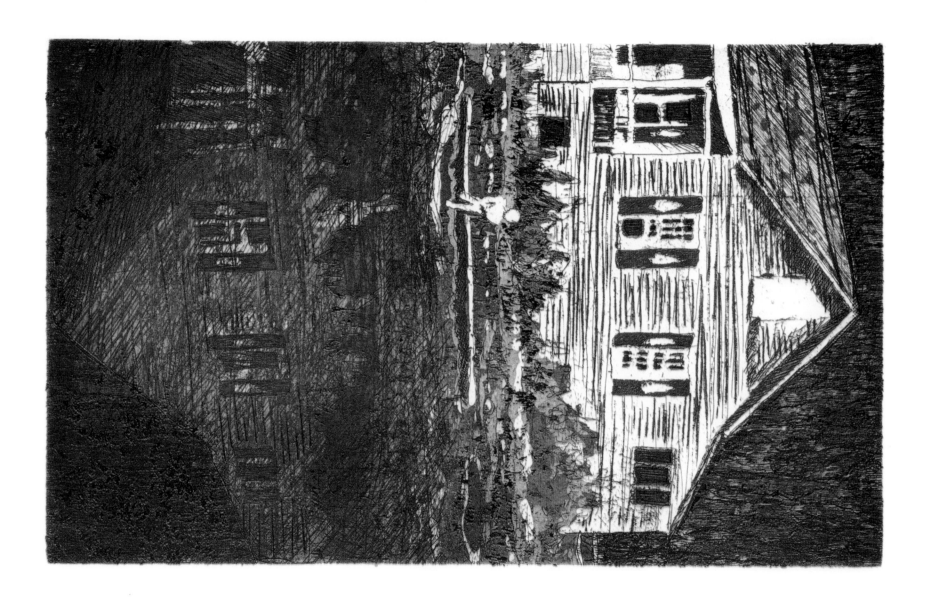

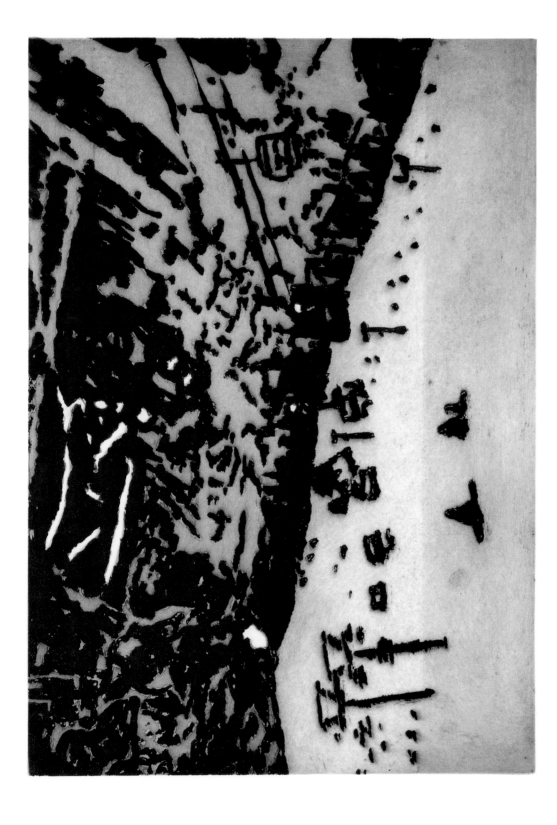

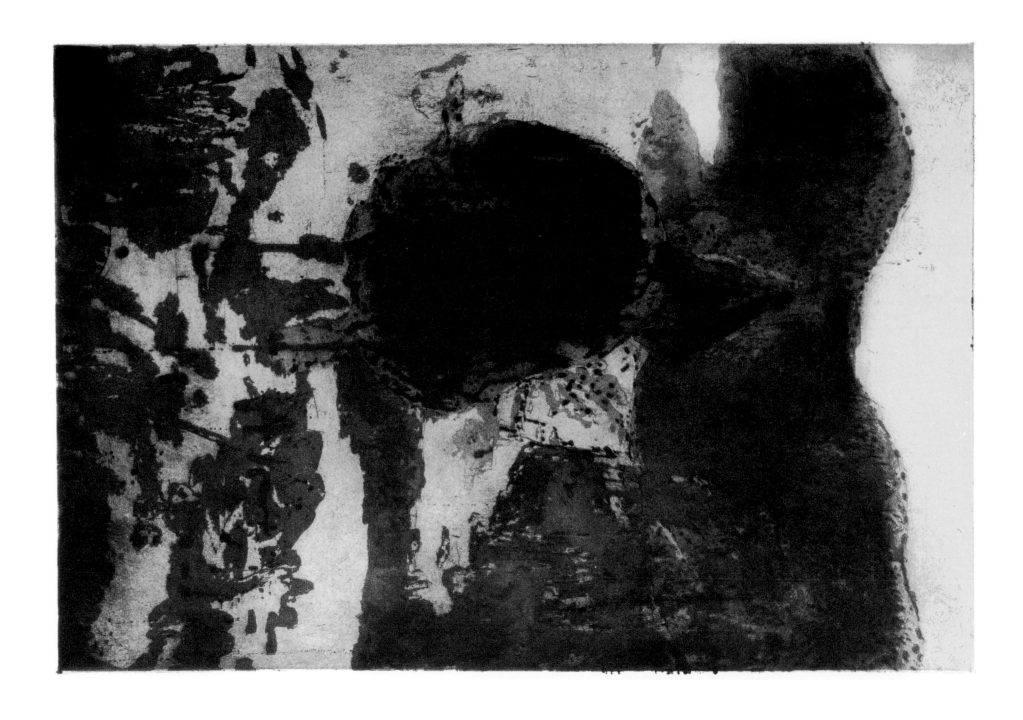

Peter Doig Grasshopper 9 Figure in a Mountain Landscape

SCREEN, 1997

DARREN ALMOND, JAKE & DINOS CHAPMAN, MAT COLLISHAW, ANYA GALLACCIO, SIOBHÁN HAPASKA, ABIGAIL LANE, GEORGINA STARR, SAM TAYLOR-WOOD, GILLIAN WEARING, CERITH WYN EVANS, CATHERINE YASS

DESCRIPTION: 11 screenprints, title-page, colophon and portfolio case.

EDITION: 75 sets, of which the first 45 sets are presented in portfolio cases. Numbers 46 to 75 are the artists' copies. There are an additional 15 portfolio sets numbered on the colophon I–XV for the artists and the publisher. Between 5 and 10 artist's proofs of each print also exist.

INSCRIPTIONS: Each print signed by the artist on the reverse apart from Darren Almond's print which is signed and numbered on the front. The colophon page is numbered.

SIZE: Maximum sheet size 74.9 x 88.9 or 88.9 x 74.9cm (29½ x 35 or 35 x 29½in).

PAPER: 300gsm Somerset Satin, except Mat Collishaw's print which is 175 micron Melinex polyester board.

TECHNIQUE: Screenprint. PRINTER: Proofed and editioned at Coriander Studio, London.

BINDING: Wooden portfolio case covered in black buckram, with the portfolio title screenprinted on the cover in red. Made by G. Ryder & Co. Ltd.

TYPOGRAPHY: Title and colophon pages designed by Phil Baines in Toulon and printed by Coriander Studio, London.

DARREN ALMOND

Multiple Working
Sheet 73 x 88.9cm
(28¾ x 35in)
image 14 x 72cm
(5½ x 28⅜in).
Screenprint: 4 screens, plus varnish and embossing.

JAKE & DINOS CHAPMAN

Double Deathshead
Sheet 73.4 x 88.3cm
(28⅞ x 34¾in),
image 71.3 x 86.4cm
(28 x 34in).
Screenprint: 4 screens, plus varnish and phosphorescent ink.

MAT COLLISHAW

Untitled
Sheet and image
85.9 x 57.2cm (33¾ x 22½in).
Screenprint on 175 micron Melinex polyester board: 9 screens, no varnish.

ANYA GALLACCIO

Broken English August '91
Sheet and image
68 x 88.5cm (26¾ x 34¾in).
Screenprint: 9 screens, plus varnish.

CATHERINE YASS

Stage
Sheet and image
74 x 88.8cm (29⅛ x 35in).
Screenprint: 9 screens, plus varnish.

SIOBHÁN HAPASKA

Untitled
Sheet and image
57.8 x 88.9cm (22¾ x 35in).
Screenprint: 8 screens, plus 2 varnish screens.

ABIGAIL LANE

Dinomouse Sequel
Mutant X
Sheet 56.8 x 88.3cm
(22⅜ x 34¾in),
image 30.5 x 63.5cm
(12 x 25in).
Screenprint: 5 screens, no varnish.

GEORGINA STARR

You Stole My Look!
Sheet 88.8 x 72cm
(22¾ x 28⅜in).
Screenprint: 11 screens, plus varnish.

SAM TAYLOR-WOOD

Red Snow
Sheet and image
74.9 x 88.4cm
(29½ x 34¾in).
Screenprint: 9 screens, plus varnish.

GILLIAN WEARING

The Garden
Sheet and image
60.6 x 88.9cm (23⅞ x 35in).
Screenprint: 9 screens, plus varnish.

CERITH WYN EVANS

The Return of the Return of the Durutti Column
Sheet and image 74 x 87.8cm
(29⅛ x 34½in).
Screenprint: 2 screens with phosphorescent ink.

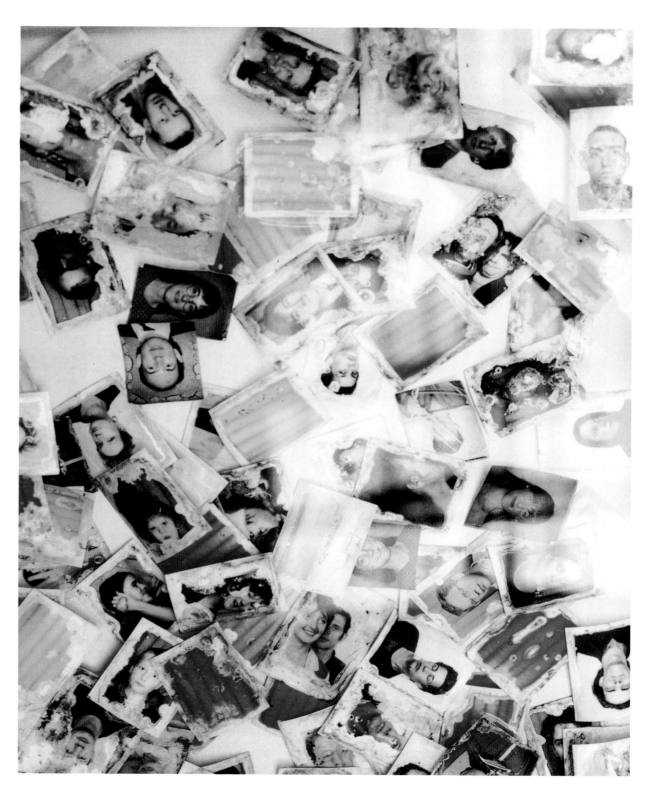

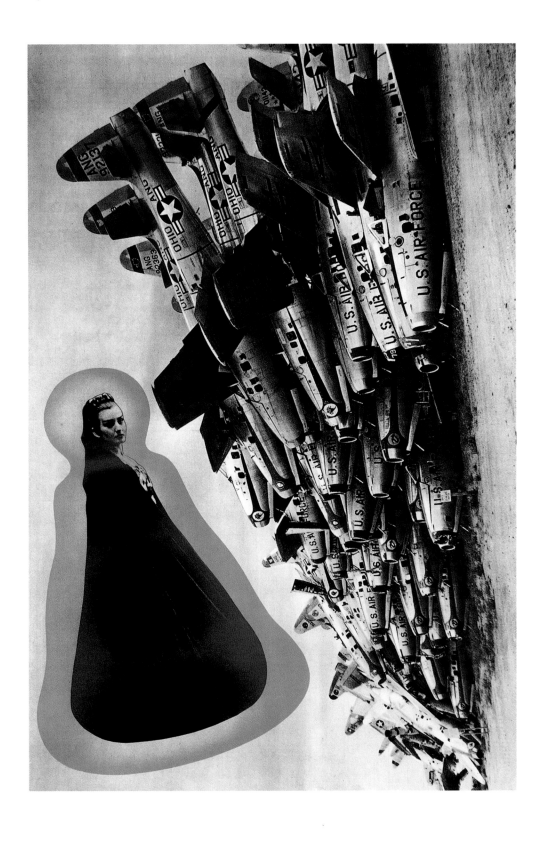

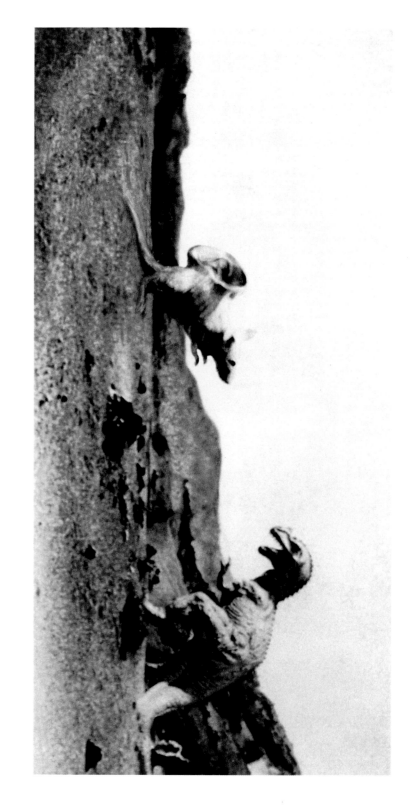

Abigail Lane Dinomouse Sequel Mutant X from Screen

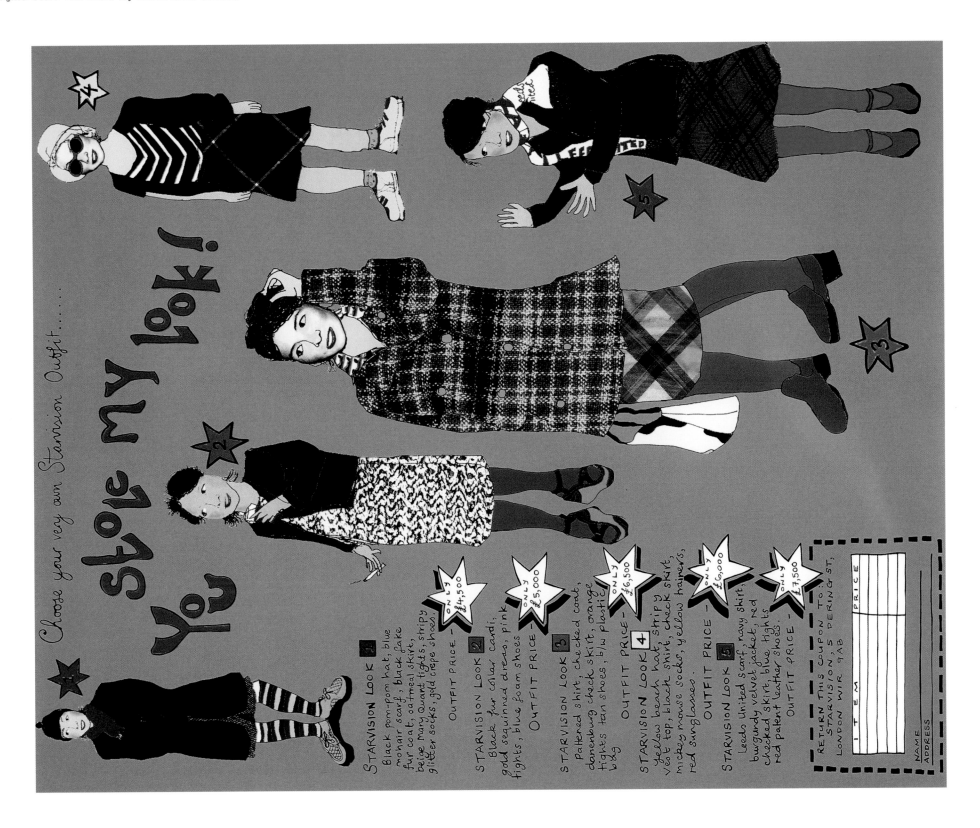

DESCRIPTION: 4 screenprints.

EDITION: 40 sets numbered 1 to 40, plus 8 artist's proof sets.

INSCRIPTIONS: Each print numbered by the artist 1 to 4, signifying the order. The first print is signed.

SIZE: Sheet and image 87.8 x 66.3 cm (34½ x 26⅛in).

PAPER: 310gsm Somerset Satin.

TECHNIQUE: Screenprint: 3 photographic screens plus 1 line image and varnish.

PRINTER: Proofed and editioned at Coriander Studio, London.

BINDING: None

TYPOGRAPHY: None

ANGUS FAIRHURST
WHEN I WOKE UP IN THE MORNING, THE FEELING WAS STILL THERE, 1997

When I woke up in the morning, the feeling was still there.

When I woke up in the morning, the feeling was still there.

When I woke up in the morning, the feeling was still there.

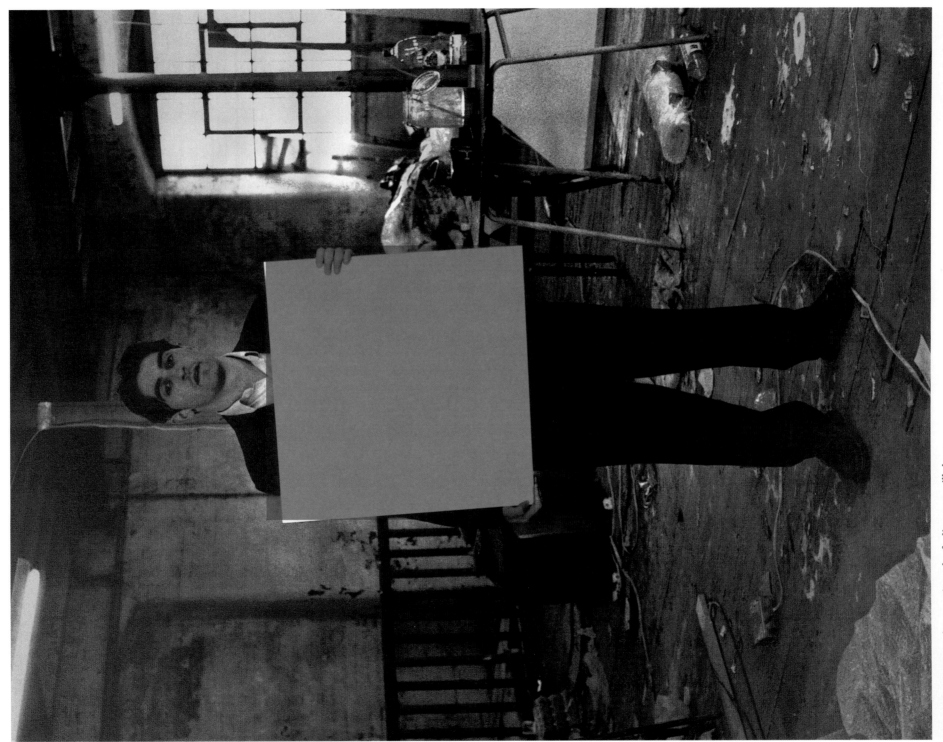

When I woke up in the morning, the feeling was still there.

DESCRIPTION: 5 hand-printed woodcuts.

EDITION: 12 sets numbered 1 to 12, plus 2 artist's proof sets and 2 *hors de commerce* sets.

INSCRIPTIONS: Each print signed and numbered by the artist.

SIZE: Sheet 60 x 53.5 cm (23 ⅛ x 21 in), image 40.5 x 40.5 cm (16 x 16 in).

PAPER: 145gsm Zerkall Smooth.

TECHNIQUE: Colour woodcuts, hand-printed by the artist using roller, spoon and hand-rubbing, and between one and between one and three separate blocks per print.

1 One woodcut block.
2 Two woodcut blocks.
3 Three woodcut blocks.
4 Three woodcut blocks.
5 Three woodcut blocks.

PRINTER: The artist

BINDING: None

TYPOGRAPHY: None

CHRISTOPHER LE BRUN
MOTIF LIGHT, 1998

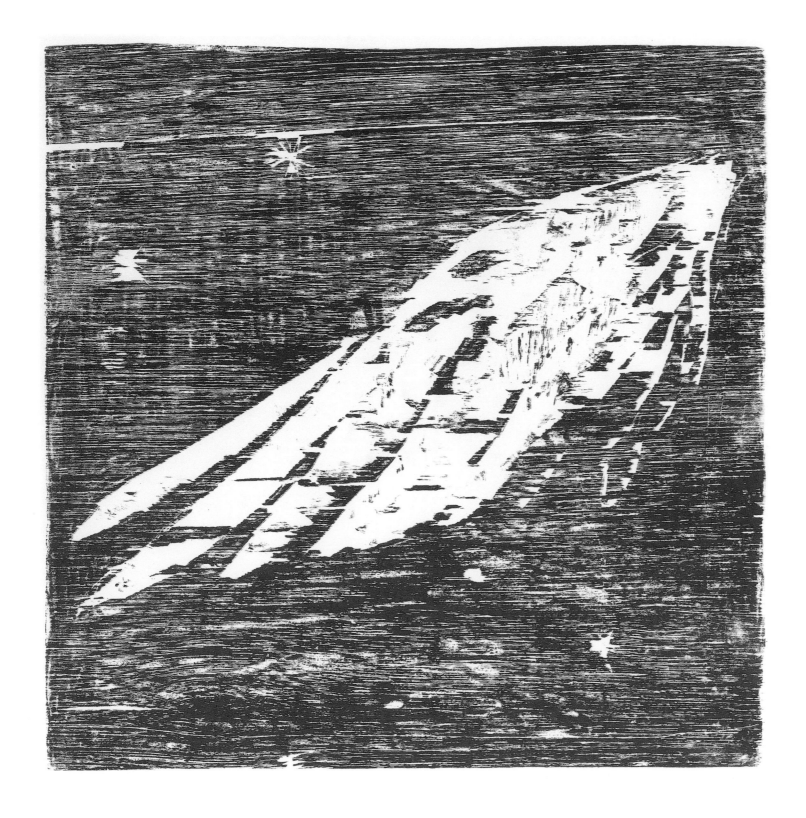

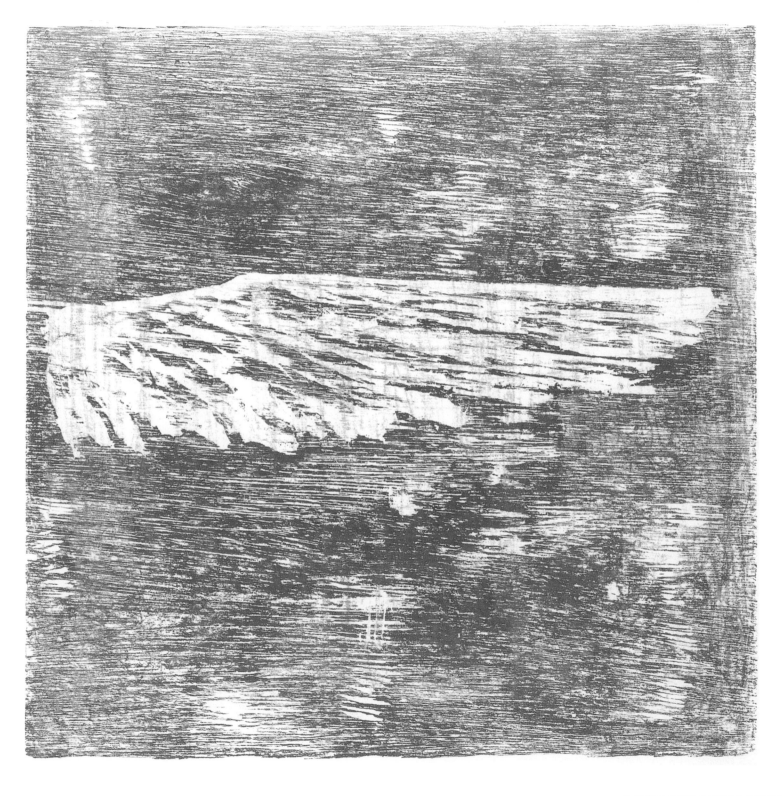

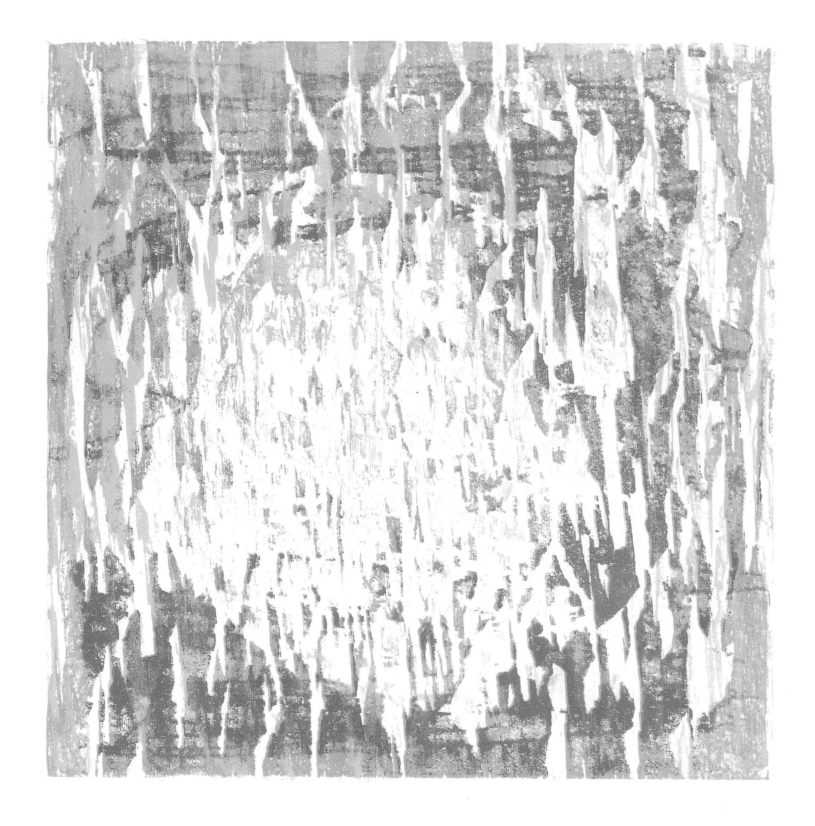

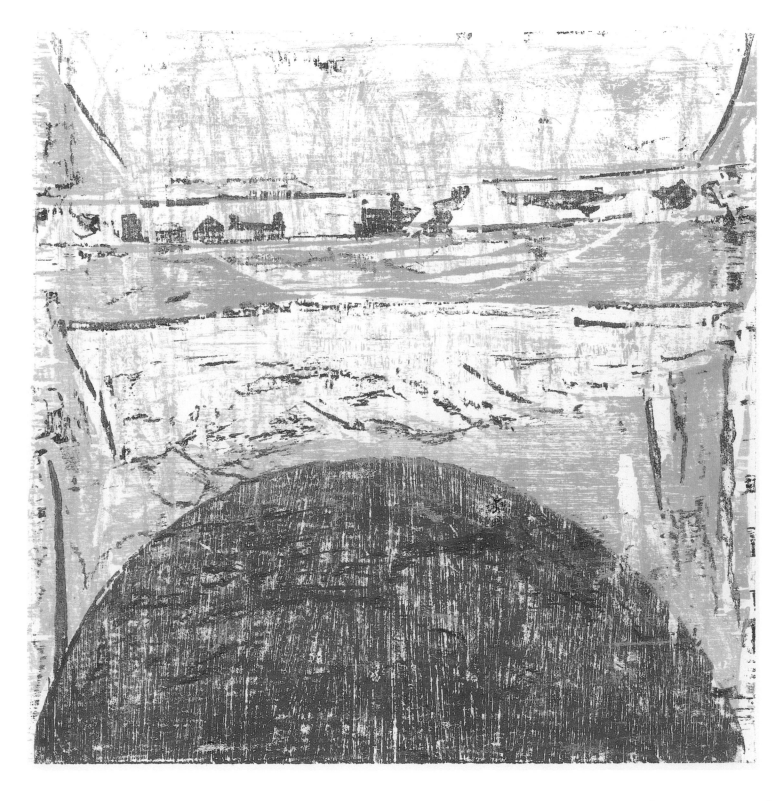

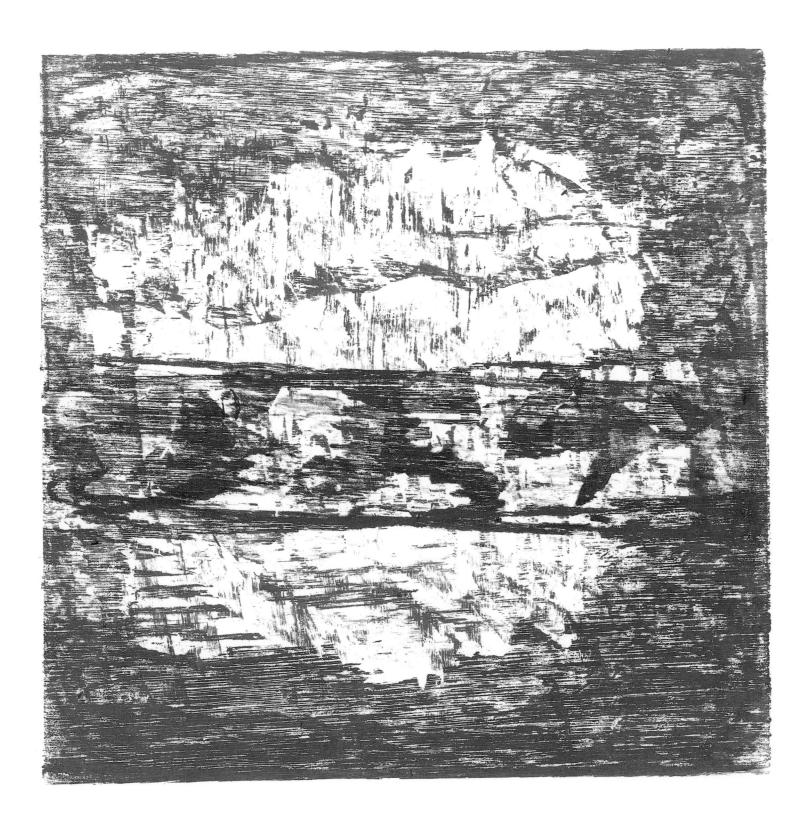

DESCRIPTION: 9 prints with title-page, colophon and portfolio case; another edition of 9 prints without margins, dry-mounted on to aluminium boards.

EDITION: 12 sets numbered 1 to 12, plus 5 proof sets. There is also a further edition of 9 numbered sets and 5 proof sets, with the prints cut down to the image size and dry-mounted on to aluminium boards.

INSCRIPTIONS: Each print signed and numbered by the artist on the reverse. The prints dry-mounted on to aluminium boards are signed on the reverse of the boards.

SIZE: Portfolio edition: Sheet 48 × 55.9 cm (18⅞ × 22 in). image 44.6 × 53.5 cm (17½ × 21⅛ in). Edition dry-mounted on to aluminium boards: 44.6 × 53.5 cm (17½ × 21⅛ in).

PAPER: Gelatine tissue on a polyester sheet.

TECHNIQUE AND PRINTER: Pigment transfer prints, proofed by Adam Lowe from four-colour stochastic separations. These were prepared by Adrian Lack at the Senecio Press from electronically generated video images made by the artist with technical assistance from Sam Hodgkin and stored on a CD-ROM. The prints were editioned at Permaprint, London, using gelatine tissue produced by Ultrastable Colour Systems, and printed onto a polyester sheet.

BINDING: Wooden portfolio case covered in black buckram, made by G. Ryder & Co. Ltd.

TYPOGRAPHY: Designed by Phil Baines in Amasis.

ANISH KAPOOR
WOUNDS AND ABSENT OBJECTS, 1998

GARY HUME
PORTRAITS, 1998

DESCRIPTION: 10 screenprints, title-page, colophon and portfolio case.

EDITION: 36 sets numbered 1 to 36, plus 10 artist's proof sets.

INSCRIPTIONS: Each print signed and titled by the artist, and numbered on the colophon page.

SIZE: See below.

PAPER: 410gsm Somerset Satin.

TECHNIQUE: Screenprint: between 3 and 15 screens per print, and between 1 and 3 varnish screens per print.

PRINTER: Proofed and editioned at Coriander Studio, London.

BINDING: Wooden portfolio case covered in brown buckram with an original image by the artist screenprinted in orange on the cover. Made by G. Ryder & Co. Ltd.

TYPOGRAPHY: Title-page and colophon designed by Phil Baines in Argo and screenprinted by Coriander Studio, London.

INDIVIDUAL TITLES AND SIZES:

1 *Whistler:* Image 90.8 × 69.8cm (35¾ × 27½in), sheet 108.1 × 86.2cm (42½ × 34in).

2 *Angel:* Image 92.6 × 72.7cm (36½ × 28⅝in), sheet 108.4 × 89.5cm (42⅝ × 35¼in).

3 *Young Woman:* Image 90.8 × 61cm (35¾ × 24in), sheet 108.5 × 77.9cm (42⅝ × 26¾in).

4 *Yellow Hair:* Image 90.7 × 56.6cm (35¾ × 22¼in), sheet 108 × 84cm (42½ × 33⅛in).

5 *Funny Girl:* Image 90.6 × 68.7cm (35⅝ × 27in), sheet 108 × 84cm (42½ × 33in).

6 *Poor Thing:* Image 90.7 × 68.7cm (35¾ × 27in), sheet 107.5 × 85cm (42⅜ × 33½in).

7 *Lady Parker:* Image 91 × 63.3cm (35¾ × 24⅞in), sheet 108.3 × 79.8cm (42⅝ × 31⅜in).

8 *Cerith:* Image 90.6 × 67.8cm (35⅝ × 26⅝in), sheet 108.6 × 83.9cm (42¾ × 33in).

9 *Adult:* Image 90.7 × 69.1cm (35⅝ × 27¼in), sheet 108.3 × 86.1cm (42⅝ × 33⅞in).

10 *Francis:* Image 91 × 71.5cm (35⅞ × 28⅛in), sheet 107.8 × 87.5cm (42⅜ × 34½in).

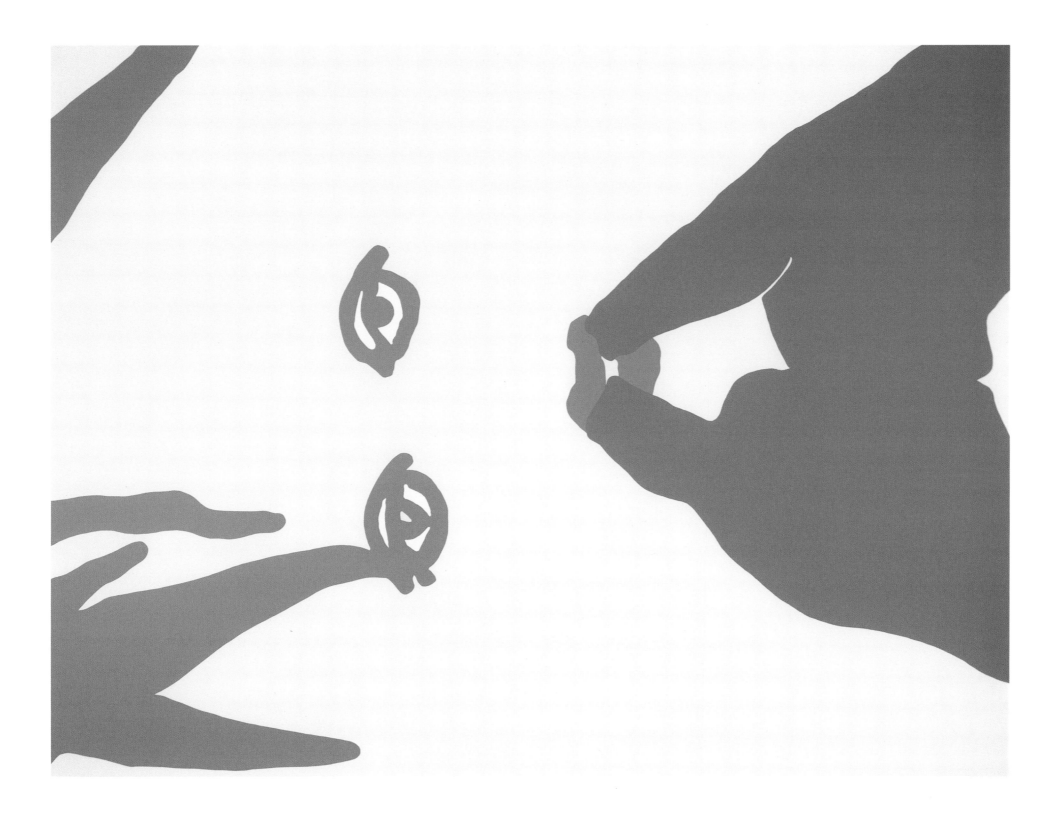

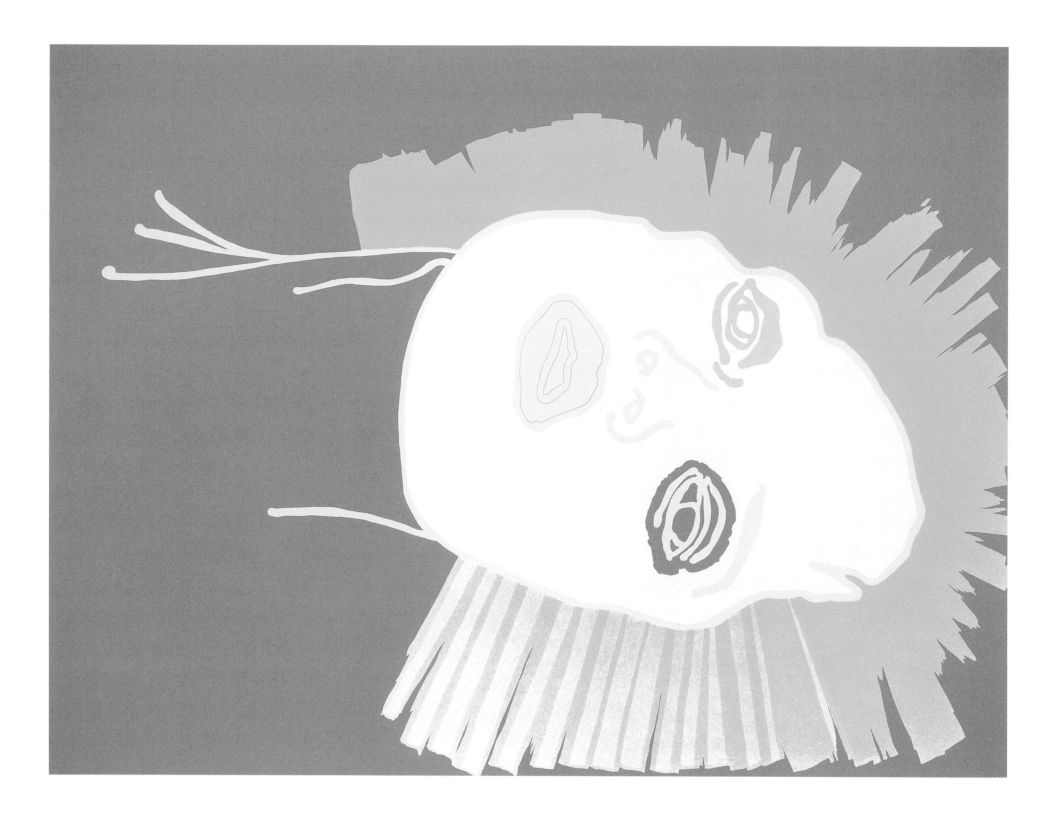

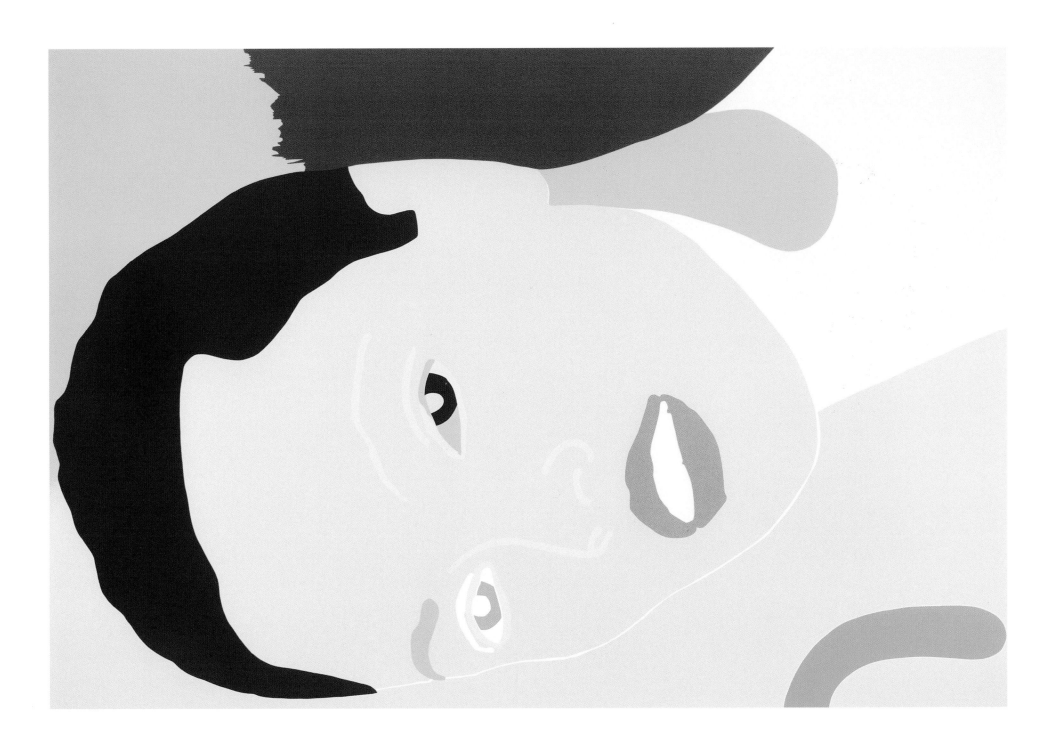

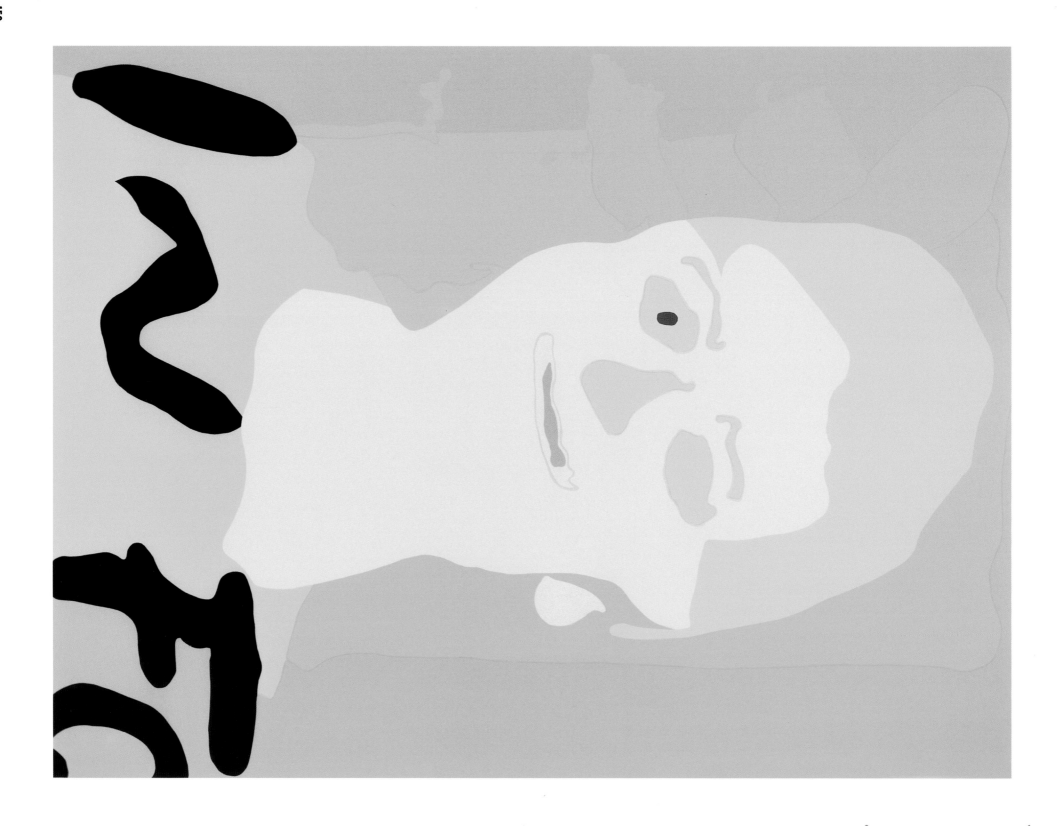

TERRY FROST
MADRON WOODCUTS,
1998

full set of ten woodcuts

**DESCRIPTION, EDITION &
SIZES:** Four different editions
of *Madron Woodcuts*:

Madron Woodcuts: 10-part
woodcut with title-page,
colophon and portfolio case
in an edition of 35, plus 8
proof sets and 1 BAT. Total
size: 84 × 345cm
(33 × 135⁷⁄₈in).

Madron Woodcuts (Curve):
9-part woodcut in an edition
of 8. Total size: 84 × 310.5cm
(33 × 122½in).

*Madron Woodcuts (Half
Moons)*: 10-part woodcut in
an edition of 8. Total size:
84 × 345cm (33 × 135⁷⁄₈in).

Madron Woodcuts (Boats):
7-part woodcut in an edition
of 8. Total size: 84 × 240cm,
(33 × 94½in).

INSCRIPTIONS: Each print
signed and numbered on the
reverse and the *Madron
Woodcuts* set numbered on
the colophon page. Each sheet
in all four editions numbered
in preferred sequence.

SIZE: Individual sheet size
varies from 84 × 33.4cm to
84 × 34.3cm (33 × 13¹⁄₈in to
33 × 13½in). Maximum length
when joined together:
84 × 345cm (33 × 135⁷⁄₈in).

PAPER: 310gsm Somerset
Satin.

TECHNIQUE: Colour woodcuts
with multiple inkings. All
printed to edge of sheet apart
from *Madron Woodcuts
(Curve)*.

PRINTER: Proofed by Hugh
Stoneman and Michael Ward
and printed at Stoneman
Graphics, Cornwall.

BINDING: *Madron Woodcuts*
presented in a wooden
portfolio case covered in
orange cloth, with a design
by the artist screenprinted on
the cover. Made by G. Ryder
& Co. Ltd.

TYPOGRAPHY: Colophon and
title-page drawn and
designed by the artist, and
screenprinted by Coriander
Studio, London.

Terry Frost Madron Woodcuts Curve

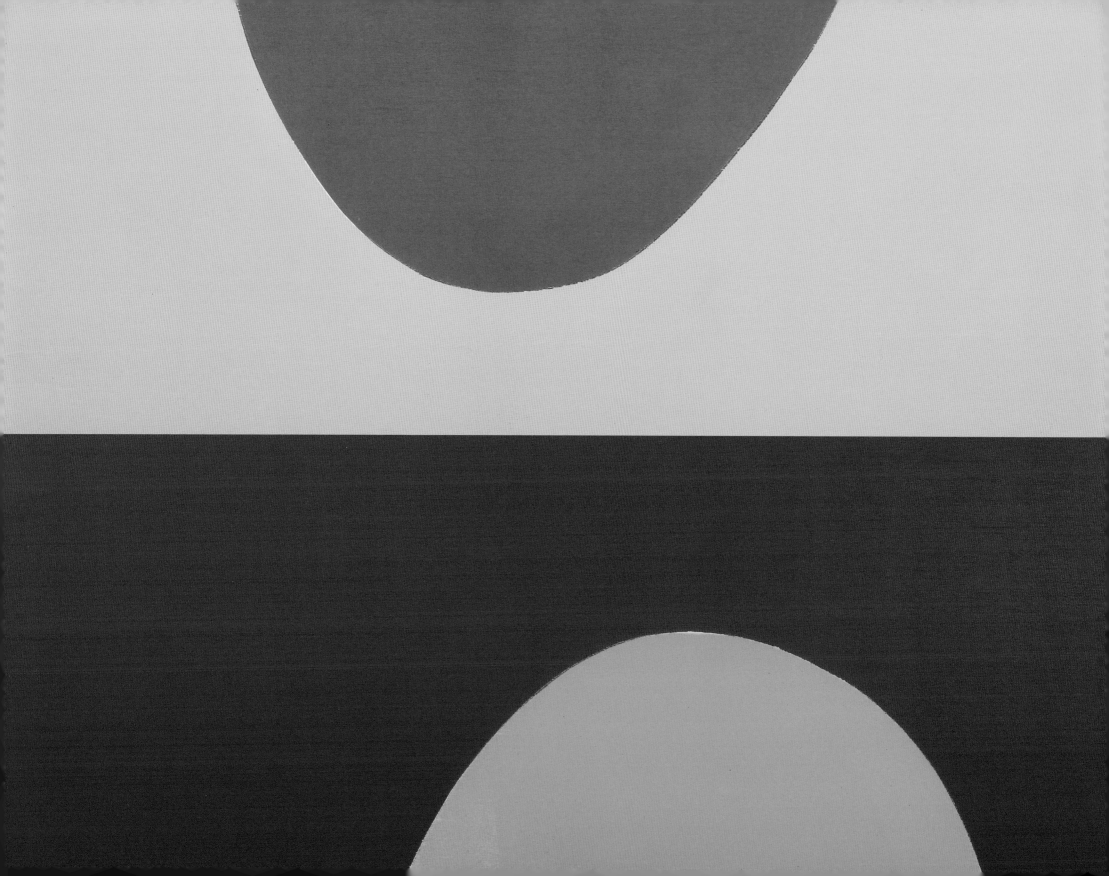

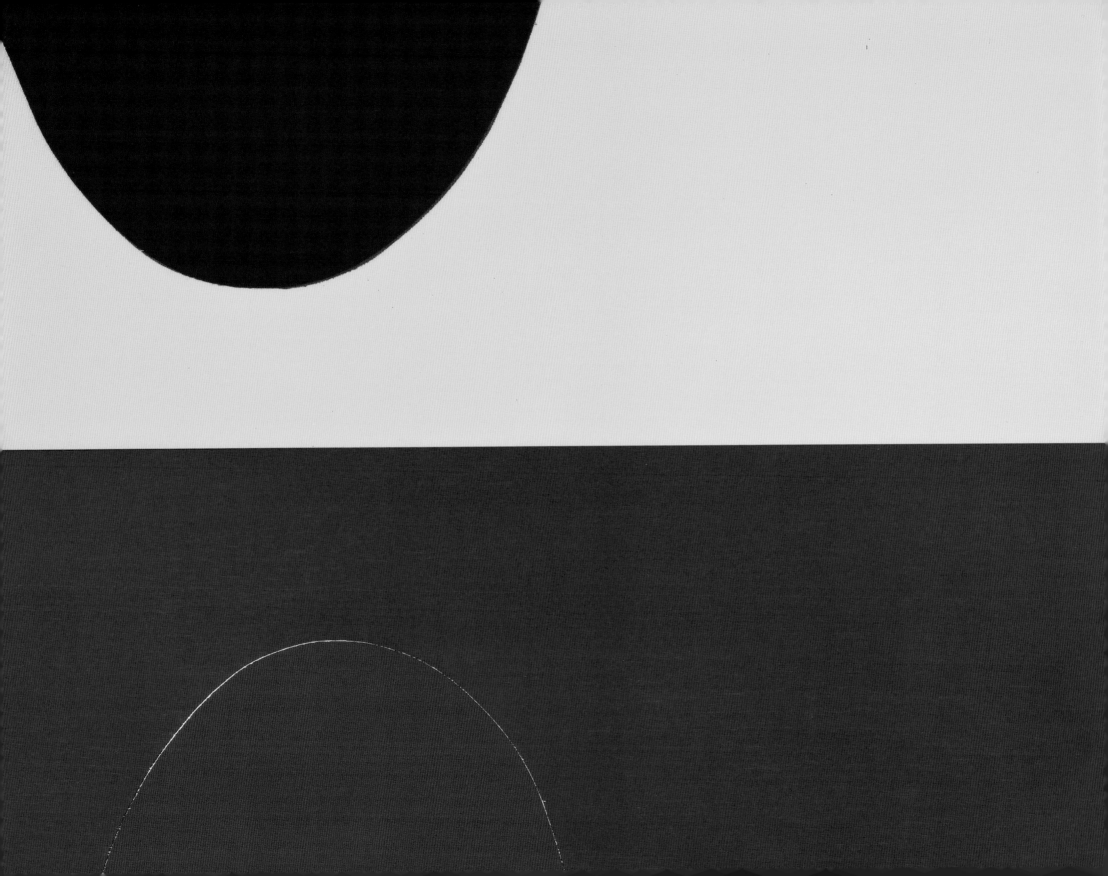

DESCRIPTION: 8 multi-part prints, title-page, colophon and portfolio case (for the first 35 sets). Each set is made up of 16 separate sheets forming one triptych, six diptychs and one single print. The works are as follows:

1 *Kilometre Theatre.*
Sheet and image
73.6 × 267 cm
(29 × 105⅛in).
3 sheets Velin Arches,
20 screens, no varnish.

2 *A Pavilion for Parliament –*
Dish of Decisions.
Sheet and image
148 × 88.9 cm (58¼ × 35 in).
2 sheets Somerset Satin,
13 screens plus varnish.

3 *An Ideal Home.*
Sheet and image
89 × 147.2 cm (35 × 58 in).
Left sheet Somerset Satin,
7 screens plus varnish;
right sheet Velin Arches,
10 screens plus varnish.

4 *Designer Traffic Jam –*
Celebration of an
Intersection.
Sheet and image
143.5 × 135 cm
(56½ × 53⅛in).
Top sheet Velin Arches,
14 screens plus varnish;
bottom sheet Somerset
Satin, 5 screens plus
varnish.

5 *Façade Park.*
Sheet and image
145 × 89 cm (57 × 35 in).
Left sheet Somerset Satin,
3 screens plus varnish;
right sheet Velin Arches,
17 screens plus varnish.

6 *Great Arch of Art.*
Sheet and image
73.5 × 89 cm (28⅞ × 35 in).
1 sheet Somerset Satin,
15 screens plus 2 varnish
screens.

7 *Storehouse / Starehouse*
of Art.
Sheet and image
89 × 73.5 cm
(35 × 28⅞in).
2 sheets Somerset Satin,
13 screens plus 2 varnish
screens.

8 *Xerox City.*
Sheet and image
88.5 × 146 cm
(34⅞ × 57½in).
2 sheets Somerset Satin,
8 screens plus varnish.

EDITION: 45 sets numbered
1 to 45 (the first 35 sets
presented in portfolio cases),
plus 5 proof sets and 5 *hors*
de commerce sets.

INSCRIPTIONS: Each print
signed and numbered by the
artist.

PAPER: 400gsm Velin Arches
and 400gsm Somerset Satin.

TECHNIQUE: Screenprint.

PRINTER: Proofed and
editioned by Coriander
Studio, London.

BINDING: Wooden portfolio
case covered in black
buckram, with the artist's
name screenprinted in matt
black on the cover. Made by
G. Ryder & Co. Ltd.

TYPOGRAPHY: Designed by
Bruce McLean with Coriander
Studio, London, in Helvetica.
Brochure designed by
Phil Baines.

BRUCE McLEAN
KILOMETRE THEATRE AND SEVEN OTHER
SEMINAL ARCHITECTURAL PROJECTS, 1998

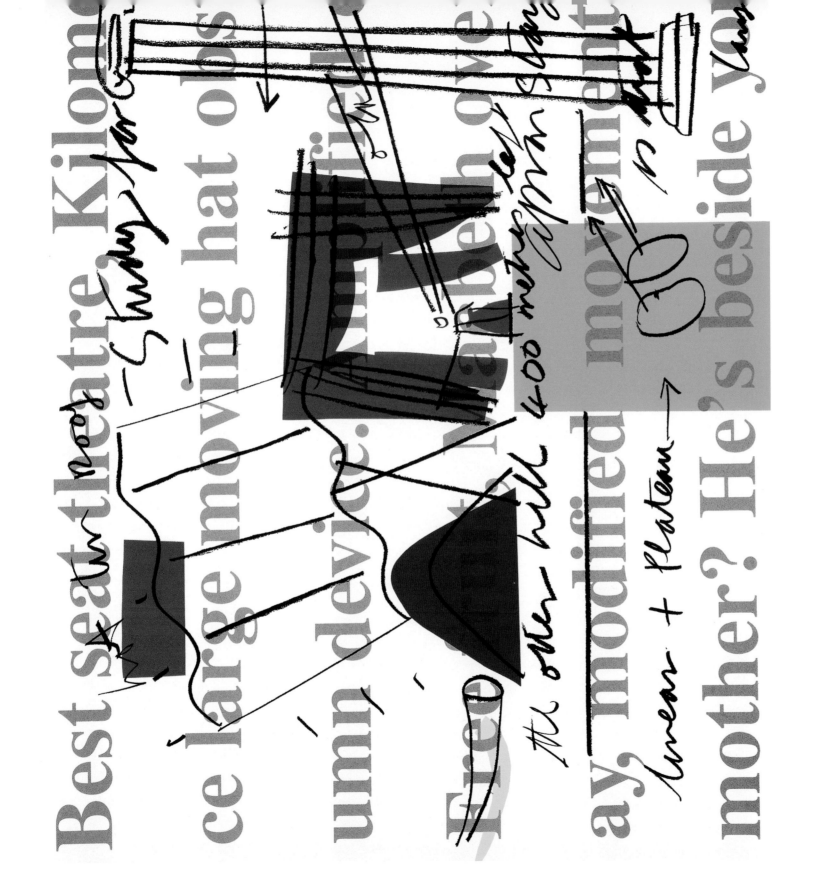

theatre, from myself

construction plus design sh

crackle crunch and

Mile- a Street-car Na

and communica

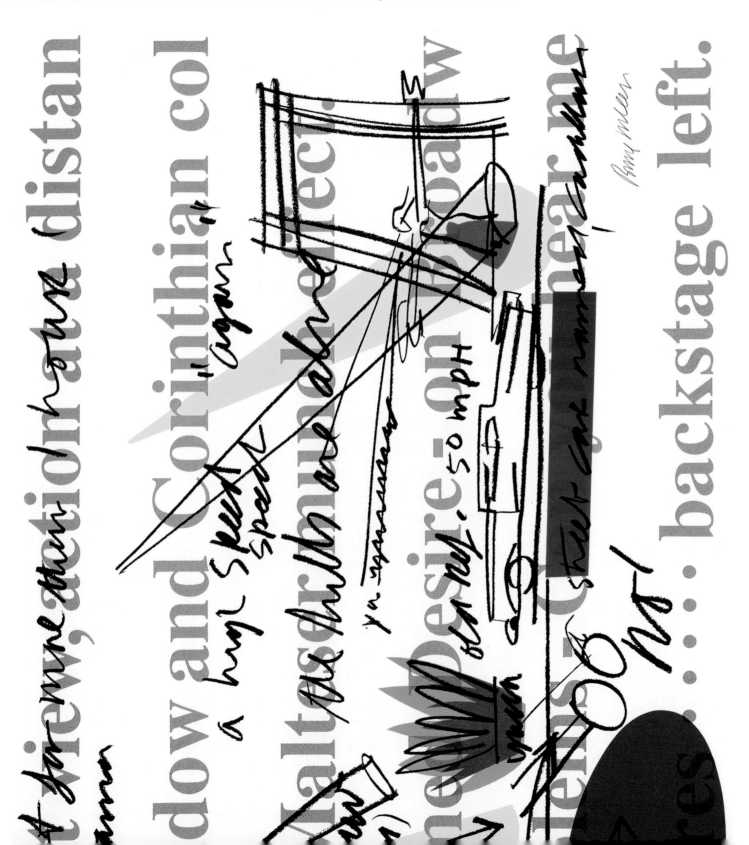

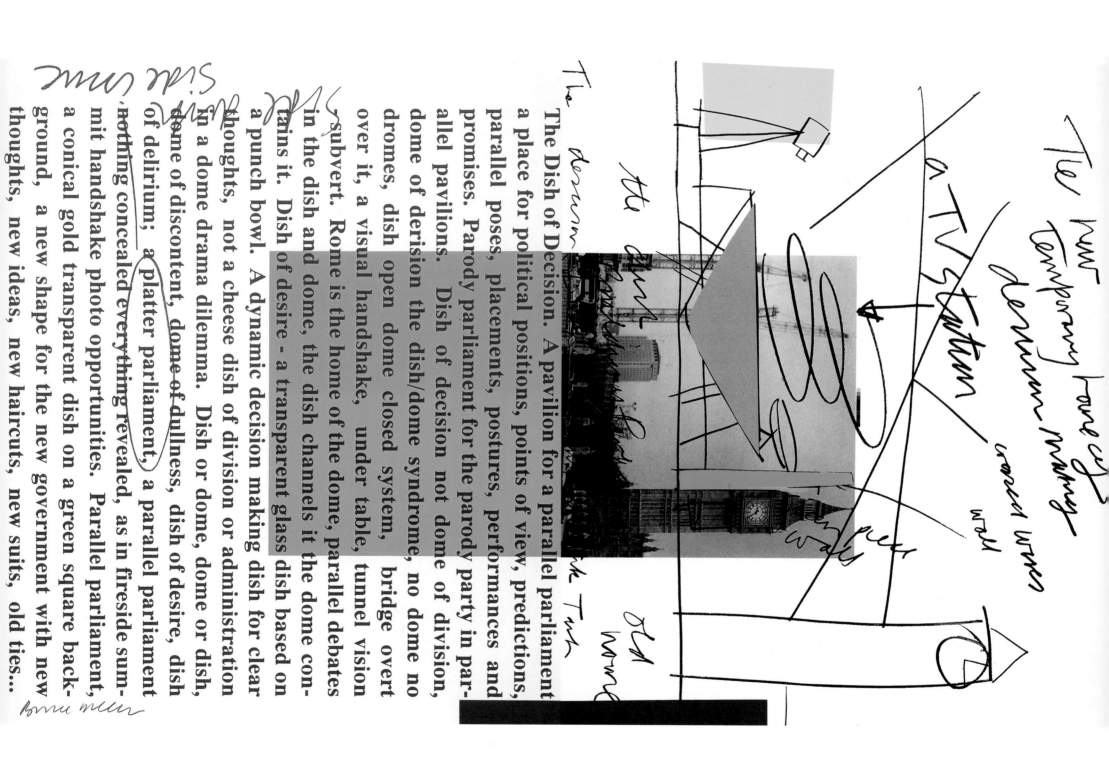

The Dish of Decision.

The Dish of Decision. A pavilion for a parallel parliament a place for political positions, points of view, predictions, parallel poses, placements, postures, performances and promises. Parody parliament for the parody party in parallel pavilions. Dish of decision not dome of division, dome of derision the dish/dome syndrome, no dome no dromes, dish open dome closed system, bridge overt over it, a visual handshake, under table, tunnel vision subvert. Rome is the home of the dome, parallel debates in the dish and dome, the dish channels it the dome contains it. Dish of desire – a transparent glass dish based on a punch bowl. A dynamic decision making dish for clear thoughts, not a cheese dish of division or administration in a dome drama dilemma. Dish or dome, dome or dish, dome of discontent, dome of dullness, dish of desire, dish of delirium; a platter parliament, a parallel parliament nothing concealed everything revealed, as in fireside summit handshake photo opportunities. Parallel parliament, a conical gold transparent dish on a green square background, a new shape for the new government with new thoughts, new ideas, new haircuts, new suits, old ties...

Bruce McLean Kilometre Theatre and Seven Other Seminal Architectural Projects 4 Designer Traffic Jam – Celebration of an Intersection

177

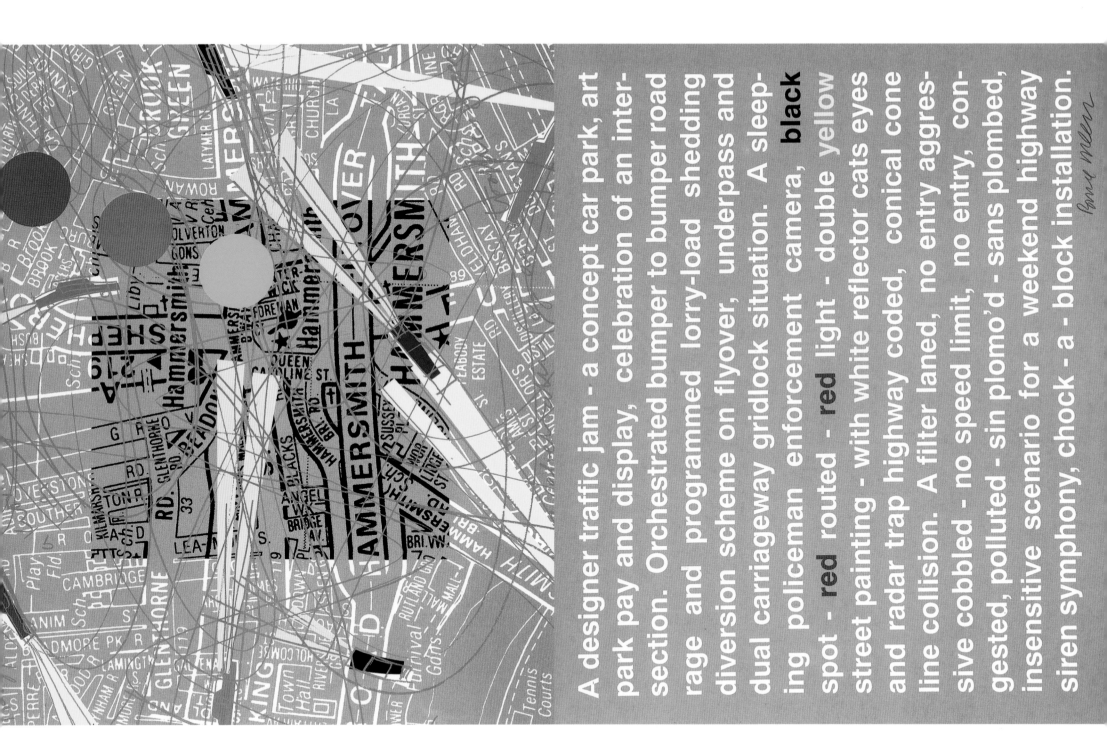

A designer traffic jam – a concept car park, art park pay and display, celebration of an intersection. Orchestrated bumper to bumper road rage and programmed lorry-load shedding diversion scheme on flyover, underpass and dual carriageway gridlock situation. A sleeping policeman enforcement camera, **black** spot – red routed – **red** light – double yellow street painting – with white reflector cats eyes and radar trap highway coded, conical cone line collision. A filter laned, no entry aggressive cobbled – no speed limit, no entry, congested, polluted – sin plomo'd – sans plombed, insensitive scenario for a weekend highway siren symphony, chock – a – block installation.

window ensemble based loosely covere[d]
ref. misinterpreted Bonnard/Mon[e]
moment, and the sensational belgia[n]
butcher's chopping block conversio[n]
into a skylight fixture, we addre[ss]
the microwave digi diner/cool dee[p]
freeze type LA longing pad in lin[e]
with three balanced flues, one pat[io]
door onto sundeck sundial suburba[n]
submerged in spurge situations,
what makes today's master bedroo[m]
with revived ensuite bathro[om]
avoca... lush mama s...
conve...
folia...

in
victorian propped up planted an
lit habitatily brick I've got th
wrong end of the stick shit house

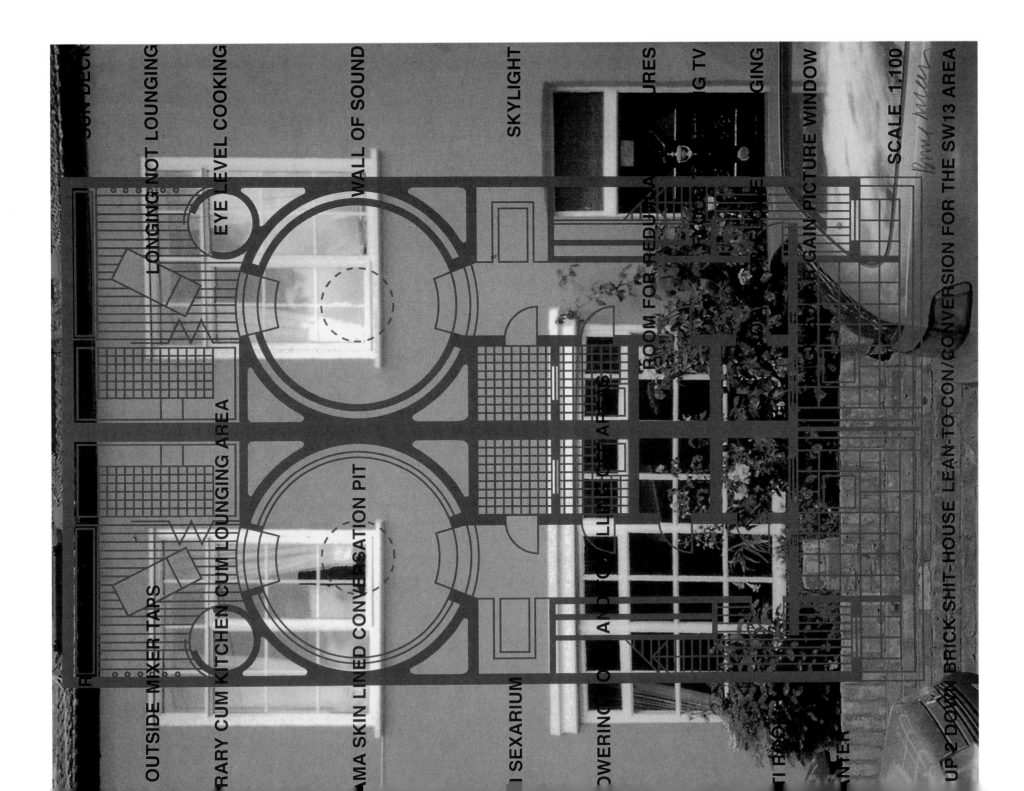

SUN DECK · LONGING NOT LOUNGING · EYE LEVEL COOKING · WALL OF SOUND · SKYLIGHT · ...URES · ...G TV · ...GING · ...AIN PICTURE WINDOW · SCALE 1:100

OUTSIDE MIXER TAPS · ...RARY CUM KITCHEN CUM LOUNGING AREA · ...AMA SKIN LINED CONVERSATION PIT · ...SEXARIUM · ...OWERING... AND... ...LLING... ...S · ROOM FOR REDU... · ...TI RO... · ...NTER · UP 2 D... BRICK-SHIT-HOUSE LEAN-TO-CON/CONVERSION FOR THE SW13 AREA

Measured moments adjacent angles to the grand arena, a stand that moves with the race, a wall of death, a south facing sliding stadium situation. From the south east facing north at specific angles measured minutes and calculated heights above sea level directly under a flight path the huge stand whose shape is determined by the disposition and con figuration for today's purpose of fences walls partitions of various heights - theatrical flats of colours - Munsel scale visual balance postur precinct in Parasol park promenading along the side stroller come lake length swim pool channel - we see - feel the energy from the sound wa score board mark, park screen, Muybridge measured numbered nume ated nudist nudge zone. To the side and down we have a slope/pla place for serious and seminal slipping, sliding, strolling, skiing, sledg ing. At the bottom a track for sloping, loping and post-modern peram bulating, walk way works, pre-war walking, modernist stalking. Th drome dome syndrome sin drome, a sexarium multisex complex for th under stimulated strollers, device den obsession centres, trans ava garde and modern mock tudor free form gesture areas, communi gestures fine gesture etc. Situated deep in graph grove a centre f obsessive measurement, weight, speed, height, length, width, time, girt angle parallel to the promenade pergolated pose pool, energised fro the south wall capta espray screen, measured, numerated, timed, pe formance pod above the sky invisibly screened by thermal thermostat sexual sealing ceiling transparent roof sun black factor canopy - Var able, determined sun strength morning awning sunset blind, etc etc et

The Arch of Art is a place for a public view of Whitehall, the Mall and Northumberland Avenue - it is not a place for a private view. Squaring the square and addressing Admiralty Arch, referencing the Gate of the Kiss, framing the endless column and the new table of silence in Parliament Square. The structure of this great work of wonderment (see Q.E.2. in Trafalgar Square) will be determined by the artists, architects, scientists, engineers, philosophers, writers, composers and builders that it will house.

The work is the art no Harvey installations, no administra- no sponsors, no commissions, no patrons, no experts, no academies, no franchised restaurants, no parties, no private views, no logos. Art is the way, not in the way of art, re. wayside pulpit, early conceptual street works - sites specific. 90% of the cost of the build-ing will be spent on the works, the works being the building, which will not be repositioned, stored, exhibited, auctioned or deconstructed from time to time in other buildings. Stored dust, censored, removed or re-positioned, recontextualised and buried under the great museums of dust.

Bruce McLean

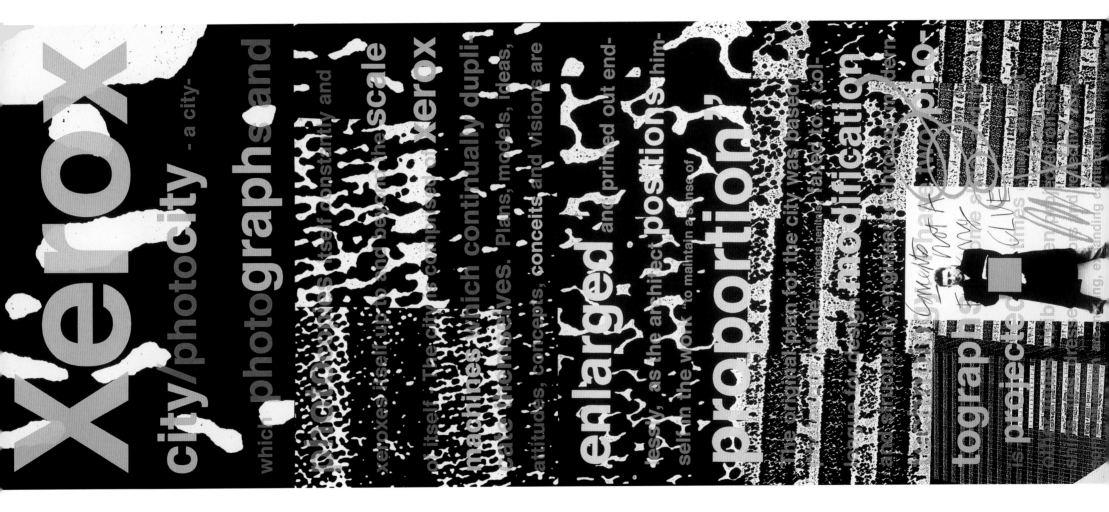

Xerox

city/photocity - a city-

which photographs and

photographs itself up to and beyond the scale

xeroxes itself up to and beyond the scale

of itself. The city comprises of xerox

machines which continually dupli-

cates themselves. Plans, models, ideas,

attitudes, concepts, conceits and visions are

enlarged and printed out end-

lessly, as the architect positions him-

self in the work "to maintain a sense of

proportion"

The original plan for the city was based

modification

DESCRIPTION: 9 etchings with title-page, colophon and portfolio folder.

EDITION: 30 sets numbered 1 to 30, plus 10 artist's proof sets, 2 printer's proof sets and 1 BAT.

INSCRIPTIONS: Each print signed, inscribed and numbered by the artist.

SIZE: Sheet 50 x 65cm (19⅝ x 25½in), plate 37 x 51cm (14½ x 20⅛in).

PAPER: 270gsm Moulin du Gué.

TECHNIQUE: Colour etching.

1 Aquatint and deep-bite etching with blind emboss printing on one copper plate.

2 Aquatint and deep open-bite etching on one copper plate.

3 Transfer aquatint and dust-grain gravure on one copper plate, and deep-bite etching on one steel plate.

4 Random etching on one steel plate, and deep-bite etching on a second steel plate.

5 Aquatint and deep-bite etching on one copper plate.

6 Aquatint and deep-bite etching on one copper plate.

7 Transfer aquatint and dust-grain gravure on one copper plate, and deep-bite etching on one steel plate.

8 Aquatint and deep-bite etching on one copper plate.

9 Unetched tone from one steel plate, and deep-bite etching on a second steel plate.

PRINTER: Proofed and editioned by Hugh Stoneman at Stoneman Graphics, Cornwall.

BINDING: Portfolio folder designed by the artist and covered in red buckram. Made by Charles Gledhill.

TYPOGRAPHY: Designed by Phil Baines in Argo.

IAN MCKEEVER
BETWEEN SPACE AND TIME, 1999

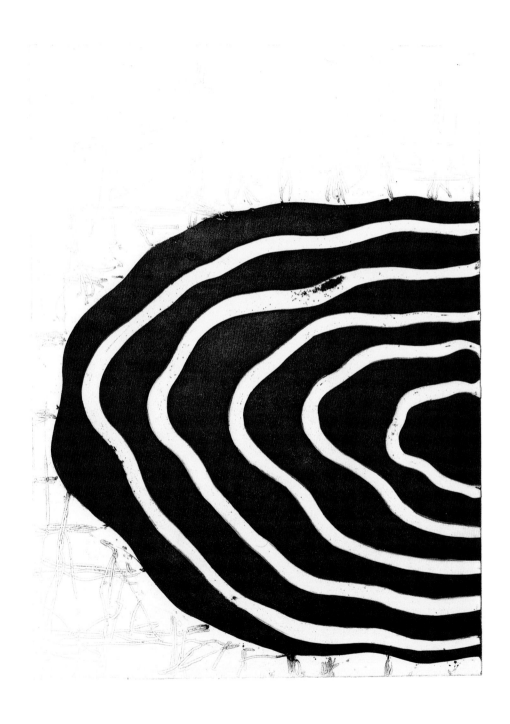

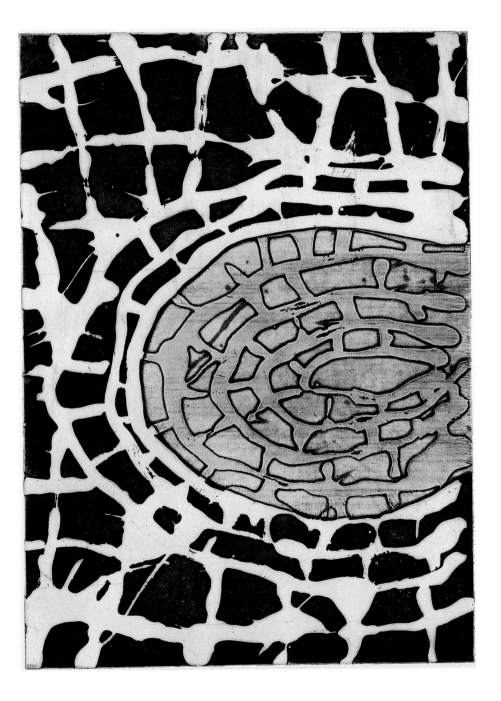

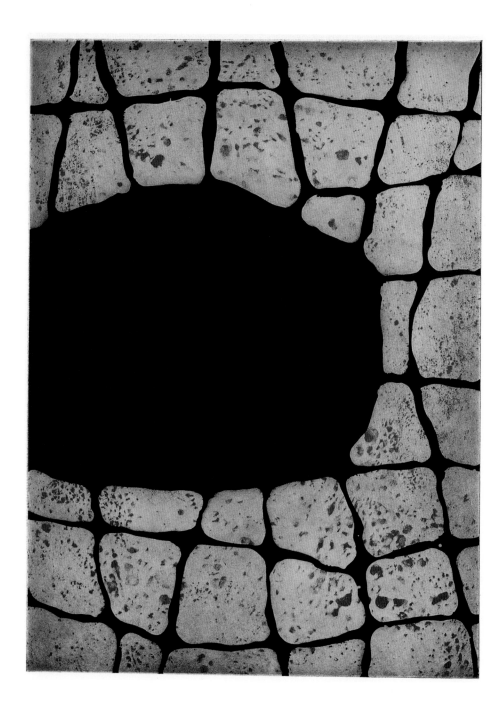

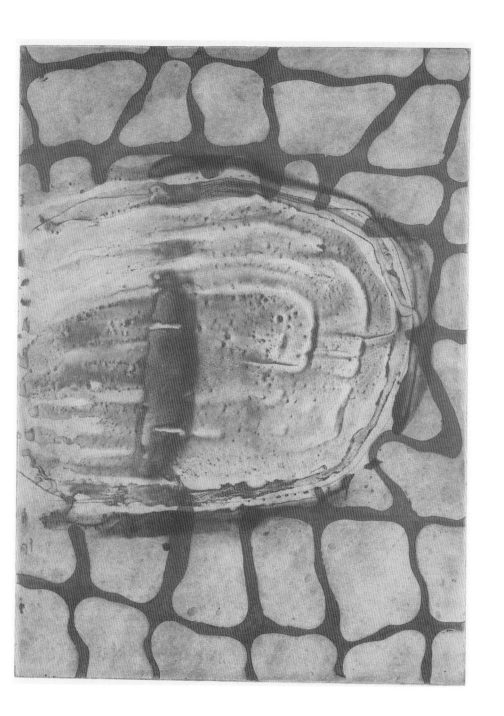

DESCRIPTION: First edition: 83 etchings with title-page and colophon in a portfolio case and 5 copies bound as a book. There are three variant sets: see below.

EDITION: First edition: Black ink on white paper, 15 sets numbered 1 to 15, plus 5 artists' proof sets, 1 *hors de commerce* copy, 2 printer's proof sets, 2 artists' sets for hand colouring, 5 proof sets bound into books and 1 BAT. Second edition: White ink on black *chine collé*, 10 sets numbered 1 to 10, plus 3 artists' proof sets and 1 BAT. Third edition: 4 sets printed on *chine collé* cartoons.

INSCRIPTIONS: First edition: each print signed by the artists and numbered on the colophon page; the 5 sets bound into books are signed on the colophon page. Second edition: each print signed and numbered by the artists on the reverse. Third edition: each print signed by the artists on the reverse.

SIZE: Sheet 34.5 x 24.5cm (13⅝ x 9⅝in); plate sizes vary (like Goya's original *Disasters of War* plates) between 11.5 x 14.5cm (4½ x 5¾in) and 14 x 20cm (5½ x 7⅞in).

PAPER: 300gsm Somerset TP Textured. Second edition printed on black mingei *chine collé*; third edition printed on *chine collé* cartoons from *The Big Fun Colouring Book*.

TECHNIQUE: Etching: hardground, softground, drypoint and aquatint.

PRINTER: Proofed and editioned at Hope (Sufferance) Press, London.

BINDING: Wooden portfolio case covered in brown cloth and book-bindings in leather (made only for the first edition), designed by Charles Gledhill in collaboration with the artists, and made by Gledhill.

TYPOGRAPHY: Title and colophon pages (made only for the first edition) designed and hand-printed in letterpress by Simon King.

JAKE & DINOS CHAPMAN
THE DISASTERS OF WAR, 1999

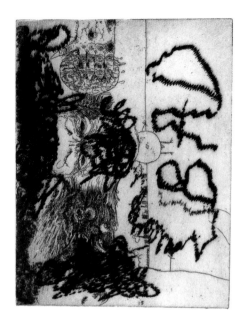
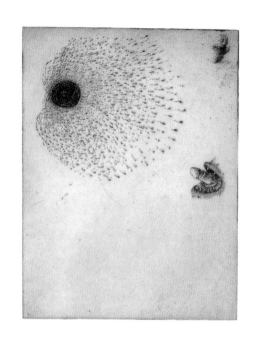
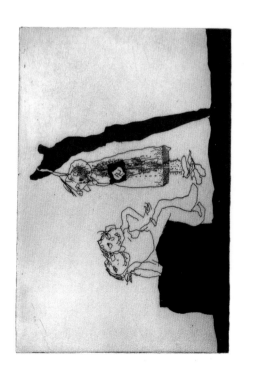
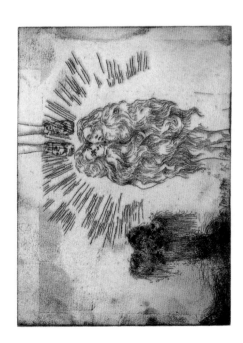
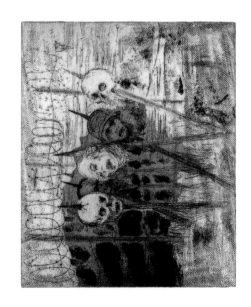

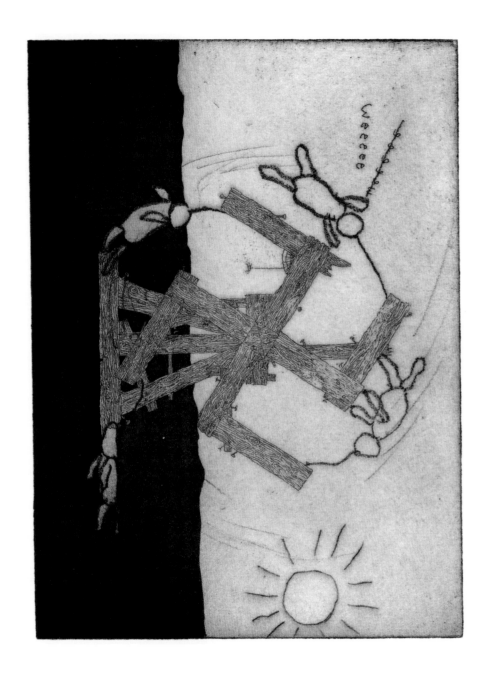

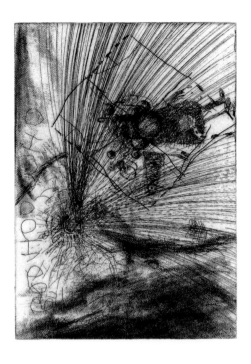

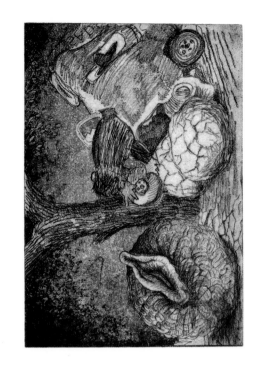

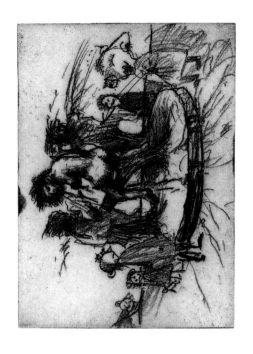

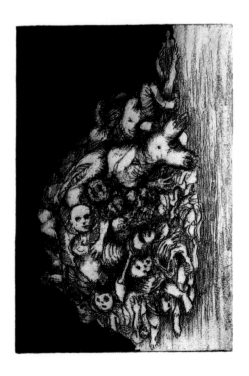

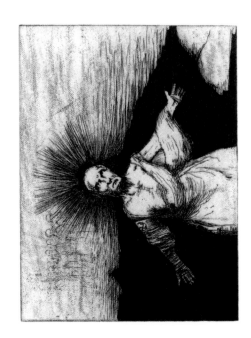

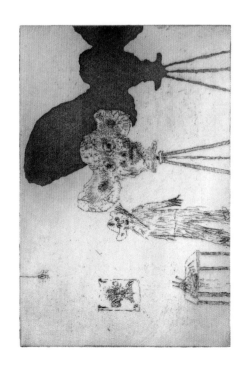

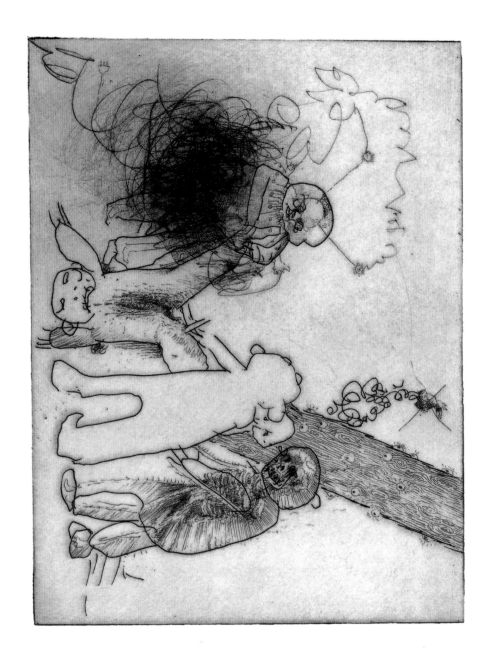
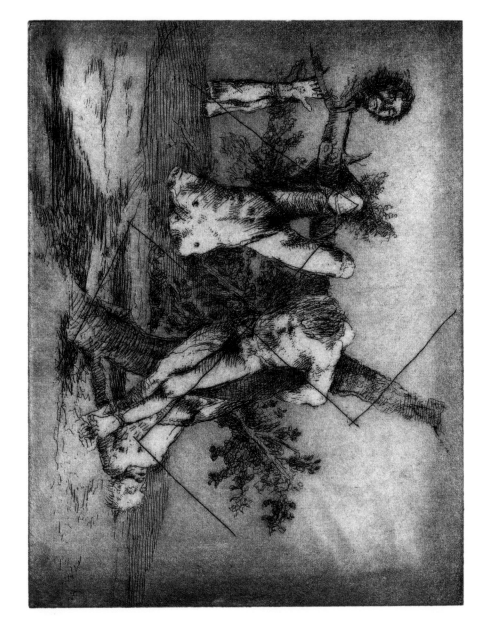

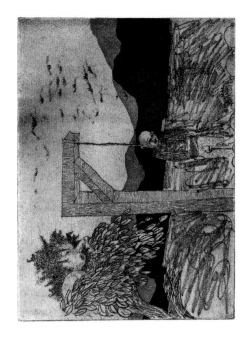

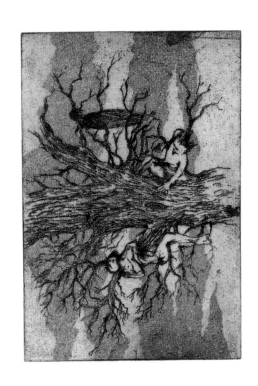

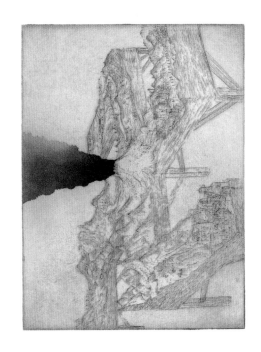

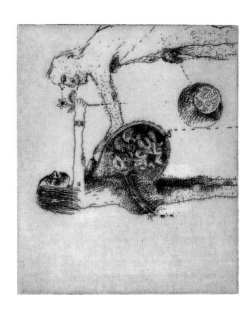

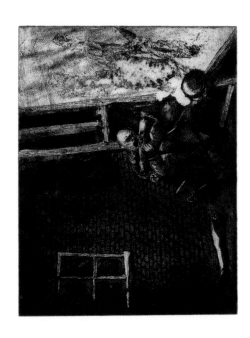

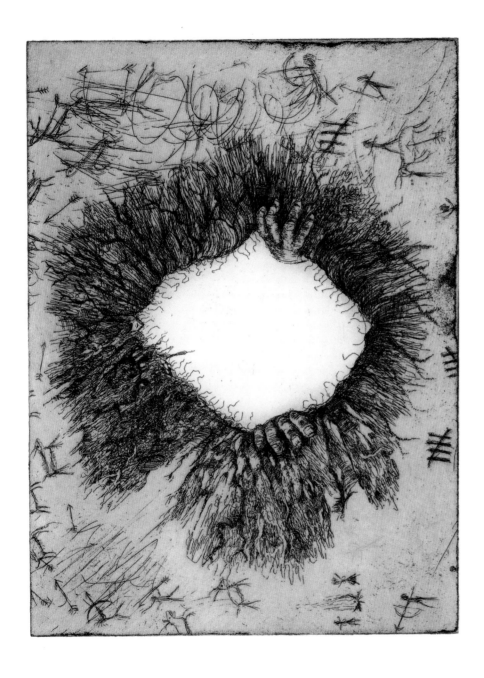
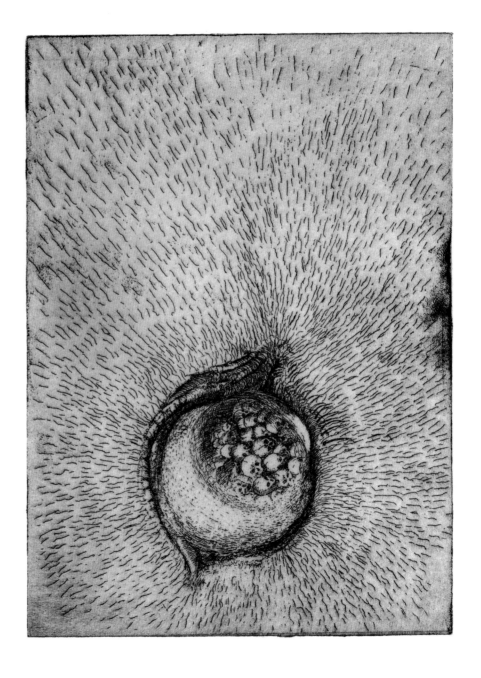

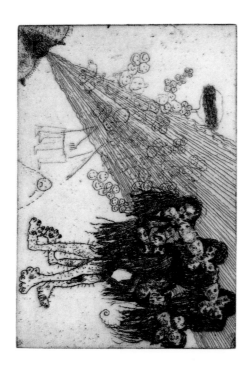

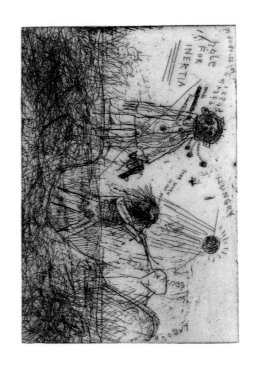

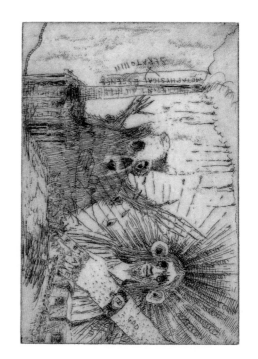

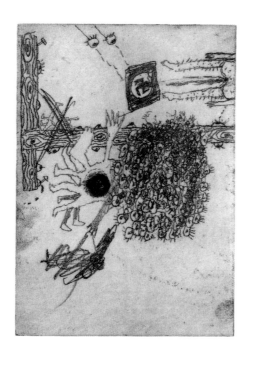

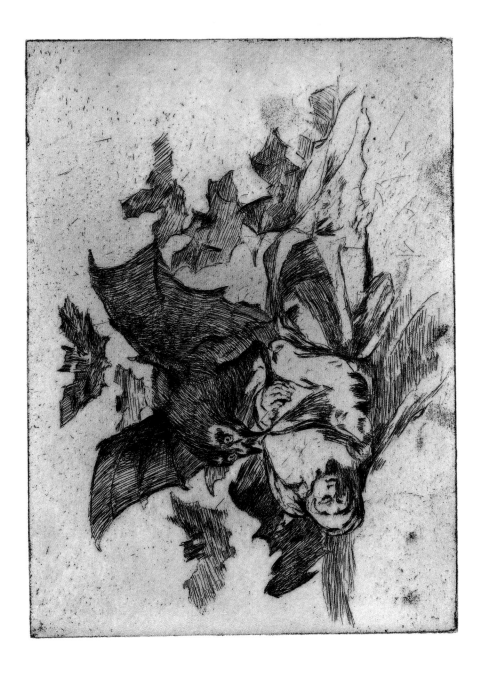

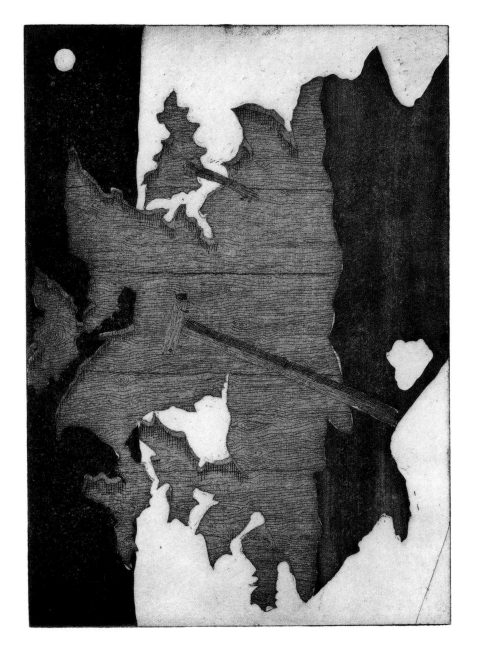

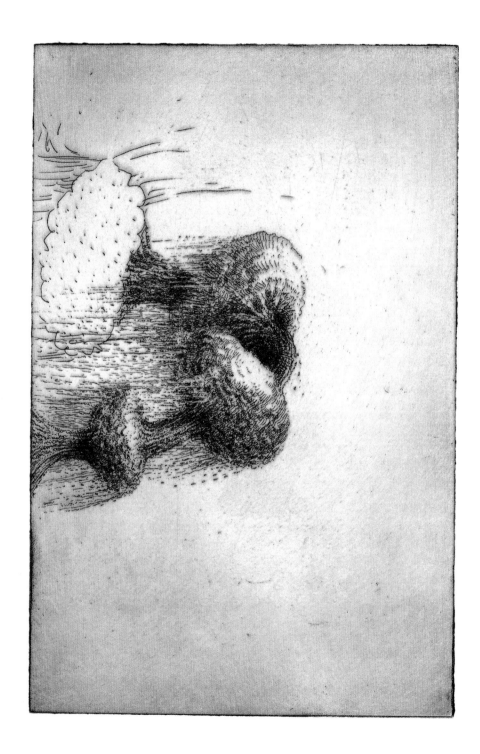

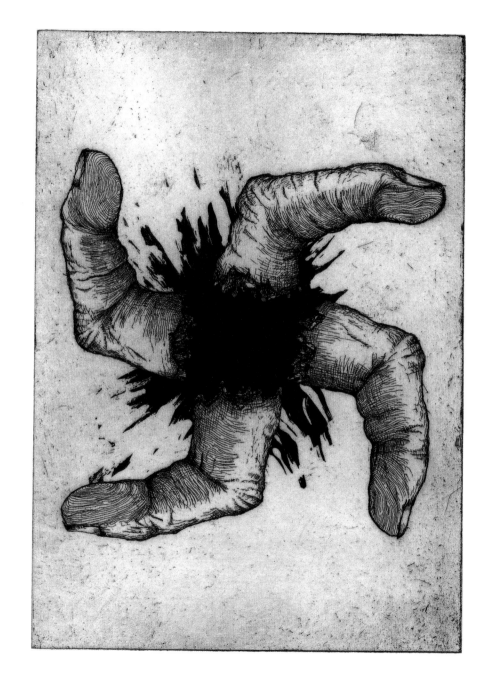

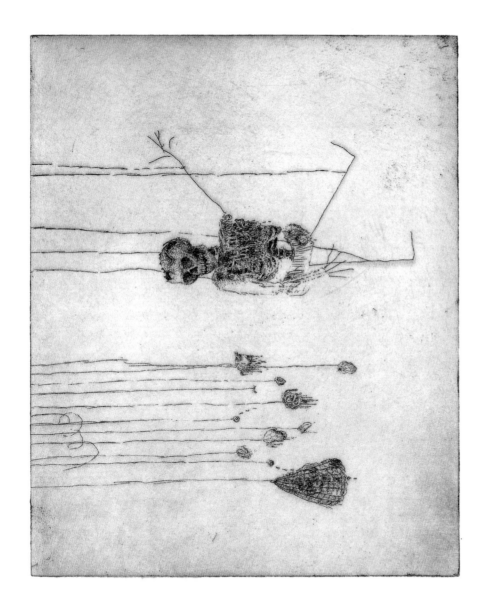

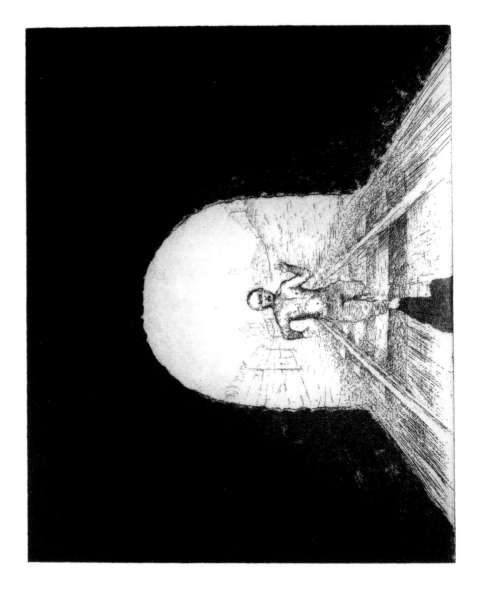

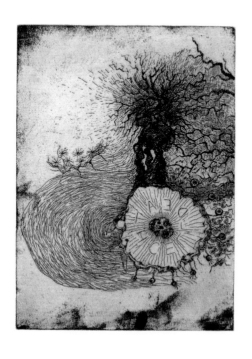

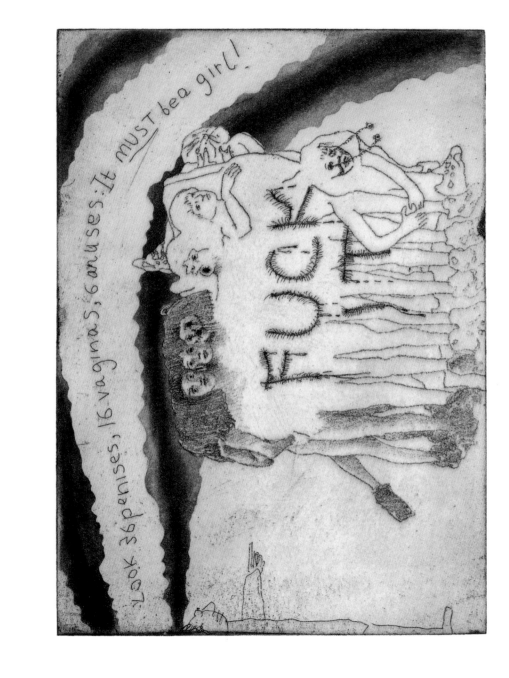

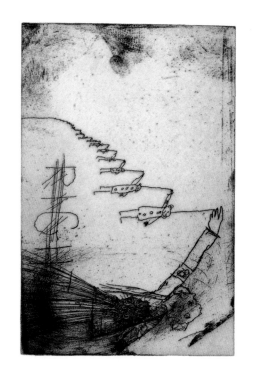

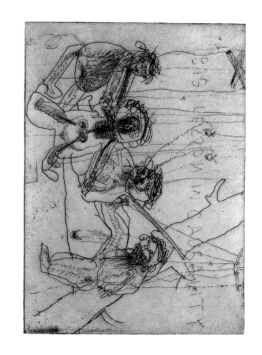

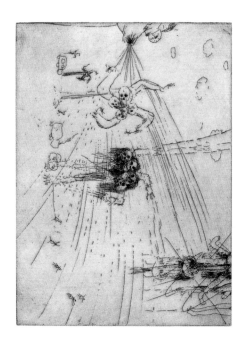

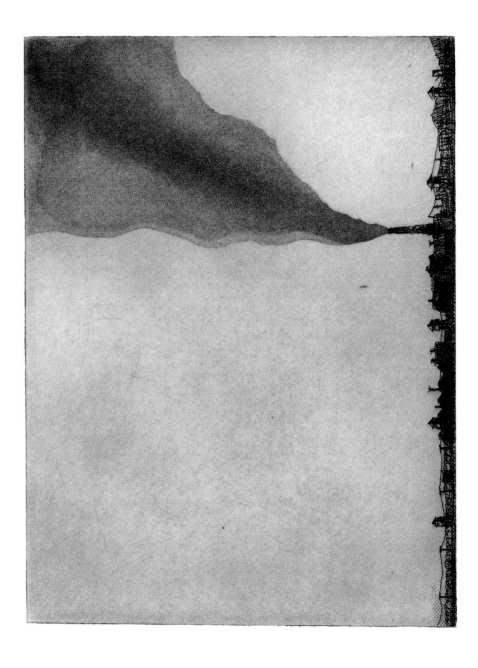

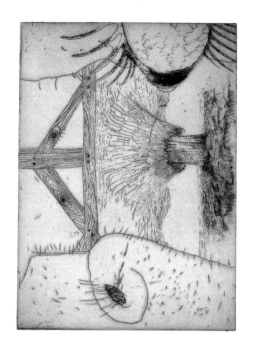

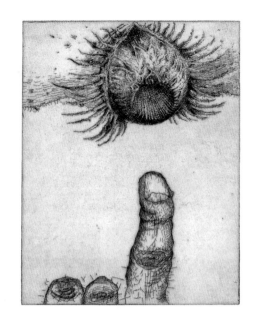

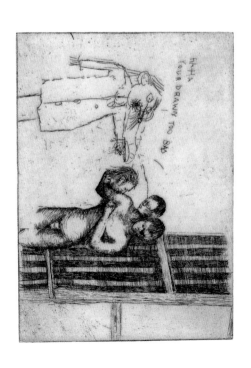

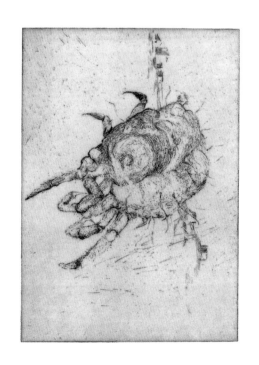

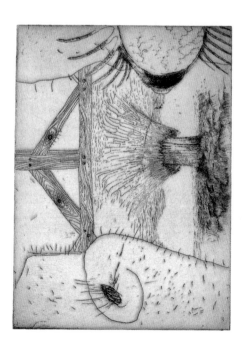

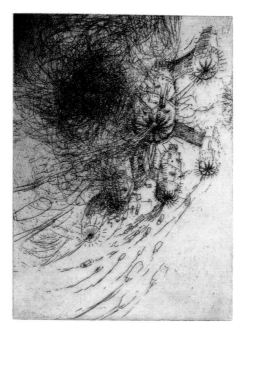

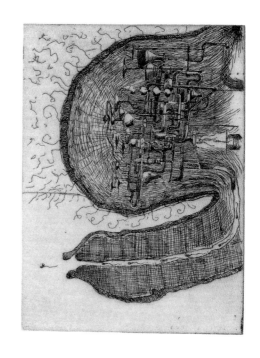

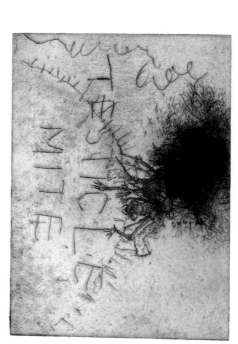

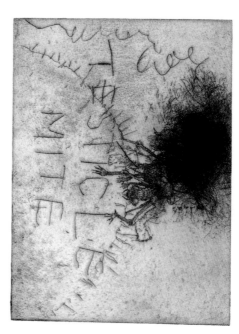

PATRICK HERON
THE BRUSHWORK SERIES, 1999

DESCRIPTION: 11 etchings with title-page, colophon and folder.

EDITION: 38 sets numbered 1 to 38, plus 15 artist's proof sets and one printer's proof set.

TYPOGRAPHY: Title-page etched with a drawing by the artist (with colophon on the verso), designed by the artist and printed by Hugh Stoneman.

INSCRIPTIONS: Each print Estate-stamped with the artist's signature, and numbered and signed on the verso by the artist's daughters, Katharine and Susanna Heron.

SIZE: Sheet 79.5 × 67cm (31¼ × 26⅜in), plate 58 × 43.8cm (22⅞ × 17¼in).

PAPER: 300gsm Velin Arches Blanc.

TECHNIQUE: Colour etching: sugarlift on steel plates

1 Three plates: sugarlift.
2 One plate with 3 colours applied *à la poupée*: sugarlift.
3 Four plates: sugarlift and open-bite.
4 Three plates: sugarlift.
5 Three plates: sugarlift.
6 Three plates: sugarlift.
7 Two plates: sugarlift.
8 One plate: sugarlift.
9 Three plates: sugarlift.
10 Four plates: sugarlift.
11 Two plates: sugarlift.

PRINTER: Plate-making and proofing by Hugh Stoneman; editioned at Stoneman Graphics, Cornwall.

BINDING: Folder covered in pink cloth designed by the artist, with a design embossed on the cover. Made by Charles Gledhill.

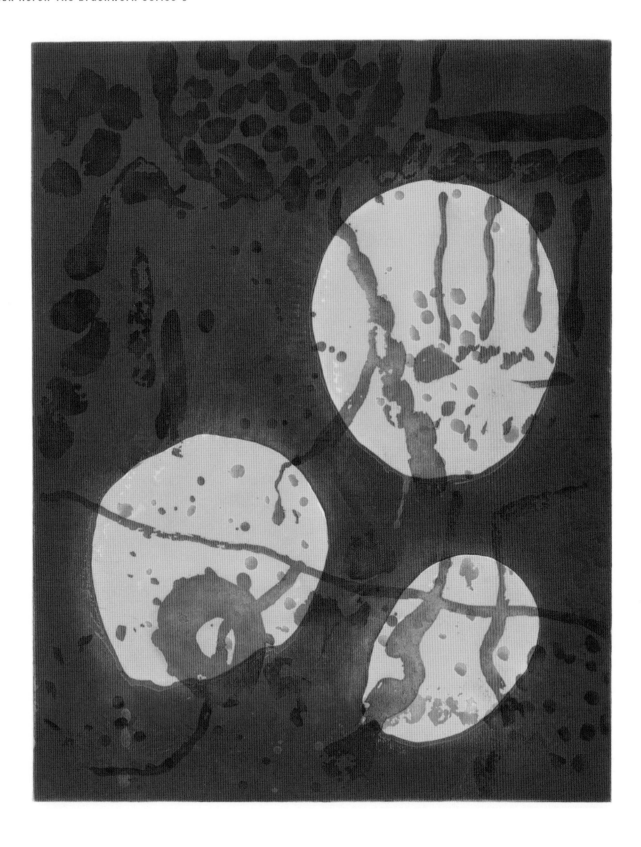

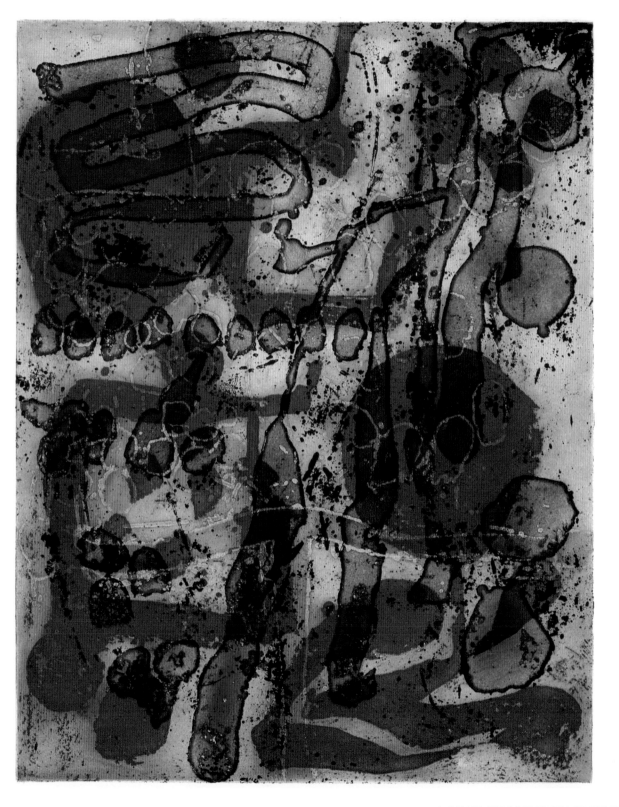

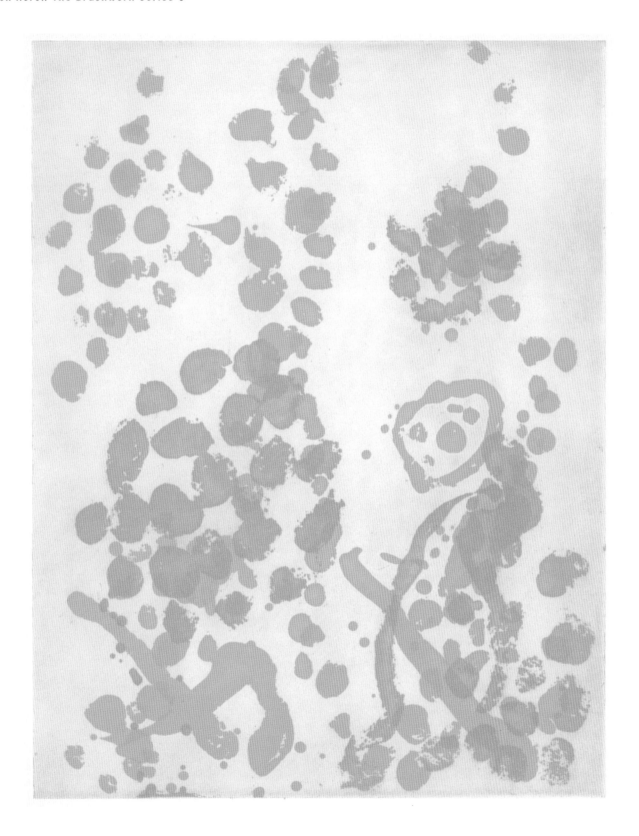

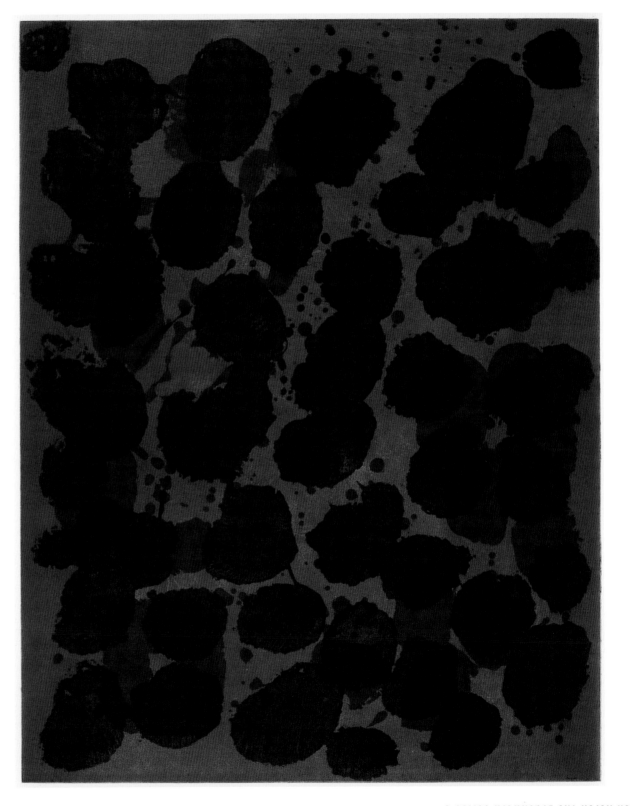

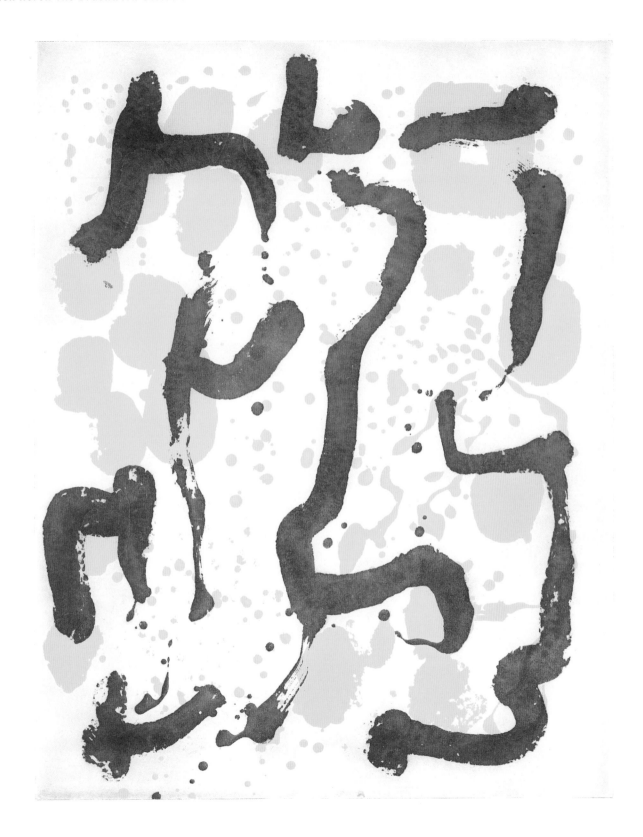

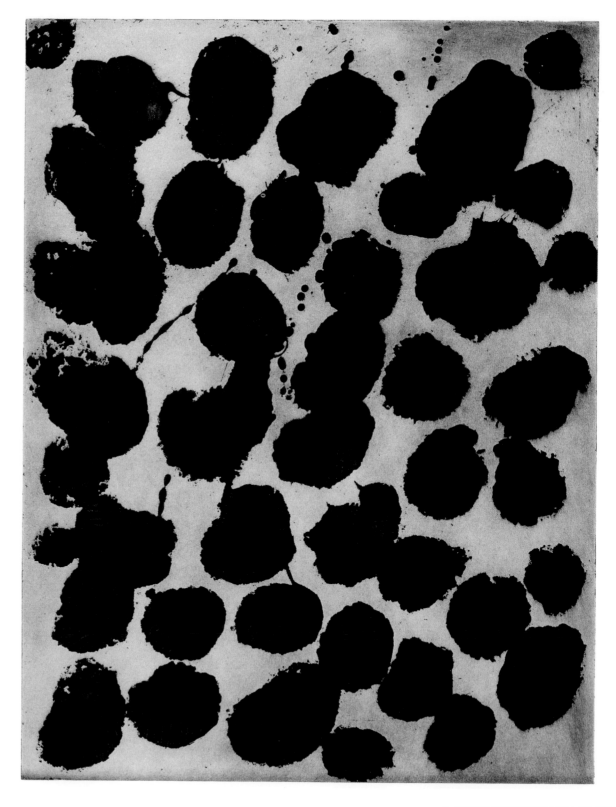

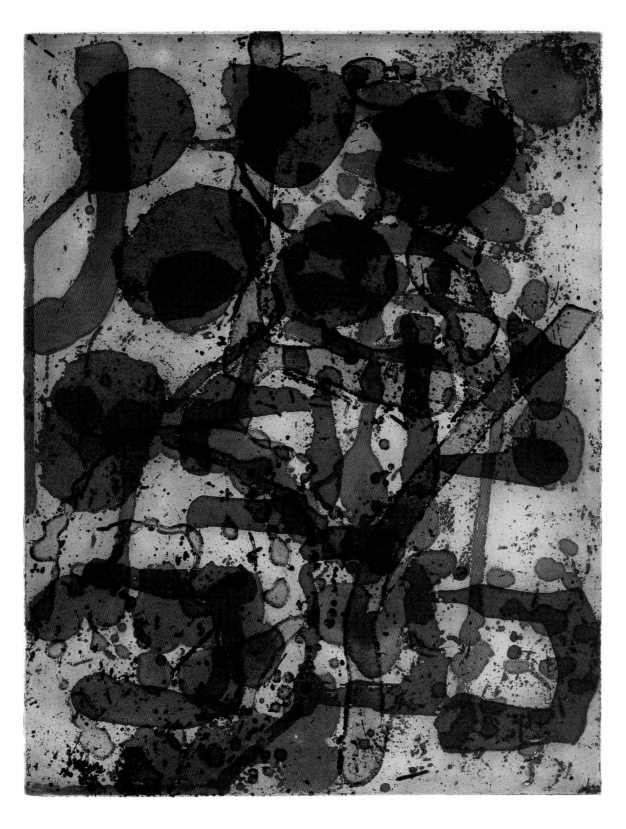

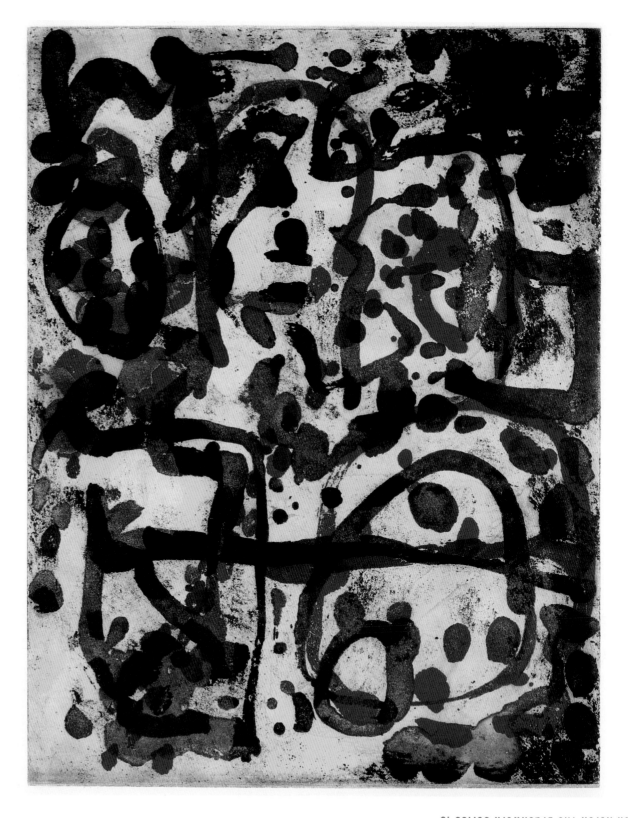

Patrick Heron The Brushwork Series 10

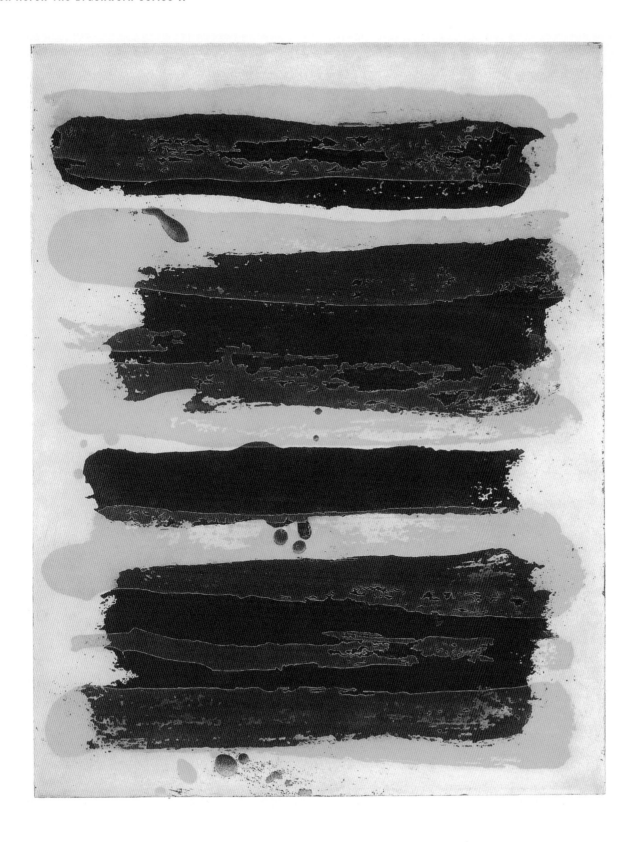

DESCRIPTION: 13 screenprints with certificate.

EDITION: 150 sets, plus a small number of artist's proof sets.

INSCRIPTIONS: Each print signed; each set issued with a numbered certificate.

SIZE: Sheet 153 x 101.5 cm (59½ x 40 in).

PAPER: 410gsm Somerset Tub-Sized Satin.

TECHNIQUE: Screenprint: between 3 and 7 screens per print.

PRINTER: Proofed and editioned at Coriander Studio, London.

BINDING: None

TYPOGRAPHY: Certificate and brochure designed by the artist with Jonathan Barnbrook, and printed in off-set lithography.

DAMIEN HIRST
THE LAST SUPPER, 1999

DAMIEN & HIRST

Beans™

Chips™
400 micrograms

112 Chips

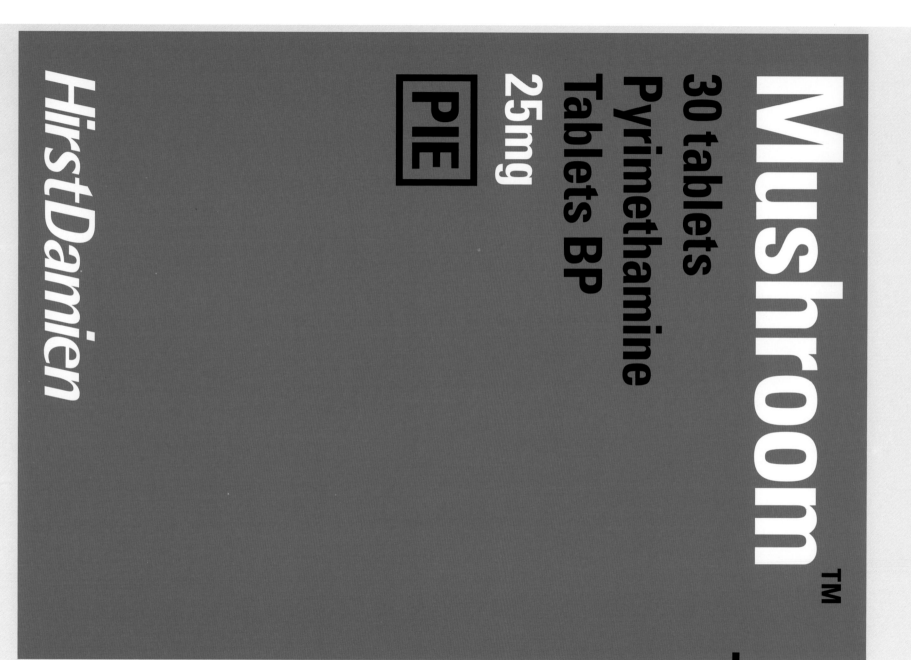

Mushroom™

**30 tablets
Pyrimethamine
Tablets BP**

25mg

PIE

HirstDamien

5036-23

Damien

Steak and Kidney*

Ethambutol Hydrochloride

Tablets
400mg

100 Tablets

sausages

TRADEMARK

intraconazole 100 mg per capsule

4 capsules

DAMIEN-HIRST Ltd
Saunderton, High Wycombe,
Buckinghamshire HP24 9QY

Omelette ™
ondansetron

tablets 8mg

Each tablet contains
8mg ondansetron
as ondansetron hydrochloride dihydrate
Also contains lactose and maize starch

10 tablets

HirstDamien

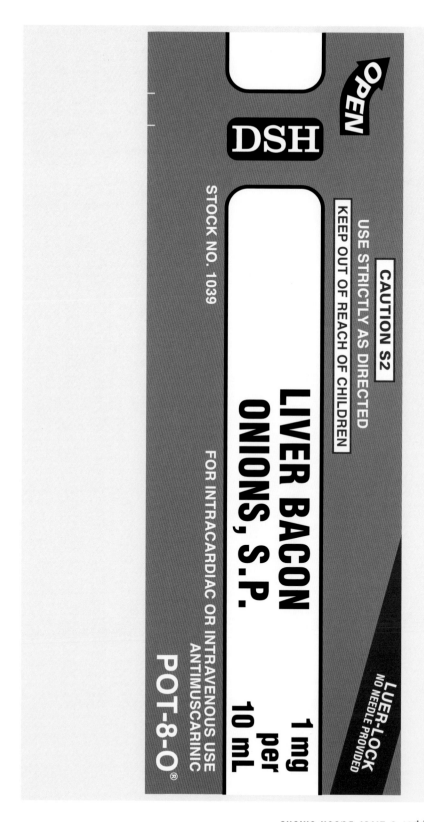

Salad ™ tablets

Lamivudine

Each coated tablet contains
lamivudine 150mg

60 tablets

HirstDamien

Chicken ®

Concentrated Oral Solution
Morphine Sulphate

20mg/ml

Each 1ml contains Morphine
Sulphate BP 20mg

120ml

Damien
Hirst

Sandwich®

Saquinavir

200 mg

270 Capsules

Hirst

Each film-coated tablet contains
150mg moclobemide

Use only as directed by a physician

KEEP OUT OF REACH
OF CHILDREN

Store in a dry place

GRAVY

PL0031/0275 PA 50/81/2

Hirst Products Limited
Welwyn Garden City England

30 Tablets

Meatballs

Hirst

150mg

Cornish 100mg/5ml Pasty

Rifampicin B.P.

To be taken by mouth

Peas

CHIPS

100ml Syrup

DESCRIPTION: 25 colour woodcuts, title-page, colophon and portfolio case.

EDITION: 35 sets numbered 1 to 35, plus 6 artist's proof sets, 1 printer's proof set and 1 BAT.

INSCRIPTIONS: Each print signed and dated by the artist on the reverse and numbered on the colophon page.

SIZE: Sheet and image 37.5 × 37.5 cm (14 ³/₄ × 14 ³/₄ in).

PAPER: 400gsm Velin Arches Blanc.

TECHNIQUE: Colour woodcut with using 3 blocks per print, each printed twice. All printed to edge.

PRINTER: Proofed and editioned by Hugh Stoneman and Alan Cox and printed at Stoneman Graphics, Cornwall.

BINDING: Portfolio case covered in orange cloth with a design by the artist screenprinted on the cover. Made by G. Ryder & Co. Ltd.

TYPOGRAPHY: Title-page and colophon drawn and designed by the artist and screenprinted by Coriander Studio, London.

TERRY FROST
ORCHARD TAMBOURINES, 1999

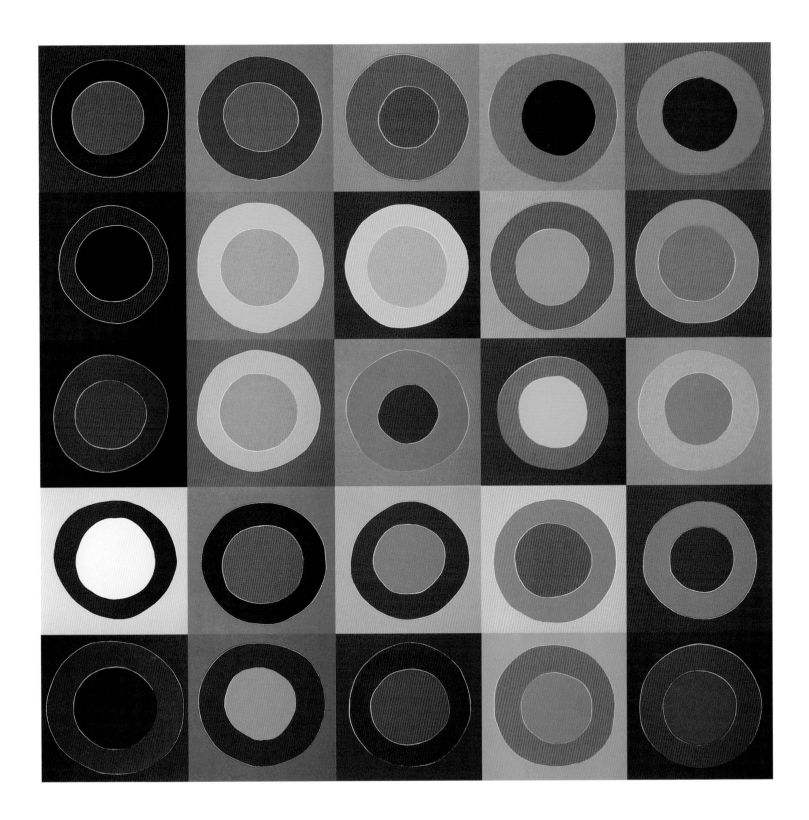

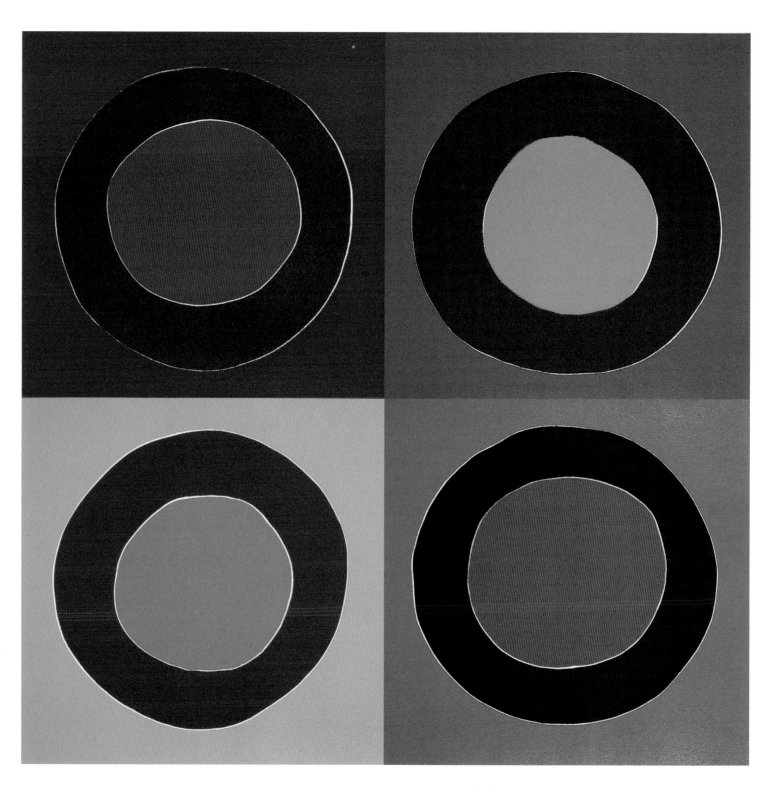

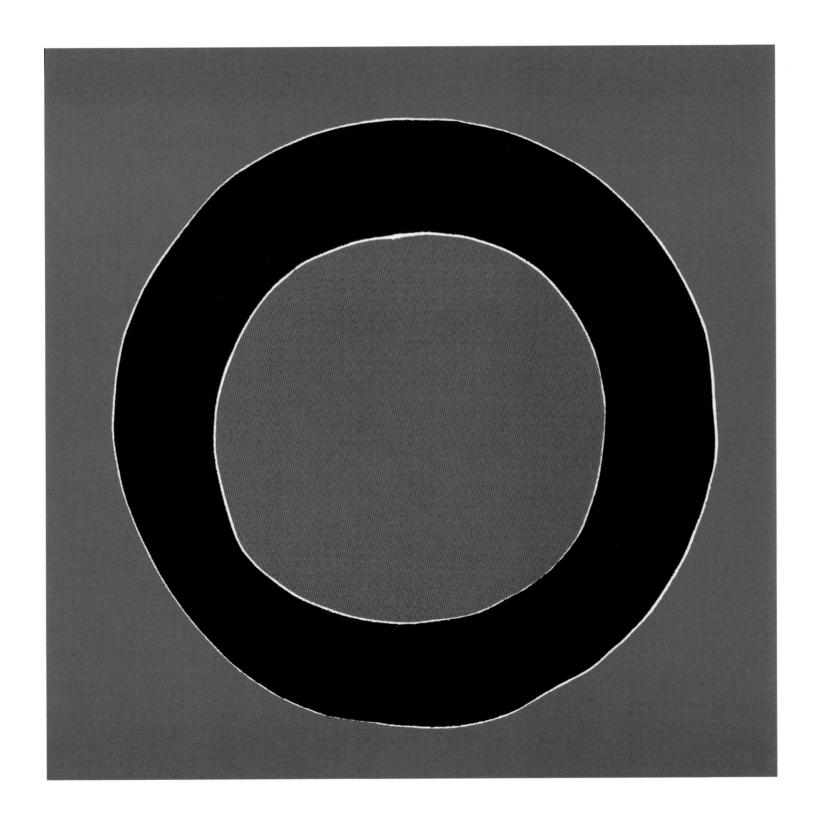

DESCRIPTION: 10 linocuts bitten with caustic acid, with hand-colouring.

EDITION: 20 sets numbered 1 to 20, plus 4 proof sets and 1 BAT.

INSCRIPTIONS: Each print signed, numbered and dated by the artist.

SIZE: Sheet and image 92 x 61cm (36¼ x 24 in). Sheet sizes vary very slightly throughout the edition.

PAPER: 310 Somerset Tub-Sized Satin; and 250gsm Velin Arches Noir for prints 3 and 6.

TECHNIQUE: Linocuts bitten with caustic acid, with hand colouring.

1 One split block in seven pieces, with hand colouring.

2 Two blocks.

3 One block printed on black paper.

4 Two blocks, one of which split into two pieces, with three printings.

5 One block.

6 One block split into two pieces, printed on black paper.

7 One block split into two pieces, with hand colouring.

8 Two blocks, three printings.

9 One block split into two pieces, with hand colouring.

10 One block split into three pieces, with hand colouring.

PRINTER: Proofed and editioned at Hope (Sufferance) Press, London.

BINDING: None

TYPOGRAPHY: None

BILL WOODROW
THE BEEKEEPER, 2000

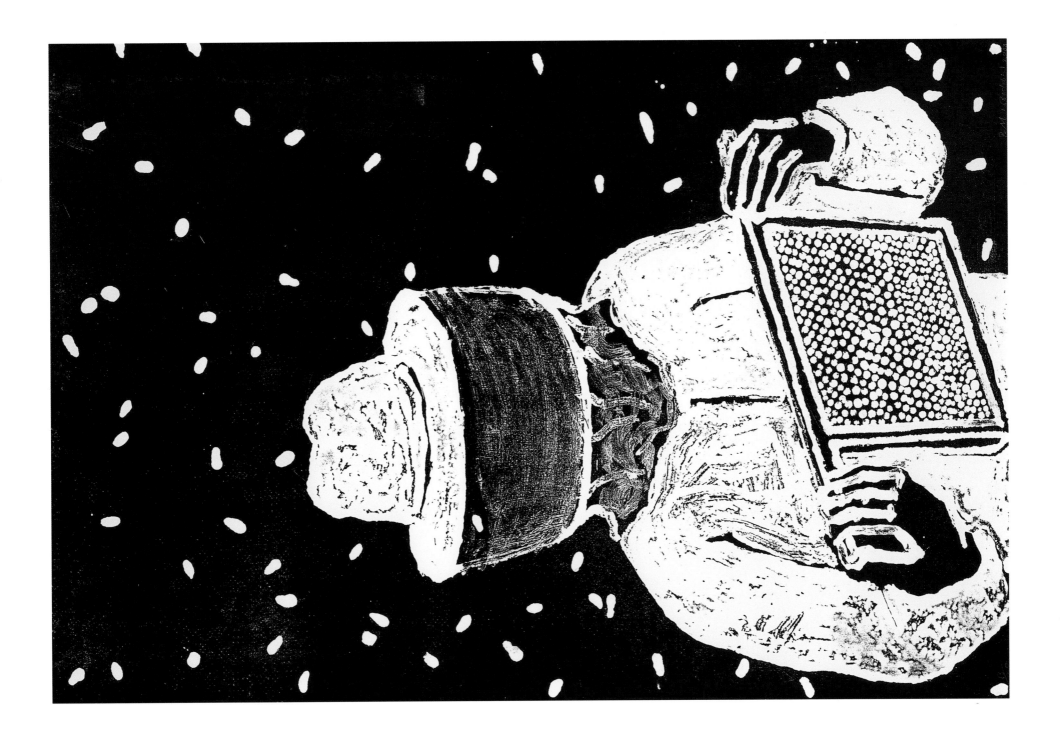

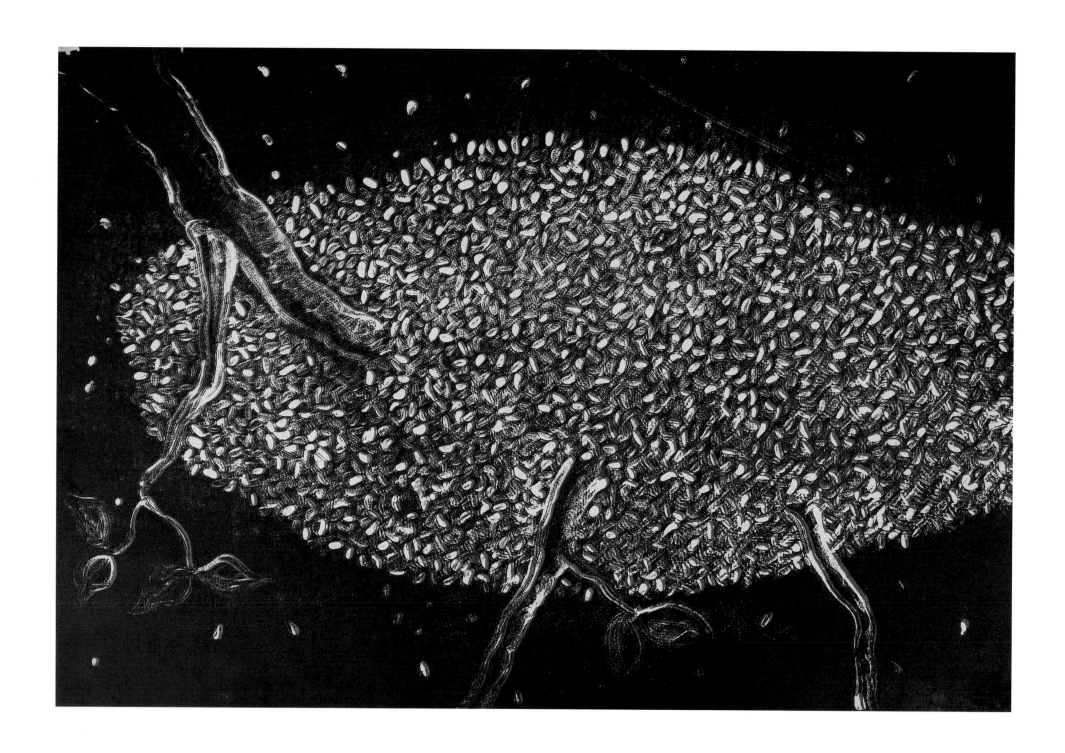

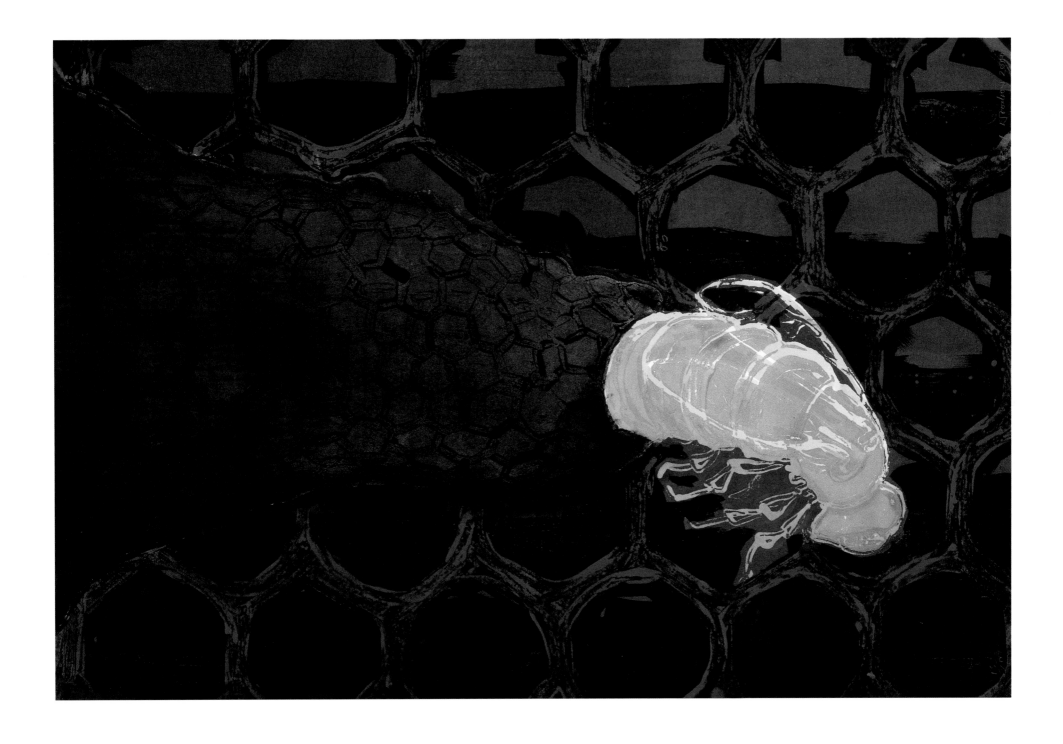

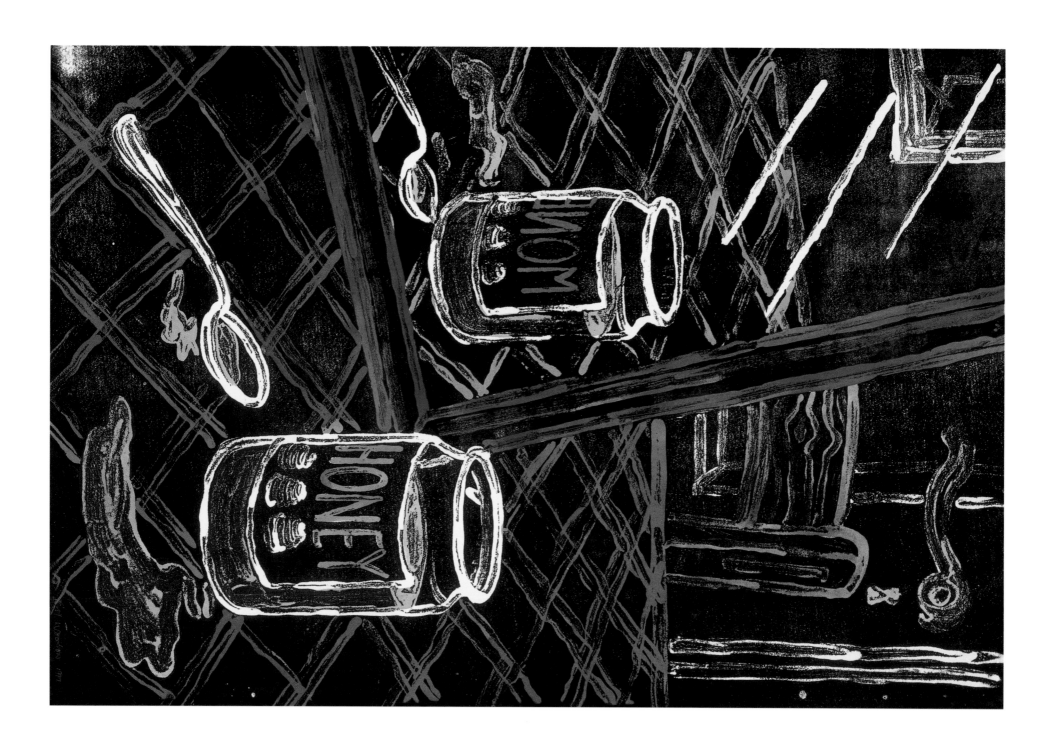

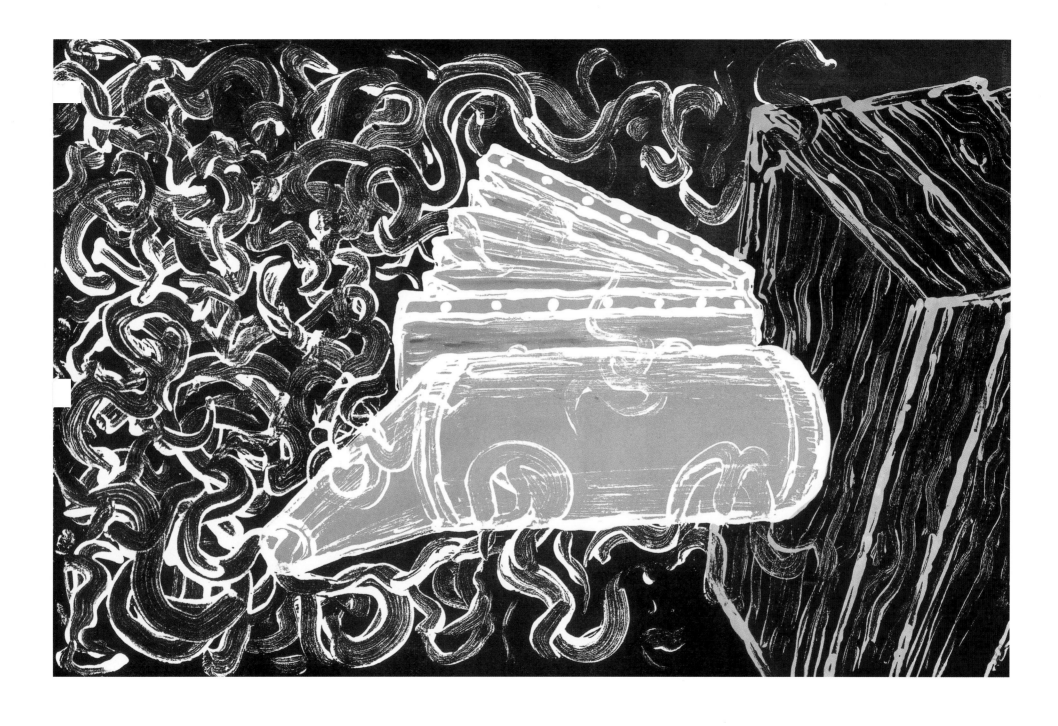

DESCRIPTION: 20 etchings
with title-page, colophon
and portfolio case.

EDITION: 30 sets numbered
1 to 30, plus 6 artists' proof
sets, 3 artists' sets for hand
colouring and 1 BAT.

INSCRIPTIONS: Each print
signed and numbered by
the artists on the reverse
and numbered on the
colophon page.

SIZE: Sheet 46 x 38cm
(18⅛ x 15 in),
plate 22.9 x 17.7cm (9 x 7 in).

PAPER: 300gsm Somerset
TP Textured.

TECHNIQUE: Etching:
softground, hardground and
sugarlift (with felt-tip pen).

PRINTER: Proofed and
editioned at Hope
(Sufferance) Press, London.

BINDING: Wooden portfolio
case covered in black
buckram, with the artists'
names printed in matt
black on the cover. Made
by G. Ryder & Co. Ltd.

TYPOGRAPHY: Title and
colophon pages designed
and printed in letterpress
by Simon King in Cumbria.

JAKE & DINOS CHAPMAN
EXQUISITE CORPSE, 2000

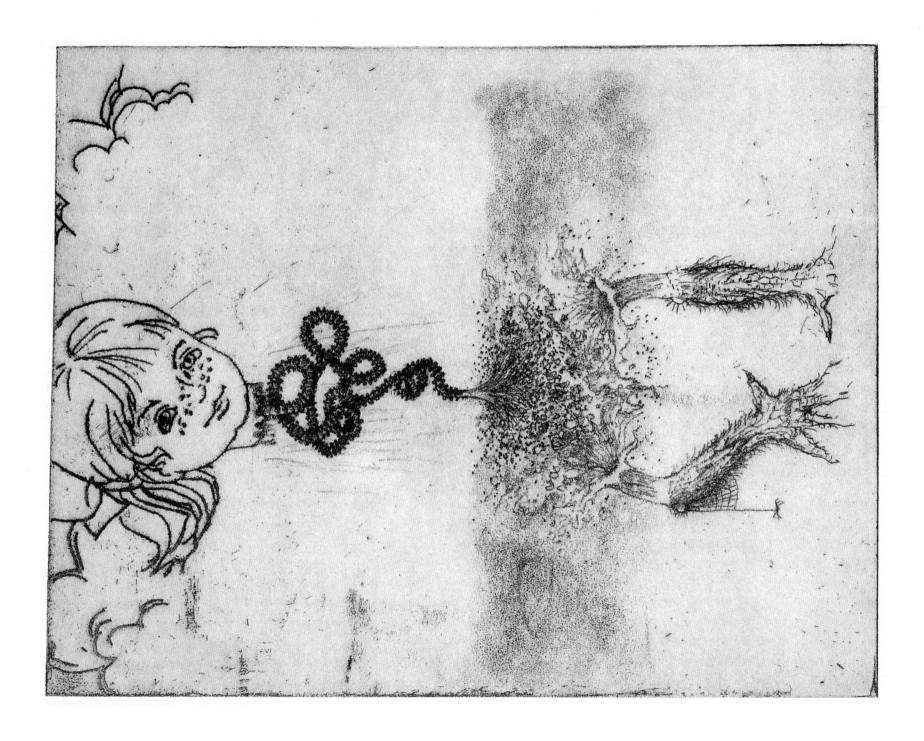

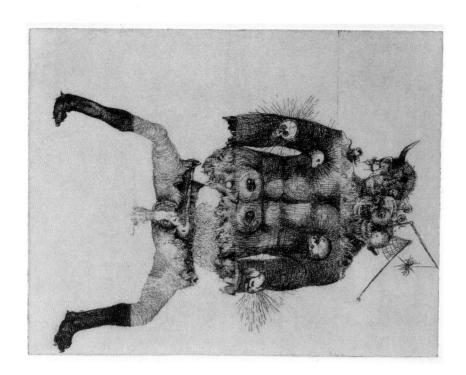

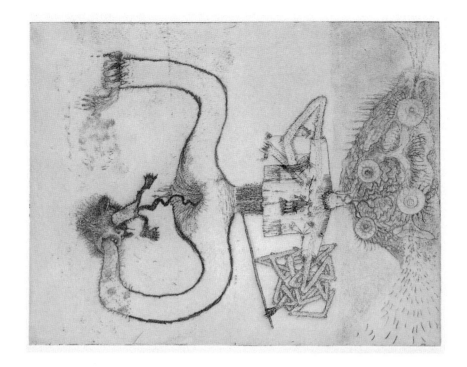

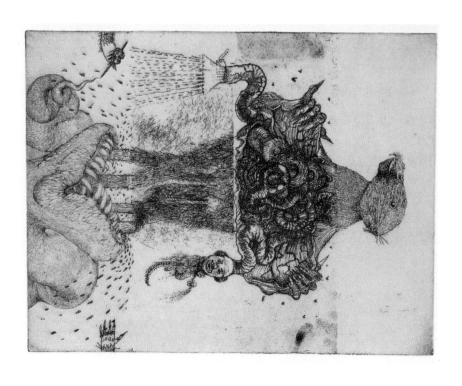

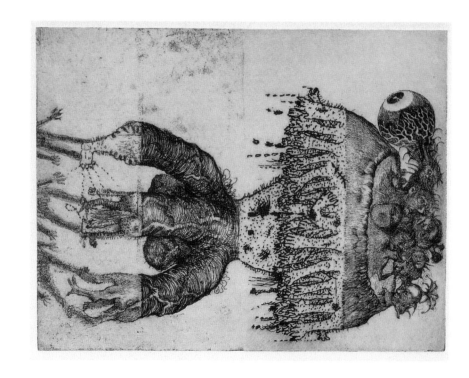

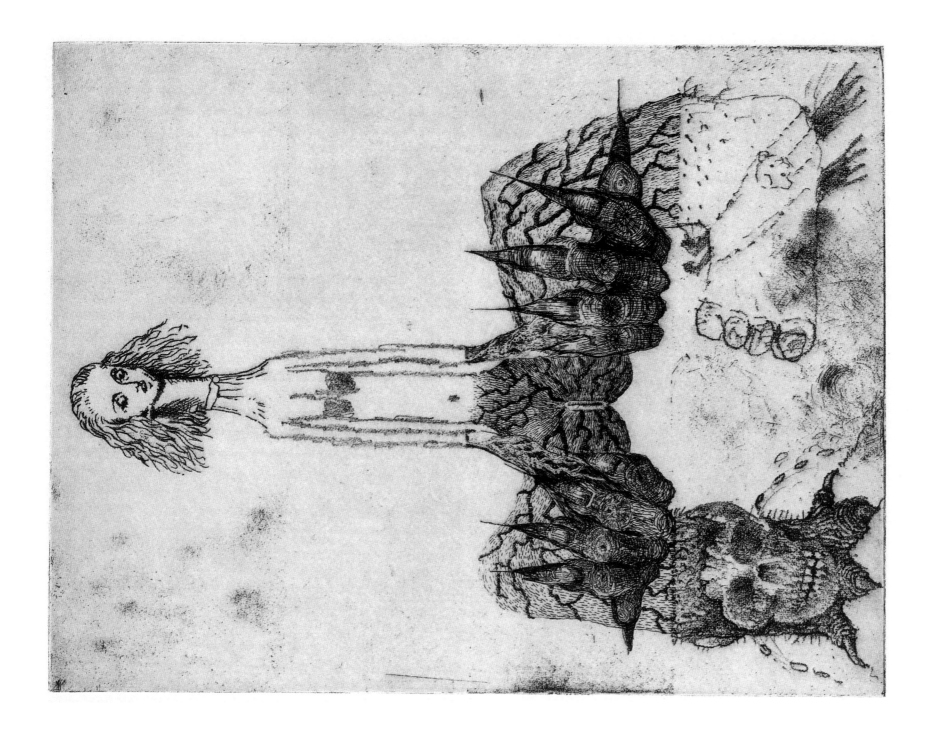

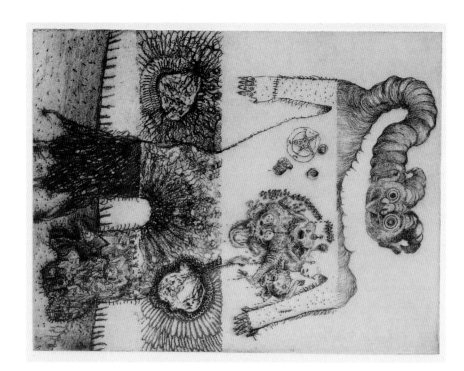

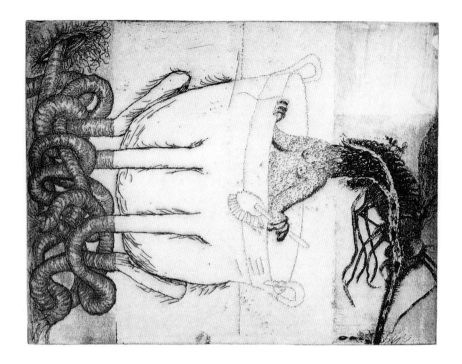

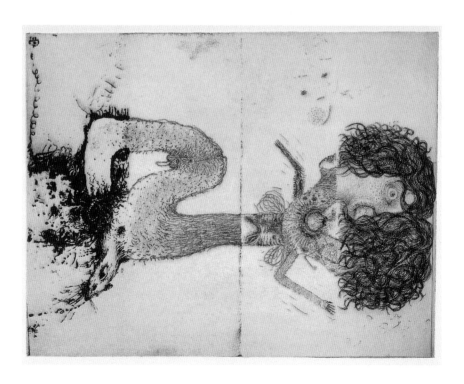

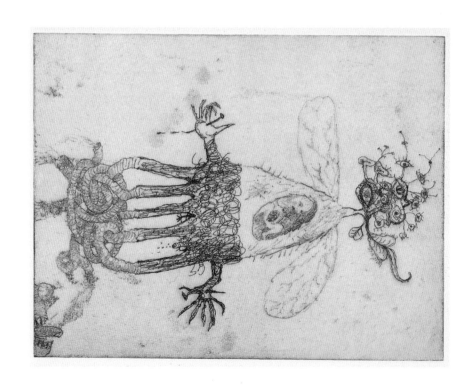

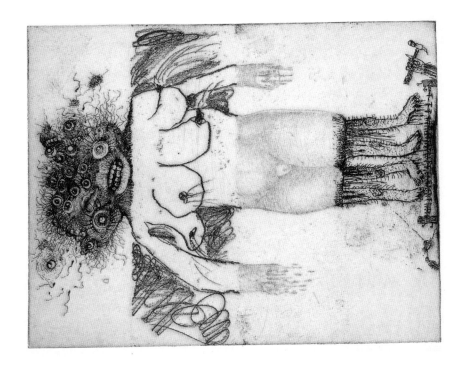

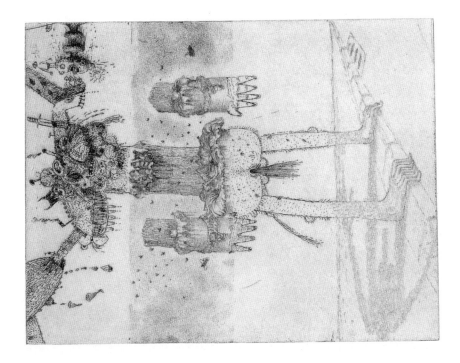

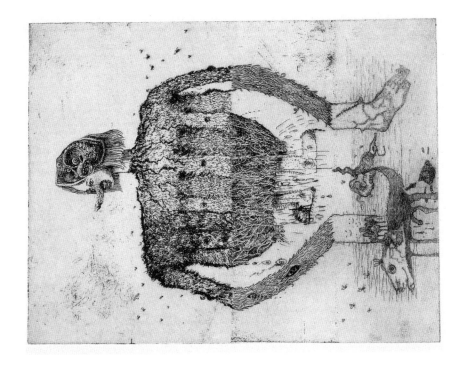

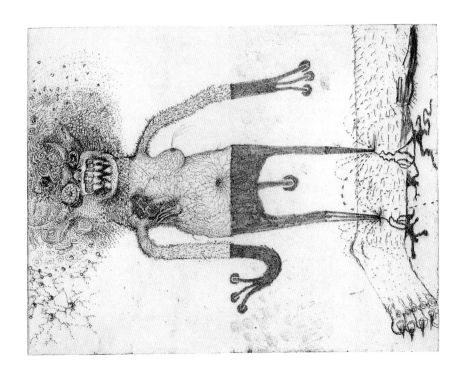

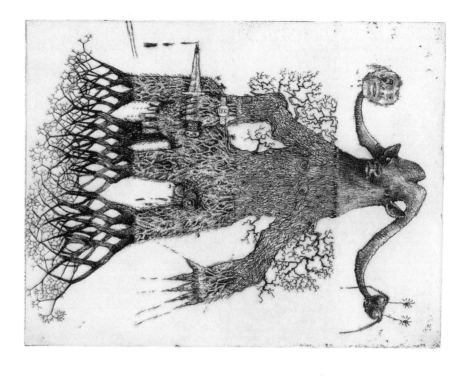

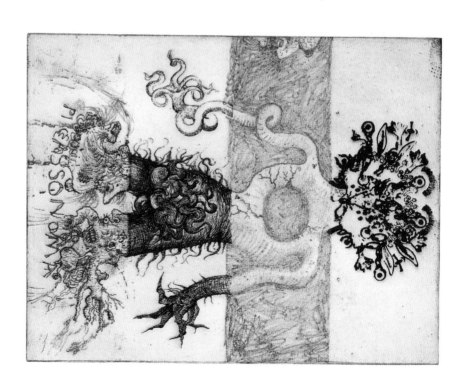

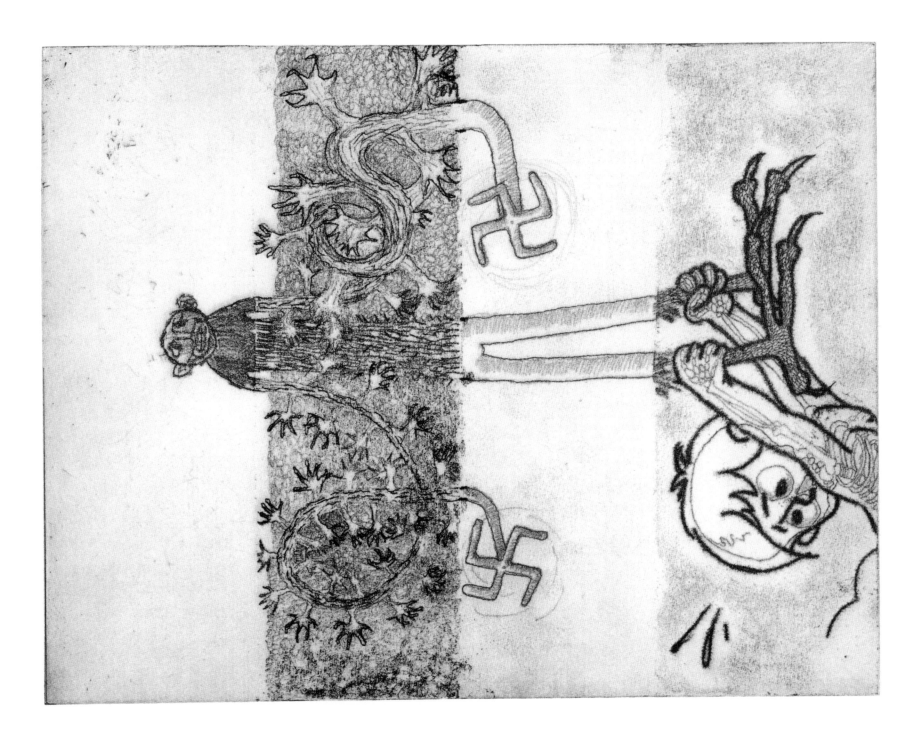

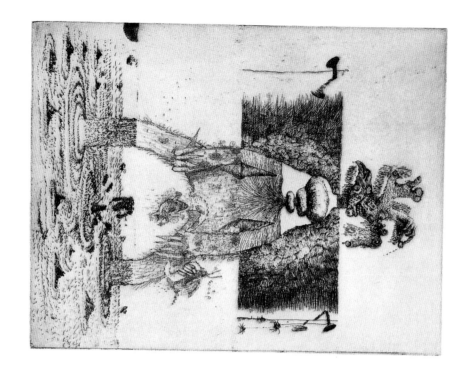

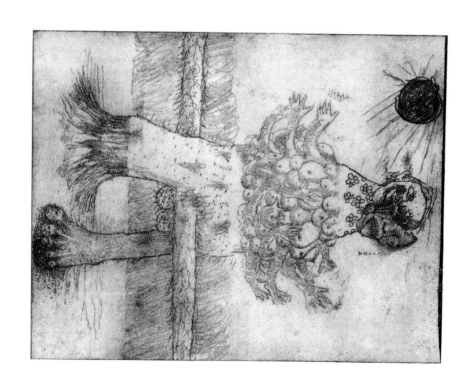

DESCRIPTION: 9 photogravure and etched prints, title-page, colophon and portfolio case.

EDITION: 30 sets numbered 1 to 30, plus 6 artist's proof sets, 1 printer's proof set and 1 BAT.

INSCRIPTIONS: Each print signed and numbered by the artist on the reverse.

PAPER: 270gsm Moulin du Gué.

TECHNIQUE: Colour photogravure with etching, engraving and burnishing.

1 Four plates
2 Three plates
3 Three plates
4 Two plates
5 Three plates
6 Three plates
7 Three plates
8 Three plates
9 Three plates

SIZE: Sheet 49.7 x 65cm (19½ x 25½in), plate 31.5 x 25.5cm (12⅜ x 10in).

BINDING: Portfolio case covered in green cloth, with the artist's name printed on the cover. Made by G.Ryder & Co. Ltd.

TYPOGRAPHY: Designed by Phil Baines in Praxis.

PRINTER: Photogravure plate-making by Hugh Stoneman. Proofed and editioned by Hugh Stoneman and Mike Ward at Stoneman Graphics, Cornwall, and Atlas Print Studio.

ADAM LOWE
EMULSION, 2000

DESCRIPTION: 8 screenprints and colophon page.

EDITION: 45 sets numbered 1 to 45, plus 10 artist's proof sets, 1 archival set and 1 printer's proof set.

INSCRIPTIONS: Each print signed and titled by the artist and numbered on the colophon page.

SIZE: Sheet 127 x 101.6cm (50 x 40 in), image 106.7 x 86.4cm (42 x 34 in).

PAPER: 410gsm Somerset Tub-Sized Satin.

TECHNIQUE: Screenprint: between 2 and 6 screens per print, and up to 4 varnish screens per print.

PRINTER: Proofed and editioned at Coriander Studio, London.

BINDING: None

TYPOGRAPHY: Colophon designed by Phil Baines in Verdana and screenprinted by Coriander Studio, London.

GARY HUME
SPRING ANGELS, 2000

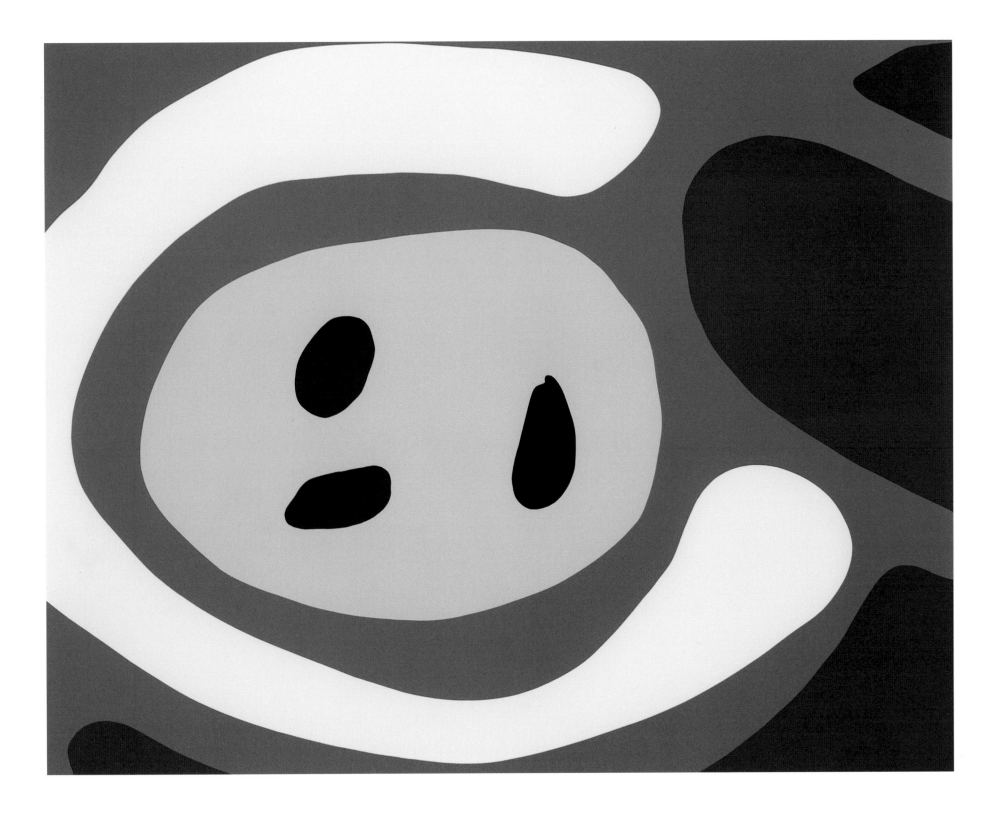

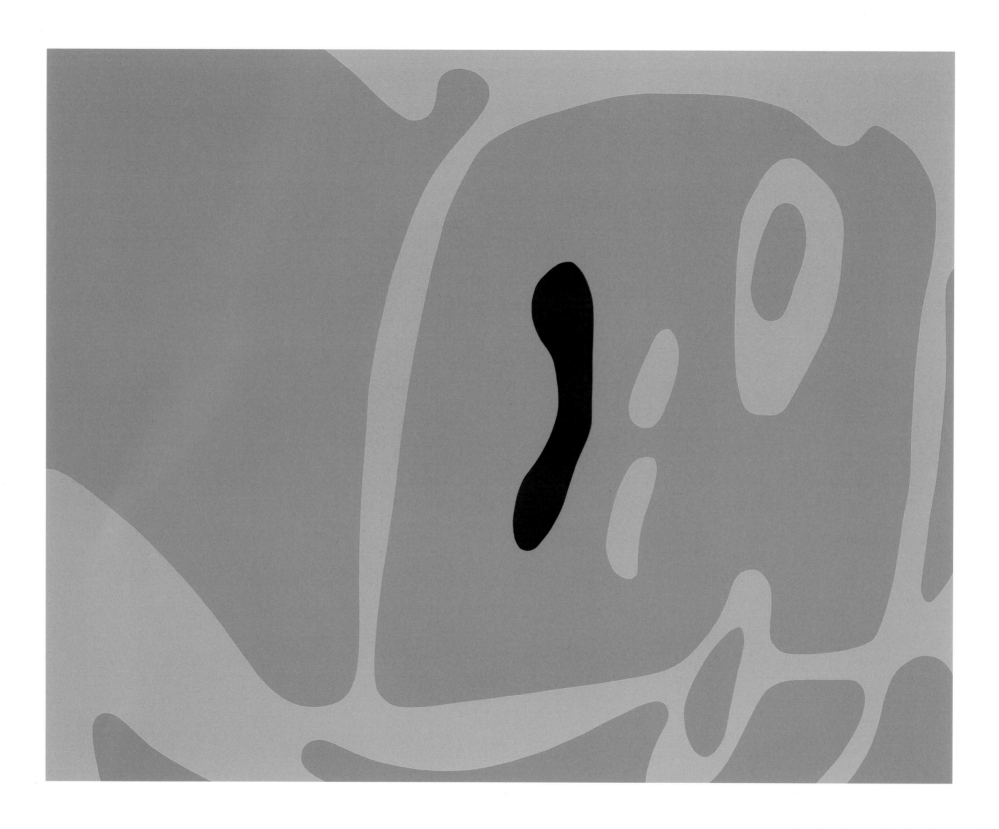

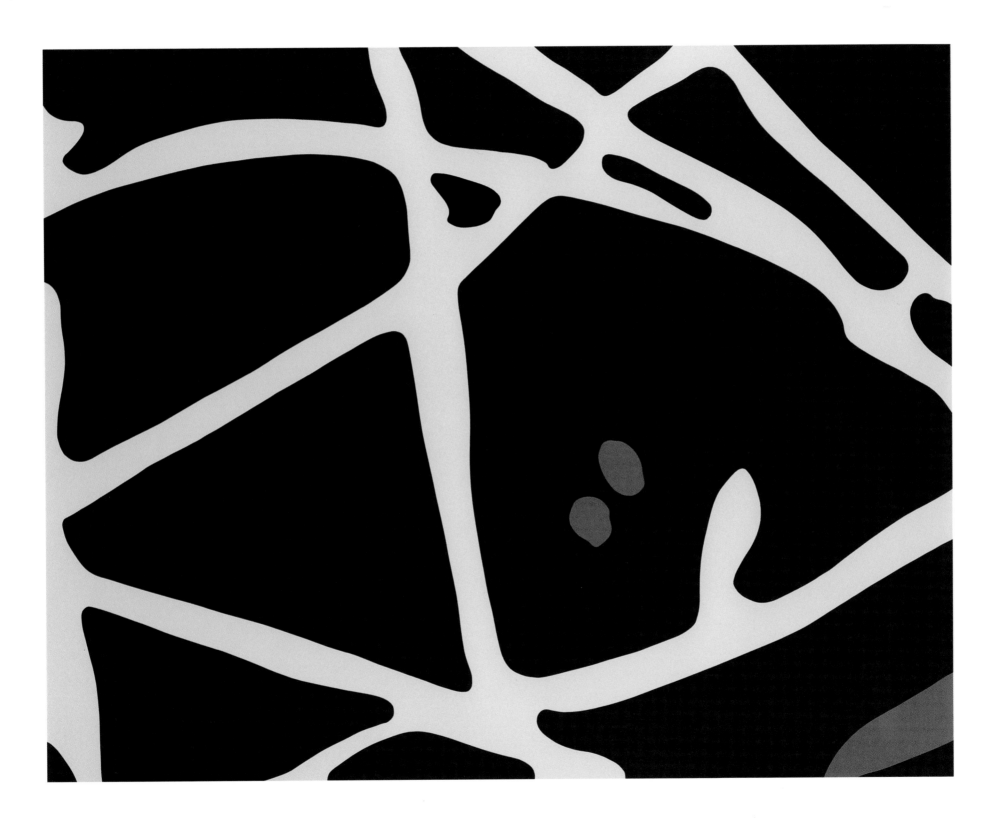

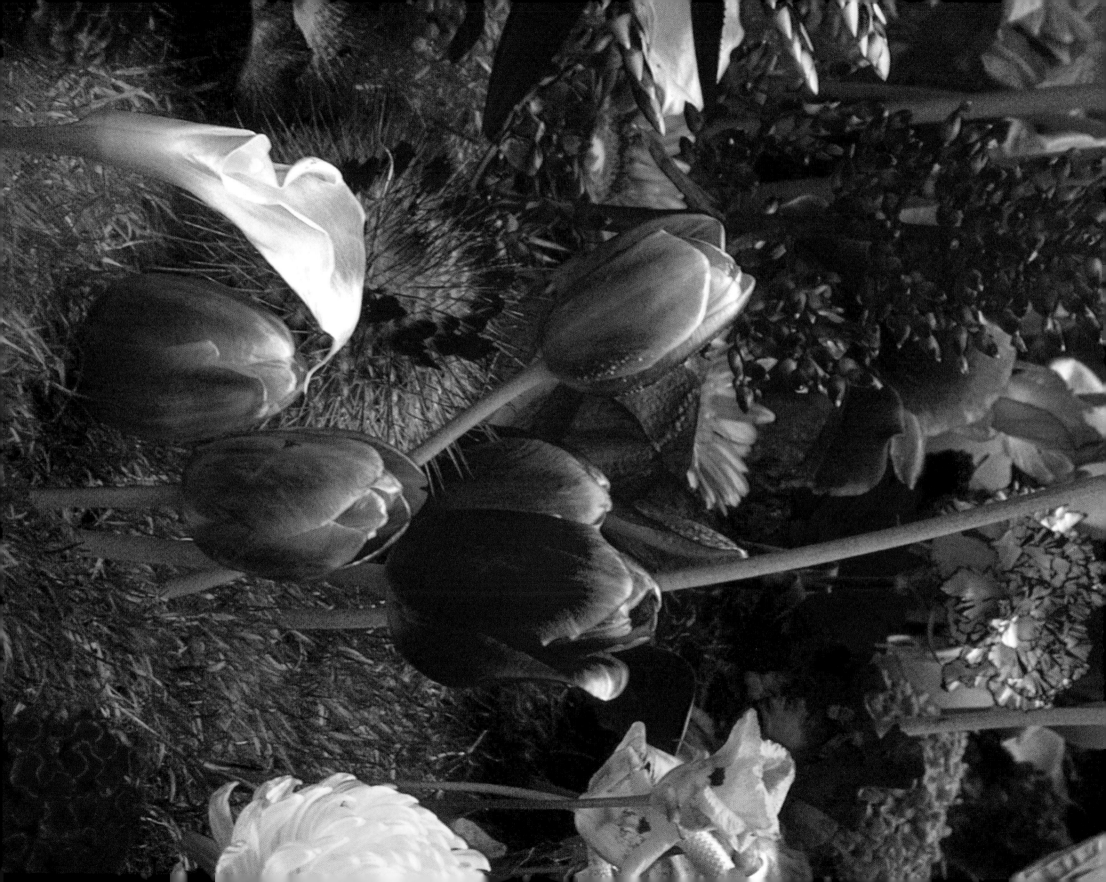

MARC QUINN
GARDEN², 2000

DESCRIPTION: 8 pigment prints.

EDITION: 45 sets numbered 1 to 45, plus 6 artist's proof sets and 1 printer's proof set.

INSCRIPTIONS: Each sheet signed and numbered by the artist on the reverse.

SIZE: Sheet and image 80.6 x 124.5cm (31¾ x 49in).

PAPER: 330gsm Somerset Velvet Enhanced.

TECHNIQUE: Pigment prints (digital ink-jet prints) with varnish, from 35mm colour slides taken by Marc Quinn. The slides were scanned on a Drum Scanner and manipulated on Mackintosh in Adobe Photoshop. Printed using pigment ink and drop-on-demand ink-jet printer (Mimaki 6-colour pigment printer using onyx Postershop RIP).

PRINTER: Proofed by Adam Lowe and Adrian Lack at the Senicio Press, Charlbury. Printed by Pedro Miro and Carmen Corral at the Estampa Digital, Centro de Investigación y Desarrollo Calcografía Nacional, Real Academia de Bellas Artes de San Fernando, Madrid.

BINDING: None

TYPOGRAPHY: No colophon or title-page; brochure designed by Phil Baines.

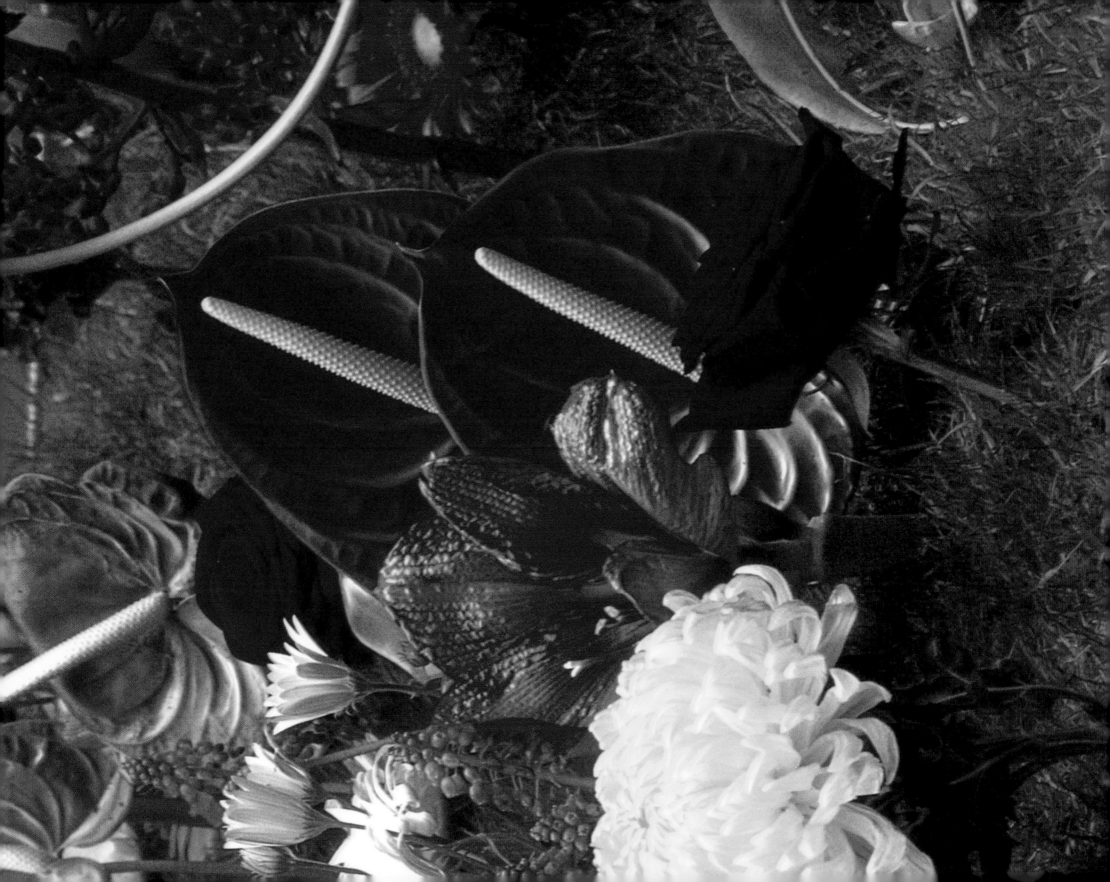

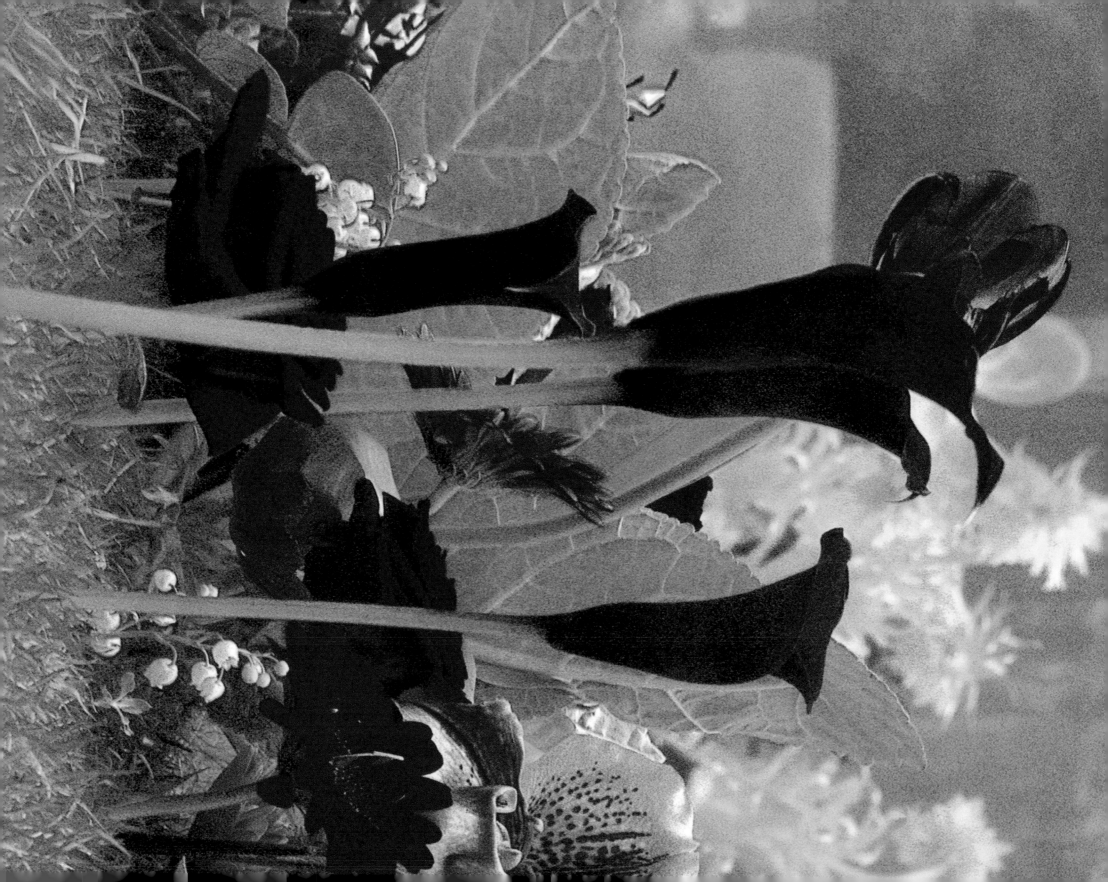

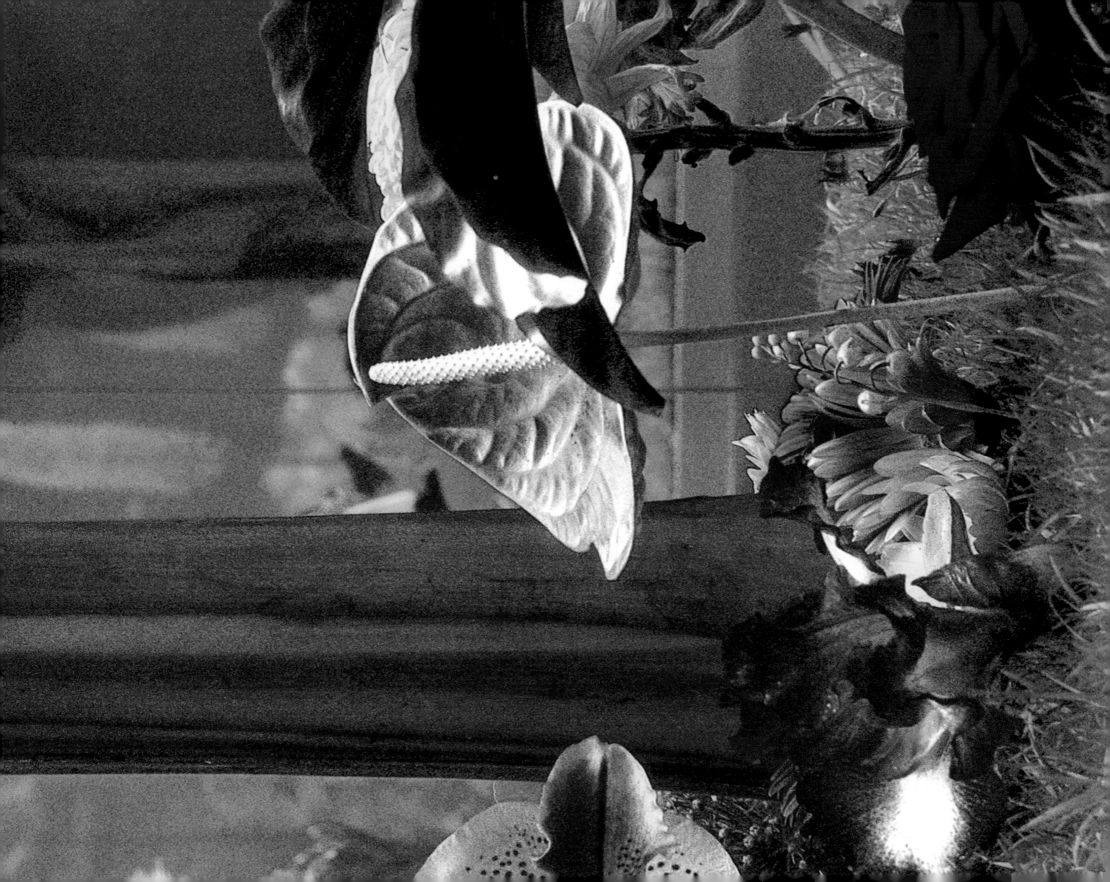

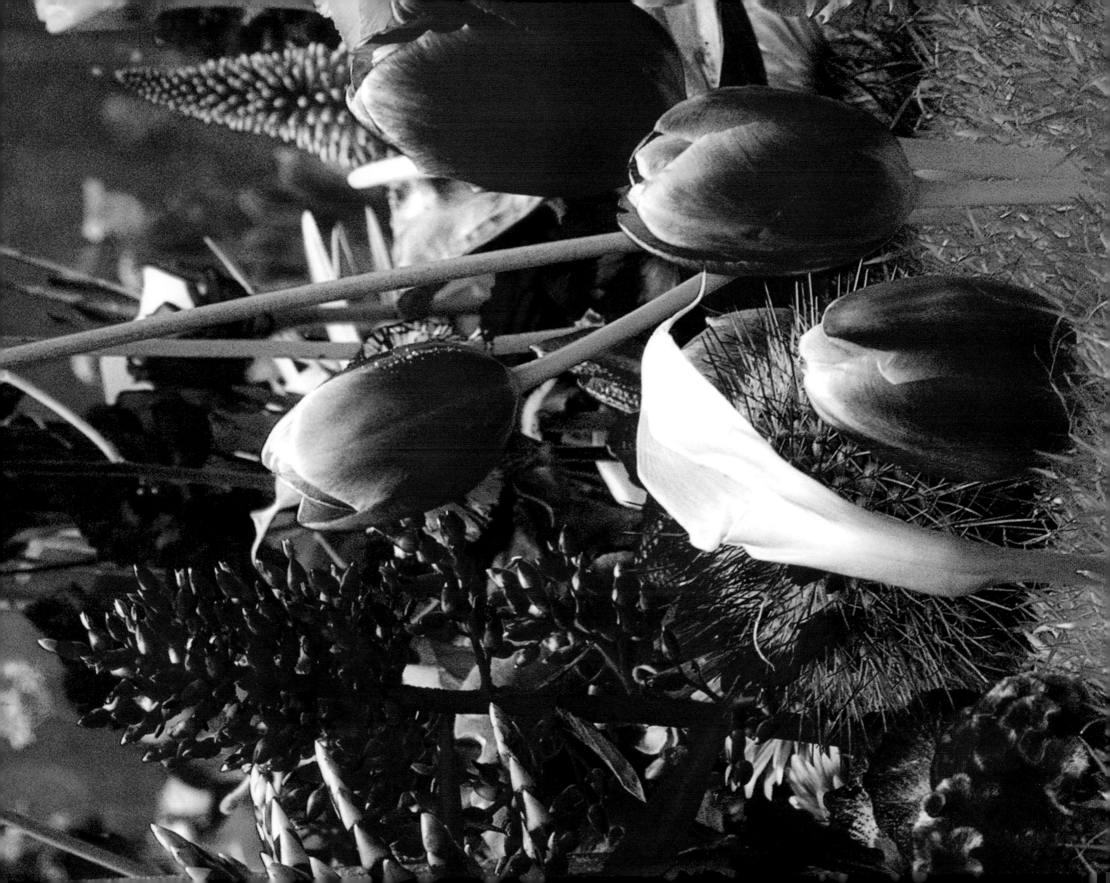

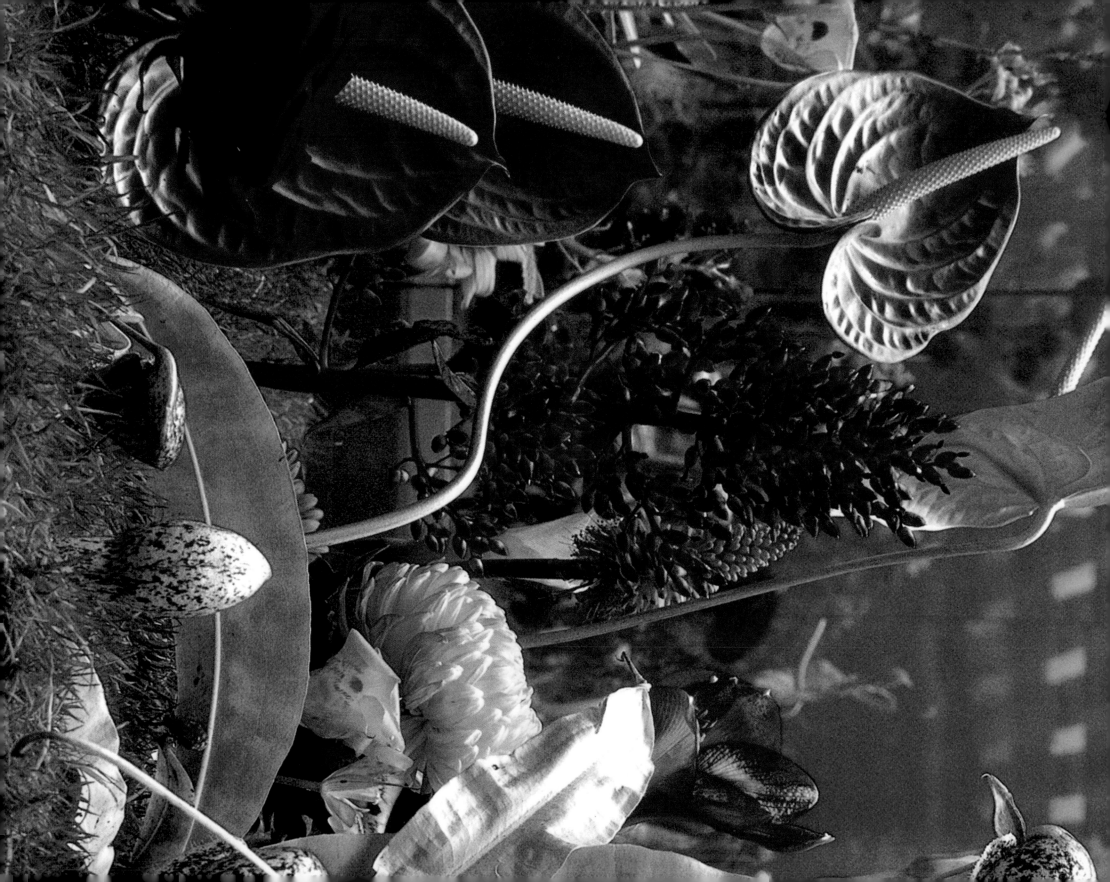

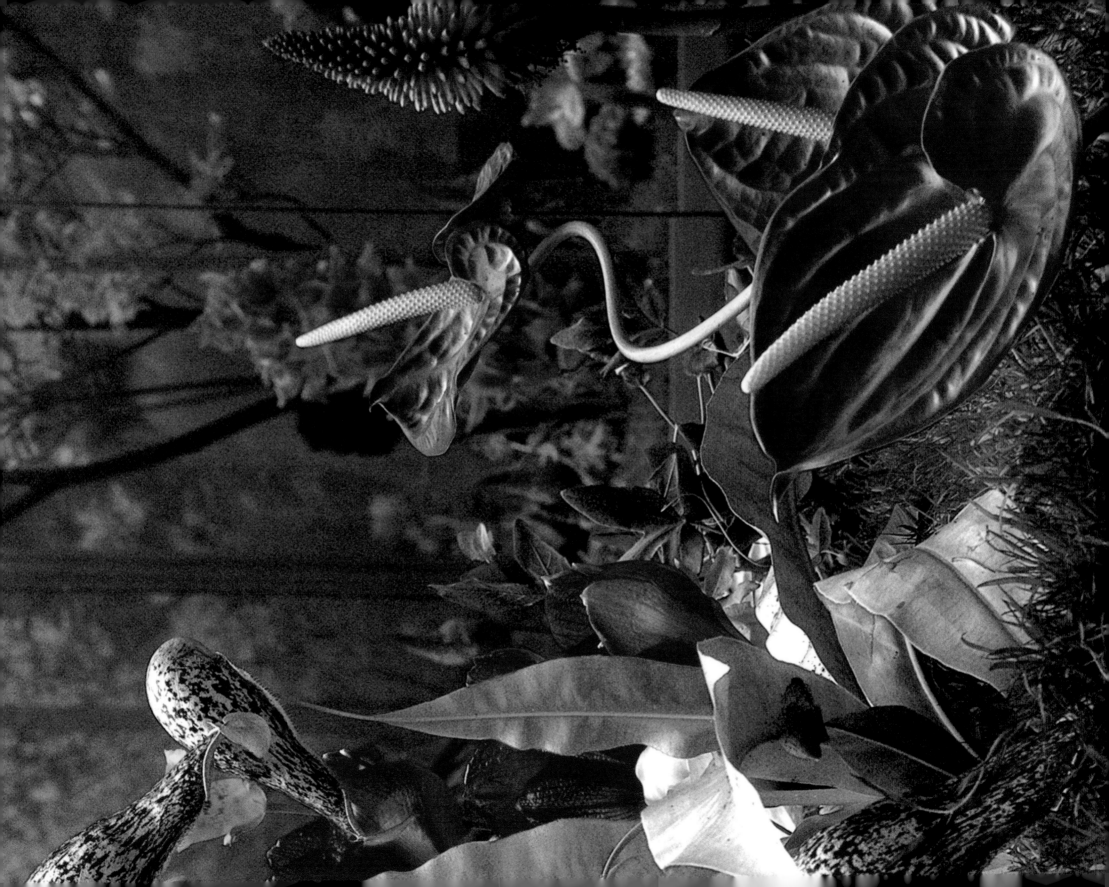

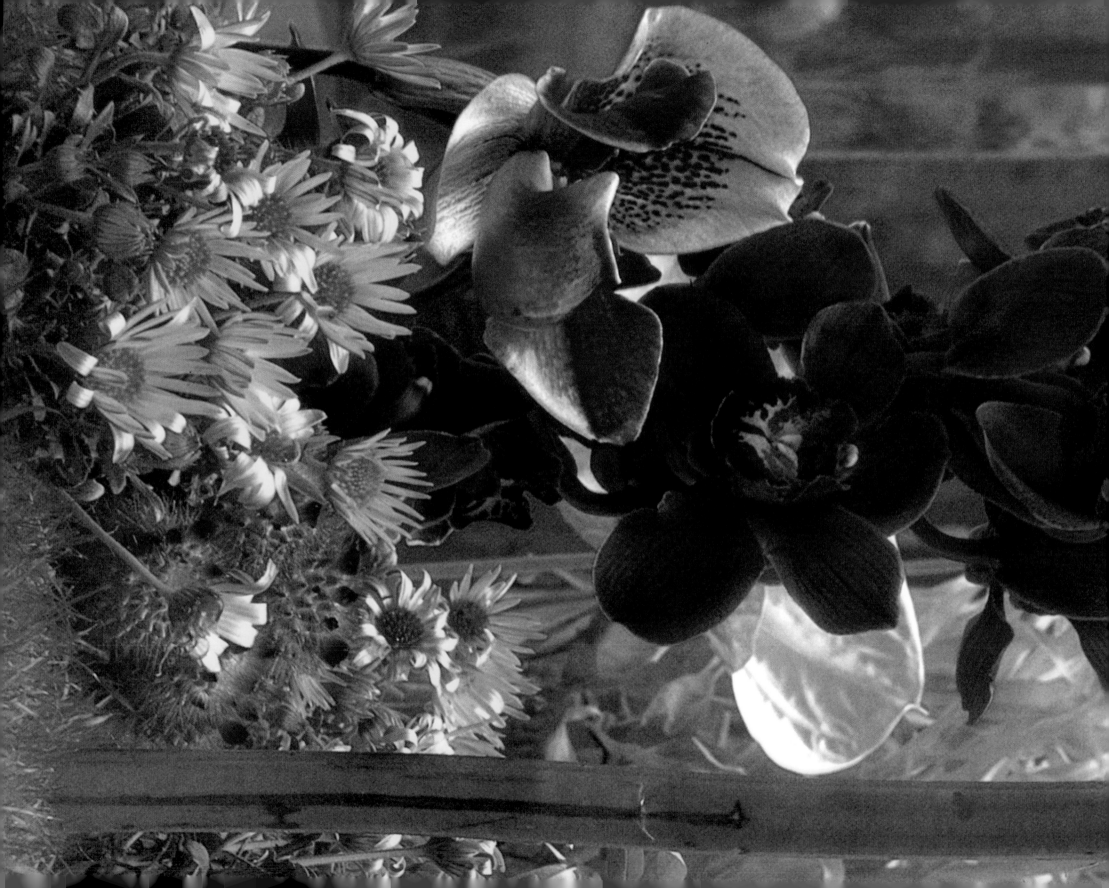

CATALOGUE COMMENTARY

Most of the following texts are based on interviews with the artists. Unless otherwise stated, all quotations are taken from these interviews.

MARC QUINN EMOTIONAL DETOXIFICATION, 1995

Many of Marc Quinn's works originate in casts of his own body — casts made in materials as varied as lead, rubber, glass, resin, blood and shit. For nearly a year, from 1994 to early 1995, Quinn worked on a series of seven sculptures entitled *Emotional Detox: The Seven Deadly Sins*. Standing between 75 cm and 90 cm tall (29¼ and 35½ in), they were assembled from casts of the artist's head and torso, and show his face being pulled and pushed by his own disembodied hands. The title *Emotional Detox* alludes to a period of more than one year when Quinn abstained from alcohol. Commenting on the series, Sean Rainbird writes: 'Detoxification is shown both as an overpowering physical convulsion to rid the body of poisons, and as a psychological battle to gain mental stability. This struggle against dependency involves a painful release as repressed emotions are newly experienced, forced out and sweated through the skin.' (Tate Gallery, London, *Marc Quinn: Art Now*, brochure, 1995.)

The sculptures originated in plaster casts from which wax casts were made, and these in turn were the basis of the lead casts. Windows cut into the torsos enable the viewer to see the internal structure of each cast, complete with the 'runners and risers' which allowed the molten metal to channel into the figure during the casting process. This internal scaffolding forms what Quinn refers to as a kind of 'petrified circulation system'. The figures were left in a rough, unpolished state, the surfaces scarred with nails, nail holes and crusty seams. The fragmentary nature of the sculptures, with the hands cut off at the wrists and the arms wrenched from their sockets, puts them in a long tradition of expressive, fragmentary sculpture, which includes Rodin and has its origin in battered antique marbles. Quinn also acknowledges a debt to the eighteenth-century sculptor Franz Xaver Messerschmidt, who made a series of busts showing extreme facial contortions. Quinn's series of seven sculptures was first exhibited in the Art Now series of displays at the Tate Gallery, London, in July 1995.

The ten etchings in the series *Emotional Detoxification* were made shortly after the sculptures and pursue the same theme. Quinn had made a few small etchings in the 1980s, but his only published print was a photographically-generated screenprint, *Template for my Future Plastic Surgery*, produced for the *London* portfolio and published by Paragon Press in 1992 (see Scottish National Gallery of Modern Art, *Contemporary British Art in Print*, 1995, pp.46–51). Rather than use screenprint for the present series of prints, Quinn preferred to use etching because of its parallels with sculpture. Not only is etching effectively a way of carving into metal, but the acid-based, alchemical nature of the medium is analogous to the process of casting in metal. Quinn remarks: 'With etching you are working with chance. It's also

like sculpture because you are working with real physical forces.' The fact that acid is at the heart of the etching process also relates to the visceral, almost surgical quality which characterises Quinn's work.

As in much of Quinn's art, the prints and sculptures deal with the dialogue between the inside and the outside, between external appearance and the feelings within. In the sculptures the lead, apparently oozing out of seams and cracks all over the body, assumes a powerful visual metaphor for the cathartic expulsion of toxic waste. The body is caught in a frozen moment of agony. Just as the sculptures are composed of cast body-parts assembled together in a deliberately crude fashion, so the prints are made from several separate etched plates printed over each other. The etchings were drawn after photographs of the sculptures, though they are not exact copies. Quinn made seven separate plates after each of the seven sculptures, and the prints feature one or more of these plates in various different combinations, some of them printed in reverse or upside-down or layered one on top of the other. So, for example, the fifth print features just one plate, printed twice in reverse; and the seventh print features three of the plates, layered one over the other, each printed in a different colour.

The first print, a self-portrait, acts as an introductory image. It was made by shining a light at Quinn's profile, while an assistant drew the outline of the shadow on a copper etching plate. Most of the plates were made in softground etching, a technique which records the random finger-marks which result from the initial drawing process. Quinn was keen to retain these marks, which mirror the rough surfaces of the sculptures. With the exception of the first print, the order of the others is not crucial. The sequence does not match the order in which the prints were made but was decided upon once all ten etchings had been printed.

While the prints and sculptures allude to the battle with alcohol addiction, their frame of reference is wider. Quinn remarks: 'They're partly about how I felt when I came off alcohol but it's more to do with jumbled feelings. It's about the idea of being an artist, chopping up your life and it becoming the work. As an artist you cannibalize your life and put it together again as art. The prints take this a step further. In the prints, the sculptures are chopped up again and turned into these new images. The sculptures are like shells of your past self, cut up and recombined; the etching plates are cut up and recombined in the same way. I had been off alcohol for a year and a half when I made the prints. It takes a long time to come to terms with. It took a year to make the sculptures then another few months before I made the prints.'

Deacon had made some prints, including screenprints printed on polythene, during his Foundation Year at Somerset College of Art from 1968–69. He made no further editioned prints until 1987 when he produced a group of large etchings, printed by Peter Kneubühler in Zürich: entitled *Muzot*, they were published by Margarete Roeder in New York.

Although Deacon's sculptures seem to be self-contained, abstract forms, they have a close if enigmatic relationship with photography. Over the years, Deacon has collected a large body of photographic images which echo his drawn and sculpted oeuvre in an indirect, sideways manner, confirming rather than inspiring certain patterns and forms. This interest remained largely unknown until 1990 when he published a book, *Atlas: Gondwanaland and Laurasia*. The double-page spreads in the first part of the book featured colour photographs placed centrally on the left page and related drawings on the right; the second half of the book featured photocopies of photographs on the right page, followed by a drawing on the following right-hand page (the left side remained blank). The pairing suggested some sort of relationship, though the nature of that relationship remained deliberately ambiguous. It was not clear if the photograph had inspired the drawing or if the drawings had provoked him to take certain types of photographs. This pairing of photographic and drawn images, and an investigation into what Deacon refers to as 'the space in between them', has been a recurring feature of the artist's subsequent work and catalogues.

Deacon and Charles Booth-Clibborn began discussing a potential print project late in 1995. At that time Deacon was making a series of small drawings, four to a page, in black ink (he eventually made about eighty of these drawings). They discussed the possibility of making a series of linocuts or a set of rubber stamps or wood engravings based on the drawings, which would be produced as individual images, not as groups of four. Deacon had also recently produced two series of photographs, one using found images, the other using his own photographs. Both series were titled *This is Not a Story*. The first set was shown as a group of nine in a 3 × 3 square arrangement; the second was shown in a single line of eight images. Gradually, the idea of using drawn images was displaced in preference to making a set of screenprinted photographic images. Deacon remarks: 'I had recently grouped the photographs that I take or collect under several general headings. It's a fairly loose categorisation and in part comes from a growing recognition that it is possible to recognise repetitions in the things that I photograph or the images that I collect. This repetition intrigues me since it is largely unconscious.

The idea of selecting one image from each (or most) of these groups began to emerge. In the end we arrived at a selection of twelve photographs. All the photographs were taken by Deacon himself. One of them, the image of the flock of geese (print E in the series), was then produced as a test silkscreen print.

Although the concept had shifted from the small drawings to photographic images, Deacon continued to make ink drawings, but on a slightly larger scale. When he saw the first trial photographic print, he decided he would like to somehow incorporate drawn images into the prints, proposing that the drawings be used as a kind of postage stamp on top of the photographic images. A second trial print was made using one of the drawings. From a group of about fifteen drawings, Deacon selected twelve which would in some way match or echo the photographs. The remaining photographs were produced as large screenprints and the drawings were printed life-size on top of them. The relationship between the position of the drawing on the photographic image was like a stamp on an envelope. The sequence corresponds to the order in which the drawings were made. Deacon comments that 'The process of matching drawings to photograph was intuitive but in each case there is a reciprocal relation of some sort between the two.'

The earliest photograph used in the portfolio dates from 1988, the most recent from June 1996. The photographs depict the following subjects: *A*: A chalk hillside in the Limousin region of France. *B*: A swarm of bees on a broken piece of concrete wall, photographed near the entrance at the MUKHA gallery in Antwerp, where Deacon was installing an exhibition. *C*: A figure of St John in the Bavarian National Museum in Munich. *D*: A bag of frozen peas, de-thawing after the artist's freezer had broken down. *E*: Canada geese flying over the estuary of the River Crouch in Essex. *F*: A rock in the sand on the Dorset coast near Lulworth. *G*: A poplar tree at Kassel, where Deacon had installed a sculpture for the Documenta exhibition. *H*: A cloud viewed from a train. *I*: A plant, possibly a clematis, at a garden near Stourhead, England. *J*: A house in Helsinki. *K*: Stubble burning in southern England, photographed from an aeroplane. *L*: An air-conditioning plant of a hospital in Toronto.

The title, *Show & Tell*, is taken from an educational game commonly used in American schools: the pupil will bring an object along to school and tell the class about it. The phrase 'Show and Tell' describes two different kinds of description or definition, though the way they connect or overlap is ambiguous. In Deacon's work, photography and drawing work in a parallel way, and their conjunction in the screenprints draws attention to the 'space' between them.

This text is partly based on a letter of October 1997, from the artist to Julian Haynen of the Kaiser Wilhelm Museum in Krefeld, and on an undated text written by the artist for the Tate Gallery, London.

RICHARD DEACON SHOW & TELL, 1996

PETER DOIG TEN ETCHINGS, 1996

but which is rarely treated by the painter: a crowd of people leaving a stadium; a car driving along a road; buildings in woods; landscapes with telegraph poles. Just as Baudelaire in his essay *The Painter of Modern Life* invited the artist to find a form of heroism in the ordinary and the contemporary, so Doig, more than a century later, looks to the unfocused, unarticulated corners of modern life. Edward Hopper, an artist Doig greatly admires, did something of this kind in the mid-twentieth century. In Doig's work, the artist and viewer seem to observe the scene from a distance, often from behind trees or a thicket. The time and season are indeterminate but possibly twilight or dusk. It is as if we were prying or spying on something, an unseen event which has recently taken place or is about to happen. Doig's images seem to stand at the edge of a narrative, and are more arresting because of this.

Doig had made some prints during his Foundation Course year at Wimbledon School of Art from 1979–80, but apart from a few unpublished etchings dating from the early 1990s he made no further prints before embarking on the present project. Since his paintings are built up in stages and in layers (often over a very long period of time), he decided to make the prints in etching, a technique which encourages a similar layering approach.

All ten etchings derive from Doig's own paintings from the period 1992 to early 1995. Doig describes the process as 'a way of cataloguing some of the work I had made over the previous years.' He began work on at least twenty separate etchings at the Hope (Sufferance) Press in London, but gradually narrowed the selection down to ten. They were developed over a long period of time and changed considerably as Doig worked on them.

While all of the etchings originate in paintings, these paintings do in turn originate in photographic images, most of them taken by Doig himself. All but three of the prints depict Canadian scenes. The exceptions are the two *Concrete Cabin* prints which depict Le Corbusier's *Unité d'habitation* building in Briey, in North-eastern France (the paintings date from 1992); and *Red House* which develops from a newspaper photograph of a bombed house in Bosnia. The two *From 'Pond Life'* etchings focus on a small section of the 1992 painting *Pond Life*, though here the pond and tangled undergrowth in the foreground is eliminated and replaced by three enigmatic figures walking towards the house. *Rosedale House* likewise takes a section of a painting of a large house in the suburbs of Toronto.

Some of the etchings were made from two plates. The etched plate is printed on to the paper in the normal way, but the paper is left in the press. It is then itself printed on to a fresh etching plate ('off-set' etching). The ink acts as a resist, and when it is bitten with acid, leaves a much softer line than can be achieved directly with an etching needle. Some of the plates were made as sugarlift etchings. *From 'Pond Life'* (no.3) and *White Out* were printed on *chine collé* – an ultra-thin layer of paper which provides a general background colour. Two additional prints were made: *Jetty* and a second version of *Ski Jacket*, using just the second sugarlift plate. They were not included in the portfolio set but were issued as separate, single prints (see Appendix, p.334).

Doig's imagery is part Romantic, part urban, part mass market (some of his imagery is taken from holiday brochures and B-movies). It is at once unusual and mundane – the type of subject which might be addressed in magazines or on television,

Langlands and Bell are most widely known for their enigmatic relief constructions based on architectural plans. These reliefs, begun in 1986 and initially incorporated into furniture, portray ground plans or isometric views. They are generally made in low relief in white-painted wood, MDF and lacquer, and are presented as framed and glazed constructions. The buildings often have a strategic brief, and include prisons, churches, synagogues, art galleries, company headquarters and geo-political organizations.

Their first treatment of the mosque subject came in 1991 when they made a long relief of The Great Mosque of Ibn Tulun al-Qatai, in Cairo, in the form of a trapezoid isometric construction suspended before a black background, so that it appears to be floating in space. In 1995 they made a diptych of The Abbey Church of St Benedictus in Vaals, Holland, paired with the Ka'ba in Mecca. This effectively shows two different types of perspective: the classical, western kind in the Abbey, with lines converging at the Cross on the altar; and a 'mental' perspective embodied in the Ka'ba, the holy shrine of Mecca, which Muslims face whenever they pray. Immediately after making this work they returned to the subject of mosques, beginning with the Mosque of Hassan in Rabat, Morocco, the Great Mosque of Cordoba in Spain, the Mosque of al Hakim in Cairo, and the Friday Mosque at Gulbarga, India (see Serpentine Gallery, London, Langlands and Bell, 1996, cats.54–60). Some of these mosques were presented as ground plans, others as suspended isometric reliefs. When they were invited to make a print project for Paragon Press in 1996, Langlands and Bell decided to base their project on the mosque theme. Part of their interest in mosques stemmed from the location of their studio in Whitechapel in the East End of London, which is adjacent to the main local mosque, and from which they hear the sound of the call to prayer twice a day.

This was Langlands and Bell's second print project. Their first had been a single blind-embossed print on paper, *UNO City*, made for the *London* portfolio, a set of prints by eleven artists working in London, which was published by Paragon Press in 1992 (see Scottish National Gallery of Modern Art, *Contemporary British Art in Print*, 1995, pp.46–51). The method of blind embossing parallels their sculptural work since it produces a sculptural, three-dimensional image. Both the reliefs and the embossed prints occupy real space, as of course do the buildings themselves. This was an important consideration in their choice of technique.

Mosque architecture develops from the house of the Prophet Muhammad. In 622AD he moved from Mecca to Medina and there constructed a large 'house' some 56 metres square. It was essentially a low,

four-walled enclosure, with small rooms along one side, a covered area along another, and two plain walls. With a large courtyard in the centre, this simple plan was taken as the prototype for mosque architecture. The other defining feature of mosques is that they are oriented towards Mecca. When Muslims pray, they face in the direction of the Ka'ba, no matter where they live. The mosque wall which faces Mecca contains a niche, the *mihrab*, which is evident in the ground plans; at the opposite end, near the entrance portal, there is often a minaret. Following the layout of the Prophet's house, mosques generally have a large open courtyard, often containing a fountain or pool where the faithful wash before prayer. In the prints by Langlands and Bell, the *mihrab* is at the top and the entrance portal, when it is present, is at the bottom.

Islam spread rapidly following Muhammad's death, and covered an area stretching from Spain to China. The mosques which Langlands and Bell selected for the series are all celebrated and important examples, and they follow similar plans. Most date from the ninth and tenth centuries, though the ground plans may represent long and different building campaigns conducted over several centuries. Shortly before work on the project the artists visited one of the mosques, at Cordoba. Now known as 'La Mesquita', it was converted into a Cathedral in the late fifteenth century, at the time of the re-conquest of southern Spain from the Moors.

Langlands and Bell begin their work intuitively. The finished works are rich in associations which encompass themes of belief, control, surveillance, hierarchy, power, order, community and identity. The artists believe that buildings are suggestive of the communities which construct them and use them, indicating the shared aspirations of those communities. The mosque, in which the faithful throughout the world are at fixed times all facing towards a single point, suggests a global community. The mosque and its ground plan become symbolic of a *mentalité*, a certain conviction or system of belief. The ground plans can therefore be seen as kinds of 'portraits' of a community and its way of thinking. The artists remark: 'Different building types tend to embody different aspects of the way we live and think and different areas of our social life. So whether they are international organization buildings founded in the spirit of utopian idealism or these mosques which are founded in a religious idealism, or in prison architecture, where you find the determining power of architecture most emphasised, different types of architecture can come to embody or symbolise different primary aspects of the way architecture operates for us, projecting our aspirations and enabling our intentions.'

Each print consists of embossed and raised sections. Langlands and Bell made drawings of the ground plans on tracing paper and these were transferred on to zinc plates with photosensitive emulsion. The prints are intended to be float-mounted in lacquered white frames of a specific type. In the prints, the architectural forms such as pillars and exterior walls read as raised sections occupying real space. The numerous raised dots in many of the prints are the pillars which support archways, beams or occasionally domes. Some elements in the ground plans have been slightly altered in their prints. For example the interior walls in the Qal'a of the Banu Hammad have been straightened slightly; and the minaret of the Great Mosque of Samarra (which is 150m wide) has been represented as a stylized circle, in reference to the spiralling path which ascends the minaret. The final order of the ten prints in the portfolio was an aesthetic decision, and was decided once the full set had been made. They were first exhibited at the Victoria Miro Gallery, London, in 1996.

The portfolio of ten prints is issued with the following artists' statement:

If architecture at its most elementary represents an attempt to reconcile the apparent endlessness of nature by enclosing personal or social space within the natural space of the wider world, religious architecture emphasises this strategy by proposing to define a personal or social space within the absolute space of oblivion.

The geometry of the religious building is predicated on the assumption of a mythic geometry which orders events beyond the building's point of focus, the ark, the cross or the mihrab: beyond this world. The temporal reality of this geometry is a structure where the spiritual dimensions of a community take physical form as an emblematic act of enclosure. The original process of inclusion / exclusion remains, a latent symbol of identity and intent.

In 1988 Whiteread began making casts of the insides of ordinary domestic objects, initially casting a wardrobe, and subsequently casting beds, floors, baths and even whole rooms. Made in plaster, rubber or resin, the works duplicated the space within the objects in an arresting and richly metaphorical way. Whilst having clear formal references to minimalist sculpture, her negative casts also evoke the history of the objects and the people who once used them. In 1993 Whiteread made a cement cast of the inside of a terraced three-story house in the East London borough of Hackney, where she has lived and worked since the mid-1980s. Standing alone and making visible the private, anonymous space that countless unknown people had inhabited, it stood as a poignant symbol of memory and mortality. *House* was demolished, amidst great controversy, in 1994.

Demolished, Whiteread's first print series, continues the themes explored in *House*, indeed the first sequence of four photographs was taken in October 1993, the month *House* was unveiled. The prints originate in a set of twelve of the artist's own photographs of buildings under demolition in Hackney. There are four images of three demolition sites. The first set shows the demolition of two tower blocks on the Clapton Park Estate, Mandeville Street; the second, photographed in March 1995, shows the demolition of the Bakewell Court and Repton Court blocks on the same Estate (these are the two buildings left standing in the foreground of the first set of prints); and the third set, taken in June 1995, shows the demolition of tower blocks on the Trowbridge Estate, in London E9. All three sites are a short walk from 193 Grove Road, London E3, where Whiteread made *House*.

photographing buildings under construction: both projects are concerned with the physical make-up of a space used or inhabited by people. The photographs selected for *Demolished* were taken as part of this project and, although they were taken over a period of two years, Whiteread envisaged at the time that they might somehow be used in a future work. Her vantage points were carefully chosen to avoid the milling crowds the events attracted; she even obtained permission to go inside one of the buildings before it was blown up. The first photograph in the third set was taken a few days before the buildings were demolished, in order to obtain a clear shot of all four tower blocks together.

In the same way that Whiteread's negative casts of baths and mattresses suggest the ghostly trace of the human body without actually describing it, so the photographs of the tower blocks connote the countless lives that have been lived within them. In the sequence of prints the buildings are presented as solids and negatives, their upright, anthropomorphic forms replaced in the final image by empty space. The destruction of the tower blocks alludes to death as much as it does to social regeneration. They are memorialized buildings, and like memorials the images record loss while at the same time preserving memory. As Whiteread comments: 'It was strange: some people were celebrating and others were crying because these were their homes. You can look at it in two ways, as an optimistic view of London or as a pessimistic view of London. I was trying to capture that in these prints.'

The *Demolished* screenprints were Whiteread's first prints since *Mausoleum under Construction*, a screenprint made for the *London* portfolio, which was produced by Paragon Press in 1992. That single print was generated from a photograph found in a book, and similarly the *Demolished* prints are screenprints taken directly from photographs — in this case Whiteread's own 35mm colour slides. Just as her sculptures are seemingly unmediated casts, in which the touch of the artist's hand is absent, so photographs avoid the expressive gesture. Both methods present information as bald statements of fact. The prints are like obituary photographs, fixing a moment eternally in the present. By translating the colour slides into grainy black and white prints, Whiteread emphasised that documentary aspect.

Photography holds an important place in Whiteread's work: she has a huge archive of documentary images, taken by herself or cut from magazines. When she began casting objects in the late 1980s she also began

The six artists were each invited to make a pair of prints. Unlike the artists who contributed to the Screen portfolio and who all produced screenprints, the artists who contributed to this set were free to choose their technique. The sizes of their works also differ slightly. The series was co-published by the Paragon Press and the Alan Cristea Gallery.

BILL WOODROW

Woodrow's two prints each incorporate a pair of images on the same sheet. Both pairs depict the same imagery: a ship in a glass bottle on the left and a brain in a glass jar on the right. These subjects have interested Woodrow for many years. The ship in a bottle appears in a number of Woodrow's drawings, and obliquely in sculptures on the theme of The Ship of Fools. The brain appears in several drawings and also in a small bronze sculpture, *Our World*, made for the British Art Medal Society in 1997. It is in the form of two halves of a brain, which split to reveal male and female genitals within.

The linear drawing *Reliquary* was made first. The overlapping imagery relates to Woodrow's print series *Greenleaf*, which he made for Paragon Press in 1992 (see *Contemporary British Art in Print*, 1995, pp.188–91). The title refers to the reliquaries commonly found in Italian churches. These contain artefacts which have acquired an aura of reverence, though their origin is usually uncertain. In the same way the brain has no obvious, visual connection to a particular individual. The ship in the bottle is also an enigma, though one of a different nature. The prints also play upon the question of scale, the brain being life-size while the ship is in miniature. This kind of dislocated narrative, in which parallels are suggested but precise readings are avoided, is typical of Woodrow's work.

HAMISH FULTON

Since 1969 Fulton's work has been specifically concerned with the experience of walking. He has written that 'My art-form is the short journey—made by walking in the landscape.' From 1969 and throughout the 1970s his walks were re-presented in the form of black and white photographs made on the walks, with accompanying titles and inscriptions set below the photograph. Since the early 1980s much of his work has been in the form of text pieces, either printed in catalogues, painted on walls, or produced as prints. The texts are, in a sense, poetic equivalents for the feelings and thoughts he experiences on the walks.

Fulton has made walks in Western Europe, Japan, Nepal, North and South America and Australia. Some of the walks are made in the company of friends, some alone. On the walks he takes a small notebook in which he records his thoughts. Generally he uses one notebook for each walk. These notebook records, made in pen, are the direct ancestors of the text peices, which may be presented as wall-texts, prints, books or posters. The two prints included in this portfolio refer to walks made in Japan (to date he has made seveteen seperate walks in Japan) and France.

LISA MILROY

Milroy first visited Japan in 1990, on the occasion of a British Council exhibition (*British Art Now: A Subjective View*). At that time, she was known for her paintings of objects such as shoes, coins, lightbulbs and stamps, depicted in a neutral space on a white background. During 1993 she began to think of the still life no longer in terms of objects, but became more interested in the context in which things were found and began to paint pictures of the world around her. In the last three months of that year she lived in Tokyo where she produced a series of paintings based on her observations of the city.

In 1994, Milroy returned once more to Japan and spent a month's residency at the Kyoto City University of Arts in Kyoto. During this time she made four paintings of the old wooden town houses typical of the city. This was her second series of paintings of buildings: the first group was made in Rome earlier that year, and a series based on London buildings followed the Kyoto series. Milroy recalls: 'I love the way the buildings in Kyoto offer themselves up to view, but the interiors remain strictly private. The combination, and separation, of a powerful visual experience and unspoken feeling is something that endlessly fascinates me.'

When she was asked to contribute prints for the present portfolio project, Milroy decided to base them on the memory she had of these Kyoto houses. Just as her earlier 'object paintings' deal with matters of scrutiny, cataloguing and the pleasure of looking, so these concerns were continued in Milroy's paintings and prints of buildings. She observes: 'The paintings of the town houses were so satisfying to make that I wanted another way of experiencing the pleasure I had in doing them. I thought I could re-visit something of the experience I had had in making the *Kyoto House* paintings, which are essentially described through light and shadow, via the drawing and shading of a printing process. Each print contains a pair of houses. I enjoy what happens in making comparisons of things — in cataloguing the surfaces, noticing the similarities and differences of the houses in the image, and they become almost abstract, both inviting and picturing a contemplative state of mind.' Milroy first made pencil drawings on acetate sheets, and these were then made as photogravure etchings, which Milroy reworked in softground. They were

printed on *chine collé* paper, which gives the etchings a rich, luminous quality.

IAN McKEEVER

These two prints followed three enormous canvases, two of them measuring 265 × 703 cm (104¼ × 276¾ in), and the third measuring 265 × 527 cm (104¼ × 207½ in). The three paintings, executed between 1994 and 1995, were titled *Marianne North No.1, No.2* and *No.3*. They were made up of skeins of translucent white veils which seem to hover above black holes: these features are also the subject of McKeever's *After Marianne North* etchings.

Marianne North was a nineteenth-century explorer and amateur painter. She constructed a house in Kew Gardens, London, which contains more than 800 of her botanical paintings, hung from floor to ceiling. McKeever has admired the house for many years and dedicated his three paintings to her. There is nothing in common with the imagery in her paintings, but he felt an affinity with her explorations (he has also travelled extensively), was, like her, self-taught as a painter, and was similarly interested in the sensuous, almost sexual nature of certain natural forms.

McKeever selected etching as the medium in which he could foreground his interest in this layering of soft whites over a dense, concentrated black. He produced about ten images in total, and selected two prints for the portfolio. Both etchings were made from two plates: in both there is an aquatint plate which gives a soft, slightly out-of-focus black area; the second plate in the first print was made in drypoint, and the second plate in the second print was done in softground etching. The drypoint of the first print gives firmer, harsher line, while softground facilitates a softer mark akin to pencil or crayon. The imagery was drawn directly onto the plates: there were no preliminary sketches. McKeever remarks: 'I am increasingly involved in the way the paintings and prints feed off and into each other. I build the paintings with diaphanous veils: the forms are alluded to without ever being consolidated. One of the interesting things about printmaking is that in the prints I can sense more clearly, make the forms more solid and concrete. They affirm the paintings.'

While working on this pair of prints, McKeever produced a series of five etchings which have been published separately: see Appendix, p.333.

These were the first etchings Davey had made. They were drawn directly onto the etching plates with a sugar-based ink. The *Pair* etchings of a knife and fork inaugurated a series of drawings on the same theme: the suggestion is of peas being chased around a plate. The *Eye* print develops from Davey's print project, also called *Eye*, which was published by Paragon Press in 1993. In that suite of six screenprints, two dwelt upon the repeated image of a glass eye and a glass bottle-stopper, seen from different angles, as if they were falling and rotating in space. The present *Eye* print is an etched variant: the eyes are formed from bottle tops pressed onto the softground plate; the dark central form was made with an earplug. Both prints incorporate the circular form which has been a recurrent motif in Davey's sculpture; paired elements have also been a feature of Davey's three-dimensional work.

The two prints display the artist's concern with mark making, and the nature of the mark and image as the ink looses its ability to establish an emphatic line. This is a consistent concern in Davey's drawings, which are often monotypes, drawn on one sheet, and then transferred by pressure on to another. The drawing of the hands contrasts the strong line of the fully inked brush as it delineates the grasp of the fingers, and, as the ink runs dry, the hairs of the hand and the shifting mass of peas. The eye forms disintegrate and become like coffee-cup stains as the ink loses its power to make itself felt. They are dysfunctional marks, analysing themselves in the process of working imperfectly.

A second state of the *Eye* etching was published separately as an individual print: see Appendix, p.333.

and paintings. Moreover, he uses the identical 'platonic' image of these items on each occasion, drawn in a way which might be likened to a pictorial dictionary. In the present screenprints he used imagery — the fan, chair and torch; the shoes, filing cabinet and bucket — which had appeared in his work on many previous occasions. Since 1995 he has generated these images on computer, selecting from his dictionary of objects, and composing them on screen. These computer-generated images act as the models for the tape drawings in which the objects are overlaid in a complex web of lines; and, as here, the prints in which objects are evenly distributed across the picture plane. For these prints, Craig-Martin originated a design on computer, then passed copies of small acetate drawings and colour notations to the printers for transferral to screenprint.

GRENVILLE DAVEY

The three objects in *Close Relations* and *Distant Relations* are set out with such determined clarity and factual presence that a narrative connection seems probable. But it is a disjointed, frustrated narrative. The objects are partly domestic, partly office, partly neither of these; their relationship is simultaneously distant and close, as if the two concepts were somehow identical. Craig-Martin remarks: 'My hope in the work is that by bringing certain objects together, you start to see connections, narratives, metaphors between some of them, and then the next one doesn't fit the pattern, and you have to look again. I try to create as many threads of meaning as possible. But every one of them is at some point denied [...] I have a passion for clarity, but I am drawn to contradiction and complexity.' (Interview in Waddington Galleries, London, *Michael Craig-Martin: Conference* 2000, pp.6–8.)

MICHAEL CRAIG-MARTIN

During the 1960s and 1970s Michael Craig-Martin's work was associated with minimalism and conceptual art. His current work, although demonstrably readable and pictorial, deals with related issues. Like the minimalists, he is concerned with banal, mass-produced objects; and like the conceptual artists, he exploits the ambiguities between signs and symbols, and the things they purport to represent.

Since 1978 Craig-Martin has built a vocabulary of images of ordinary, man-made objects, and has used these principally in works drawn with sticking tape stuck directly onto walls, and also in drawings, prints

This set of prints is part of an on-going series in which Ofili travels to a particular location, armed with a set of copper etching plates, makes a group of ten etchings — normally making one a day — and prints them on his return to London. The series began in 1992 when Ofili was a student at the Royal College of Art in London. That year he went to Barcelona and produced a set of etchings (entitled *Barcelona*) which he printed in an edition of ten. These were his first etchings and, unusually, they were made by scratching the hardground copper plates with a very hard pencil rather than with the customary etching needle. The following year Ofili made another set of ten etchings in Berlin. He made the first etching on the flight from London to Berlin, then made eight in the city itself, one per day, and executed the last one on the return flight to London. The third set, which followed a similar procedure and pattern, was made in New York. Prior to each trip, Ofili established the kind of mark-making notation he would use in each set of prints. The *Barcelona* prints were built from cross-hatched marks; in Berlin he made the etchings with small dots; and the *New York* prints are composed of concentric wave patterns which fold in on themselves. There were ten prints in each of these three series, all of the same size and format.

The imagery in the prints relates to the particular locations, although the references are usually oblique. Ofili describes these ventures as being in the spirit of the walks made by Richard Long and Hamish Fulton, but done in a manner which was personal to him. Instead of seeking out wild nature, he sought out famous, even hackneyed, tourist spots: 'I was picking up on what someone like Long was doing, but doing it in a way that meant something to me. It's a way of getting to know somewhere, in an inside-out manner, paying some attention to what's going on and paying no attention, because doing these prints is very intense and they demand a lot of attention. It's an odd kind of tourism.'

The present set — the fourth in Ofili's series — was made on the west coast of North Wales, when Ofili stayed at the house of a friend in Llanbedr in September 1996. Although Ofili had visited Wales before, he had not been to this particular area. The etchings were done in much the same way as the three earlier sets, all of which were published by the artist himself. Prior to making the trip, Ofili made experiments on a small etching plate, and elected to construct all the prints with a tightly grouped diamond pattern. As ever, he took just ten of the prepared etching plates and no spares, so that any mistakes would become an integral part of the work. There were no preparatory drawings.

In North Wales, Ofili made two prints on the first day of the trip, 10th September, followed by one per day for the next six days, and two on the last day before driving back to London. He drove to different locations, chosen at random but within an hour's drive of Llanbedr. The plates were mapped out with a basic design and filled in with the diamond patterning. Much of the imagery responds to the feel of the particular location, but does so in an allusive way which may not be immediately apparent. Thus the etching of Snowdon features the outlines of mountain peaks; the spiralling rings in *Llanbedr* join in the centre, making reference to the fact that the artist was staying in Llanbedr and it was at the centre of the trip; *Castle Harlech* features rectangular slits which mimic the arrow slits within the castle walls; the inter-connecting peak structures in *Twynitywod Morfaharlech* respond to the sand dunes by Harlech; the forms in *Llanberis* were inspired by a group of trees; the print etched in Blaenau Ffestiniog was made while Ofili was looking into the sun, and the sun itself is recorded as a starburst in the bottom right corner. The etchings were made in the morning, though two of them, *Blaenau Ffestiniog* and *Portmeirion* were begun in the morning and finished in the evening.

Describing his way of working on the etchings, Ofili remarks: 'On a personal level this is a very nourishing way of working, it can take me to places within myself which are unfamiliar, and that can feed into the painting. It's like deep-sea diving: you pick something up and then come back to the surface with it, rather than have a pre-designed image which you then go and make. It's about having a vague idea, going somewhere, looking and responding. They're really old-fashioned, simple prints. It's a way of looking at a place through my eyes.'

Though Ofili has not made etchings since 1996, he intends to make more sets, based on this same theme of travel and discovery.

The *Night Fishing* etching came from a magazine advertisement for fishing in Northern Canada, which Doig found in Canada House, Trafalgar Square. This was developed into a painting in 1993 (it is the earliest source in this set of etchings), but it was substantially altered in the etched version.

The *Grasshopper* etchings are marginally larger than those in *Ten Etchings*. Each print was made from between one and three separate etching plates; *Camp Forestia* also has a double printing of the same plate, printed in two colours. The title *Grasshopper* (which is also the title of an earlier painting) is taken from a quote found in a book on the history of ice hockey (a sport the artist plays), in which a nineteenth-century farmer, after settling in the prairies, remarks: 'Man is a grasshopper here, a mere insect making way between the enormous discs of heaven and earth.'

Following the print series *Ten Etchings, 1996* (illustrated pp.47–59; commentary p.307). Doig made another set of ten etchings, *Blizzard*, which was published by Editions Salzau, Berlin, early in 1997. The present series of prints was made towards the end of the same year, when Doig was preparing new work for his first major solo exhibition, which began at the Kunsthalle in Kiel in March 1998, and subsequently toured to the Kunsthalle in Nürnberg and the Whitechapel Art Gallery in London. Whereas the etchings in the *Ten Etchings* suite had all developed from pre-existing paintings made by Doig, some of the *Grasshopper* etchings follow the paintings, some were developed alongside the paintings, and others have been made as etchings but not (yet) as paintings. By this stage Doig, who makes comparatively few drawings, was using etching almost as a sketchbook. Gradually, he began to develop new ways of treating the imagery — particularly masking and hiding form — in the etchings and subsequently used the etchings as the starting point for the paintings. Also, Doig has found that in etching he can work in a subdued, almost monochromatic palette, while the paintings, which are very much larger in scale, demand a brighter range of colours.

All the images originate in some way in photographic images, either as photographs taken by the artist or found in magazines; or in still images taken from videos — sometimes made by the artist specifically for the purpose. For Doig, the precise source of the photographs is of little consequence, and they might be found in a travel magazine, a horror video or one of the artist's own photographs. However they invariably centre upon the relationship between the figure and the landscape, and often seem to evoke the artist's childhood in Canada.

Reflections (What Does Your Soul Look Like?) is an extreme close-up of one element of a photograph taken by Doig. The two etchings which centre on skiing, *Ski Lift* and *Ski Hill*, were derived from videos which Doig had made specifically as possible source material for painting. They were played on television and Doig photographed them from the screen. Neither of these images has been made as a painting.

The *Canoe Lake* etching was made while Doig was working on the 200 x 300 cm painting of the same title. Following on from a painting of 1990, which treated the same motif of a canoe drifting on a placid lake (*Swamped*), it ultimately derives from a still image taken from the horror film *Friday the 13th* (1980). In the film the woman trailing her hand in the water — the only survivor of a murderer's rampage — is about to be rudely disturbed when the murderer reappears from the water and grabs her. Here,

though, the twilight image is Romantic in feel. The print itself combines the central image from the film with landscape elements derived from a photograph Doig had taken of a frozen lake. Commenting on the unusual marriage of source material, which is partly sublime, partly horrific, Doig notes: 'I find images that remind me of a certain time, of certain works from the past. This image from *Friday the 13th* could have come out of some Gothic or Romantic painting. It becomes part of visual currency. There may be some irony, but it's also taking something from a mundane source and trying to give it some weight.'

The etching *Daytime Astronomy* precedes the painting of the same title, made in 1997–98. The source for the figure is a photograph by Hans Namuth of the artist Jackson Pollock reclining in long grass and reading a book. In the painting he is smaller but occupies the centre of the painting; here he is tucked away to the side, just by the road. But in both etching and oil, the figure almost completely disappears. For Doig the identity of the figure is irrelevant: instead it was the form of the figure and its suggestion of a disjointed narrative (what is he doing there?) which was of interest. It is a non-determined season and time, somewhere between night and day, winter and summer.

Lunker is a generic name for a big fish. This image derives from a magazine advertisement for fishing. *Camp Forestia* derives from a portion of a large painting showing a house in a landscape; the reflection in the water, the most prominent feature of the painting, is suppressed in the etching. In the way that Doig 'samples' photographic sources, pulling parts from several images, mixing them and stretching them, so in the etchings he uses the paintings (or more accurately photographs that the paintings were based on) and samples and alters these.

The etching *Figure in a Mountain Landscape* was made at the same time as the painting of the same title, but departs from the painting in a number of ways: in the print, the figure seems to be absorbed into the landscape. The image in the etching is reversed. It derives from a photograph dating from the 1920s of one of the Canadian 'Group of Seven' artists painting *en plein air*. By this stage Doig's etchings were affecting the paintings. In this instance, effects obtained by chance in the etching, because the plate was not fully clean, were transposed into the painting. Although Doig began using the photographic reproduction as his point of reference while working on the painting, he subsequently set this aside and painted after the etching instead.

In 1992 Paragon Press published the group portfolio *London*. Comprising prints (with one exception they were all screenprints) by Dominic Denis, Angus Fairhurst, Damien Hirst, Michael Landy, Langlands and Bell, Nicholas May, Marc Quinn, Marcus Taylor, Gavin Turk, Rachel Whiteread and Craig Wood, it was intended to showcase a younger generation of artists, born in the 1960s and resident in London, who were acquiring an international reputation.

The same principle characterises the *Screen* portfolio, which again includes work by a young generation of London-based artists (born between 1958 and 1971 and therefore roughly the same age as Charles Booth-Clibborn of the Paragon Press) and consists exclusively of screenprints. The project had the same format as the *London* portfolio: apart from the requirement to make a screenprint, the only limitation was to make a work less than 76 × 89cm (30 × 35 in) in size. The title *Screen* refers to the screenprint technique but also references the fact that most of the artists had worked with video or photography. The screenprint technique offered artists who had little experience of traditional print mediums, the opportunity to make prints which somehow characterise their work. Once more, the concept was to create a kind of portable exhibition which would showcase the work of this younger generation, and the artists were encouraged to make prints which typified their current concerns. The selection of artists was maded by Booth-Clibborn with Charles Asprey and Thomas Dane of Ridinghouse Editions. The prints were made between February and July 1997 and were first exhibited at the Anne Faggionato Gallery, London, in November 1997.

DARREN ALMOND

In his youth Almond was a train-spotter, and he travelled widely throughout Britain by train. Much of his art now concerns time and journeys. For example he made an enormous digital clock in which the numbers flip over with a heavy click. He has also made a series of nameplates in cast aluminium in imitation of the plaques on British 125 inter-city trains. A recent series has concerned the bus stop at Auschwitz.

Almond commissioned British Rail to make a cast aluminium nameplate, bearing his own name, in exactly the same typeface and form as that used on the HST 125 inter-city train. To make the print, he photographed the metal version and from this made a photo-screenprint. It was printed with two layers of silver, overlaid with several layers of red and sealed with seven layers of varnish to create a surface which has the feel of a hand-painted sign. An embossed metal plate was made from the same photograph (by Tower Engraving, London) and this was used to emboss the silver text and edge and the holes designed for the ten fixing rivets. The screenprint version is slightly smaller than the metal plate.

The train on which these metal plaques first appeared, the HST 125 inter-city, has a diesel locomotive at either end, and is therefore called a Multiple Coupling. The title of Almond's print also references the print as a multiple. It was Almond's first print, though he has since made other screenprinted nameplates.

JAKE & DINOS CHAPMAN

The Chapman brothers had made screenprints independently when they were students, but this was their first co-authored print. They had previously made a number of mannequin-type sculptures featuring weirdly mutated Siamese twins, with conjoined heads or limbs and genitalia sprouting from unlikely places. Their *Double Deathshead* screenprint takes that concern into a two-dimensional medium. Their image extends similar motifs found in Nazi SS regalia and in the Jolly Roger pirate flag. The double-headed device may also contain an autobiographical reference to the two artist-brothers, though they describe this as coincidental. The print is issued with a pair of plastic eyes on springs — 'Droopy Eyes' — which are to be fixed to the glazed image once it has been framed, covering the central pair of eyes. Dinos Chapman remarks: 'The eyes deflate any sense of menace, the whole image deflates itself.'

MAT COLLISHAW

Collishaw's work embraces photography, video and objects. This is a photograph of the artist's son, surrounded by crisp packets and drink cans, screenprinted on to a shiny, melinex sheet.

The Chapmans provided the printers with a life-size ink drawing of the skulls, and the screenprint was made from this. It is their first image incorporating joined double skulls — a motif they subsequently used in an editioned sculpture; single skulls have appeared in other works.

ANYA GALLACCIO

Much of Gallaccio's work concerns decay and dissolution — a giant block of ice melting; a huge candle slowly burning away in a public square; a web of flowers stretched across a room, slowly decomposing. This print (the artist's first since leaving art college) was an extension of a work Gallaccio had made for the exhibition *Broken English*, held at the Serpentine Gallery, London, in 1991. That work consisted of a large, shallow tray of water covering the Gallery floor, with small photo-booth photographs floating on the surface. The photographs — there were around 1000 of them — were of artists, curators, gallery staff and critics. Using the address book of a couple of curators, she telephoned artists, curators and dealers — most of whom she did not know — and asked them to contribute a strip of photographs of themselves and to invite anyone else who might wish to be included. She added a large number of photographs showing the empty booth with only the coloured curtain. 'It was my naïve attempt to include everyone, to make the whole picture. The formal structure of the passport-size photograph made everyone equal. Once I put the photographs in the water they started to form narratives, who floated next to who and who sank etc. Some of the images survived the experience, others totally washed away. Some mysteriously disappeared and others were added by visitors to the exhibition. The audience saw a sea of nameless faces, but for those with any professional involvement it was a mirror, looking for themselves or their friends.' The work acted as a metaphor for the transience and fickle nature of the art-world, mirroring the falling from fashion of a style, artist or dealer.

Gallaccio kept the photographs after the exhibition and, when asked to make a print for the *Screen*

portfolio, used a selection of them. While some of the figures had been unfamiliar in 1991, many were famous or powerful by 1997, when she made the print. As Gallaccio observes: 'It was a sort of document of a moment in time, a suspended moment.' The passport photos were floated in a small tray of water and re-photographed on medium format film.

SIOBHÁN HAPASKA

Hapaska is known for her enigmatic and beautifully crafted fibreglass sculptures. This print shows the American operatic soprano Maria Callas, floating imperiously above a mass of American air-force planes, grouped together as if in a graveyard.

ABIGAIL LANE

The print combines a film-still of a dinosaur in a landscape from the film *One Million Years BC* (made in 1966 and featuring Raquel Welch) with an image of a mouse with a human ear grafted on to it. The mutant mouse was created by Charles and Jay Vacanti in a laboratory in Massachusetts. Taking a few cells of human cartilage, they managed to make the samples multiply within the mould of a human ear, so that the cartilage took on the ear's shape. After four weeks the ear was grafted onto a hairless mouse, which has no immune system and therefore does not reject the foreign body. The scientists saw this as the first step in the manufacture of replacement elements for damaged or missing human body parts. Abigail Lane found the small film-still of the dinosaur in a book, fed it into a computer, edited out one of the dinosaurs (they were a fighting pair) and added the mouse, which was taken from a magazine illustration. The artist comments: 'I think the ear-winged mouse has a mythical quality, an aberration to match any unicorn, faun or mermaid. Only this time it is real. In *Dinomouse Sequel Mutant X*, past and present face each other on equal ground — albeit a film set.'

GEORGINA STARR

The first version of this print was published early in 1997 in Issue One of Starr's comic *Starvision*. The comic introduced her Tuberama story (about a group of people on the Northern Line tube, who sing and dance on their way to meeting their doppelgangers at the Doppelstat station: it was subsequently transformed into a musical animation and soundtrack) and other characters from Starr's world. She wore the five outfits during the making of the comic, and made them the subject of an advertisement in the style of 1960s girls' comics, such as *Bunty*. Readers were effectively invited to take on Starr's persona by wearing her clothes. A cut-out coupon was included in the corner for people to select an outfit. The figures were drawn by hand and fed into a computer, along with scanned samples of fabric and photographs of the artist's own face. The various elements were manipulated in Photoshop. Starr made a larger version of the image for her exhibition at the Philip Rizzo Gallery in Paris in April 1997. It was one of a number of images taken from the comic, enlarged and plastered all over the gallery walls. The clothes themselves were displayed on a portable clothes-rack. On the opening night of the show, models wore the clothes, thereby becoming Georgina Starr doppelgangers for the evening. The vertical-format image was then used for the *Screen* screenprint.

CERITH WYN EVANS

The Durutti Column derives its name from the revolutionary anarchist Buenaventura Durruti, who was involved in the Civil War in Spain in the 1930s. In 1936 he led a column of 6000 men (hence 'Durruti Column') to liberate the city of Saragossa from the Fascists. The effort failed, and Durruti was subsequently killed in Madrid.

In November 1966 a group of Marxist students, allied to the Situationist International, was elected to the student union of the University of Strasbourg, and they promptly occupied the university buildings. Their demonstration has been seen as an important forerunner of the riots of May 1968 which nearly led to a Revolution in France. The students plastered the walls of the university with posters, including one called *The Return of the Durutti Column*, showing two cowboys from a Hollywood film who became modern stand-ins for Durruti's band of men. (The mis-spelling of Durruti's name was presumably accidental.) They added speech bubbles to their poster, introducing a text about reification, the dictionary definition of which is 'to convert a person, abstraction etc. into a thing; to materialize.' Perhaps the most celebrated anti-art work made by the Situationists was a book covered in sandpaper which would ruin any book placed next to it on the shelf. In 1979 the name The Durutti Column was appropriated by a New Wave music group who, inspired by the 1960s anarchists rather than by the 1930s revolutionary, used the same image of the men on horseback on the cover of an album.

In 1997 Cerith Wyn Evans appropriated the same image, and translated the French-language speech-bubbles into English. The print plays on the notion of reification — of converting something into something else — in that Durruti's name had come to signify something entirely different (and was even spelt

SAM TAYLOR-WOOD

This print was originally made as a double-page spread for a magazine published to coincide with the exhibition *Spellbound: Art and Film*, at the Hayward Gallery, London, in 1996. It was one of a series of images relating to the cinema, which were commissioned for the magazine by *Sight and Sound*. Like much of Taylor-Wood's work, *Red Snow* presents a dysfunctional narrative, in which the viewer is impelled to link the two possibly unrelated images.

GILLIAN WEARING

In 1992 Wearing began a series of works in which she approached people in the street, gave them a sheet of paper, asked them to write something on it, and then photographed the individuals holding the message. (The series of about 600 works is titled *Signs that say what you want them to say and not Signs that say what someone else wants you to say*.) The photographs probed the gap between what a person looks like (how they dress, their age, their bearing and expression) and what they might be thinking, and what we might be thinking of them. Given complete freedom to choose their own words, the people's texts, often of a confessional and intimate nature, yet made for a total stranger, were in turns funny, surprising, direct and strangely moving.

Wearing has also made a number of videos based on the theme of confession. *The Garden* screenprint originates in a still photograph taken at the time of the making of such a video, also called *The Garden*, in 1993. Wearing asked a transvestite whom she knew well, a prostitute whom she knew vaguely, and an escort, whom she had never met, to assemble in the garden and shoot a video. She had purchased several T-shirts in London, each emblazoned with slogans, and the 'cast' was invited to pick a shirt and perform in the video. Wearing herself is depicted in the print, second left. This unscripted anti-documentary, the product of an afternoon's filming compressed into a three minute video, shows them mucking about, hosing each other, and getting tipsy on wine. The T-shirts, like uniforms, simultaneously declare and mask the nature of the character.

CATHERINE YASS

In 1994 Yass began a series of large-scale transparency photographs, often depicting the interiors of institutional buildings such as hospitals and prisons. Displayed on the walls in lightboxes, they were a combination of negative and positive films sandwiched together. This treatment (arrived at accidentally when a film was mis-loaded) gave the scenes a haunting, surreal quality: the scenes looked simultaneously real and fictitious.

In 1997 Yass received a commission from the Barbican Art Centre, London, to take photographs for display in a series of small exhibitions in an area of the entrance foyer. She made two photographs and these were shown as part of this exhibition series entitled *Cell*. The works, entitled *Stage: Left* and *Stage: Right* depict the stage set behind the centre's principal theatre. Through the negative-positive process, the pulleys and stage machinery are presented as a buzzing, hyperactive entanglement of blue and green.

The *Stage* screenprint is taken from a section of the transparency *Stage: Right*. The left side and bottom edge have been cropped to create an almost abstract image. Continuing her interest in the interface between the real and the illusory, Yass also made a pair of photographs of some of the lesser-known actors, posed in a foyer area. Likewise, the subject of the print — a stage being the place where reality is rendered as artifice in order to dramatise reality — offered a metaphor for Yass's work, in which the objectivity and realism of photography is turned, almost literally, inside-out, and remastered.

The print, the first Yass had made, is almost identical in size to the lightbox photographs. It was taken on 5 × 4 in transparency film and then re-made as a 10 × 8 in transparency for the production of the screenprint.

differently) in the 1960s, and then in the late 1970s, as it had been appropriated and reappropriated, in a Duchampian gesture carried out over several generations. Moreover the character of Wyn Evans's print affirmed that conversion, in that it is printed in luminous ink. Seen in normal light it appears to be a blank sheet of yellow-green card: only when the lights are turned out does the image appear and the reified image literally reify. The cowboy who, as the speech-bubble puts it, 'just drifts', also finds form in the print, in that the cartoon appears as a glowing image when the lights are turned off, but its resonance gradually drifts away until it is reactivated again by light.

In the early 1990s Fairhurst began a series of works made after greatly enlarged postcards. He drilled holes in a regular grid pattern all over the work, and inserted a plastic clothes-shop tag in each hole. Working in this way, he made a series of four large photographic panels, *Man with Dream Colours*, of a man sitting in a chair holding primary coloured canvases, alternately blue, purple, red and yellow: each panel was pierced with hundreds of the plastic tags. He also made four similar panels, *Man who Wants to Know What the Back of his Head Looks Like*, of a man seen from behind wearing green, blue, red and yellow T-shirts.

In 1992 Fairhurst made a screenprint for the *London* portfolio, which was published by Paragon Press and features eleven prints by the young generation of artists working in London (see Scottish National Gallery of Modern Art, *Contemporary British Art in Print*, 1995, pp 46–51). Fairhurst's contribution was a print entitled *When I Woke up in the Morning, the Feeling was Still There*. Made from a photograph taken in the artist's studio, it showed the same suited man featured in *Man with Dream Colours*, holding a blank panel with a yellow square printed over it. The present set of four prints takes four photographs from the same series. The caption refers to that 'just-come-to-after-the-night-before' feeling. It alludes, perhaps, to a hangover or a night of drugs or love, but is not specific about the object or the nature of the 'feeling'. The coloured squares are hard-edged and precise (recalling paintings by Malevich and Yves Klein) but do not quite fit into the space left for them. Fairhurst comments: 'I wanted to play on the mis-alignment of the hard form and the notion of the feeling, both physical and emotional, which is something you cannot be so sure about.' The prints have a specific sequence: red, green, yellow and blue.

Christopher Le Brun has made a number of projects in association with the Paragon Press: these include published: *Fifty Etchings* 1989, *Four Riders* 1992–93, and a set of photogravure etchings entitled *Wagner*, 1994. The present prints, *Motif Light*, were Le Brun's first woodcuts.

Le Brun's painting, printmaking and, more recently, sculpture, relate to each other in complex ways. Working on a number of prints or paintings simultaneously, inventions or effects achieved in an etching may reappear subconsciously in a painting, and in turn in a sculpture — or vice versa. This dialogue between painting, printmaking and sculpture now generates and helps to resolve much of the imagery in Le Brun's work. Moreover, one painting or print may be the result of a huge amount of experimentation in one or another medium. This is the case with the five prints which make up *Motif Light*, which were the end product of a major campaign of printmaking. Just as the project *Fifty Etchings* 1990 began as an open-ended invitation to make some etchings and developed into a mammoth project, so *Motif Light* was the end result of a great many woodcuts, which were eventually distilled to just five prints. The prints were co-published by Paragon Press and Marlborough Graphics Ltd.

In 1997 Le Brun was given a number of plywood sheets, measuring 40 x 40cm, in which to experiment and make images. He cut these on his studio table using a simple chisel and hammer. Unaccustomed to the technique, he began by making work with a strong, emphatic subject — a portrait head, a figure of death on a horse. There were no preliminary drawings, only rough outline sketches on the plywood blocks themselves. Having spent about two weeks producing a group of woodcut blocks, he travelled to Hugh Stoneman's printing studios in Cornwall, and began proofing the images. Le Brun had a great deal of experience in printmaking, and therefore an exact idea of the image he wanted, but had no experience with the woodcut medium. When he saw the proofs come off the press he was surprised by their heavy, emblematic character: they seemed too much like German Expressionist woodcuts. His work tends to depend on effects of layering and concealment, on indistinct, veiled images appearing as if through dense undergrowth or through a thick atmosphere. The heavy pressure of the printing press seemed ill-suited to such effects. Le Brun spent a week proofing different images, recutting the blocks and cutting new ones, but found that the press could not give him impressions of the light, silvery tone he sought. He made some larger prints, but these were also unsatisfactory, and also made some prints made from several pieces of wood fitted together to print

in different colours (two of these were subsequently published: *Yellow Tower*, and *Yellow Tower with Black Border*: see Appendix, p.334.) Le Brun also experimented with different techniques, including drills and routers.

Dissatisfied with the results, he decided to try to hand-print the woodcuts at his London studio. Laying a sheet of paper on the inked-up woodcut block, he would press the paper down with the palm of the hand, and then rub the paper with the back of a spoon. By this process he could control the pressure gestures done with the density of the image — in a way which was not possible with a heavy press. With this approach it is also possible to lift the edge of the paper and check the density of the image; and Le Brun could also feel the edges of the cut wood and therefore apply extra pressure to certain elements of the print. Satisfied with this procedure, the artist made further woodcuts at his studio.

The resulting prints could be classified as monoprints, since the spoon-printing method was impossible to replicate exactly over the full edition. For example, the vertical graphic lines in the third print are the traces of the spoon as it wipes the ink in an up-and-down motion. It may be seen that the character of the prints was achieved through a two-stage process: the cutting of the blocks and the hand-printing of the blocks. The small size of the edition — there are just 12 sets of the five prints — was a consequence of this laborious, manual method of printing.

The prints do not have individual titles, but they do, mostly, develop from imagery found in Le Brun's earlier work. The wing motif in the first, second and fourth prints develops from a series of wing motifs found in the *Fifty Etchings* series (numbers XIV, XV, XVI and XLII): these in turn develop from oil paintings dating from the mid-1980s. Le Brun found the woodcut technique particularly appropriate to this motif, the splintered edges producing a fragile, feathery line. The tree motif in the fifth print also appears in *Fifty Etchings*, obscuring a silvery moon. The disc motif in the fourth print, and less emphatically in the third and fifth prints, dates to paintings of the early 1980s. It is partly a formal device, a curved form standing next to a strong vertical form, but also resonates with suggestions of the moon or a planet. The third print develops from an earlier lithograph of the surface of water, and seems to suggest the moon reflected in the water. These woodcuts went through numerous proofing stages, as Le Brun printed, re-cut, printed and re-cut, trying different colour combinations, until he had the soft, veiled effects he was searching for.

The first print is made from a single wood block. The second is likewise made from a single block, but the artist then laid the printed paper on a second, uncut piece of plywood, which had been coated with a grey ink: this second printing was made with graphic gestures done with the back of the spoon. The third print was made from two blocks, a 'wave block' and a 'disk block', one of them again printed with very uneven, graphic marks from the spoon. The fourth print was made from two blocks, in two different colours, and the fifth is also from two blocks, but one of them was printed twice, the second time with brown ink, and the printing done through selective, localised rubbing. Le Brun happened to have the paper — a humble mass-produced type — in his studio when he began proofing the prints, and found its light weight ideally suited to the hand-printing process.

Le Brun began work on about twenty images in total, and some of these are composed of two or more separate woodblocks. He worked extensively on seven or eight prints, and then selected five for the series. The chosen sequence depended on visual balance, the disk or reflected moon print seeming to fall naturally in the middle of the series; strong vertical images border the series to left and right in the form of the first and fifth prints. The technique of woodcut printing, in which cuts made with the chisel effectively equal light when printed, gave the set their title.

Kapoor was one of several artists commissioned to make a 'TV Sculpture' for a series of programmes produced by Sam Hodgkin for transmission on UK Channel 4 television in 1998. The other artists were Richard Hamilton, Jake and Dinos Chapman and Damien Hirst. Rather than make a programme about art, the concept of the series was to transform the television set itself into a work of art. Kapoor's contribution, a seven-minute broadcast entitled *Wounds and Absent Objects*, evolved from experimentation with digital TV post-production equipment. Via electronic matting devices, Kapoor made an electric impulse morph into pulsating, vividly coloured forms.

For this series of prints, Kapoor selected a number of still images from the video and had them saved on CD-ROM. The digital information was then transferred to film and made as pigment transfer prints printed on to a polyester base. In the pigment transfer process, the negative image is exposed to ultraviolet light on to a sensitized sheet of film coated with a pigmented gelatine layer. When it is exposed to the light, the gelatine layer hardens. The exposed film is then dipped in water and brought into contact with a sheet of polyester. The two sheets are pressed together with a roller and left to stand before being immersed in hot water. The hot water melts the unexposed gelatine, revealing a positive image on the polyester base. To produce a coloured image via this process, four sheets of gelatine coloured with different pigments (corresponding to cyan, magenta, yellow and black) must be layered together. The procedure is extremely time-consuming and a speck of dust caught in the fourth and final gelatine layer will ruin the print.

This process, which dates back to the 1860s, is related to photogravure and collotype, but is rarely used today. It acts as an analogue for Kapoor's sculpture, since rather than being a dye, the colour is pure pigment, bound in a layer of gelatine (moreover the colours do not fade). The colour seems to hover behind or in front of the surface of the print, giving the same sense of an infinite, bottomless void that characterizes many of Kapoor's pigment-covered sculptures. Just as Kapoor's sculptures are finished in such a way that hand-made marks are eliminated, so this is true of these prints. Like the sculptures, they are conceived as metaphors for the self, suggesting the dark space within and alluding, in a general sense, to the world of the subconscious.

Twelve sets of the nine prints were issued in portfolio cases, while nine sets were dry-mounted on to aluminium boards and trimmed to the edge of the image.

Prior to making this set of screenprints, Hume had made only two prints, both of them based on drawings: he had no involvement in the printing of either. One of these prints was included in the group portfolio *Other Men's Flowers*, published by Paragon Press in 1994.

For the present set, Hume chose to use screenprint, a printing process which parallels his painting style of flat, unmodulated gloss paint on aluminium panels. At the time he began work on the prints, he had made a number of paintings featuring animals, inspired in particular by the *Unicorn Tapestries* in the Musée de Cluny in Paris. Accordingly, his first notion was to make a Bestiary — a group of prints of animals — based directly on these paintings. He began by making two prints of animals — a bird after the painting *Aviary* and a *Seahorse* (see Appendix, p.335), then out of curiosity made a print based on one of his portrait paintings. He then decided to make the whole portfolio on the theme of portraiture. He had, in the previous few years, made a large number of portrait paintings, and these served as the basis for the screenprints.

Hume selected a group of twelve portrait paintings, and made twelve prints after them: two were rejected, making a portfolio of ten screenprints. The original paintings were all based on small drawings made on transparent acetate sheets: these were projected on to aluminium panels, traced and coloured with household gloss paints. In making the prints, Hume made new acetate drawings based very closely on the paintings, and projected these on to sheets of paper 108cm tall (a size dictated by the projected size of the portfolio case) and traced them. Screenprint stencils were then cut for each separate colour in each of the prints. All the prints are the same height, though they vary slightly in width, according to the format of the original painting. The colours in the prints vary slightly from those in the paintings, and were established through a long period of experimentation: the new, smaller scale of the images and the different properties of ink as opposed to paint, determined a different set of colour values. Sections of the prints have selected spot varnishes, some of them very thick.

The original paintings, on which the prints are based, date from 1994 to 1998: some of those paintings were based on photographs while others were purely imaginary. *Whistler* is simply a man whistling, with his fingers in his mouth. *Angel* was inspired by a photograph found in a fashion magazine, but was changed considerably in Hume's original painting. *Young Woman* is an imaginary portrait. Hume describes *Yellow Hair*, based on a painting of 1994, as being inspired by a girl at a disco: 'When you're

out dancing and a pretty girl comes up and dances and goes away again it's like this, it leaves an impression on the retina.' *Funny Girl*, after a painting of 1995, is based on a photograph printed alongside an obituary on the comedian Peter Cook. *Poor Thing*, based on a painting of 1994, is an imaginary image of a middle-aged, mentally disabled woman, looking into a diner in New York, with the text 'Information' printed on the glass and seen in reverse — as if the viewer were in the diner looking out at her. *Lady Parker* is based on a painting of 1998, which is itself based on Holbein's drawing of *Grace, Lady Parker*, c.1533–36. *Cerith*, based on a painting of 1997, is a portrait of a friend of Hume's, though it began as an imaginary portrait. *Adult* was based on a photograph found in a magazine, when Hume was living in New York: it was inspired by the type of intelligent, self-confident and forbidding women Hume encountered in the city's commercial art galleries. And *Francis* is taken from a photograph printed alongside an obituary of Francis Bacon.

There is no particular sequence to the prints, though the sequence as illustrated here (and within the portfolio case) was selected by Hume to give a rhythm of different colours and shapes. Hume's exigent colour requirements meant that a great deal of proofing and reprinting had to be done at the Coriander screenprinting studio before the artist was completely satisfied with the edition. The project was completed in approximately six months.

The individual prints in each of the friezes are numbered to show Frost's preferred order; the strips can be framed individually and put alongside each other, or framed in one long frame. There is a preferred sequence, though the artist is not troubled if owners wish to vary this sequence. *Madron Woodcuts* is presented in a box with a design by the artist; the other three sets are sold as loose sets.

The project grew out of a proposal Frost submitted for the new Ministry of Transport building in London. At the invitation of the architect, Frost conceived a number of friezes for the bare walkways around each floor. Working on small collages on card just 7 × 3 inches in size, he made sets of these strips which would be joined together to create long friezes. Frost envisaged that the full-scale works would be approximately 24 foot in length, but the commission was not forthcoming.

Since the late 1940s Frost has made prints in etching, drypoint, lithography, screenprint, monoprint and linocut. Paragon Press published the artist's first major suite of linocuts, *Trewellard Suns*, in 1989. Frost has also made a small number of woodcuts, but these were mainly small, uneditioned prints such as Christmas cards. For the present project, he decided to make woodcut versions of the architectural friezes. Initially the proposal was to make just one of the friezes, *Madron Woodcuts*, but as proofing commenced, three of the other proposals were also made as woodcut sets.

The woodcuts were printed at Stoneman Graphics in Penzance, not far from Frost's studio in Newlyn. Hugh Stoneman made enlarged versions of the maquettes and cut the wood blocks, which are in coarse plywood. Other wood types were tried, but the plywood had the density of grain which Frost sought. A great deal of proofing was done to obtain the exact colours Frost wanted, and in enlarging the maquettes this involved slight adjustments in colour. As Frost remarks of the procedure of printmaking: 'My problem is to get the exact colour. The printer's idea of yellow is different to mine. You've got to get the weight of each colour; they should all weigh the same on the scale.' To achieve this density and purity of colour, the blocks were printed twice, in slightly different colours, so that, for example, a scarlet red printed on top of a cherry red might achieve the colour quality and density which could not be obtained through a single colour printing.

The crescent moon and half-boat shapes have been a feature of Frost's work since the early 1950s. The shapes in *Madron Woodcuts: Boats* (Madron is a village near Frost's home in Newlyn) have their origin in a series of paintings of 1951–52 inspired by the sight of boats bobbing up and down in their moorings in St Ives harbour. Similarly, the crescent shapes in *Madron Woodcuts: Half Moons* can be dated back to the 1950s and more particularly the 1960s. Although these forms reference boats, the sun, the moon and the female form, they are now part of Frost's artistic vocabulary and have an independent existence within his work. Frost remarks: 'The boats – people call them boats – but they are really just clean, honest shapes.'

The prints derive from specific sketchbook drawings dating from about 1993 onwards, though some have their origin in projects dating from the 1980s. The drawings were made as proposals for architectural projects, and were not initially conceived as prints. The prints follow the sketches quite closely. The sketchbooks also contained McLean's typewritten texts, stuck in next to the sketch. Though they were not conceived as paired images, McLean chose to join the texts and drawings together in the screenprints, either overlaying the texts, or printing them on separate, adjoining sheets.

The eight proposals presented in the series of screenprints are half-serious projects, though they are full of the sense of the absurd, which typifies McLean's oeuvre. They were not necessarily made to be built. As McLean remarks: 'For me the idea is as interesting as actually doing it or building it.

McLean's interest in architecture and theatre dates back to his performance work of the late 1960s. A photographic work of 1969, *People Who Make Art In Glass Houses*, has the artist posing with mock solemnity in a broken greenhouse, holding bits of wood to form a 1960s-style sculpture. In the early 1970s his 'Pose Band', *Nice Style*, acted out performances in specially created architectural settings. Lampooning the architect as corner-stone of society, a performance of 1975, *Masterwork*, concerned an architect whose masterpiece is a design for a fish knife. Working in a broad range of art forms, including performance, painting, music, drawing, dance, stage sets, printmaking, texts, photo-pieces, film and architecture, one of McLean's central themes has been to conceive life as a staged performance. Another constant in his work is his interest in collaboration. These themes continue in the present set of screenprints, which play on architecture, theatre and public interaction with art. The conjunction of image and text found in the screenprints dates back to McLean's photo-works of the late 1960s.

Over the years, McLean has made many proposals for architectural projects. From 1984–86 he and the architect Will Alsop worked on a 'Palace of Art' project, to be created in a disused grain silo in Mortlake, London. This was not carried out. An exhibition at the Anthony d'Offay Gallery in 1987, *The Floor, The Fence, The Fireplace*, featured drawings for architectural projects and furniture, and later that year McLean carried out his first actual project, a restaurant and bar for the Arnolfini Gallery in Bristol. As Mel Gooding notes 'It was a particularly appro-priate work with which to begin: to create a space for seriously playful posing in a context of art: a place for eating, drinking, conversation and conviviality.' (Mel Gooding, *Bruce McLean*, 1990, p.158.)

Architects tend to wait to be asked to design something, but I wanted to be proactive and actually suggest something. Anything I've done in architecture is something I've proposed.'

Storehouse / Storehouse of Art was a proposal for the new Tate Gallery. Artworks would be stored on a multi-level conveyer belt, so that instead of the

Great Arch of Art was a proposal for Trafalgar Square in London. It centres on the building of a giant arch — a collaborative design by artists, architects, scientists, engineers, philosophers, writers, composers and builders. The arch would face the existing National Gallery, thus completing and defining the Square.

The idea for *Façade Park* dates back to 1984 and McLean's proposal (with Will Alsop) for a kind of art park created by artists in a disused grain silo in Mortlake, London. The yellow form could be by Claus Oldenburg, the potato form in the centre by Giuseppe Penone, the circular walkway by Richard Long. 'It would all be on a façade, maybe done photographi-cally rather than with actual buildings.'

Kilometre Theatre is an imaginary theatre design for a kilometre-long stage, enabling the entire audience to sit in the front row. Everyone gets the best seat. McLean has designed actual stage sets (and performed on them), including a production for the Ballet Rambert at Sadler's Wells Theatre, London.

A Pavilion for Parliament — Dish of Decisions is a proposal for a 'Parallel Parliament', alongside the Houses of Parliament, made in the form of a giant glass dish and incorporating a TV station. The text forms a red square over the green of Parliament Square.

An Ideal Home presents a house in Barnes, south-west London, the area in which McLean lives. Once a workers' suburb, it is now a chic residential address. The text mocks the fulsome sales pitch found in interior-design magazines: the overlaid floor plan includes a 'Room for Flower Arranging' and a 'Llama skin lined conversation pit'. This parody of the 'ideal' home first appeared in a performance by McLean's *Nice Style* group *High Up on a Baroque Palazzo* 1974, which lampooned an article published in *Homes and Garden* magazine.

Designer Traffic Jam — Celebration of an Intersection converts a traffic jam into an event one would make a special trip to attend. As McLean comments: 'If you are going to sit in a traffic jam, you might as well make something of it — watch a film, see art from your car, eat a burger. The traffic jam would be the event. You would go to sit in the traffic jam.'

visitor walking around the gallery, the gallery would travel around the visitor. The artist remarks: 'It would be like a theatre. You would have a slow Barnett Newman, a fast Andy Warhol, a still Mondrian.' The proposal was published in *Art and Design* but was not taken up.

Xerox City lampoons architectural practice: as the overprinted text puts it: 'The original plan for the city was based on photographs of the architect's genitals, faxed to a colleague for design modification and structurally engineered through structural technology.' The concept parallels the idea of building proposals going through different stages in design modification, continually being altered and eroded until they end up being entirely different — in the same way that an image blurs and degrades as it is photocopied and re-photocopied.

The drawings were made on acetate sheets. Smooth Satin paper was used for the prints featuring printed texts and photographic images, and Velin Arches paper for the prints which feature predominantly drawn images. The large blocks of text, taken from computer disc, were printed negatively: for example, the text in *Façade Park* is printed in negative black over a green rectangle. The series was proofed late in 1998, and printing began in December, but the edition was completed in January 1999. The series was first shown at the Grosvenor Gallery, London, in 1999. Shortly after completing the set, McLean and Alsop were commissioned to make an architectural project for a primary school in Irvine, North Ayrshire.

Following the death of his younger sister, for ten years, from 1987 to 1997, McKeever painted exclusively in black and white. There was one exception, the smaller of the three *Marianne North* paintings of 1995, which contained red mixed with black (see p.311). Then in 1997–98 he made a group of very large woodcut monoprints, entitled *Twelve x Eight* (there are twelve variations of eight images) in which he reintroduced colour into his work. McKeever found the experience intensely liberating, and subsequently painted a group of large paintings entitled *Assumptio*: these feature blood reds and deep blues, semi-obscured by white and black veils. Some of the paintings feature arched forms and inverted arched forms. McKeever describes this arched form as: 'perhaps alluding to some kind of human body, some kind of spiritual relation of the body to its immediate environment. I'm not describing it as a human form but there's some sort of sense of the presence of the form in the ambient space around it.' The title *Assumptio* alluded to a form which is pushing down or up, gravitating or lifting; McKeever acknowledges that the form and title probably refer at some level to his Catholic background.

After completing fifteen *Assumptio* paintings in 1998, McKeever began work on the present series of nine etchings. For some years, McKeever has alternated between printmaking and painting, finding that each practice nourishes and informs the other. Moreover he has found that the ambiguities which seem proper to the paintings then resolve themselves through the processes of printmaking: 'It's as if the painting is shrunk down, pushed through the printing press, and comes out as a declared, emphatic image.' Compared to the *Assumptio* paintings, the arched forms in the *Between Space and Time* etchings appear as much crisper forms, and this is partly due to the processes involved in making a graphic print, and partly to the smaller scale of working, where the artist is working with the fingers and hand, rather than with the body. Each series of prints tends to inform the next series of paintings, which in turn inform the prints in a cyclical manner.

Following a practice which he has established over a number of years, McKeever worked on the prepared copper and steel plates at his studio in Dorset, and periodically sent a small group of them to the printer Hugh Stoneman in Cornwall, complete with instructions about the kind of etching required (most are deep-bite etching). Stoneman would then send McKeever black and white proofs of the prints, and from these the artist could reflect upon the qualities of the drawing and the colours he might use. Once about ten proofs had been made in this way, McKeever would travel to Cornwall and spend several

days working intensively with Stoneman. The *Between Space and Time* suite of etchings evolved over a period of several months from October 1998 to April 1999 and involved three trips to Stoneman's printing studio. More than twenty prints were produced in this way, and this group was distilled to nine for the portfolio. Some of the etchings were made on one plate, some on two; some feature aquatint, others have gravure. The fourth and ninth plates were made on coarse steel plates, as opposed to the usual copper plates, which have a much finer surface. The steel plates were random etched, meaning that the raw steel surface was dunked directly into an acid bath, etching all the scratches, handling and grease marks into the plate.

The title *Between Space and Time* is a variant of a title found in William Blake's oeuvre, *Sea of Space and Time*, but deliberately avoids a landscape reference. McKeever remarks: 'So much of what painting is about is space and time, but it is a long, often slow process. What I like so much about printmaking is that it closes down so quickly and in a very short period of time you compress space. This compression is beautifully exemplified by the press itself. Just pressure and weight and in that instance when space and time are put under pressure you get an image. In the end this compression is the essence of what printmaking is about. Space and time are one in this action.' The portfolio was co-published by Paragon Press and the Alan Cristea Gallery.

This series was inspired by Goya's celebrated series of etchings, *The Disasters of War*. Made between 1810 and 1820 (but first published posthumously in 1863), Goya's prints refer to the Spanish resistance to the French during the Napoleonic wars. Graphically depicting the brutality of war, the 83 etchings (there were originally 85, but two plates were subsequently lost) show scenes of horrific torture, execution, famine and misery.

Dinos and Jake Chapman, who began working together in 1992, have admired Goya's work since they were students. Dinos Chapman remarks: 'We had been using Goya as a lynchpin in our work for a number of years. We encountered his work at art school. He's a seminal figure, a humanistic icon. He marks the point at which art was no longer the preserve of the rich or the church and subject matter had to change accordingly. I think we were aware of a good number of his works. We didn't know the originals but encountered him in books.' Following their collaborative debut, a text-work entitled *We are Artists*, the brothers' second project, made in 1993, was based on Goya's series, *Great Deeds Against the Dead*, which depicts three butchered figures tied to a tree (*Great Deeds Against the Dead²*, 1994.) The following year they made the same scene as a life-size group of three shop mannequins, and they subsequently made another mannequin version, *Year Zero*, which depicts three smiling children instead of the three tortured men. They also planned a series of sculptures, *The 82 Disasters of Yoga*, the punning anagram on Goya reflecting the improbable positions of the figures' limbs.

When Charles Booth-Clibborn of the Paragon Press invited the brothers to make a series of prints, they decided to base their work on Goya's suite of etchings. They chose to make 83 etchings, thus repeating the scale of Goya's print cycle, and also used copper plates identical in size and format to those Goya had employed nearly 200 years earlier. Although the brothers had practically no experience of etching, they determined upon the technique since that was the technique Goya had used. They also liked the fact that etching was an anachronistic medium for young, 'modern' artists to be using at the end of the twentieth century.

The brothers completed the set of prints in 28 days, working at the Hope (Sufferance) studios in London. The images were drawn directly on to the plates, without any preliminary drawings. The main techniques they employed were softground, hardground and aquatint. Dinos Chapman recalls: 'There was a certain amount of discussion, but not much of the work was pre-planned. We just went in, sat down and drew. We launched straight into it. The whole thing was very fluid. We never had to think of what to do next: these are the kinds of things we draw anyway. We did about half each and some were done by both of us.' The etchings were proofed individually as they made them, changed and re-etched, kept or rejected (a total of about ten prints was rejected). Some etchings were made very quickly; others were worked on over a period of several days.

Some of the prints are direct transcriptions of Goya's prints, and in these cases they had reproductions of the works in front of them as they worked. Plate 41 in the Chapmans' series is a direct transcription of *Las Resultas*, plate 72 in Goya's series. This image recurs in their plate 42, which shows the same scene as if it were stage scenery viewed from behind. Plate 1 of their set once more refers to Goya's *Great Deeds Against the Dead*, though here a swastika is superimposed over the image. Plate 8 shows a group of 'badly-drawn' people looking at the Chapmans' sculpture *Great Deeds Against the Dead*. Plates 27 to 30 refer to that same image, spread across four separate plates and in the process of being drawn by one of the brothers. The Chapmans' plate 9 is taken from Goya's plate 36, *Tampoco*. Plate 56 is a caricature version of Goya's plate 14, *Duro es El Paso!* And their plate 5 is a variant of the first plate in Goya's series, *Tristes presentimentos de lo que ha de acontecer*. These are the main direct references to Goya's work. Plate 70 was inspired by a print by Odilon Redon and plate 14 responds to an image in Victor Hugo's *L'homme qui rit*. There are unspecific references to Jacques Callot's series *Les Grandes misères de la guerre* and to Otto Dix's *Der Krieg* series.

Whilst some of the imagery in the Chapmans' print series responds to Goya and to the art of the past, the brothers allowed themselves to wander in different directions, inventing new imagery as they worked on the copper plates. The imagery and styles mix horror with comedy, taboo subject matter with the infantile. There are a number of references to the Nazis and to the Holocaust, and also to horror films and serial killers (modern versions of Goya's subject matter), and schoolboy comics. The colliding mixture of references in turn undermines and reinforces the pathos of Goya's original. Georges Bataille's writings, which foam with torture, eroticism, perversion and the scatological, have also had an important influence on the Chapmans' work. Some of their etchings were drawn in a deliberately childish manner: in 1998, a few months before embarking on this project, they took GCSE O-Level art examinations, and produced drawings of killings, rape and torture as a fifteen-year-old might have drawn them. There are also many references to their own sculptures. For about a year before embarking on this print project, they had been working on a vast and spectacular *mise-en-scène* entitled *Hell*. This work features some 10,000 small metal figures, all hand-cast and hand-painted and set in a nightmarish battle zone, somewhere between a Nazi death-camp and a big-budget horror film. Much of the imagery in that work is recycled in the print series (the figures in the print series are three-dimensional work and in the print series are approximately the same size), and the prints in turn inspired some of the imagery in *Hell*. The prints were made during a 28-day break from their work on *Hell*, which itself was completed more than a year later.

During work on the series, the Chapmans had some of the etchings printed on different colour papers, and this led to their making several variant sets of the series. Fifteen sets were printed in black ink on white paper and ten sets were printed in white ink on ultra-thin black paper applied by *chine collé* to white sheets. They also made four sets printed over cartoons cut from a cheap children's colouring book called *the Big Fun Colouring Book*. They were also printed by the *chine collé* method, the cartoons being cut to the size of the etched plates and stuck to the paper sheets. All four 'cartoon sets' are identical, printed over the same cartoons cut from multiple copies of the children's book (see Appendix p.335). Dinos explains: 'We were trying to find ways of hiding the image, or making it less readable and liked these crudely drawn images. Some of the fine imagery is totally hidden by the cartoons, which we liked. Our images were in some way related to those cartoon images and the combination worked surprisingly well.'

There are three hand-coloured sets of the black ink on white paper series. Rather than simply being coloured, the watercolour additions are extensive, often radically altering the nature of the etched image. Some of the colouring of the individual prints was co-authored; other prints were coloured independently. The final ordering of the 83 etchings, as illustrated here, is not critical and was determined by the publisher, not by the artists. When first exhibited, at the White Cube Gallery in London in March 1999, the coloured set was shown in a random grid pattern. When shown at the Tate, Liverpool, some of the prints were hung in the form of a spiral. Elsewhere they have been shown in straight or crooked lines. In Berlin, the 'cartoon set' was exhibited alongside Goya's series: this was the first time Jake and Dinos Chapman had seen the originals which had inspired their own work.

In 1929 Patrick Heron's father established Cresta Silks, employing artists such as Paul Nash to make designs for silk fabrics. Heron's experience with printmaking dates back to 1934 when, aged fourteen, he made his first designs for his father's company (he continued to produce textile designs for them until 1951). His first prints date from 1958, when he was one of several St Ives-based artists to make lithographs with the printer Stanley Jones for the newly-launched Curwen Press. These prints were made on zinc plates and lithographic stones in Cornwall, but were editioned in London. In the 1970s Heron made a large number of screenprints with the printer Chris Prater at Kelpra Studios, and in 1995 he produced several more lithographs with Stanley Jones.

In June 1998 a major exhibition of Heron's work opened at the Tate Gallery in London. In August Charles Booth-Clibborn approached the artist, then aged seventy-eight, and invited him to make a print project for Paragon Press. Two meetings were held at Heron's house, Eagles Nest, in Zennor, Cornwall, between Heron, Booth-Clibborn and the printer Hugh Stoneman, who has a printing studio near Penzance. Heron agreed to take part but wished to make the prints at his own studio, and not at a print workshop. Although encouraged to try etching, he was concerned that the process could not hold his colours with sufficient vibrancy. Accordingly, he initially conceived the project in terms of gouache drawings transposed into prints and made several preparatory gouaches. However, with persuasion from the printer and his own daughters, Heron agreed to make some etchings and work directly on the plates. He had made a small number of etchings before, but none of these had been editioned.

The first of the sugarlift etchings was made in Heron's studio shortly before Christmas 1998. To make a sugarlift etching, a metal plate (in this case steel), is prepared with a resin coating, and the artist paints on this with a mixture of sugar, Indian ink and water. This is coated with varnish, which does not stick to the sugar solution. The plate is immersed in warm water which removes the sugar solution, and then the plate is etched in an acid bath in the usual manner. Using the long, bamboo-stemmed Chinese brushes with which he made his gouaches, Heron painted directly onto prepared steel plates provided by Stoneman. Steel plates were preferred to copper since they can give a more vibrant colour quality.

For a period of more than three months, from December 1998 to March 1999, Stoneman went to Heron's studio most Fridays, and each time took along several of the prepared steel plates. Heron and Stoneman would normally take a long walk, then talk and have lunch, and then Heron would begin work on the plates. For Heron, this preparatory procedure was an integral part of the working process. Although elderly and frail, Stoneman recalls that he painted the plates quickly and surely, always standing up. He would work on two or three plates. He had a very good idea of the over-printing of the plates. That wasn't a problem for him. He would then choose the colour, saying "I see that in cherry red" of one plate, and choosing another colour for another plate and so on. He made colour notes with gouache. 'In this way, Heron and Stoneman worked together on the project for a total of 160 hours.

Using the colour notations provided by the artist, Stoneman would etch and print the plates and return to Heron's studio the following week with the proofed images. Very few colour changes were required. Most of the etchings were printed from three or four separate plates. The sixth and eighth prints feature one of the same plates. The third print is more complex, involving reverse masking. The layering of colour, and combination of graphic lines with more emphatic forms, is very much in the spirit of the artist's late paintings. Heron greatly enjoyed making the etchings and collaborating with the printer, so much so that he planned making a series of very large etchings, 3 x 6 foot in size.

Heron selected eleven of the prints from a group of about fifteen he had produced. He made nine pen-and-ink drawings for the cover of the portfolio binding, and selected one for embossing into the cloth. He finished drawing the colophon page on the morning of 20 March 1999 and died that evening. He had approved all the etching proofs shortly before his death and had also decided upon the sequence in which they should be presented. The etchings were printed posthumously, and stamped with the artist's signature by Heron's daughters, Katharine and Susanna Heron.

The abiding theme in Hirst's work is the interface between life and death. Some of his work feature dead animals preserved in fluids while others feature surgical equipment, skeletons, anatomical models, dead butterflies and cigarette butts. In 1989 Hirst made the first in a series of medicine cabinets containing bottles and drugs packets. These cabinets, with their neatly stacked pharmaceutical products, highlight our obsession with drugs, which seem to have replaced God in modern mythology. Attractively packaged but potentially lethal, drugs have the power to kill and cure, to make us happy or sad. In Hirst's oeuvre, the drug packet stands as a metaphor for the balance between life, death, desire and consumerism.

In 1992 Hirst created a whole Pharmacy in an art gallery. Questioned about the work he remarked: 'What was *Pharmacy* about? Confidence that drugs will cure everything. It's like a readymade. Put one on the wall and it looks confident. I went to the chemist's and thought "I wish I could make art like that", then realised I could have it as it was.'

Apart from their direct connotations with life and death, Hirst has associated drugs with food. Like food, drugs are normally taken orally and at regular intervals, perhaps twice a day, like lunch and dinner. Drugs have become common supplements and even replacements for food. In recent years Hirst has extended his business interests into the world of restaurants. In 1997 Hirst and the chef Marco Pierre White opened a restaurant called Quo Vadis in the Soho area of London. In 1998 Hirst opened another restaurant in Notting Hill. 'Pharmacy', which is densely furnished with medicine cabinets full of drug packets. This was the first in a projected chain of such restaurants. The interiors of both establishments also feature animal parts in preservatives, again alluding to the relation between food and death.

Hirst had made only one print before the *Last Supper* set: this was an untitled screenprint of coloured stones on a pink background, made for the *London* portfolio, which was published by Paragon Press in 1992. Referencing the Bible, there are thirteen screenprints in the *Last Supper* series. The prints are based on specific pharmaceutical packets. The manufacturers' logos and trademarks have been changed for Hirst's own name and variant logos, in apparent allusion to the artist's own status as a global, marketable product. The drug names have been displaced by the names of humble foods that might be found in any corner café in Britain. Hirst photocopied the original drug packets, indicated changes of text and other details, and passed the instructions to Jonathan Barnbrook, who had designed Hirst's book *I Want to Spend the Rest of my Life Everywhere, with Everyone, One to One, Always,*

Forever, Now. Barnbrook created new versions on computer, and the digital information was output onto full-scale film. The screenprints were made from these films by Brad Faine at Coriander Studio, London: each print is made from between four and seven separate stencilled screens, plus varnish. Hirst checked and proofed the images. At his request, the edition comprises 150 sets of the thirteen prints.

Some of Hirst's medicine cabinets employ drug packets in a narrative, hierarchical fashion, with headache pills on the top row, treatments for footsores at the bottom, and medicines for various other ailments in between. The chosen foods in the *Last Supper* series do not, however, have any specific correlation with the particular drug packets which they imitate, and the packets were chosen for their designs rather than for the specific properties of each drug. The author gratefully acknowledges the help of Glynnes Newell, M.R.PHARM.S, Edinburgh, for providing the following details on the individual drugs, the packaging of which inspired the prints.

Beans & Chips is based on a packet of Becotide Rotacaps®. Each pack contains 112 rotacaps, which are designed for insertion into a rotahaler and the contents inhaled. The product is used in the treatment of asthma by reducing inflammation in the lungs. Side effects include candidiasis (thrush) of the throat and mouth. The design of this print is incorporated into a stained-glass window at Hirst's Pharmacy restaurant in Notting Hill, London.

Mushroom is based on a packet of Daraprim®. The original packet contains 30 tablets of Pyrimethamine. The term BP refers to British Pharmacopeia, which is a British quality standard. Hirst's 'PIE' symbol replaces the 'P' symbol on the pack, which stands for pharmacy and symbolises that the pack may only be sold in a pharmacy, by a pharmacist. Pyrimethamine is acknowledged to be effective against malaria.

Steak and Kidney is based on a pack of Ethambutol Hydrochloride (400mg tablets). Hirst has excised the POM symbol (standing for 'Prescription only Medicine', and only legally supplied by a pharmacist on receipt of a doctor's prescription) and replaced it with PIE. The medicine is used in the treatment of tuberculosis. Side effects include a unique type of visual impairment which is usually reversible on cessation of therapy. The box which Hirst based his design upon is no longer in circulation.

Sausages is based on a 15-capsule box of Sporanox® (Itraconazole). The drug is used in the treatment of fungal infections in the vagina and feet and may also be used as a prophylactic in patients with AIDS. Side effects include dyspepsia, nausea, abdominal pain and constipation.

Omelette is based on a pack of Zofran® (Ondansetron) tablets. It is used to reduce nausea and vomiting induced by chemotherapy and radiotherapy and to prevent and treat post-operative nausea and vomiting.

Liver Bacon Onions, is based on a pack marked Atropine Sulphate BP Injection. The injection can be given in the heart or peripheral vein during a heart attack. A Luer-Lock is a syringe featuring a lockable needle. The sobriquet Pot-8-O® is a pun on potato.

Dumpling is based on a box of Zestril® (Lisinopril). The drug is used in the treatment of hypertension, congestive heart failure and acute myocardial infarction. This packaging is no longer in circulation.

Salad is based on a pack of Epivir tablets, which contain 150mg of lamivudine. They are used in combination with other antiretrovirals in the treatment of HIV with progressive immunodeficiency.

Chicken is based on a pack of Oramorph® (Morphine Sulphate) oral solution. An addictive narcotic analgesic, it is used in the management of severe pain, and is often used to alleviate pain in terminally ill patients. Side effects include constipation and urinary retention.

Sandwich is based on the drug Invirase®, which contains saquinavir. It is used in combination with other antiretroviral agents in patients with progressive HIV.

Meatballs is based on a pack of Manerix®, which contains Moclobemide. It is used in the treatment of major depression. Side effects include sleep disturbance, agitation, irritability, headaches, visual disturbances, nausea and vomiting. This packaging is no longer in circulation.

Corned Beef is based on a box of Coraone X 200 which contains Amiodarone Hydrochloride. It is used to treat abnormal symptoms of the heart rhythm when other treatments have failed. Side effects include adverse reactions affecting the heart, liver, thyroid gland, skin and peripheral nervous system.

Cornish Pasty is based on a pack of Rifadin® which contains Rifampicin. It is used as an antibiotic in tuberculosis, leprosy, legionnaires disease and prophylactically in meningococcal meningitis. Side effects include nausea, vomiting and thrombocytopenia; it may also produce a reddish discolouration of the urine, sputum and tears.

DAMIEN HIRST THE LAST SUPPER, 1999

TERRY FROST ORCHARD TAMBOURINES, 1999

Collage has informed much of Frost's work since the early 1950s. From 1951–52 he worked as an assistant to Barbara Hepworth, and at the time he was keen to become a sculptor. He has made a number of constructions and sculptures over the years, and often refers to his paintings as 'constructions'. Some of his paintings consist of painted sections of canvas cut out with scissors and collaged on to larger sheets of card or canvas. His mother's job as a dressmaker may have inspired him to work in this way.

Orchard Tambourines originated in a large collage on which Frost worked for a period of two years. A local picture framer who made card mounts for drawings, gave Frost a batch of the central, unused portions which were normally thrown away: these card pieces were eleven inches square. Frost collected a group of 25 of these squares and laid them out on his studio table in rows of five by five, rather like a chess board. He painted the boards with acrylic, and laid cut-out canvas circles on top of them. The combination of a simple circle on a square may be dated back to Russian Constructivists such as El Lissitzky, whose work Frost greatly admires. Frost continually swapped the elements about, changing the colours and positions before finally gluing them down. Frost sees the structure of the composition in musical terms: 'It's magical. The possibilities are marvellous. Move a different colour and there is discord in one arrangement, harmony in another. It's exactly like notes of music. I was always moving them and changing them around. It's like a symphony. It's good for the heart, such a thrill. It's total freedom.'

The eleven-inch-square collages were enlarged photographically to nearly 15 × 15 inch versions by Hugh Stoneman at Stoneman Graphics near Penzance. Using a jigsaw, these templates were cut into two pieces of quarter-inch plywood to create two identical sets of the three plates. The plywood sheets were printed one on top of the other with the same colour to give a very rich, dense colour. Of the process of colour printing, Frost remarks: 'The colour and pressure you can obtain in printing are different to what you can get with acrylic paint. So all the time I'm working with the prints I'm making adjustments. I'm continually making adjustments.'

The title refers in part to Stoneman's printing studios at Orchard Farm, outside Penzance, and in part to the tambourine-like form of the circles and to the musical feel of the work.

Following his exhibition of large-scale bronzes at the Tate Gallery, London, in 1996, Woodrow began looking for a thematic starting point for new studio-based work. After many weeks he decided to work on the theme of beekeeping. Woodrow recalls: 'I don't know where it came from. The title 'The Beekeeper' just popped up into my head and stuck. It seemed to have potential. It seemed rich. I think it is something that has always fascinated me.' He began making sculptures and drawings on this theme late in 1996, while at the same time working on other projects. He researched the subject in some depth and went on a weekend bee-keeping course in Hampshire. The sculptures in the bee-keeping series, which is still in progress, have been made in a variety of mediums, including bronze, stainless steel, wax, wood, jesmonite and polystyrene. One of the largest of these works, *Shadow of the Beekeeper*, was commissioned by the Nat West Bank in 1998 and was exhibited at their Gallery in London in 1999.

When Woodrow was asked to make a series of prints for the Paragon Press in 1999, he turned naturally to the subject of beekeeping. (Graham Sutherland had made prints on this theme, though Woodrow was unaware of them.) The set of ten prints, made at the Hope (Sufferance) Press, do not follow a narrative, but are instead based upon a shared theme. Much of Woodrow's work uses narrative as a point of departure, but develops the imagery in non-narrative ways. The order in which the works are viewed is not crucial: here they are classified according to the sequence in which they were made.

Woodrow had used the technique of linocut for an earlier project commissioned by Paragon Press, *The Periodic Table*, 1994 (see *Contemporary British Art in Print*, 1995, pp.192–97). Developing from Primo Levi's book of the same title, that project resulted in twenty-four black-and-white linocuts. Woodrow made no further prints until the present *Beekeeper* series. For this new project Woodrow wanted to produce coloured images and he also sought to work in a more spontaneous way. Following suggestions from the printers at Hope (Sufferance) Press, he experimented with a technique which involved painting directly onto the lino with caustic soda. This technique has been used before but is not common. Following a process of trial and error, the printers and Woodrow formulated a mixture of caustic soda and wallpaper paste which the artist painted directly onto the lino. The liquid was left overnight, and was scrubbed off the next day with a soft wire brush. The depth of the cutting depended upon the quantity of acidic mixture applied and on the length of time it was left on the lino. Occasionally some direct cutting was necessary to clarify the lines. This technique produces broad, painterly effects, and is best

employed on a large scale. At the outset Woodrow decided to make ten images. He began working on the project in Autumn 1999 and finished editioning the prints in Spring 2000. He made small thumbnail sketches for each print, but most were developed on the lino itself. He drew with felt-tip pen directly onto the lino and then painted with the caustic soda mix.

Some of the prints refer to specific practices in bee-keeping while others use bee-keeping simply as a starting point. In the first print we see the bee-keeper's hands gently cradling a tiny box carrying a queen bee. The box has corked holes at both ends and gauze over the top. Such boxes are used for transferring a queen from one hive to another. The second print surveys the surface of the honeycomb structure in a manner that recalls some of the First World War prints of Otto Dix. The third print features the bellows element of the smoker, grafted onto a skull. Woodrow recalls that the skull image came from a cheap ashtray. The fourth print develops at a tangent, showing a kind of pupa which has a close relation to the forms found in some of Woodrow's sculptures. The fifth print depicts the beekeeper examining a frame from the hive. The sixth print, which depicts a swarm of bees, is printed slightly out of register, suggesting the buzzing and surface irritation of the bees. The seventh print shows the queen bee emerging from its cell. The eighth shows an old-fashioned type of hive called a skep, which is made out of straw, over which a web of linear forms suggests the movement of a swarm of bees. The ninth print shows the product of the bees' labour, the honey, on a table. The mirror writing, 'Money / Honey', taken from the refrain in a Blues record, refers to the honey as a product of exchange: an exchange between the bees who gain shelter and the humans who provide it; and between the beekeeper and his market. This interest in the metamorphosis of one form into another — pollen into honey — and in commodities, may be related to Woodrow's sculpture of the 1980s, in which the deft cutting of simple manufactured items transformed them into entirely new objects. The bellows instrument in the last print is a 'smoker'. The beekeeper would place smouldering sacking or card in the container and puff the smoke into the hive to subdue the bees prior to examination.

Four of the prints were coloured partly by hand. The queen bee and the box in the first print was hand coloured, as was the wooden hive in the tenth print. The seventh print has four hand-painted colours and the ninth has six. The hand colouring was done by Woodrow in a water-based pigment with a minute amount of acrylic medium: it is broadly applied, making each print in the edition slightly different. The third and sixth prints were printed on black paper while the others are on white. The linos used

for several of the prints were cut into two or more pieces and each section was individually inked up in separate colours, re-assembled in jigsaw fashion and then printed in one pull. For example, the sheet of lino used to make the tenth print was cut into three separate pieces: one for the smoker, another for the box it sits on and another for the surrounding blue space. The majority of the inking of the lino sheets was done by roller; some parts were hand-painted.

The Chapman brothers found the experience of making the *Disasters of War* etchings (illustrated pp. 195–217) extremely rewarding and determined to make further etched projects. While they have always made drawings, etching has become increasingly important to them, partly because the printing process blurs the distinction between the styles of both artists, making the result more homogenous. Dinos Chapman observes: 'Etching is a very neurotic form. It allows for an incredible intensity. Also with etching you are working in reverse so it's always a surprise when it's printed. It's a way of teasing yourself.'

This desire to surprise oneself has an analogy with Surrealism, in that chance and spontaneity underlie much Surrealist art. While the Chapmans' art has been reviled for its shocking subject matter, their work has a very strong grounding in the history of art, from Goya to Surrealism. The Surrealists are credited with inventing the *Cadavre exquis* – the *Exquisite Corpse* – a parlour game in which a sheet of paper is folded horizontally, normally into four equal parts, and each player draws a section of the human body without seeing the sections drawn by the others. When unfolded the drawings often reveal amusing and remarkable confusions of form, scale and style. A group of Surrealists including André Breton and Yves Tanguy are credited with the invention of this game in 1925, though its antecedents lie in much earlier folding concertina cards, in which sections of one figure may be folded to mis-match with those of another. Whatever the case, the Exquisite Corpse perfectly suited the Surrealists' desire for an automatic art in which reason is subverted. (For a history of the Surrealist 'Exquisite Corpse', see Fundación Collecion Thyssen-Bornemisza, Madrid, *Juegos Surrealistas: 100 Cadáveres Exquisitos*, exhibition catalogue 1996.)

The Exquisite Corpse appealed to the Chapmans for the same reason that it appealed to Breton and the Surrealists, in that it hinged upon chance, but it was also the perfect vehicle for a collaborative project. For the *Disasters of War* series, the Chapmans had sometimes worked together on the same etched plates, and the *Exquisite Corpse* series was an extension of this approach. While the printing process blurred the distinction between their two drawing styles, giving the image a satisfying unity, the disrupted segments which are a feature of the Exquisite Corpse, dramatized the notion of difference. For two brothers whose work is considered as a single unit, and whose individual styles are largely unknown, this independent yet co-authored procedure offered a range of interesting possibilities. Their long fascination with mutated, excrescential bodies was also given free rein, but in a natural and

logical way. This is probably the first Exquisite Corpse series made by etching. The brothers began work on the project in 2000, immediately after finishing the vast, 10,000-figure composition, *Hell*, which occupied their attentions for more than two years.

The Chapmans decided to make a suite of twenty Exquisite Corpse etchings, and worked at separate desks at the Hope (Sufferance) printing studios in London. The copper plates were prepared in horizontal sections. Jake and Dinos Chapman each made ten etchings of the head section, and these were then bitten in acid and masked by an assistant working at the studio. The etched image was then covered with masking tape and the plates exchanged. The brothers then proceeded with the torso sections, before these too were bitten and masked; and so on. By working in this manner, instead of completing the prints one at a time, each artist was unaware of the head section he had drawn when he came to make the third section of the trunk area. This approach ensured that the four sections were randomly matched. While artists will normally proof an etching from time to time, in order to test the development of an image, the procedure adopted for this set of etchings meant that the brothers only saw what they had done once the entire set of twenty plates had been completed. Once printed, none of the plates was altered or re-etched, and none of them was rejected. The prints were made in hardground and softground etching and some drypoint. Thumbprints and other random marks associated with softground etching were deliberately left. Rather than being wiped clean, the copper plates were left with a certain amount of ink on them, to give a unifying grey tone. The project was completed in twenty days.

As with the *Disasters of War* series, the brothers made no preliminary sketches or plans. The imagery is largely invented, though there are several references to their own sculptures. Two of the etchings feature cartoons (traced in softground) from *The Big Fun Colouring Book*, which had earlier featured in the *Disasters of War* series. As with that series, the Chapmans also made several hand-coloured versions of the *Exquisite Corpse* series. One set of watercolour versions was made in the same manner as the etchings themselves, in that the brothers coloured them in turn, section by section, without seeing the earlier parts. Other versions were painted entirely by Jake or Dinos Chapman.

In 1996 Adam Lowe commissioned and produced a series of eighteen prints, entitled *Digital Prints*, which were based on the same single image (a collaged, composite image stored on CD-ROM). The prints were produced by various different, specialist workshops, using eighteen different methods of printmaking which can be used to mediate digital images: collotype, dye-transfer, photogravure, screenprint, lithography, Cibachrome etc. Each workshop was given the same digital information but each or the prints they produced had very individual characteristics. The *Digital Prints* project was followed in 1999 by a series entitled *Grey Cultured Cells*. In these prints, a section of four-colour neutral grey was printed by eighteen different processes. These were subsequently enlarged on a microscope to produce data for each particular print. The minuscule pixels, dots and grains were revealed to be multi-coloured and bewilderingly different, depending on the print process used. The prints effectively show the point at which the thing being represented meets the means of its own representation. Both projects dramatised the non-objective qualities of printmaking, showing that the mediation of information is, at a microscopic level, subject to physical properties and chance happenings which are commonly ignored. Digitally generated printing, indeed all information transfer, including everything from scientific data to television, is not a purely mechanical process but is inflected by all sorts of accidental, often invisible determinants.

These two projects were followed by the present set of nine prints, *Emulsion*. Subtitled *Cultivating an Intimacy with the Behaviour of the Physical World*, it develops the same concerns with science and artistry, the mediation of information, and the beauty of random, invisible structures. The prints were derived from a video recording made by Lowe with assistance from Dr Dave Tovee, Reader in Physics at the Department of Physics and Astronomy at University College, London. The video records the traces left by cosmic ray activity in a nuclear emulsion. In the 1920s scientists began mapping cosmic rays (low-level background radiation, ever present in the atmosphere). Sheets of glass coated with gelatine mixed with silver would be placed in lead containers and set outdoors, and some days later they would be processed and analysed. Each sheet would be covered by the traces of thousands of microscopic rays which had collided into the silver particles, producing miniature nuclear reactions. The scientists mapped the paths of these rays as they crossed the emulsion, collided, broke up and set off in different paths. Lowe's video records just one of these original postcard-size sheets. Spending several days bent over an electron microscope at x850

magnification, he mapped the rays as they went through, and across the layer of emulsion. The video was edited into a shorter 20-minute loop, which has itself been exhibited with a filtered noise soundtrack. Lowe also made a three-dimensional sculpture, in which 125 cross-sections of his microscopic journey through the emulsion, are presented as a stack of slim perspex slides, with the rays rendered as black lines shooting off in all directions.

From the video Lowe grabbed a number of still images: nine of these were selected for the print project. They map the progress of the rays as they pass through the gelatine layer. Lowe deliberately avoided the dramatic moments when the ray collides with a silver particle, and in the first print shows this reaction as an off-screen activity, with the rays bouncing off through the gelatine. The gelatine is also full of background 'noise' — specks of dust, scratches, registration marks and cracks. These are the equivalent of the different qualities dramatised in the *Digital Prints* and *Grey Cultured Cells* projects. Just as, at a microscopic level, different printing techniques are seen to determine the information we see, so random background 'noise' parleyed with the nuclear reactions, creating a dialogue with scientific mapping. Lowe remarks: 'It's a beautiful metaphor for a realist endeavour. The world isn't concrete and solid and neat. It's not based upon clear, tidy units. They are realist images which are not dependent on notions of realism. It's a bit like Paul Klee taking a line for a walk. I was following a cosmic ray in the same way that someone might follow animal tracks.' In this way, Lowe's work connects with artists such as Richard Long and Hamish Fulton, though Lowe's project was carried out at a microscopic level.

The nine still images were printed as Epsom 4-colour prints. The orange colour was a consequence of the infra-red filter fitted to the electron microscope. These nine prints were then transferred onto copper plates and printed as photogravure etchings (a process which also depends on gelatine) by Hugh Stoneman and Mike Ward at Stoneman Graphics in Cornwall. Each of the prints was made from at least two, and more commonly three or even four separate plates. The first plate is a continuous yellow rectangle, on which the photogravure images of the rays were overprinted in scarlet red. Lowe also made additional marks on the photogravure plate or on a third copper plate: these may be lines which articulate and strengthen the track of the ray, or marks which emphasise the specks of dust or rays as they descend vertically through the gelatine (these were made by simply banging a nail into the copper plate). The fifth image shows a microscopic, misprinted registration mark, enlarged to an enormous size; the third shows the cracks in the

gelatine layer near the surface of the scientific plate. Some additional burnishing and colour enhancement was done at this stage. The deep red edges of the prints are a by-product of a still image being taken from a video image. Just as the rays record their own tracks, so does the image-making process. Nuclear rays, scratches, bits of dirt, and the very processes which go into the making of the printed images, compete for attention in a tangled web of marks. The images are a fusion of nature, science and artistry. It is information in its most microscopic, elemental state, mediated through an image-making process, yet the activity recorded is shown to be confusing and difficult to decipher. Which marks are of scientific interest, which are dust, and which are part of the image-making process? The prints may thus be seen as a metaphor for searching and finding, but never really knowing what one has found.

The title refers to the very substance in which the activity of the rays is recorded, while the subtitle refers to a quote by the Nobel-prize-winning scientist Patrick Blackett. Blackett remarked that while the experimental physicist must basically be an artist and spend much of his time involved in carpentry, engineering, electrics and so on. 'During the rest he must be a physicist, that is, he must cultivate an intimacy with the behaviour of the physical world.' It is the intricate, random, confusing behaviour of the physical world that is the subject of Lowe's prints.

GARY HUME SPRING ANGELS, 2000

Hume's *Portraits* series of screenprints (illustrated pp.147–156; commentary p.320) had been based directly on pre-existing paintings. The *Spring Angels* set functioned in the opposite way, inspiring a group of paintings, and introducing a new colour range into Hume's work.

From 1998–99 Hume made several paintings entitled *Angel*: some of these were complex, layered images made up of tangled webs of fine outline drawings, while others were bolder, distorted portrait heads. The series had its origins in a trip the artist made to Brazil, where he was representing Britain in the São Paulo Biennial in 1996. He visited Oscar Niemeyer's Catholic Cathedral in Brasilia and took a number of photographs of the enormous concrete angels inside it. He subsequently made a group of small drawings, in magic-marker pens on transparent acetate sheets, based on these photographs. It is often the case in Hume's working practice that such imagery may lie unused for some time, and it was only in 1999 that he began using this material as the basis for paintings — and subsequently screenprints. The large scale of the screenprints — somewhat larger than the *Portraits* prints — was inspired by the grand scale of the concrete *Angels*. However, through the series of drawings, paintings and prints, the original source material has been heavily reworked and abstracted and their origins are now scarcely recognizable.

In 1999 Hume made two *Angel* paintings, featuring a distorted face with heavy outlines: these were *Angel Brown World*, executed in a very dark brown (it is the forerunner of the sixth print in the *Spring Angels* series, *Angel A*) and *Angel Fuchsia World*, in vibrant pink and fawn. It was at this moment that Charles Booth-Clibborn of the Paragon Press approached the artist with view to producing a new portfolio of prints, and Hume decided to base the prints on this series, which was then in progress. Some of the prints were thus based on pre-existing paintings, some were based on paintings in progress, and others (for example the fourth and fifth prints in the portfolio, *Angel F* and *Angel G*) were originated directly from the small drawings on acetate. However, Hume only resolved the colour of the prints when he made a trip to Kent in May 2000, to buy a dinghy for his son's birthday. Driving along a motorway on a beautiful spring day, he was struck by the colours of the leaves, trees, flowers and grasses, and stopped every now and again to gather material. This plant material formed the palette of the *Spring Angels* screenprints. Taking the leaves and other materials into Coriander printmaking studios in London, Hume selected matching colours. He recalls: 'Most of the images already existed as drawings which had been knocking about in the studio for some time. But they weren't alive until I found this palette they could exist in. It's influenced my whole palette.' There is selective varnishing on certain parts of each image.

Subsequently, Hume made paintings after those screenprints which were originated directly from drawings, but reversed the images, and altered some elements of the composition. Six of the images now exist in variant painted versions. The individual prints are titled according to the musical scale, as in *Angel C, D, E, F, G, A, B* and *C#*. As with the *Portraits* series, the sequence of the prints was based on visual choices and not on chronological order.

In 1991 Quinn made a work entitled *Self*. A cast replica of the artist's head, it was made from Quinn's own blood, and was preserved in a frozen state within a glass case. In the following years Quinn made a number of works kept in similarly frozen forms: one such work comprised a bunch of flowers set in a block of ice. The problems of preserving the ice, and making a flawless block, led Quinn to experiment with other materials. In 1996 he made a second version of *Self* (a new version will be made every five years) and through a process of trial and error found that silicone — the same type of viscous material used in breast implants — could preserve the head if kept at -20°C. Being inert, silicone is an ideal preservative, and it remains liquid and transparent at very low temperatures.

Having made a number of visceral works on the theme of death, Quinn wished to explore the theme of death and decay in archetypally attractive subject matter: flowers. In 1998 he extended the experiments employed in the second *Self* head, but instead used cut flowers as his raw material. Three works of 1998, all entitled *Eternal Spring*, featured vases of flowers submerged in silicone, within glass-walled refrigerated units. The flowers were simultaneously natural and unnatural, dead yet perfectly preserved. The silicone remained invisible, but its refractive index intensified the colour of the flowers making them seem hyper-real. Since the water in the cells of the flowers was frozen, the petals became solid, assuming the physical properties of glass.

At the beginning of May 2000 Quinn made an entire frozen garden for the Prada Foundation in Milan. The garden was housed within a huge transparent tank measuring 6.85m long, 2.55m wide and 2.15m tall. The tank contained 25 tons of silicone liquid, preserved at -20°C. It was constructed within a cold-room clad on all sides by mirrors. A heated passageway allowed visitors to walk all the way around the tank. Prior to making the work, Quinn spent several months studying specialist horticultural books, selecting a range of about eighty different species of flowers and plants he would 'grow' in his garden. The whole range of approximately 1000 individual plants, selected from all corners of the world, was commissioned to arrive at the Prada Foundation on the same day.

Quinn and his team of helpers began work on the garden at 7am and, without a break, completed the project in the early hours of the following day. The flowers were inserted into 'Oasis' sponges and, where necessary, supported on internal wires; the sponges were then covered with turf. Once finished, the garden, laid out on sealed trays, was carefully lowered into the huge tank of refrigerated silicone.

Full of perfectly preserved flowers cut in their prime, *Garden* could have remained in bloom forever, provided the temperature of the silicone was kept constant.

The choice of plants and their composition within the garden was deliberately unseasonal, cross-continental and unlikely. Constructed in three main areas, the tallest elements were a plumb tree in full bloom, a banana tree and a cactus. Surrounding them, spring flowers from Britain grew next to tropical fruit and desert orchids; fully-formed roses and tulips sprung directly out of the grass, pairing off with exotic vegetables. Mirroring the widespread availability of unseasonal products on offer at any supermarket, the garden constituted a bizarre but apparently real smorgasbord of simultaneously flowering plants. The effect was comparable to a scene from a David Lynch film: it looked real and appealing but at the same time the intense colours and unnatural groupings were strikingly improbable. Quinn remarks: 'The composition is to do with desire and incompatibility. The flowers would never grow alongside each other; they belong to different seasons and different habitats. It has this Last Judgement feel about it, everything coming out of the ground at the same time. It's a record of a real place. An unreal real place. A hyper-real place. The plants have traded biological life for a symbolic immortality.' The mirrors served to multiply the image of the garden, making it enfold the viewer and place him or her in the centre of a suspiciously perfect Garden of Eden. *Garden* therefore investigates the relationship between the real and the artificial, the living and the dead, the beautiful and the sinister. It is a frozen, ideal place, which the viewer cannot actually enter. Allusions to gene technology and the warping of nature for the sake of convenience and appearance may also be made.

Before constructing the garden, Quinn decided to make a series of prints based upon the project, and discussed this with Charles Booth-Clibborn of the Paragon Press. The portfolio would comprise a series of prints based upon photographs of the garden. Shortly after the garden was completed, Quinn shot a single roll of 35mm slide film of the installation, intending to return at a later date to make a more complete record. However, he was pleased with the quality of the photographs and decided to use these for the prints. Eight photographs were selected. The day-glo colours accurately record the actual colours of the flowers as seen through the silicone fluid. Seeking to preserve these unnaturally luscious hues, Quinn had the works printed in permanent pigments rather than by a conventional photo-screenprint process. Adam Lowe and Adrian Lack initially scanned the 35mm slides at The Senicio Press in

Charlbury, near Oxford. Extensive proofing and colour manipulation was done at this stage. Lowe supervised printing of the works at the Calcografía Nacional in Madrid, using a digital ink-jet printer which works with pure pigment. The permanent pigments effectively freeze the flowers for a second time, hence the title *Garden²*. Furthermore, in allusion to the thick acrylic walls of the garden tanks, and to the notion of sealing the flowers in silicone, the prints are sealed in several layers of gloss varnish.

Of the *Garden* and *Garden²* projects, Quinn remarks: 'What I like about it is that the flowers seem completely normal but in fact they are utterly transformed. They are transformed invisibly, in the sense that they seem alive but in fact they're dead.' In this sense the project is a direct elaboration of the theme embarked upon in *Self*. The project also relates to Quinn's earlier print portfolio, *Emotional Detoxification*, in that both deal with a moment frozen in time.

Using the same photographs of the garden project, Quinn has also made a series of very large prints on canvas. At the time of writing the number of canvas prints had not been determined; four or five of them repeat images found in the print portfolio while others are different. The *Garden* was exhibited at the Prada Foundation in Milan during May and June 2000 and was then disassembled. A new version will be made for exhibition in New York in 2001.

MARC QUINN GARDEN², 2000

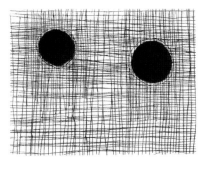

DESCRIPTION: 5 etchings

EDITION: 10 copies of each, plus 1 BAT.

INSCRIPTIONS: Each print signed and numbered by the artist.

PAPER: 450gsm Zerkall Etching.

TECHNIQUE: Etching.
I Two plates: one aquatint, one drypoint.
II Two plates: one aquatint, one drypoint.
III Two plates: one aquatint, one drypoint.
IV One plate: softground.
V One plate: softground.

PRINTER: Proofed and editioned at Hope (Sufferance) Press, London.

SIZE: Sheet 84 × 64 cm (33 × 25¹/₄ in), plate 56.8 × 45 cm (22³/₈ × 17³/₄ in).

These prints followed on from Mckeever's *After Marianne North I* and *II* etchings, made for the portfolio *A Series of Twelve Prints by Six Artists* (illustrated pp.82–83; commentary p.311).

IAN McKEEVER
FURTHERANCE I TO V, 1996

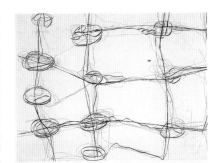 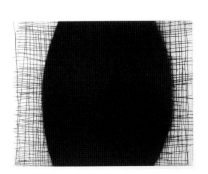 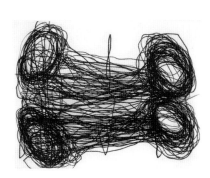

GRENVILLE DAVEY
EYE, 1996

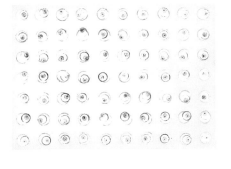

DESCRIPTION: 1 screenprint.

EDITION: 36, plus 5 artist's proofs.

INSCRIPTIONS: Signed and numbered by the artist.

PAPER: 300gsm Somerset Satin.

TECHNIQUE: Sugarlift aquatint (3 plates).

PRINTER: Proofed and editioned at Hope (Sufferance) Press, London.

SIZE: Sheet 75.7 × 57.2 cm (29³/₄ × 22¹/₂ in), plate 58.6 × 41.7 cm (23¹/₈ × 16³/₈ in).

This is a second state of the print *Eye* which is part of the group portfolio *A Series of Twelve Prints by Six Artists* (illustrated pp.84–85; commentary p.311).

PETER DOIG
JETTY AND SKI JACKET (SECOND STATE), 1996

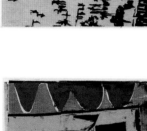

DESCRIPTION: 2 etchings.

EDITION: 10 of each, plus 1 BAT of each.

INSCRIPTIONS: Each print signed and numbered by the artist.

PAPER: 350gsm Zerkall Etching.

TECHNIQUE: Etching.
Jetty: 1 plate, hardground, aqua tint and deep open-bite *Ski Jacket*: 1 plate, sugarlift.

PRINTER: Proofed and editioned at Hope (Sufferance) Press, London.

SIZE: *Jetty*
sheet 54 × 43 cm (21¼ × 17 in),
plate 20.5 × 15 cm (8⅛ × 5⅞ in).
Ski Jacket
sheet 54 × 43 cm (21¼ × 17 in),
plate 21.8 × 14.6 cm
(8⅝ × 5¾ in).

These two etchings were made at the same time as the series *Ten Etchings*, 1996 (illustrated pp. 47–59; commentary p. 307). This second state of *Ski Jacket* was printed from just the sugarlift plate of the first version (which was printed a sugarlift plate and an off-set etching plates). Like the other prints in the *Ten Etchings* set, *Jetty* also relates to one of Doig's paintings.

CHRISTOPHER LE BRUN
YELLOW TOWER, 1998

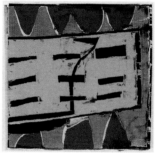

DESCRIPTION: 1 woodcut print.

EDITION: 25 plus 3 artist's proofs and 2 *hors de commerce* copies.

INSCRIPTIONS: Signed and numbered by the artist.

PAPER: Kozu-Shi 23 gsm.

TECHNIQUE: Colour woodcut.

PRINTER: Hugh Stoneman.

SIZE: Sheet 65 × 89 cm
(25½ × 35 in),
image 39 × 39 cm
(15³⁄₈ × 15³⁄₈ in).

YELLOW TOWER WITH BORDER, 1998

DESCRIPTION: 1 woodcut print.

EDITION: 20 plus 3 artist's proofs and 2 *hors de commerce* copies.

INSCRIPTIONS: Signed and numbered by the artist.

PAPER: Kozu-Shi 23 gsm.

TECHNIQUE: Colour woodcut.

PRINTER: Hugh Stoneman.

SIZE: Sheet 72.5 × 65.8 cm
(28½ × 25⅞ in),
image 60.5 × 60.5 cm
(23¾ × 23¾ in).

These prints relates to Le Brun's *Motif Light* set of woodcuts (illustrated pp. 131–135; commentary p. 318). As described in the entry on that set of prints, Le Brun cut a number of plywood blocks at his studio in London, and had them printed by Hugh Stoneman at Stoneman Graphics in Cornwall. However the artist found that the printing press gave a very strong, robust image, which was at odds with his usual imagery, which is normally veiled and obscured. *Yellow Tower*, which was cut in Cornwall, is the only print he retained from the period of experimentation. Made from four separate blocks (one for each colour), it was co-published with Marlborough Graphics Ltd. Unlike *Motif Light*, *Yellow Tower* was printed on a very light Japanese paper. *Yellow Tower with Border* is a second state of *Yellow Tower*, but with a black border.

The Chapman brothers printed three different sets of their 83 *Disasters of War* etchings. The first set was printed in black ink on white paper in an edition of fifteen (illustrated pp.195–217; commentary p.324). They then made a set in white ink on very thin black *chine collé* paper (this was produced in an edition of ten) and also an edition of just four sets printed on cartoons cut from a children's colouring book called *The Big Fun Colouring Book*. These white ink and cartoon sets feature all 83 of the etchings, but due to limitations of space, only one print from the variant sets is reproduced here.

JAKE AND DINOS CHAPMAN
THE DISASTERS OF WAR, 1999

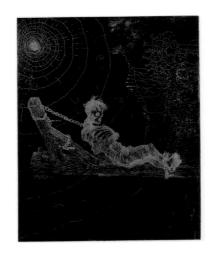

GARY HUME
SEAHORSE, 1998

DESCRIPTION: I screenprint.

EDITION: Edition of 35, plus 10 artist's proofs and one copy for each of Hume's London and New York dealers.

INSCRIPTIONS: Signed, numbered and titled by the artist.

PAPER: 410gsm Somerset Satin.

TECHNIQUE: Screenprint.

PRINTER: Proofed and editioned at Coriander Studio, London.

SIZE: Sheet 108.5 × 83.3cm (42³/₄ × 32³/₄in), image 90.8 × 67.9cm (35³/₄ × 26³/₄in).

Seahorse was originally conceived as part of the portfolio of prints which became *Portraits* (illustrated pp.147–156; commentary p.320). Initially, that portfolio began as a group of images based on animals, with view to making a *Bestiary* portfolio. *Seahorse* was the first screenprint made for that portfolio, but it was not used owing to the changed nature of the set: instead it was issued as a single print. It follows a painting of the same title, which is itself based upon a photograph found in a Pirelli calendar. Hume selected an incidental part of an image of a woman cavorting in the waves, tracing the splash patterns, and found that with minor changes the image resembled a seahorse.

DARREN ALMOND

BIOGRAPHY: Born Wigan 1971. Studied at Winchester School of Art 1990–94. Lives in London.

BIBLIOGRAPHY: Royal Academy of Arts, London, *Sensation – Young British Artists From The Saatchi Collection* (1997); Sarah Kent (intro.), *Young British Art: The Saatchi Decade* (London 1999); Royal Academy of Arts, London, *Apocalypse* (2000); Zurich Kunsthalle, *Darren Almond* (2001).

JAKE & DINOS CHAPMAN

BIOGRAPHIES: Dinos born Cheltenham 1962; studied at Ravensbourne Art School, then worked as assistant to Gilbert and George. Jake born London 1966; studied at North London Polytechnic. Both studied at Royal College of Art, London, from 1988. Began working together in 1992. Both live in London.

BIBLIOGRAPHY: ICA, London, *Chapmanworld* (1996); Gagosian Gallery, New York, *Unholy Libel: Six Feet Under* (1996); Royal Academy of Arts, London, *Sensation – Young British Artists From The Saatchi Collection* (1997); Sarah Kent (intro.), *Young British Art: The Saatchi Decade* (London 1999); Saatchi Gallery, London, *Ant Noises at the Saatchi Gallery* (2000); Royal Academy of Arts, London, *Apocalypse* (2000).

MAT COLLISHAW

BIOGRAPHY: Born Nottingham 1966. Studied at Goldsmiths College of Art, London, 1986–89. Group exhibitions include *Freeze*, London, 1988; *Modern Medicine*, London, 1990. Solo exhibitions include Karsten Schubert Gallery, London, 1990; Ridinghouse editions / Karsten Schubert, London, 1997; Galleria d'Arte Moderna, Bologna, 1999. Lives in London.

BIBLIOGRAPHY: Walker Art Centre, Minneapolis, *Brilliant! New Art From London* (1995); Royal Academy of Arts, London, *Sensation – Young British Artists From The Saatchi Collection* (1997).

MICHAEL CRAIG-MARTIN

BIOGRAPHY: Born Dublin 1941. Settled in USA 1945. Moved to England 1966, teaching at Bath Academy of Art. Artist in Residence, King's College, Cambridge, 1970–72. Taught at Goldsmiths College of Art, London, 1972–2000. Regular solo exhibitions at Rowan Gallery, London, 1969–80, and at Waddington Galleries, London, from 1982 to present. Retrospective exhibition at Whitechapel Art Gallery, London, 1989. Lives in London.

BIBLIOGRAPHY: Whitechapel Art Gallery, London, *Michael Craig-Martin* (1989); Alan Cristea Gallery, London; *Michael Craig-Martin: Prints* (1997); Kunstverein, Hannover, *Michael Craig-Martin: Always Now* (1998); Württembergischer Kunstverein, Stuttgart, *Michael Craig-Martin: And Sometimes a Cigar is Just a Cigar* (1999); Waddington Galleries, London, *Michael Craig-Martin: Conference* (2000); Tate Britain, *Intelligence: New British Art* (2000); IVAM, Centre del Carme, Valencia, *Michael Craig-Martin* (2000).

GRENVILLE DAVEY

BIOGRAPHY: Born Launceston, Cornwall, 1961. Studied at Exeter College of Art and Design 1981, and Goldsmiths' College of Art, London, 1982–85. Solo exhibitions include Lisson Gallery, London, 1987 and 1989; Kunsthalle Bern 1989; Württembergischer Kunstverein, Stuttgart 1983. Won Turner Prize 1992. Visiting Professor, London Institute; Research Fellow in Drawing, University of East London. Lives in London.

BIBLIOGRAPHY: Lisson Gallery, London, *Grenville Davey* (1989); Kunsthalle Bern, *Grenville Davey* (1992); Musée Départemental de Rochechouart, *Grenville Davey* (1994); Scottish National Gallery of Modern Art, Edinburgh, *Contemporary British Art in Print* (1995).

MICHAEL CRAIG-MARTIN

RICHARD DEACON

BIOGRAPHY: Born Bangor, Wales, 1949. Studied at Somerset College of Art 1968–69, St Martin's School of Art, London, 1969–72 and Royal College of Art, London, 1974–77. Has exhibited with Lisson Gallery, London, since 1983. Shortlisted for Turner Prize 1984; won Turner Prize 1987. Solo exhibitions include Whitechapel Art Gallery, London, 1988; Musée d'Art Moderne de la Ville de Paris 1989; Museum Haus Esters, Krefeld, 1991; Tate Gallery, Liverpool, 1999; DCA, Dundee, 2001. Trustee of the Tate Gallery 1992–97. Lives in London.

BIBLIOGRAPHY: Fruitmarket Gallery, Edinburgh, *Richard Deacon: Sculpture 1980–1984* (1988); Whitechapel Art Gallery, *Richard Deacon* (1988); Jon Thompson, Pier Luigi Tazzi, Peter Schjeldahl and Penelope Curtis *Richard Deacon* (London 1995; enlarged edition 2000); Jeu de Paume, Paris, *Un siècle de sculpture anglaise* (1996); Tate Gallery, Liverpool, *New World Order / Richard Deacon* (1999).

PETER DOIG

BIOGRAPHY: Born Edinburgh 1959. Lived in Trinidad 1961–66, then Canada 1966–79. Studied at Wimbledon School of Art 1979–80 and St Martin's School of Art, London, 1980–83. Returned to Canada 1987–89, then moved back to London, studying at Chelsea School of Art 1989–90. Solo and group exhibitions at Victoria Miro Gallery, London, since 1994. Won John Moores Painting Prize 1993 and Elliette Von Karajan prize, Salzburg 1994; shortlisted for Turner Prize 1994. Trustee of the Tate Gallery, London, 1995–2000. Solo exhibition at Whitechapel Art Gallery, London, 1998. Lives in London.

BIBLIOGRAPHY: Gareth Jones, 'Weird Places, Strange Folk. The Paintings of Peter Doig' in *Frieze*, no.6, September–October 1992, pp.25–27; Hayward Gallery, London, *Unbound: Possibilities in Painting* (1994); Victoria Miro Gallery, London / *Peter Doig: Blotter* (1995); Kunsthaus zu Kiel / Whitechapel Art Gallery, London, *Peter Doig: Blizzard Seventy-Seven* (1998); Virginia Button, *The Turner Prize* (Tate, London, 1999); Kunsthaus Glarus, *Peter Doig – Version* (1999); Thad Ziolkowski, 'Peter Doig' in *Artforum* February 2000; Johanne Sloan, 'Rainbows and other Ruins' and Daniel Richter, 'Dots on Doig' in *Afterall*, no.2, 2000.

ANGUS FAIRHURST

BIOGRAPHY: Born Kent 1966. Studied at Canterbury College of Art 1985–86 and Goldsmiths College of Art, London, 1986–89. Solo exhibition at Karsten Schubert Ltd., London, 1990–94; Sadie Coles Gallery, London, 1998; Ursula Blickle Stiftung, Kraichtal, 1999. Lives in London.

BIBLIOGRAPHY: Gregor Muir, 'Angus Fairhurst' in *Frieze*, June–August 1994; Serpentine Gallery, London, *Some Went Mad, Some Ran Away* (1994); Walker Art Centre, Minneapolis, *Brilliant! New Art From London* (1995); Ursula Blickle Stiftung, Kraichtal, *Angus Fairhurst* (1999); Royal Academy of Arts, London, *Apocalypse* (2000).

SIR TERRY FROST

BIOGRAPHY: Born Leamington Spa 1915. Prisoner of War in Germany 1941–45 when he was encouraged to draw by artist Adrian Heath. Studied art in St Ives 1946–47, and Camberwell School of Art, London, 1947–50, then returned to St Ives. Gregory Fellow in Leeds 1954–57. Moved to Banbury 1964 and taught in Coventry and Reading. Returned to Cornwall in 1974, settling in Newlyn. Solo exhibitions include Leicester Galleries, London, 1952; Arts Council touring exhibition, 1976; Waddington Galleries, London, from 1960; Royal Academy of Arts, London, 2000; Beaux-Arts Gallery, London, 2000. Royal Academician 1992. Knighted 1998. Lives in Cornwall.

BIBLIOGRAPHY: Elizabeth Knowles, David Lewis, et.al., *Terry Frost* (Aldershot 1994); Mel Gooding, *Terry Frost: Act and Image. Works on Paper Through Six Decades* (London

2000); Royal Academy of Arts, London, 1991; British Art Show 4, 1995; Tokyo Opera City, Releasing the Senses, 1999; Terry Frost (London 2000).

HAMISH FULTON

BIOGRAPHY: Born London 1946. Studied at Hammersmith School of Art, London, 1964–65, and Royal College of Art, London, 1966–68. Solo exhibitions include Galerie Konrad Fischer, Düsseldorf, 1969; Kunstmuseum, Basel, 1975; Stedelijk van Abbemuseum, Eindhoven, 1985; Albright-Knox Art Gallery, Buffalo, and National Gallery of Canada, Ottawa, 1990; Serpentine Gallery, London, 1991. Lives in Canterbury, Kent.

BIBLIOGRAPHY: Hamish Fulton, Skyline Ridge (London 1975); Hamish Fulton, Roads and Paths (Munich 1978); Hamish Fulton, Camp Fire (Stedelijk Van Abbemuseum, Eindhoven, 1985); Staatliche Kunsthalle, Baden-Baden, Hamish Fulton (1992); Serpentine Gallery, London, Hamish Fulton: Bird Song (1991); Hamish Fulton, Walking Passed – Standing Stones, Cairns, Milestones, Rocks & Boulders (IVAM, Valencia, 1992); Scottish National Gallery of Modern Art, Edinburgh, Contemporary British Art in Print (1995); Angela Vettese, Hamish Fulton, Walking Artist (2001).

ANYA GALLACCIO

BIOGRAPHY: Born Glasgow 1963. Studied at Goldsmiths College of Art, London, 1985–88. Solo exhibitions include Karsten Schubert Gallery, London, 1991; Galerie Krinzinger, Vienna, 1993; Art Pace, Texas, 1997; Delfina, London, 1998. Group exhibitions include Broken English, Serpentine Gallery, London, 1991; British Art Show 4, 1995; Tokyo Opera City, Releasing the Senses, 1999; Innsbruck, The Invisible Touch, 2000. Lives in London.

SIOBHÁN HAPASKA

BIOGRAPHY: Born 1963. Studied at Middlesex Polytechnic 1985–88, then Goldsmiths College of Art, London, 1990–92. Solo exhibition at ICA, London, 1995; Entwistle Gallery, London, 1997. Group exhibitions include Wonderful Life, Lisson Gallery, London, 1993; Konsthall, Stockholm, 2000. Lives in London.

BIBLIOGRAPHY: ICA, London, Siobhán Hapaska (1995); Sarah Kent (intro.), Young British Art: The Saatchi Decade (London 1999).

PATRICK HERON

BIOGRAPHY: Born Leeds, 1920. Moved close to Newlyn, Cornwall, in 1925, to St Ives in 1928 and to Welwyn Garden City in 1929. Studied part-time at Slade School of Art 1937–39. Moved to London 1945. Wrote extensively on art from 1945, particularly in New Statesman and Nation. First London solo exhibition at Redfern Gallery, 1947. Retrospective exhibition at Wakefield City Art Gallery 1952. Moved to Eagles Nest, in Zennor, Cornwall, in 1955, and remained there until his death. First New York exhibition 1960. Trustee of Tate Gallery 1980–87. Made stained-glass window for new Tate St Ives 1992. Retrospective exhibition at Tate Gallery, London, 1998. Died 1999.

BIBLIOGRAPHY: Ronald Alley, Patrick Heron: The Development of a Painter (London 1967); Vivien Knight (ed.), Patrick Heron (London 1988); Mel Gooding, Patrick Heron (London 1994); Tate Gallery, London, Patrick Heron (1998); Mel Gooding (ed.), Painter as Critic. Patrick Heron: Selected Writings (London 1998); Waddington Galleries, London, Patrick Heron: Early Paintings 1945–1955 (2000).

DAMIEN HIRST

BIOGRAPHY: Born Bristol 1965, grew up in Leeds. Studied at Leeds College of Art, then Goldsmiths College of Art, London, 1986–89. Organised the exhibitions Freeze (1988) and Modern Medicine (1990), which launched the reputations of a new generation of young artists, including his own. Won Turner Prize 1995. Numerous mixed exhibitions including Young British Artists I at the Saatchi Gallery, 1992. Solo exhibitions include ICA, London, 1991; Gagosian Gallery, New York, 1996 and 2000. Lives in Devon and London.

BIBLIOGRAPHY: ICA, London, Damien Hirst: Internal Affairs (1991); Sarah Kent, Shark Infested Waters. The Saatchi Collection of British Art in the 90s (London 1994); South Bank Centre (UK touring exhibition) British Art Show 4 (1995); Gagosian Gallery, New York, Damien Hirst, No Sense of Absolute Corruption (1996); Gordon Burn et al., Damien Hirst, I Want to Spend the Rest of My Life Everywhere, with Everyone, one to one, Always, Forever, Now (London 1997); Royal Academy of Arts, London, Sensation – Young British Artists From The Saatchi Collection (1997); Saatchi Gallery, London, Ant Noises at the Saatchi Gallery (2000); Gagosian Gallery, New York, Damien Hirst: Theories, Models, Methods, Approaches, Assumptions, Results and Findings (2000).

GARY HUME

BIOGRAPHY: Born Kent 1962. Studied at Goldsmiths College of Art, London, 1985–88. Represented Britain at Venice Biennale, 1999. Solo exhibitions at Scottish National Gallery of Modern Art, Edinburgh, and Whitechapel Art Gallery, London, 1999. Lives in London.

BIBLIOGRAPHY: Southbank Centre, London, The British Art Show 1990 (1990); Hayward Gallery, London, Unbound: Possibilities in Painting (1994); Kunsthalle Bern, Gary Hume Paintings (1995); Parkett, no.48, pp.12–45, 1996; Royal Academy of Arts, London, Sensation – Young British Artists From The Saatchi Collection (1997); British Pavilion, XLVIII Venice Biennale, Gary Hume, 1999; Whitechapel Art Gallery, London, Gary Hume (1999).

ANISH KAPOOR

BIOGRAPHY: Born Bombay, India, 1954. Studied at Hornsey College of Art, London, 1973–77 and Chelsea School of Art 1977–78. Artist in Residence, Walker Art Gallery, Liverpool, 1982. Solo exhibitions include Lisson Gallery, London, since 1982; Kunsthalle, Basel, 1985; Kunstverein Hannover, 1991; Fondazione Prada, Milan, 1995; Hayward Gallery, London, 1998. Represented Britain at Venice Biennale, 1990 (awarded Premio Duemila); won Turner Prize 1991. Lives in London.

BIBLIOGRAPHY: Kunstnernes Hus, Oslo, Anish Kapoor (1986); Jeremy Lewison, Anish Kapoor: Drawings (Tate Gallery 1990); British Council, British Pavilion, XLIV Venice Biennale, Anish Kapoor (1990); Jeu de Paume, Paris, Un siècle de sculpture anglaise (1996); Hayward Gallery, London, Anish Kapoor (1998); Germano Celant, Anish Kapoor (Milan 1998).

ABIGAIL LANE

BIOGRAPHY: Born Penzance 1967. Studied at Bristol Polytechnic 1985–86 and Goldsmiths College of Art, London, 1986–89. Exhibited in Freeze, London, 1988. Solo exhibitions include Karsten Schubert, London, 1992; ICA, London, 1995; Museum of Contemporary Art, Chicago, 1998. Lives in London.

BIBLIOGRAPHY: Sarah Kent, Shark Infested Waters. The Saatchi Collection of British Art in the 90s (London 1994); Serpentine Gallery, London, Some Went Mad, Some Ran Away (1994); ICA, London, Abigail Lane (1995); Royal Academy of Arts, London, Sensation – Young British Artists From The Saatchi Collection (1997); Museum of Contemporary Art, Chicago, Abigail Lane: Whether the Roast Burns, the Train Leaves, or the Heavens Fall (1998); Sarah Kent (intro.), Young British Art: The Saatchi Decade (London 1999).

LANGLANDS & BELL

BIOGRAPHY: Ben Langlands born London 1955; Nikki Bell born London 1959. Both studied at Middlesex Polytechnic, London, 1977–80, and have worked together since then. Exhibitions include Film Makers Co-Op, London, 1978 and 1980; Air Gallery, London, 1987; Kelvingrove Museum, Glasgow, 1992; Château de Chambord & La Criée (FRAC Centre), 1993; Serpentine Gallery, London, 1996; New York MoMA, *Architecture as Metaphor*, 1997; *Pasato, Presente, Futuro*, 47th Biennale di Venezia 1997; Yale Centre for British Art, New Haven, 1999; Central House of the Artist, Moscow, 2000. Live in London.

BIBLIOGRAPHY: Jackie Apple, *The Book as Object/Subject* (Bookworks, 1980); Adrian Dannant, *Langlands and Bell* (6 vols., Frankfurt, London, 1996); Royal Academy of Arts, London, *Sensation – Young British Artists From The Saatchi Collection* (1997); Sarah Kent (intro.), *Young British Art: The Saatchi Decade* (London 1999); Akiko Miyake and Nobuo Nakamura, *Lets Talk About Art* (CCA Kitakyushu 1999); Nick Barley, *Breathing Cities – The Architecture of Movement* (London, 2000).

CHRISTOPHER LE BRUN

BIOGRAPHY: Born Portsmouth 1951. Studied at Slade School of Art, London, 1970–74 and Chelsea, School of Art 1974–75. Solo exhibitions include Kunsthalle Basel, 1985, Astrup Fearnley Museum, Oslo, 1995.

Exhibited with Nigel Greenwood Gallery, London, and Speroni Westwater, New York, until 1992; since then has shown regularly with Marlborough Fine Art. Trustee of the Tate Gallery, London, 1990–95, and Trustee of the National Gallery, London, from 1995. Lives in London.

BIBLIOGRAPHY: Fruitmarket Gallery, Edinburgh, *Christopher Le Brun: Paintings 1984–1985* (1985); Stephen Bann, *Christopher Le Brun: Fifty Etchings* (London 1991); Marlborough Fine Art (London), *Christopher Le Brun: Recent Work* (1998); National Gallery, London, *Close Encounters: New Art from Old* (2000).

ADAM LOWE

BIOGRAPHY: Born Oxford 1959. Studied at Ruskin School of Drawing, Oxford, 1979–81, and Royal College of Art, London, 1982–85. Established Permaprint in Crosby Row, London, 1994. Solo exhibition at the Russian State Museum, St Petersburg, 2000. Won international prize for technical innovations in printmaking, Spain, 2000. Lives in London.

BIBLIOGRAPHY: *Adam Lowe* (ArT Random, 1991); Pomeroy Purdy Gallery, London, *Registration Marks* (1992); Reeds Wharf Gallery, London, *Baseless Fabric* (1994); Adam Lowe (ed.), *Digital Prints* (London 1997); Kettle's Yard, Cambridge, *Noise* (2000); Atwerp Open, *Laboratorium* (1999); Ludwig Museum, St Petersburg, *The Texture of Print: Adam Lowe Published

Prints 1990–2000 (2000); *Premio Nacional de Grabado Calcografía Nacional* (Madrid 2000).

IAN McKEEVER

BIOGRAPHY: Born Withernsea, Yorkshire, 1946. Moved to London 1965 to study English literature. Self-taught, he began painting in 1969. First solo exhibition at Cardiff Arts Centre 1971. Retrospectives at Kunstverein Braunschweig 1987 and Whitechapel Art Gallery, London, 1990. Since 1991 has lived on a farm in Dorset. Lecturer at Slade School of Art, London, 1992–96.

BIBLIOGRAPHY: Whitechapel Art Gallery, London, *Ian McKeever: Paintings 1978–1990* (1990); Matt's Gallery, London, *The Marianne North Paintings* (1995); Scottish National Gallery of Modern Art, Edinburgh, *Contemporary British Art in Print* (1995); University of Brighton, *Ian McKeever: Works on Paper* 1981–1996 (1996); Alan Cristea Gallery, London, *Ian McKeever: Colour Etchings* (1998); Alan Cristea Gallery, London, *Ian McKeever: Twelve x Eight and Other Woodcut Monoprints 1997–98* (1998); Alan Cristea Gallery, London, *Ian McKeever: Paintings and Works on Paper* (2000).

BRUCE McLEAN

BIOGRAPHY: Born Glasgow 1944. Studied at Glasgow School of Art 1961–63, and at St Martin's School of Art, London, 1963–66. Worked in performance art from late 1960s as well as in painting and printmaking. Solo exhibitions include Galerie Konrad Fischer, Düsseldorf 1969; *King for a Day*, a one-day exhibition at the Tate Gallery, London, 1972; Stedelijk Van

Abbemuseum, Eindhoven, 1982; Whitechapel Art Gallery, London, 1983. DAAD Fellowship in Berlin 1981. Lives in London. Teaches printmaking at Slade School of Fine Art, London.

BIBLIOGRAPHY: Mel Gooding, *Bruce McLean* (Oxford 1990); Jeremy Hunt, *Bruce McLean Prints 1978–1991* (London 1992).

LISA MILROY

BIOGRAPHY: Born Vancouver 1959. Studied in Paris 1977–78 then moved to London. Studied at St. Martin's School of Art, London, 1978–79, and Goldsmiths College of Art 1979–82. Won John Moores Prize 1989. Solo exhibitions include Third Eye Centre, Glasgow, 1989; Mary Boone Gallery, New York, 1989; Kunsthalle Bern 1990; Waddington Gallery, London, 1993; Chisenhale Gallery, London, 1995; Tate Liverpool, 2001. Lives in London.

BIBLIOGRAPHY: Third Eye Centre, Glasgow, *Lisa Milroy* (1989); Chisenhale Gallery, London, *Lisa Milroy: Travel Paintings* (1995); Tate Liverpool, *Lisa Milroy* (2001).

CHRIS OFILI

BIOGRAPHY: Born Manchester 1968. Studied at Chelsea School of Art 1988–91, and Royal College of Art, London, 1991–93. Won British Council travelling scholarship to Zimbabwe, 1992. Has exhibited with Victoria Miro Gallery, London, since 1995. Solo exhibitions include Gavin Brown's Enterprise, New York, 1995, and Southampton Art Gallery / Serpentine Gallery, London, 1998–99; drawing exhibition at Victoria Miro Gallery, 2000. Won Turner Prize 1998.

BIBLIOGRAPHY: Stuart Morgan, 'The Elephant Man' in *Frieze* no.15, March–April 1994, pp.40–43; Walker Art Centre, Minneapolis. *Brilliant! New Art From London* (1995): Royal Academy of Arts, London, *Sensation – Young British Artists From The Saatchi Collection* (1997); Southampton Art Gallery and Serpentine Gallery, London, *Chris Ofili* (1998); Virginia Button, *The Turner Prize* (Tate, London, 1999); Sarah Kent (intro.), *Young British Art: The Saatchi Decade* (London 1999); Paul Miller, 'Deep Shit: An interview with Chris Ofili' in *Parkett*, no.58, 2000.

MARC QUINN

BIOGRAPHY: Born London 1964. Studied History and History of Art at Cambridge University 1982–85. Worked as assistant to sculptor Barry Flanagan 1982–86. Solo exhibitions include Jay Jopling / Grob Gallery, London, 1991; Tate Gallery, London, 1995; Gagosian Gallery, New York, 1998; Kunstverein Hannover, 1999; Fondazione Prada, Milan, 2000; *White Cube²*, London, 2000. Lives in London.

BIBLIOGRAPHY: Sarah Kent, *Shark Infested Waters. The Saatchi Collection of British Art in the 90s* (London 1994); Marc Sanders, 'Invasion of the Body Sculptures in *Dazed and Confused*, no.13, 1995. pp.42–45; Royal Academy of Arts, London, *Sensation – Young British Artists From The Saatchi Collection* (1997); Will Self, David Thorp, Mark Gisbourne, et.al., *Marc Quinn: Incarnate* (London 1998); Sarah Kent (intro.), *Young British Art: The Saatchi Decade* (London 1999); Fondazione Prada, Milan, *Marc Quinn* (2000).

GEORGINA STARR

BIOGRAPHY: Born Leeds 1968. Studied at Middlesex Polytechnic 1987–89, Slade School of Fine Art 1990–92 and Rijksakademie Van Beeldende Kunst 1993–94. Group exhibitions include *The British Art Show 4*, 1995; Museum of Modern Art, New York, *New Photography 12*, 1995; Stedelijk Van Abbemuseum, Eindhoven, *I.D.* 1996; Museum of Modern Art, Kyoto and Museum of Contemporary Art, Tokyo, *Visions of The Body*, 1999. Solo exhibitions include Kunsthalle Zurich, *Visit to a Small Planet*, 1995; Tate Gallery, London, *Hypnodreamdruff*, 1996; Ikon Gallery, Birmingham, *Tuberama*, 1998; Anthony Reynolds Gallery, London, *The Bunny Lakes are Coming*, 2000. Lives in London.

BIBLIOGRAPHY: Kunsthalle Zurich, *Visit to a Small Planet* (1995); Stedelijk Museum, Amsterdam, *Wild Walls* (1995); South Bank Centre (UK touring exhibition) *British Art Show 4* (1995); Henry Moore Institute, Halifax *The Cauldron*, (1996); The Power Plant, Toronto, *Hypermnesiac Fabulations* (1997); Museum of Contemporary Art, Sydney, *Picture Britannica* (1997); Ikon Gallery, Birmingham, *Georgina Starr* (1998).

SAM TAYLOR-WOOD

BIOGRAPHY: Born London 1967. Studied at Goldsmiths College of Art, London, 1987–90. Solo exhibitions include The Showroom, London, 1994; Chisenhale Gallery, London, 1996; Kunsthalle Zurich and Louisiana Museum of Modern Art, Humlebaek, 1997; Fondazione Prada, Milan, 1998; Hirshhorn Museum, Washington, DC, 1999. Shortlisted for Turner Prize 1998. Lives in London.

BIBLIOGRAPHY: Walker Art Centre, Minneapolis, *Brilliant! New Art From London* (1995); Chisenhale Gallery, London, *Sam Taylor-Wood* (1996); Royal Academy of Arts, London, *Sensation – Young British Artists From The Saatchi Collection* (1997); Kunsthalle Zurich and Louisiana Museum of Modern Art, *Sam Taylor-Wood* (1997); Fondazione Prada, Milan, *Sam Taylor-Wood; Five Revolutionary Seconds* (1997); Fundació la Caixa, Barcelona, *Sam Taylor-Wood* (1997).

GILLIAN WEARING

BIOGRAPHY: Born Birmingham 1963. Studied at Chelsea School of Art 1985–87 and Goldsmiths College of Art, London, 1987–90. Solo exhibitions include City Racing, London, 1993; Chisenhale Gallery, London, 1997; Kunsthaus Zurich, 1997; Serpentine Gallery, London, 2000. Won Turner Prize 1997. Lives in London.

BIBLIOGRAPHY: Adrian Searle, 'Gillian Wearing' in *Frieze*, September–October 1994, pp.61–2; Royal Academy of Arts, London, *Sensation – Young British Artists From The Saatchi Collection* (1997): Virginia Button, *The Turner Prize* (Tate, London, 1999); Sarah Kent (intro.), *Young British Art: The Saatchi Decade* (London 1999); Tate Britain, *Intelligence: New British Art* (London 1999); Serpentine Gallery, London, *Gillian Wearing* (2000).

RACHEL WHITEREAD

BIOGRAPHY: Born London 1963. Studied at Brighton Polytechnic 1982–85 and Slade School of Art, London, 1985–87. Solo exhibitions include Chisenhale Gallery, London, 1990; Stedelijk Van Abbemuseum, Eindhoven, 1993; Tate Gallery, Liverpool, and Palacio de Velázquez, Madrid, 1996–97; Serpentine Gallery, London, and Scottish National Gallery of Modern Art, Edinburgh, 2001. Won Turner Prize 1994; represented Britain at 1997 Venice Biennale. Major works include *House*, 1993–94 (destroyed); and *Judenplatz Holocaust Memorial*, Vienna, 2000. Lives in London.

BIBLIOGRAPHY: Karsten Schubert Ltd., London, *Rachel Whiteread: Plaster Sculptures* (1993): Friedrich Meschede (ed.), *Rachel Whiteread: Gouchen* (Stuttgart 1993): *Parkett*, no.42, 1993, pp.76–111; James Lingwood (ed.), *Rachel Whiteread: House* (London 1995): Tate Gallery, Liverpool, *Rachel Whiteread: Shedding Life* (1996): British Pavilion, XLVII Venice Biennale, *Rachel Whiteread* (1997): Royal Academy of Arts, London, *Sensation – Young British Artists From The Saatchi Collection* (1997): Sarah Kent (intro.), *Young British Art: The Saatchi Decade* (London 1999).

BILL WOODROW

BIOGRAPHY: Born near Henley, Oxfordshire, 1948. Studied at Winchester School of Art 1967–68, St Martin's School of Art, London, 1968–71, and Chelsea School of Art 1971–72. Solo exhibitions including Kunsthalle, Basel, 1985; Fruitmarket Gallery, Edinburgh, 1986; Kunstverein, Munich, 1987; Imperial War Museum, London, 1989; Tate Gallery, London, 1996; Trustee of the Tate Gallery from 1996. Lives in London.

BIBLIOGRAPHY: Museum of Modern Art, Oxford, *Bill Woodrow: Beaver, Bomb and Fossil* (1983); Fruitmarket Gallery, Edinburgh, *Bill Woodrow: Sculpture 1980–86* (1986); Musée des Beaux-Arts Le Havre and Calais, *Bill Woodrow: Eye of the Needle, Sculptures 1987–1989* (1989); Jeu de Paume, Paris, *Un siècle de sculpture anglaise* (1996).

CERITH WYN EVANS

BIOGRAPHY: Born Llanelli, Wales, 1958. Studied at St Martin's School of Art 1977–80, and MA in Film and Video at Royal College of Art, London, 1982–84. Solo exhibitions include White Cube, London, 1996; British School at Rome 1998; Tate Britain (Art Now series) 2000. Lives in London.

BIBLIOGRAPHY: Marc Sladen, 'Cerith Wyn Evans' in *Frieze*, no.30, 1996, p.75; Royal Academy of Arts, London, *Sensation – Young British Artists From The Saatchi Collection* (1997); *The Saatchi Collection* (1997); Sarah Kent (intro.), *Young British Art: The Saatchi Decade* (London 1999).

CATHERINE YASS

BIOGRAPHY: Born London 1963. Studied at Slade School of Art 1982–86, Hochschule der Künste, Berlin, 1984–85 (Boise travelling scholarship 1986–87) and Goldsmiths College of Art, London 1988–90. Participated in *British Art Show 4*, 1995. Solo exhibitions include Laure Genillard Gallery, London, 1992 and 1996; New Art Gallery, Walsall, 2000; Asprey Jacques, London, 2001; Jerwood Gallery, London, 2001. Lives in London.

BIBLIOGRAPHY: South Bank Centre (UK touring exhibition), *British Art Show 4* (1995); Greg Hilty, *Catherine Yass* (London 2000).

ACID: Used in etching to bite into the surface of the metal plate and create line or tone. Nitric acid, hydrochloric acid and ferric chloride are commonly used.

A LA POUPÉE: A very precise method of inking an etching plate, using a piece of scrim, folded around itself and formed into a point. The folded scrim resembles a small rag doll, hence the French term poupée. This pointed form of the pad permits very careful multiple colouring of a single plate. This technique was used in the inking of the etchings by Patrick Heron.

AQUATINT: Aquatint is a means of producing tone rather than line. The artist covers the etching plate with grains of rosin (a type of resin). When the plate is immersed in acid the liquid eats into the metal around each grain, leaving a tiny etched ring around each. The acid can be applied over the whole plate to give an even tone or painted on by hand to create the effect of brushstrokes.

ARTIST'S PROOF: The artist normally makes several 'proofs' (see below) of the finished print outwith the numbered edition. Works from the numbered edition are available for general sale while the artist or publisher may retain the artist's proof copies for their own use.

BAT: Stands for 'Bon à tirer' (good for printing), a French term which means that the final proofed print has been checked and approved by the artist and that the printers can edition the print, using the BAT as a guide.

BURNISHING: Done with a burnisher, a steel tool which has a smooth, rounded point. By rubbing the point on the metal etching plate, the metal flattens to make it print in a lighter, softer form.

CHINE COLLÉ: Chine is an extremely thin type of rice paper. It can be stuck ('collé' in French) on to the printing paper, prior to printing the image, in order to give a different ground tone. This technique was used by the Chapman brothers in the two variant editions of their *Disasters of War* etchings, and also by Peter Doig in *Ten Etchings* and by Lisa Milroy for her prints in the mixed portfolio *Twelve Prints by Six Artists*.

COLOPHON: Printed page in book or portfolio carrying mainly technical information about the contents, for example date, paper type, printer, technique etc.

DEEP-BITE ETCHING: By leaving the etching plate for a long time in the acid bath, the acid bites very deeply into the etched lines.

DRYPOINT: A technique similar to etching except that instead of drawing into the waxy ground and then biting into the plate with acid to produce a line, the line is scratched directly into the plate with a sharp needle, which can be used much like a pen. This technique produces fine ridges of metal on either side of the scratched line: when inked the ridges retain a quantity of ink and this gives the printed line a rich, velvety quality.

DYE: A tinted liquid with no physical body, used in many photographic processes.

EDITION: Prints can be made in editions of between one and many thousand copies. With most printing techniques the plate or screen will become worn if very many prints are made, so to maintain quality

(and exclusivity) editions of original prints are usually kept below one hundred copies and normally average between thirty and fifty copies. Prints made up of several different plates can be extremely complicated and time-consuming to edition, so in these cases editions are kept low for practical reasons.

ENGRAVING: The engraver pushes a lozenge-shaped chisel called a 'burin' through the plate (either metal or wood), leaving a clean-edged incision. This technique requires a great deal of control and is not suited to spontaneous mark-making.

ETCHING: A metal plate, normally copper, zinc or steel, is covered with an acid-resistant layer of rosin mixed with wax (this is called the 'ground'). With a sharp point, the artist draws through this ground, but not into the metal plate. The plate is placed in an acid bath and the acid bites into the metal plate where the drawn lines have exposed it. (If the plate is left in the acid for a long time, the technique is known as deep-bite etching: see above.) The waxy ground is cleaned off and the plate is covered in ink, then wiped clean, so that ink is retained only in the etched lines. The plate can then be printed through an etching press. The strength of the etched lines depends on the length of time the plate is left in the acid bath.

HARDGROUND ETCHING: This is the normal etching method, but it is referred to as hardground to distinguish it from softground etching (see below).

HORS DE COMMERCE: French term meaning that this copy of a print or book is intended for display purposes only and is not for sale.

INK-JET (PIGMENT) PRINT: The principle behind ink-jet printing was established over 100 years ago. Recent developments in piezoelectric technology have resulted in increasingly high resolution colour prints. When subjected to an electrical charge, the piezoelectric crystal expands, forcing ink through an array of microscopic holes onto the surface of the paper or other surface. The resolution of the print is significantly enhanced if the paper is coated with an impermeable barrier to keep the droplet on the surface. Until recently, ink-jet printers could only use dye inks, but improvements to the ink and print heads are resulting in pigment inks. These have reduced colour range but increased life expectancy. Marc Quinn's *Garden?* was printed by this technique.

LETTERPRESS: A traditional method of printing text. The text is set in metal or wooden letters: these letters are in reverse and in relief. The surface is inked up and the paper is pressed down on to it.

LINOCUT: The artist cuts into the surface of a piece of lino with a simple gouge, knife or engraver's tool. The surface of the lino is inked and printed: this can be done by passing it through a press, though it can also be done manually by rubbing the paper onto the lino with a spoon or similar implement. Bill Woodrow's *The Beekeeper* prints are colour linocuts made from several linocut sections fitted together.

LITHOGRAPHY: Lithography means, literally, stone drawing. In addition to fine grain lithographic stones, metal plates can also be used for lithography. The method relies on the fact that grease repels

water. An image is drawn in a greasy medium onto the stone or plate, which is then dampened with water. Greasy printing ink rolled onto that surface will adhere to the design but be repelled by the damp area. The inked image is transferred to the paper via a press. For large editions, the grease is chemically fixed to the stone and gum arabic, which repels any further grease marks but does not repel water, is applied to the rest of the surface. For colour lithography the artist uses a separate stone or plate for each colour required.

MEZZOTINT SCREENS: A random dot screen used for photographic screenprints, as opposed to a mechanically-generated dot screen. Rachel Whiteread's *Demolished* prints were made with mezzotint screens.

MONOPRINT: This is a single, unique print, made by the artist with this intention. A monoprint can be produced by any printing technique — screenprint, etching, lithography — but is only issued as a single print, and is not editioned. Christopher Le Brun's *Motif Light* prints could almost be classified as monoprints, since they are hand-printed individually, using hand rubbing and a spoon, and each is marginally different.

MONOTYPE: The artist may draw or paint onto a surface such as glass or metal and then press paper onto the image to take its impression. Because the ink or other medium is transferred to the paper only one good impression can be made.

OFF-SET ETCHING: The etched plate is printed on to the paper in the normal way, but the paper is left in the press. It is then itself printed on to a fresh etching

plate, in other words, it is 'off-set'. The ink acts as a resist, and when it is bitten with acid, leaves a much softer line than can be achieved directly with an etching needle. Some of the etchings in Peter Doig's *Ten Etchings* series were printed in this way.

OFF-SET LITHOGRAPHY: A technique developed at the end of the nineteenth century, it works on the same principal as lithography (see above), ie. relying on the fact that grease repels water. A large, rubber-covered cylinder rolls over the inked-up lithographic plate so that the ink is transferred onto the rubber. The cylinder then rolls over a sheet of paper, on to which the image is transferred. This double-transfer technique allows the artist's design to be printed the right way around (in straightforward lithography the image is printed in reverse). The off-set lithography process can be highly automated and is widely used in commercial printing to make large numbers of prints very quickly. Books are normally printed by the off-set method.

OPEN-BITE ETCHING: The artist paints directly on to the metal etching plate with acid.

PHOTOGRAVURE: This technique was common in the late nineteenth century but is rarely used today. Essentially it means transferring a photographic image onto an etching plate. A photograph is taken of a painting or other image, then the photograph is transferred on to a large sheet of bromide film. From these bromides large transparencies can be made, to the scale of the desired print. The transparency is exposed to a sensitized sheet of gelatine and is then transferred on to a copper plate with a squeegee. The image is etched through the gelatine film on to the copper

PIGMENT TRANSFER PRINT: Developed in the 1870s by the French photographer Louis Ducos du Hauron, he adapted the monochrome carbon photographic process by adding coloured red, green and blue pigments to the gelatine in place of the carbon black. This pigmented gelatine is sensitized and exposed through a negative to ultraviolet light. The coated paper is bathed in cold water and brought into contact with a sheet of paper or other support using a roller or squeegee. It is immersed in hot water and the coated paper is peeled away from the support and the gelatine rinsed away, to reveal the image. This process must be repeated four times (corresponding to cyan, magenta, yellow and black) to achieve a full colour image. Anish Kapoor's *Wounds and Absent Objects* prints were made by this process.

PROOF OR STATE: When the artist draws or etches on to the plate or lithographic stone, or uses any other such printing technique, he or she may wish to print the image from time to time to see how it is progressing: this is known as 'proofing' the image. These intermediate prints are known as 'trial proofs' or 'states'. Once proofed the artist can resume work on the image. Often an artist will proof the work several times before being satisfied with the result and can produce as many as thirty or forty trial proofs or states. In some cases the artist may conceive these trial proofs as publishable prints in their own right, and may make editions of the print at various stages in its making (Rembrandt did this). These editioned proofs are called 'states'. When the finished print is editioned, the artist generally makes a small number of proof copies outwith the numbered edition: these are known as 'artist's proofs' (see above).

PIGMENT: A physical body which produces colour.

SCREENPRINT: Also known as silkscreen. In its simplest form, this is a technique by which the artist blocks out sections of a fine, woven screen (formerly made of silk) which is stretched over a frame. With a squeegee, ink is pressed evenly through the screen onto a sheet of paper beneath. Only the areas of the screen not blocked out will be printed. Screenprints bearing several colours are made by printing through several different screens, one screen for each colour. Normally an artist will paint onto transparent sheets of film (the same size as the desired print) with a special photo-opaque paint through which light does not penetrate. The artist will use as many of these transparent sheets (separations) as the numbers of colours required in the print, and each sheet must be aligned very carefully with the others. The films are transferred onto the silkscreens via a light-sensitive process: only the areas which are painted by the artist will be blocked out and will not allow ink through. Screenprinting only became widely used in Europe from the late 1940s.

PRINTER'S PROOF: As with artist's proof copies, the publisher may make a copy (see above) of the print, outwith the full edition, for the printer to retain: this would be kept for record purposes.

ROSIN: A type of resin used in the production of aquatint and spitbite etchings.

SEPARATION: In screenprinting (see above) each colour is originated on a separate, transparent sheet of film, known as a separation. A complex screen-print requiring fifteen different colours will normally require fifteen different separations. A further subtlety is that a single separation may be used to generate two or more silk-screens, each of a slightly different density and each to be printed with the same colour. When such screens are printed on top of each other the colour has a rich, natural appearance.

SILKSCREEN: See Screenprint.

SOFTGROUND ETCHING: A variety of etching which uses a soft etching ground, composed of etching ground to which Vaseline or tallow has been added: this gives a soft, sticky ground which takes impressions easily. It may be used by the artist in two principal ways. Firstly, the artist may draw freely onto a sheet of paper laid on the softground plate: when it is removed it takes with it the sticky softground ink and the exposed plate may be etched in the usual way.

SPITBITE: An etching technique. The copper plate is first covered with powdered rosin, in exactly the same way that an aquatint plate is prepared. The artist applies acid onto this layer and it slowly bites through to the plate. The artist can literally spit into the acid to create different effects, though this is not an essential part of the spitbite process.

STATE: See Proof.

STOP-OUT: An etching term. The etching plate can be placed in an acid bath for a short time, taken out, and parts of the plate stopped out with varnish. When the plate is put back in the acid, the stopped out areas will not be bitten any further though the rest of the plate will continue to be bitten. With this technique the artist can make a print with a variety of fine and heavily etched lines of varying tones.

SUGARLIFT ETCHING: The etching plate is first coated with the powdered rosin used in the aquatint process. The artist then paints an image onto this with a special, water-based ink to which sugar has been added, and then coats the plate in varnish. The plate is immersed in warm water. The sugar dissolves and lifts off the coat of varnish to expose the metal. This ground is then etched with acid following the normal etching method. The technique gives an unusual, painterly effect.

TITLE-PAGE: The page or sheet at the front of the book or portfolio, bearing the title of the project and the artist's name.

TRANSFER LITHOGRAPHY: The artist draws or paints on to a sheet of transparent paper resembling greaseproof paper. The image on the paper is transferred, in reverse, onto a photo-sensitized lithographic stone or plate by shining light through it. Because the litho-graph prints in reverse, the final printed image is the same way around as the original image drawn or painted by the artist.

VARNISH: Also known as glaze, this is an ink with no pigment which has varying levels of gloss or matt finish. It is often used as the final screenprinted layer in screenprints, and protects the surface.